S0-AEO-686

The Figurative Tradition
and the
Whitney Museum of American Art

*Paintings and Sculpture
from the Permanent Collection*

The Figurative Tradition and the Whitney Museum of American Art

Paintings and Sculpture from the Permanent Collection

Patricia Hills and Roberta K. Tarbell

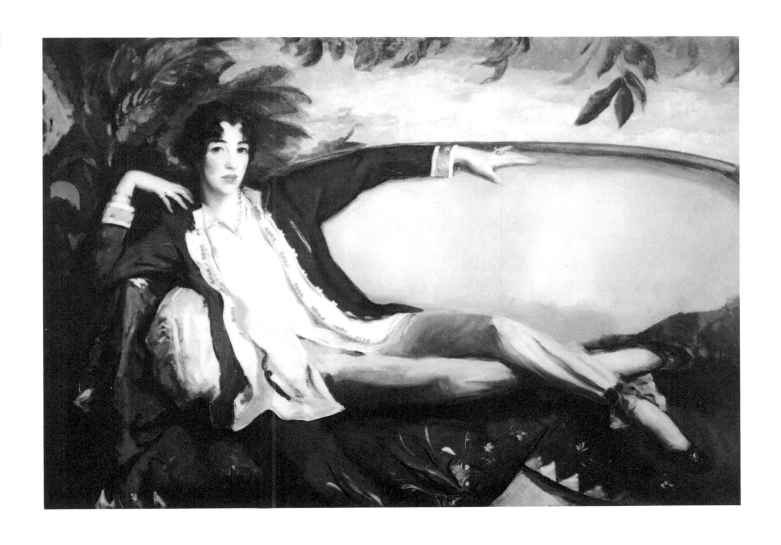

Whitney Museum of American Art, New York

in association with

Newark: University of Delaware Press *London and Toronto:* Associated University Presses

This book was published in conjunction with an exhibition at the Whitney Museum of American Art, June 25-September 28, 1980, supported by a grant from Manufacturers Hanover Trust Company. The publication was organized at the Whitney Museum by Doris Palca, *Head, Publications and Sales,* James Leggio, *Copyeditor,* Anita Duquette, *Rights and Reproductions,* and Anne Munroe, *Assistant.*

Tom Hudspeth, *Research Assistant,* served as exhibition assistant to the curators.

Copyright © 1980 by the Whitney Museum of American Art, 945 Madison Avenue, New York, New York 10021

Published in a hard-cover edition by

Associated University Presses
Cranbury, New Jersey 08512

Associated University Presses
Toronto M5E 1A7, Canada

Associated University Presses Ltd.
Magdalen House
136-148 Toolery Street
London SE1, 2TT, England

LIBRARY OF CONGRESS CATALOGING IN PUBLICATION DATA
Whitney Museum of American Art.
 The figurative tradition and the Whitney Museum of American Art.

 Bibliography: p. 183
 1. Figurative art—United States—Exhibitions.
2. Art, Modern—20th century—United States—Exhibitions.
3. Whitney Museum of American Art—Exhibitions.
I. Hills, Patricia. II. Tarbell, Roberta K.
III. Manufacturers Hanover Trust Company. IV. Title.
N6512.5.F5W46 1980 709'.73'07401471 80-12650

ISBN 0-87427-029-4
ISBN 0-87413-184-7 (hard cover)

front cover:
Duane Hanson, *Woman and Dog,* 1977 (Pl. 30).

back cover:
Leon Kroll, *Nude in a Blue Chair,* 1930 (Pl. 5).

frontispiece:
Robert Henri, *Gertrude Vanderbilt Whitney,* 1916 (Pl. 2).

Photographs are by Geoffrey Clements with the following exceptions:
The Baltimore Museum of Art, Fig. 144; Peter A. Juley and Son Collection, Smithsonian Institution, Washington, D. C., Figs. 79, 85; The New Britain Museum of American Art, New Britain, Connecticut, Fig. 10; Percy Rainford, Figs. 31, 52, 62, 72, 101; Steven Sloman Fine Arts Photography, Fig. 160; Jerry Thompson, Figs. 78, 88, Pls. 13, 14, 15, 31, 32; John Waggaman, Figs. 16, 17, 69.

Designer: Katy Homans
Typesetter: Trufont Typographers, Inc.
Printer: Eastern Press, Inc.

Contents

Sponsor's Message

Speaking for all of my colleagues at Manufacturers
Hanover, it is a pleasure for us once again to be
supporting a program at the Whitney Museum, this
time as it shares the richness of twentieth-century
American figurative art with the viewing public. This
exhibition is a particularly appropriate subject for our
sponsorship, for indeed the paintings and sculpture
represented are a celebration of America, a sounding of
the nation's unique tempo and temperament and the
vast diversity of its people. Our hope is that friends from
all walks of life will find joy in spending some time with
these remarkable works of art.

John F. McGillicuddy
Chairman of the Board and President
Manufacturers Hanover Trust Company

Foreword

The Whitney Museum of American Art was founded by Gertrude Vanderbilt Whitney in 1930, culminating her activities as the most important private patron of American art of her times. She established the institution both to house her own collection of more than 600 works (which she first offered to the Metropolitan Museum of Art in 1929 and was turned down) and as a means to continue the active support of American artists that she had begun more than twenty-five years before. Most of her patronage reflected her particular enthusiasm for figurative art, an interest maintained by the Museum in varying degrees throughout its history.

The daughter of Cornelius Vanderbilt, Gertrude grew up surrounded with works of art. In her early life she was certainly aware of the work of Augustus Saint-Gaudens, who carved portrait reliefs of her and her brother as well as the giant caryatids supporting the mantle in the entrance hall of the 37-room Vanderbilt home on Fifth Avenue between Fifty-seventh and Fifty-eighth Streets. When she was twelve, her father purchased for $52,000 one of the most famous paintings of the period, *The Horse Fair* by Rosa Bonheur, and gave it to the Metropolitan Museum of Art where he was chairman of the executive committee. It was the conservative, predominantly figurative art of the academic tradition that Gertrude knew as a young adult. Following her marriage to Harry Payne Whitney and the birth of their three children, she continued her study to become a professional figurative sculptor whose work would win commissions and prizes.

Mrs. Whitney's support of the arts was motivated by social and humanitarian concerns as well as artistic ones. She often purchased works of art as a way of helping artists in need. In extending financial assistance, she was particularly attracted to artists whose work had an affinity to her own. Many of the artists she supported were then considered part of the avant-garde and actively resisted the restrictive exhibition policies of the academies, but they were far less radical than the artists supported by Alfred Stieglitz, those who generally worked in abstract styles influenced by European modernism. For the most part, the artists whose work Mrs. Whitney exhibited and purchased remained committed to representational art, following a tradition established by Thomas Eakins and later continued through the activities of The Eight and the Art Students League.

In her work as a patron, Mrs. Whitney relied on a circle of friends and advisers comprising mostly figurative artists. With her assistant, Juliana Force, who became the first Director of the Museum, she consulted artists such as Alexander Brook, Assistant Director of the Whitney Studio Club from 1924 to 1928, Peggy Bacon, Guy Pène du Bois, Jo Davidson, Yasuo Kuniyoshi, and his wife at that time, Katherine Schmidt. As should be expected, the artists they recommended for her support were in sympathy with their own concerns. There were exceptions, of course, like Stuart Davis who bridged the gap between realism and abstraction, but on the whole the art Mrs. Whitney assembled, which became the core of the Museum's collection, was dominated by figurative art. Juliana Force, Director of the Museum from 1931 to 1948, and Hermon More, Director from 1948 to 1958, both worked closely with Mrs. Whitney to implement her ideas, and after her death in 1942 they continued to do so. As a result, figurative art remained a dominant aspect of the Museum's activities through the 1940s and 1950s.

The Museum has grown enormously since its founding in 1930, but the principles for which it was established have never been dismissed. Through the work of Lloyd Goodrich, associated with the Whitney Museum since 1931 and Director from 1958 to 1968, and his successor, John I. H. Baur, associated with the Museum since 1952 and Director from 1968 to 1974, the commitment to figurative art remained strong even as abstraction became the prevailing aesthetic in the years following World War II.

It is my belief that the strength of an institution derives from its continuing recognition of the ideas upon which it was founded. The Whitney Museum has always maintained its commitment to living artists and has continued to build upon the strengths of the collection donated by Mrs. Whitney. Now, after several decades in which abstraction dominated American art, artists are once again turning to realism and the figure. This publication and the exhibition it accompanies offer a view of a segment of the Permanent Collection that is strongly associated with the history of the Museum and an opportunity to see the perspectives these works may provide for the future. We are particularly thankful to the Manufacturers Hanover Trust Company, which has made this project possible.

Tom Armstrong
Director

Preface and Acknowledgments

Gertrude Vanderbilt Whitney and the Whitney Museum of American Art have played an important role in the history of art during our century. Since the preference of Mrs. Whitney, Juliana Force, and the staff of the Museum during its early decades was for figurative painting and sculpture, it is timely to focus on this aspect of the Permanent Collection in an exhibition celebrating the 50th Anniversary of the founding of the Museum. Such an anniversary suggests an occasion for reflection about the origins of the Permanent Collection. It is an auspicious time to examine both the philosophy of its founder and the aesthetic directions of figurative art with which she was so closely connected.

During the post-World War II years, changes occurred in American art which profoundly affected the direction of figurative painting and sculpture. Abstract artists questioned the traditionally rendered figure as a suitable form for aesthetic concerns, whereas humanistic realists, often afflicted with cultural pessimism, challenged traditional naturalism for being inadequate to the complexities of content. The Whitney Museum responded by accommodating the many tendencies which the staff had the foresight to recognize as valid. In the past two decades many artists have returned to the figure, and their works in the Whitney Museum collection represent an important gauge to measure the vitality of recent trends.

We would like to acknowledge our gratitude to Rudolf Baranik, John I. H. Baur, Wanda Corn, William I. Homer, and Kevin Whitfield for reading all or part of the catalogue and for discussing the important issues with us. The artists we interviewed whose works are included have been most helpful in telling us about their own art and the circumstances under which it was produced. They include Robert Arneson, Jack Beal, Chaim Gross, Alex Katz, Herbert Katzman, David Levine, Seymour Lipton, Alice Neel, Philip Pearlstein, and Raphael Soyer.

Others who have aided us in our research or have directed us to books, catalogues, and articles we might otherwise have overlooked include Lawrence Alloway, Susan E. Cohen, William Doreski, Ruth Gikow, Frank Goodyear, Jr., Charles Guiliano, Flora Irving, Gail Levin, Jean Lipman, Garnett McCoy, Patterson Sims, and May Stevens. For other courtesies we would also like to thank Helen Ferrulli, Deborah Gardner, Jeanette Hughson, Joan M. Marter, Dan and Dana Zwanziger, and the staff of the University of Delaware Library. Hills would also like to extend her gratitude to her colleagues at Boston University, particularly David Hall and Mel Wiseman, for their encouragement and advice.

Tom Hudspeth, our assistant, handled the details of collecting photographs, finding articles, and collating the catalogue information. We are grateful for his diligence and good humor throughout the project.

And, finally, we want to thank Tom Armstrong for providing us with the opportunity and the occasion to study the figurative tradition in America; without his continued and sustained enthusiasm the project would not have been realized.

P. H.
R. K. T.

The Figurative Tradition
and the
Whitney Museum of American Art

*Paintings and Sculpture
from the Permanent Collection*

CHAPTER I

Gertrude Vanderbilt Whitney as Patron

ROBERTA K. TARBELL

Gertrude Vanderbilt Whitney had a pervasive influence on American figurative art through her galleries, her purchases of paintings and sculpture, her financial and organizational support of institutions, and the funds she provided to individual artists. Private patronage was more important than either religious or civic commissions during the early twentieth century in the United States. Artists whose work was unacceptable to the juries of the academies needed the opportunity to exhibit their own work and also to confront new ideas in art from others. Mrs. Whitney, Alfred Stieglitz (through his "291" gallery), Hamilton Easter Field (Ardsley Studios), Martin Birnbaum (Berlin Photographic Gallery), Marius de Zayas (Modern Gallery), and Edith Gregor Halpert (Downtown Gallery) encouraged artists not only by exhibiting their paintings and sculpture but also by purchasing their works. Of all these patrons, Mrs. Whitney probably had the most decisive influence on figurative artists.

Henry McBride wrote in 1942: "It is not an exaggeration to say that there is not a contemporary artist of note in America who has not been helped by Mrs. Whitney. From the moment of her first emergence into public life she began a system of philanthropies that finally placed the entire country in her debt."[1] In 1949

John Sloan wrote: "No one will ever know the extent of the private benefactions Mrs. Whitney performed through Mrs. Force. The records have been destroyed, probably at Mrs. Whitney's request. But of my own knowledge I know of innumerable artists whose studio rent was paid, or pictures purchased just at the right time to keep the wolf from the door, or hospital expenses covered, or a trip to Europe made possible."[2] Malvina Hoffman recorded that although Mrs. Whitney was "thin, and fragile in appearance, [she] worked tirelessly but was never too busy to help young sculptors; her generosity was well known to the profession."[3] In a letter to the editor of the *New York Herald Tribune*, Eugene Speicher went even further, saying that she was the most valued single patron and devoted friend of the American artist.[4]

It is a well-known fact that Gertrude Vanderbilt Whitney (1875–1942), heiress to the Vanderbilt fortune, founded the Whitney Museum of American Art in 1930, but her support of artists from 1904 to 1930 and the lesser-known aspects of her patronage during those years have not been fully recognized. One of the earliest recorded recipients of Mrs. Whitney's art patronage was the Greenwich House of Social Settlement, located on the lower East Side. She was elected to their first board of trustees in 1902, and she sponsored and taught studio classes in clay modeling. Greenwich House received her support throughout her life.

In 1900 Mrs. Whitney began to study sculpture

Fig. 1. Jean de Strelecki. Gertrude Vanderbilt Whitney, c. 1917. Photograph, 8½ × 6⅝ inches. Collection of Flora Miller Irving.

seriously, receiving instruction in modeling from Hendrik C. Andersen and James Earle Fraser. By 1904, she was conscious that her money and social position made her patronage equal to her sculpture as an expression of creative energy. Indeed, her sculptural works were often not taken seriously because of her place in society. In 1904 she recorded her goals in her journal: "To see artists and find out [their] wants would be a good start. To found a Beaux Arts — with painting and modelling in connection. Tuition low Scholarships. Exhibition rooms. Raise money for building." She accomplished all of these during the ensuing decades.

In 1907 Gertrude Whitney helped to organize at the Colony Club an exhibition of paintings by Arthur B. Davies, Ernest Lawson, and Jerome Myers. She purchased two by Lawson, one of her earliest expressions of interest in and patronage of American realist artists. Davies wrote to her of the importance of her work: "Mr. Fraser has spoken to me of your desire to insist on a more vital movement in those American artistic qualities as yet not sufficiently perceived elsewhere."[5]

When the National Academy of Design's jury rejected paintings by Luks, Shinn, Sprinchorn, and Kent for their spring exhibition of 1907, Henri withdrew his works. Mrs. Whitney filled a scrapbook with clippings documenting the controversy and adopted the philosophy of the burgeoning independent movement as her own. These principles were summarized and articulated ten years later in the *By-Laws of the Society of Independent Artists* of which organization she had become a director and benefactor:

> *(1) to hold exhibitions, whether annual or periodical, of contemporary art; (2) to afford American and foreign artists an opportunity to exhibit their work independently of any jury; (3) to promote solidarity among American artists and to further cooperation between American and foreign artists, to the end of achieving vigorous and united art expression; (4) to organize or provide for the giving of lectures or the reading of papers upon art subjects, and the publication and dissemination of art brochures, letters or pamphlets in furtherance of the objects and purposes of the Society; (5) to assist in the furtherance and dissemination of a knowledge and appreciation of contemporary fine art by either holding or aiding in the holding of exhibitions or lectures; and (6) the accumulation of funds for the purpose of making its annual exhibitions permanent features of its activities.*[6]

But already in 1907 Mrs. Whitney understood these goals of the independent artists and perceived their need for patrons to provide them with aesthetic and economic freedom.

She decisively purchased four paintings from the landmark exhibition of The Eight in 1908 at the Macbeth Gallery.[7] Making up her mind before the public and the critics had a chance to react, she wrote a check for $2225 on February 2, the day before the opening. During March 1908, as the exhibition was being packed for shipment to the Pennsylvania Academy of the Fine Arts in Philadelphia, Mrs. Whitney also purchased four red chalk drawings and one monotype by Everett Shinn.[8]

Mrs. Whitney offered support to institutions as well as to individuals. In 1906 the National Sculpture Society was having difficulty finding adequate exhibition space. Three hundred sculptors were invited to take part in an exhibition planned for the fall of 1907, but it was canceled because the National Academy of Design and the Architectural League had already leased the gallery space of the American Fine Arts building for the best months of the year. The Metropolitan Museum refused to have an exhibition of contemporary American works of art, and Madison Square Garden was too expensive to rent. The minutes of the February 14, 1906, meeting of the National Sculpture Society (Karl Bitter presiding) record: "Mr. French reported on the proposed exhibition of the National Sculpture Society. He stated that Mrs. Harry Payne Whitney was enthusiastically interested in the scheme and would do all in her power to help make the exhibition a success."[9] Daniel Chester French concluded on April 19, 1907, that "There seems actually to be no available place in New York in which to hold our exhibition."[10] Karl Bitter was finally able to procure the Municipal Arts Society building in Baltimore, Maryland. One year later, in April 1908, four hundred works by one hundred artists were on view in what was then called the "Armory Show," preceding the more famous exhibition of that name by five years.

Other institutions were bolstered in their exhibition efforts by Mrs. Whitney. In 1911 she wrote a check to the National Academy of Design for $1300. Whether or not she was solely responsible, the National Academy of Design dramatically increased the number of sculptures that it exhibited over the next few years. In 1905 thirteen sculptures were shown, seventy in 1907, and 167 in 1912, without a corresponding increase in paintings. Possibly, since sculpture requires pedestals

for exhibition, her contribution was used to purchase new bases. When Dana H. Carroll reviewed an exhibition of the National Academy in 1913, he also noted "evidences of a distinct advance toward open-mindedness, of a willingness to recognize modern tendencies," [11] the kind of aesthetic freedom championed by Mrs. Whitney.

She and several of her friends and relatives (including her uncle William K. Vanderbilt) endowed for the Society of Beaux-Arts Architects a "Paris Prize." It was intended for a "scholar to pursue his studies first class at the Ecole des Beaux-Arts in Paris for two and one-half years." William Van Alen, whose Chrysler Building was erected in 1930, received the Paris Prize in 1908. [12]

Not all the institutions Mrs. Whitney supported were as conservative as the National Sculpture Society, the National Academy of Design, and the Society of Beaux-Arts Architects. She also provided some financial backing for the Madison Gallery at 305 Madison Avenue, which offered free exhibitions to little-known independent American artists and which was operated by Clara S. Davidge as part of Coventry Studios, her

decorating firm. The idea of the 1913 Armory Show was conceived at the Madison Gallery in December 1911 by the four artists whose work was then on view — Jerome Myers, Elmer MacRae, Walt Kuhn, and Henry Fitch Taylor. Mrs. Whitney was sympathetic and understanding of their problems in finding a place to exhibit their non-academic art and, when Clara Davidge asked for $1000 for decorations for the Armory Show, she received it. Mrs. Whitney's sister-in-law, Dorothy Whitney Straight, also donated $1000.

Mrs. Whitney not only agreed philosophically with the aims of the independent movement in America but guaranteed its solvency. John Sloan recalled that she paid the deficit of the Society of Independent Artists every year from its inception in 1917 until sometime after the opening of the Whitney Museum in 1931 (Fig. 2). [13]

In January 1917 Mrs. Whitney guaranteed $5000 toward an exhibition of Ivan Mestrović's sculpture at the Baumgarten Galleries, which apparently did not materialize. She and Charles Dana Gibson planned an exhibition of the work of five sculptors to be displayed at the Boston Public Library. Mrs. Whitney's art patronage also extended to Newport, Rhode Island, where she was married in 1896 at her family home "The Breakers," set up a studio in 1900, and worked on sculpture from time to time throughout her life. During the 1910s she organized exhibitions and paid for insurance and transportation of work by John Gregory, Paul Manship, George Bellows, Arthur B. Davies, William Glackens, Ernest Lawson, and herself at the Art Association of Newport.

From 1923 to 1930 Mrs. Whitney provided financial and moral support to *The Arts*, a magazine which published the works and ideas of independent American artists and, through its national circulation, projected her philosophy of supporting American art and artists nationwide. *The Arts* was founded in 1920 by another energetic patron of American art, Hamilton Easter Field, who also served as its first editor. After Field's unexpected death in 1922 at the age of forty-nine, Forbes Watson, who had been art critic for the *New York World* and the *New York Evening Post*, became editor of *The Arts*. Lloyd Goodrich, Director of the Whitney Museum from 1958 to 1968, was an editor of *The Arts* in the 1920s.

An unusual focus of Mrs. Whitney's support was *Brancusi v. The United States*, a case initiated in 1926 by Edward Steichen and Brancusi and underwritten by Mrs. Whitney at Steichen's request. A bronze version of

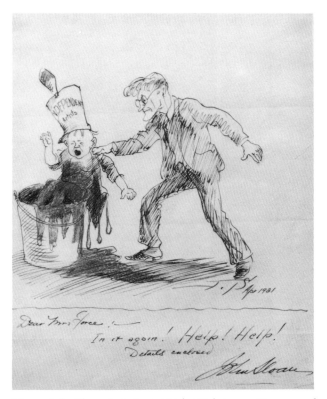

Fig. 2. *John Sloan.* In it Again! Help! Help! *1931. Crayon and ink on paper.*

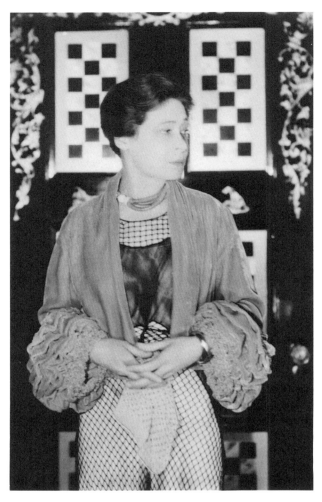

Fig. 3. *Juliana Force, c. 1930.*

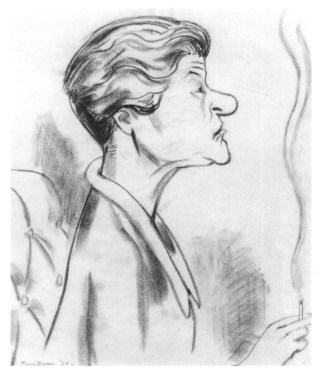

Fig. 4. *Peggy Bacon.* Juliana Force, 1934. *Charcoal on paper, 16 ¾ × 13 ⅞ inches. Whitney Museum of American Art; Gift of Mr. and Mrs. Joshua A. Gollin, 74.84.*

Brancusi's *Bird in Space* was refused tariff-free entry because U.S. customs officials claimed that it was not a work of art and therefore subject to duty as a raw material. In 1928 the Supreme Court handed down the decision in favor of Brancusi.

Of the many outlets Mrs. Whitney's art patronage found before 1930, the most influential were the exhibitions and activities in her own studio (1907–14), the Whitney Studio (1914–27), the Whitney Studio Club (1918–28), and the Whitney Studio Galleries (1928–30).

At her newly acquired sculpture studio at 19 Macdougal Alley, Mrs. Whitney's mentors, protégés, and colleagues gathered as early as 1907. Her studio was always a place where artists could assemble in an atmosphere of camaraderie to share common goals and problems. Mrs. Whitney organized impromptu and informal exhibitions which were not publicized and are largely undocumented. To enlarge the exhibition space, she purchased the adjacent building at 8 West Eighth Street.

The small Eighth Street building was altered so that on the first floor were two galleries and on the second, an office for Juliana Force, who joined Mrs. Whitney in 1914 to manage the gallery and the many other facets of her patronage over the next thirty-four years (Figs. 3, 4). Mrs. Force's vital role in implementing Mrs. Whitney's various programs and purchases on behalf of American artists was described in 1949 by Hermon More, then Director of the Whitney Museum of American Art, and Lloyd Goodrich, then Curator: "Every action of either Mrs. Whitney or Mrs. Force was really the action of both, for it was taken after full consultation and in complete agreement."[14]

An active, more regular exhibition program began at the Whitney Studio in December 1914 with benefit exhibitions for war charities to help fund a hospital that Mrs. Whitney established in France. In addition, one-man exhibitions, group exhibitions with such themes as *To Whom Shall I Go for My Portrait*, and competitions with prizes were held. In 1918 *Indigenous Exhibitions* were held at the Whitney Studio (Fig. 5). About twenty

painters were provided with blank canvases, the size chosen by lot, and during the designated week in February they painted subjects of their choice. During three days in March, twenty sculptors modeled clay together. In addition to their individual sculptures, they also created a statuette (no longer extant) of Mrs. Whitney surrounded by her coterie.

As a sculptor herself, Mrs. Whitney was particularly aware of the difficulty sculptors had in finding places to exhibit their work. She provided exhibition opportunities at the Whitney Studio for sculptors Andrew O'Connor, Malvina Hoffman, Florence Lucius, Grace Mott Johnson, Aristide Maillol, Cecil de Blaquere Howard; works by Mrs. Whitney were exhibited as well. Painters were not neglected, and John Sloan and Guy Pène du Bois had their very first one-man exhibitions at the Whitney Studio. Ernest Lawson, Gifford Beal, Randall Davey, Charles Demuth, Walt Kuhn, Henry Schnakenberg, and Allen Tucker were among the painters represented in Whitney Studio exhibitions between 1916 and 1924.

One especially important exhibition for American artists was the *Overseas Exhibition* which Mrs. Whitney organized and shipped to Venice to the International Art Exhibition, held from May to November 1920. It was subsequently shown in London, Sheffield, Paris, and New York — at the Whitney Studio — in 1921. Mrs. Whitney purchased from the show seven paintings which she gave to seven museums of art in the United States.

Between 1915 and 1917 a loosely organized group

of patrons, the Society of Friends of Young Artists, sponsored four juried competitions of works exhibited at the Whitney Studio. In 1917 Mrs. Whitney explained that the Whitney Friends was established in the spring of 1915

> to give young artists in this country the opportunity to show their work and make it known to the general public. Any student may send his work to our exhibitions. This not only helps him by giving the public the chance of viewing his work, and possibly buying it, but it also allows him to judge of his own capacities in comparison to others.
>
> The annual exhibitions of the various established societies are already overcrowded, and the private galleries seldom accept the work of unknown men. . . . Only when we shall have given our young artist the opportunity of studying the art of the centuries to train and develop his taste; only when we shall have provided sufficient studios and schools in which he may make known his work; only then can we hope that American art will become what it promises to be, a fresh and vital expression of a new, great art.[15]

Mrs. Whitney's next encouragement for young American artists was the Whitney Studio Club, organized by about twenty artists in 1918, with headquarters at 147 West Fourth Street, a building she owned. Blendon Campbell recalled in 1949 in an interview with Rosalind Irvine that on the main floor there were two exhibition galleries and downstairs a library filled with art books, a squash court, and a billiard room. The Campbells lived on the second floor and on the third, Salvatore Bilotti, an Italian stonecarver who had assisted Mrs. Whitney on her marble sculptures. The core of the Club's charter members included a group who studied together at the Art Students League: Peggy Bacon, Alexander Brook, Katherine Schmidt, Reginald Marsh, Henry Schnakenberg, Louis Bouché, Dorothy Varian, and their teacher Kenneth Hayes Miller. Annual exhibitions of the membership (which in 1928 numbered four hundred) were held from 1918 through 1928. They were the forerunners of the Whitney Museum Annual (or Biennial) exhibitions which continue to the present day. In 1923 the Whitney Studio Club moved to a house adjacent to the Whitney Studio,[16] and Alexander Brook was hired to assist Juliana Force and Gertrude Whitney in selecting works, organizing, and installing exhibitions, a job he held for five years. In

Fig. 5. The Indigenous Exhibition *at the Whitney Studio February 1918, possibly painted by George Luks. John Sloan is at far right; Mrs. Whitney and George Luks, in the center. Present whereabouts of the painting unknown.*

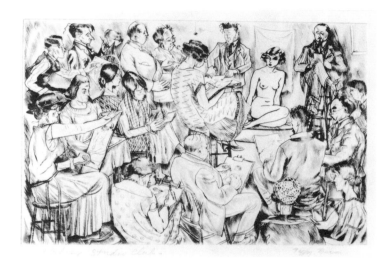

Fig. 6. Peggy Bacon. The Social Graces, 1935.
Drypoint, 10⅞ × 7⅜ inches. Whitney Museum
of American Art; Purchase, 36.42.

Fig. 7. Peggy Bacon. The Whitney Studio Club, 1920s.
Drypoint, 5⅞ × 8-15/16 inches. Whitney Museum of Ameri-
can Art; Gift of Gertrude Vanderbilt Whitney, 31.596.

addition to exhibitions and sketch classes at the Club, artist-participants remember its warm and congenial atmosphere, which had been Mrs. Whitney's intent (Figs. 6, 7).

From November 1926 through November 1928 the Whitney Studio Club shop, managed by Alexander Brook, was in business on the top floor of 10 West Eighth Street. Prints, watercolors, and drawings were sold there, encouraging not just the artists but also collectors. In November 1928 the Whitney Studio and the Whitney Studio Club were succeeded by the Whitney Studio Galleries. Juliana Force stated in an interview in the *New York Herald*, November 7, 1928, that the Galleries would be run as a commercial gallery for contemporary art rather than as "an organization of artists philanthropically inspired." Forty one-artist exhibitions and several group shows were held there. The Galleries were dissolved in March 1930, two months after the inception of the Whitney Museum of American Art.

In all of these Whitney-named enterprises from 1914 to 1930 it was Mrs. Whitney's objective to show the work of the most progressive artists because the modernism and experimental nature of their work prevented their acceptance in the annuals of the National Academy of Design, the National Sculpture Society, and the Carnegie Institute. These artists seemed

relatively traditional, however, especially after the influx of such expatriates as Marcel Duchamp in 1915 and the emergence of the intellectually volatile Arensberg circle and New York Dada. Artists associated with Mrs. Whitney's organizations generally favored figurative work, as opposed to the emphasis on abstraction of the Stieglitz circle. Whitney artists accepted the basic premise of selecting a recognizable

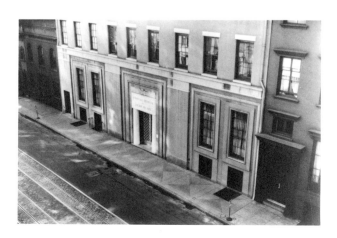

Fig. 8. Exterior of the Whitney Museum of American Art, Eighth Street.

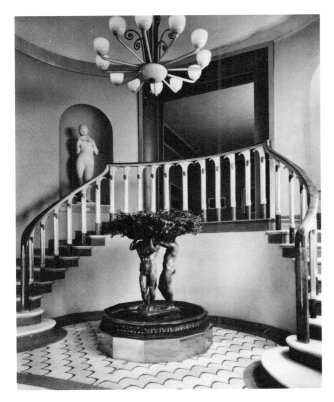

Fig. 9. *Lobby of the Whitney Museum, Eighth Street. Fountain by Gertrude Vanderbilt Whitney, 1913 (see Fig. 68), and* Wood Nymph *by John Gregory, in the niche, now in the collection of Flora Whitney Miller.*

Fig. 10. *Opening exhibition of the Whitney Museum of American Art, Eighth Street.*

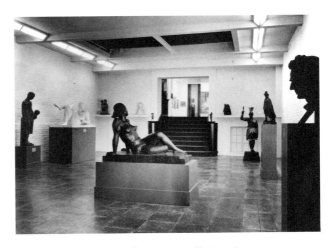

Fig. 11. *Permanent Collection installation, Summer 1932, Whitney Museum of American Art, Eighth Street.*

human figure and then dealt with problems of scale, composition, costume, sensuality, external appearance, surface treatment, and the like. Early twentieth-century avant-garde artists, on the other hand, denied the figural canon and either reinvented figural types or used the machine, psychology, or non-objective form as their central motivating force or symbol.

By 1929 Mrs. Whitney had acquired more than six hundred works in her personal collection, most of which became part of the Permanent Collection of the Whitney Museum of American Art. Most of the works were purchased from the various exhibitions sponsored by Mrs. Whitney. Thus the selection of works that entered the Permanent Collection of the Whitney Museum was greatly affected by a policy initiated by Mrs. Whitney, probably because of the "no-jury, no-prizes" policy of the new Society of Independent Artists which held its first exhibition in April 1917. After that year, Mrs. Whitney no longer held competitive juried exhibitions and instead used funds designated for prizes to purchase works from the exhibitions. According to Alexander Brook, the Whitney Studio and Whitney Studio Club were not competitive with commercial galleries but provided a "steppingstone for the artists to gain recognition from critics and dealers. . . . Introduc-

tory exhibitions [were] specifically limited to those who did not have an outlet for their work."[17]

Paul Rosenfeld observed at the time of the opening of the Whitney Museum of American Art that its Permanent Collection was formed for purposes other than those of a museum. Works were often purchased to support struggling artists, for Juliana Force and Mrs. Whitney were as interested in the human needs of the artists as they were in connoisseurship. This backing for American artists was critical in establishing their reputations, bringing their works to public view, and

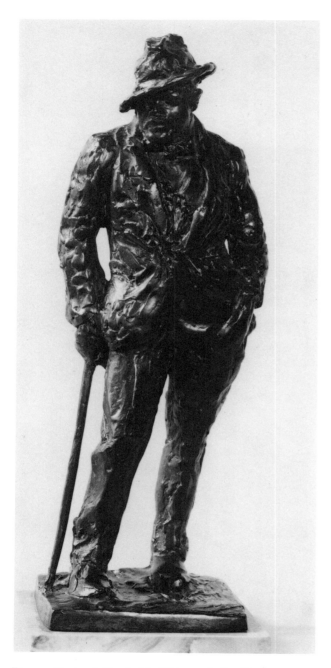

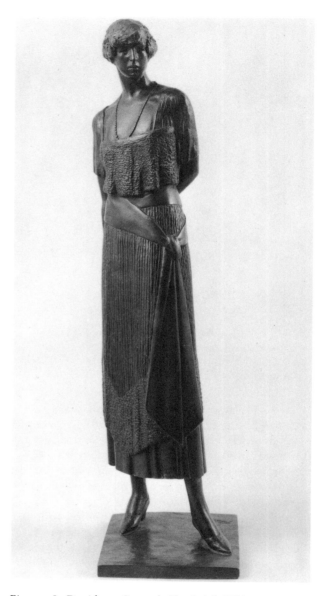

Fig. 13. *Jo Davidson.* Gertrude Vanderbilt Whitney, c. 1917. *Bronze, 20 × 5 ½ × 4 ¾ inches.* Whitney Museum of American Art; Gift of Flora Whitney Miller, 68.24.

Fig. 12. *Gertrude Vanderbilt Whitney.* Jo Davidson, 1917. *Bronze, 20 inches high. Collection of Flora Whitney Miller.*

encouraging them to create at their very highest level.

Support of individual artists is more difficult to assess than that of new or existing institutions, but it constituted one of the most decisive aspects of Gertrude Vanderbilt Whitney's patronage. Those artists were able to work at a higher, more innovative level than they would have without Mrs. Whitney's interest and funds — if they had even been able to continue as artists at all. Among the many who received contracts to teach or funds for study or studio expenses from Mrs. Whitney between 1905 and 1930 were Arthur Lee, Bernard Karfiol, Edgar McAdams, Jo Davidson,

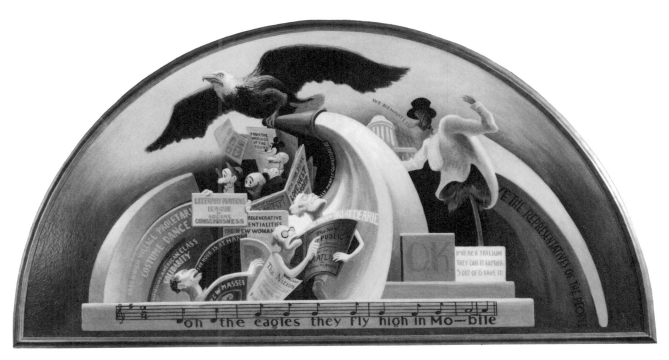

Fig. 14. Thomas Hart Benton. Political Business and Intellectual Ballyhoo, *1932. Egg tempera mural, 56½ × 108 inches. The New Britain Museum of American Art, New Britain, Connecticut.*

Morgan Russell, John Gregory, Michael Brenner, Emanuele Ordono de Rosales, Herbert Haseltine, Stuart Davis, John Steuart Curry, and Reuben Nakian. In addition, her purchase of a painting or sculpture secured basic living expenses for the artist for several months. She was careful not to demean artists by pure philanthropy, and their responses upon receipt of checks indicate the importance of her support. Arthur Lee wrote to Mrs. Whitney from Paris on September 18, 1907: "I am safe in Utopia for another two years thanks to you. . . . There is nothing better than to be young and to be studying art in Paris."[18] In 1907 she "stored" the sculpture of her teacher Hendrik C. Andersen in her garden to save him the expense of a warehouse, and he wrote her from Rome that year for funds to cast a monumental multi-figure sculpture:

I need help; yet I am, I confess, most reluctant in asking you if in the course of the casting you would be willing to help me with any part. Yet when I think of the definite accomplishments of the work I am willing to go to any length and therefore frankly ask you if you feel inclined to give perma-

nence of the casting of these groups into bronze.
I would have had more money if I had given myself up to portraits, but I would not have time to do this important work.[19]

From 1908 to 1916 Mrs. Whitney provided Morgan Russell with a small allowance. After she had mailed a particularly generous check to Russell, he replied from Paris, April 1, 1910:

While awaiting your answer I was rather gloomy not knowing what to expect, but upon receiving it I fairly leaped into the air — all because I was again to have days and weeks to grow and work freely.[20]

In the same letter Russell also commented on the "overwhelming sense of moral responsibility" that the check brought. "I take [the check] as meaning that you were satisfied with the use made of the last one." During the years he was receiving financial support from Mrs. Whitney, Russell was a co-founder of Synchromism, one of the few early twentieth-century American

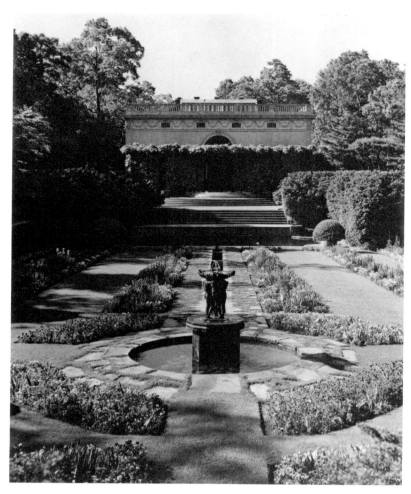

Fig. 15. *Mrs. Whitney's studio in Old Westbury, Long Island, designed by William Adams Delano, 1910 – 13.*

avant-garde concepts that interested European artists.

Another artist supported by Mrs. Whitney, Juliana Force, and Whitney-named organizations was Thomas Hart Benton, who in 1932 painted the murals *The Arts of Life in America* (Fig. 14), installed in the library of the Whitney Museum on West Eighth Street. According to Benton, the murals were to stimulate "young artists, aesthetes, and amateur sociologists."[21]

One of the most fascinating documents of Mrs. Whitney's patronage is the still-intact Beaux-Arts style studio she built on the Whitney family estate in Old Westbury, Long Island, to replace the blacksmith's shop she had been using (Fig. 15). The architect was William Adams Delano, a friend of the family who had studied with V.-A.-F. Laloux at the Ecole des Beaux-Arts (graduated 1902) and who was known for his fine traditional buildings on Manhattan and Long Island.[22] Plans for the studio (twenty feet high, sixty long, and forty wide) and several auxiliary rooms were drawn in 1910, and by 1913 the elegant symmetrical building

with formal gardens was completed. Paul Chalfin designed and installed mosaics on the floor and vault of the entrance portico.[23]

Mrs. Whitney commissioned her life-long friend Howard Cushing to paint murals in the curved stairwell.[24] Cushing devised imaginative tropical flora and fauna at the lower level culminating in a portrait of Mrs. Whitney, dressed in her Bakst costume, greeting guests from her position on the wall opposite the top of the stairs (Figs. 16, 17). The walls of the upstairs bedroom were painted in black and gold by Robert Chanler.[25] The eclectic equestrian battle scene reminds one both of Uccello's *Battle of San Romano* and northern Renaissance figure types. The walls of the bathroom are painted with an underwater scene by Chanler to suggest a submarine grotto. Later Chanler participated in Whitney Studio exhibitions and activities and painted exotic decorations for Mrs. Whitney's Macdougal Alley studio. She helped him through a financial crisis in 1918, and during November 1926

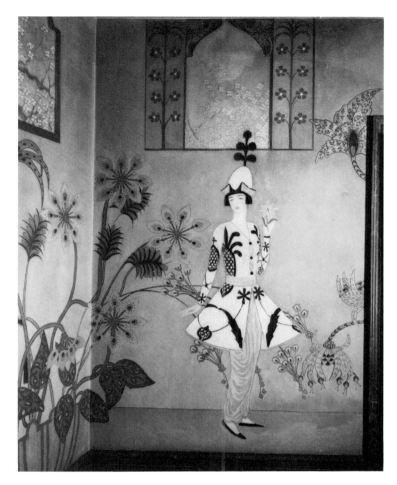

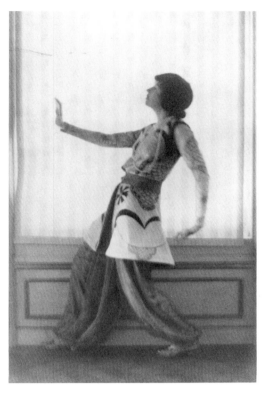

Fig. 16. Howard Cushing. Gertrude Vanderbilt Whitney in Bakst Costume, *mural for second floor stairwell, Old Westbury studio, c. 1915. Oil on canvas. Collection of Flora Whitney Miller.*

Fig. 17. Baron de Meyer. Gertrude Vanderbilt Whitney in Bakst Costume, *c. 1913. Photograph, 9 ¼ × 4 ⅞ inches. Collection of Flora Miller Irving.*

Chanler had a one-man exhibition of portraits at the Whitney Studio Club.

Maxfield Parrish was commissioned during the spring of 1910 to paint murals for the four walls of the studio's reception room (Fig. 18). The six-by-nineteen-foot mural decorations were placed above the dark wood wainscoting so that the rectangular format of the murals would not be interrupted by fenestration. Parrish wrote to Mrs. Whitney in 1912 that the background would be "evening blue" because, "I am sure you will agree with me, that . . . there is nothing more beautiful in all nature than figures against a sky. . . ."[26] He also explained that his scheme was of a medieval fete or masquerade taking place in a loggia, courtyard, and garden. Even with an established artist like Parrish, Gertrude Whitney provided an opportunity of sorts — he expressed his appreciation and delight with the freedom he had been allowed in rendering the murals and thought the results were better because of it. He continued, "It is tremendously interesting to have

this chance to revel in color as deep and as rich as you please. . . ."[27] There were some difficulties with the murals. After he had accepted the commission he started on "acres of decorations" for the Curtis Publishing Company building in Philadelphia. The Whitney panels finished in 1918 were out of scale with the panels completed in 1914, and the murals were not the same measurements as the spaces to accommodate them, so adjustments had to be made. However, these recently restored mural panels are prime examples of a mode, now part of history, of which Parrish was a master.

The strong personal philosophies of Gertrude Vanderbilt Whitney that form the common thread of all her activities as a patron were based on an unflagging belief in American art and American artists. She favored figurative art over abstract and representation, and realism over more intellectual aesthetic philosophies. Thus, she is very different from Alfred Stieglitz, Walter Arensberg, Mabel Dodge, Gertrude and Leo Stein, Dr. Claribel and Miss Etta Cone, and Katherine Dreier,

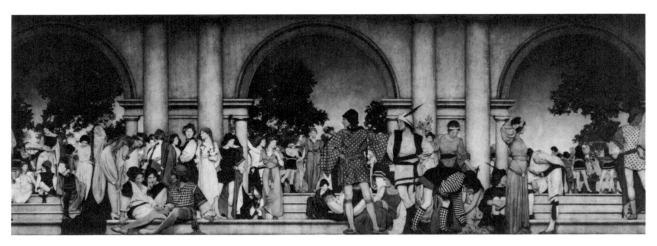

Fig. 18. *Maxfield Parrish. Mural for reception room, Old Westbury studio. Oil on canvas, 6 × 19 feet. Collection of Flora Whitney Miller.*

all of whom supported vanguard artists, but closer to Hamilton Easter Field.

In addition to affirming artists' aesthetic quests, Mrs. Whitney tried to provide them with economic freedom through the exhibition and purchase of their work as well as occasional outright gifts of money, especially in times of emergency. She helped the artists help themselves in their own fields of endeavor. Forbes Watson stated that her aim was "simple, to stimulate current creative forces by showing and buying the works of current creative artists." [28] The Whitney Museum was the formalized institution that emerged after twenty-five years of private sponsorship.

In a speech at the opening of the Whitney Museum of American Art on West Eighth Street in 1931, Mrs. Whitney described her patronage: "For twenty-five years I have been intensely interested in American art. I have collected during these years the work of American artists because I believe them worthwhile and because I believed in our national creative talent. Now I am making this collection the nucleus of a museum devoted exclusively to American art." [29]

In 1954 the Whitney Museum moved from Eighth Street to a new building erected at 22 West Fifty-fourth Street. Lloyd Goodrich wrote:

The new museum's basic principles had already been shaped by years of experience, and they have not changed essentially since . . .: that the contemporary art of a nation has a special importance for its people . . .; that a museum's function is not merely to conserve the past but to play an active part in the creative life of the present; that a museum should always be open to the new, the young and the experimental; that it should never forget that the artist is the prime mover in all artistic matters; that it should support his freedom of expression, respect his opinions and avoid any attempt to found a school. [30]

At the time of its founding the Whitney Museum was the only museum devoted to American art and one of the few focusing on contemporary art. From 1931 forward, Mrs. Whitney's role as a patron was channeled through the Museum's activities. The part that the Whitney Museum and Juliana Force played in the Public Works of Art Project in 1933 and 1934 and decisions made by the staff on the new Museum are really another story. The Annuals of the Whitney Museum reflected its founder's preference for figurative art well into the 1950s. Until her death in 1942, Mrs. Whitney remained active in making selections from the Annual exhibitions; by 1935 she had added 350 new works to the Museum's collection.

After World War II, American artists assumed international leadership. Some of the atmosphere of confidence and originality motivating them can be credited to the economic and aesthetic freedom fostered by Mrs. Whitney's support. The rise of Abstract Expressionism challenged the validity of figurative art, with which Mrs. Whitney is identified as artist and patron. Representations of people in paintings and sculpture are reemerging — however simplified, geometricized, stylized, distorted, or fragmented, but as creative as non-objective expressions.

Color Plates

Pl. 1. John Sloan. The Hawk (Yolande in Large Hat), *1910.*

Pl. 2. Robert Henri. Gertrude Vanderbilt Whitney, *1916.*

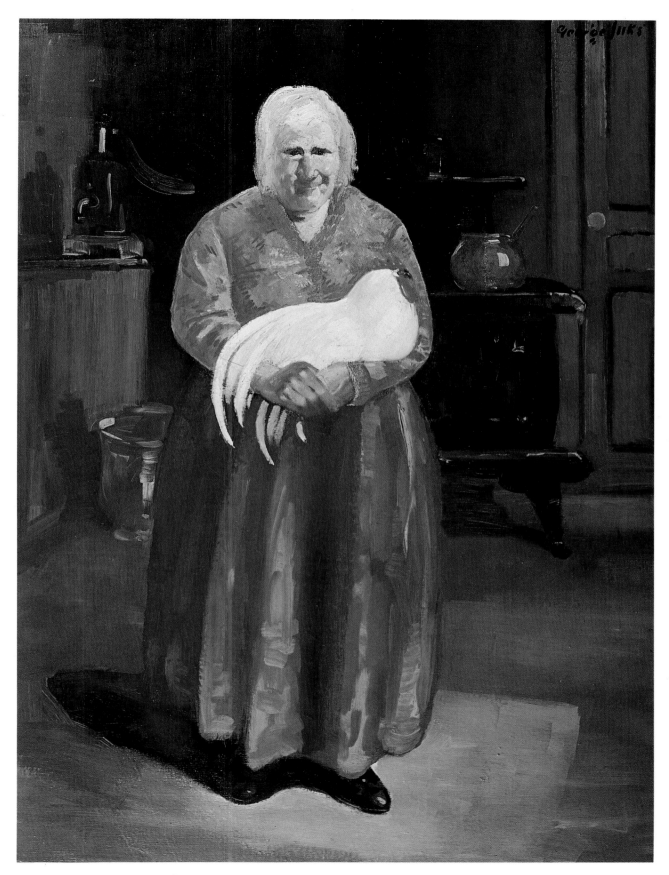

Pl. 3. George Luks. Mrs. Gamley, *1930.*

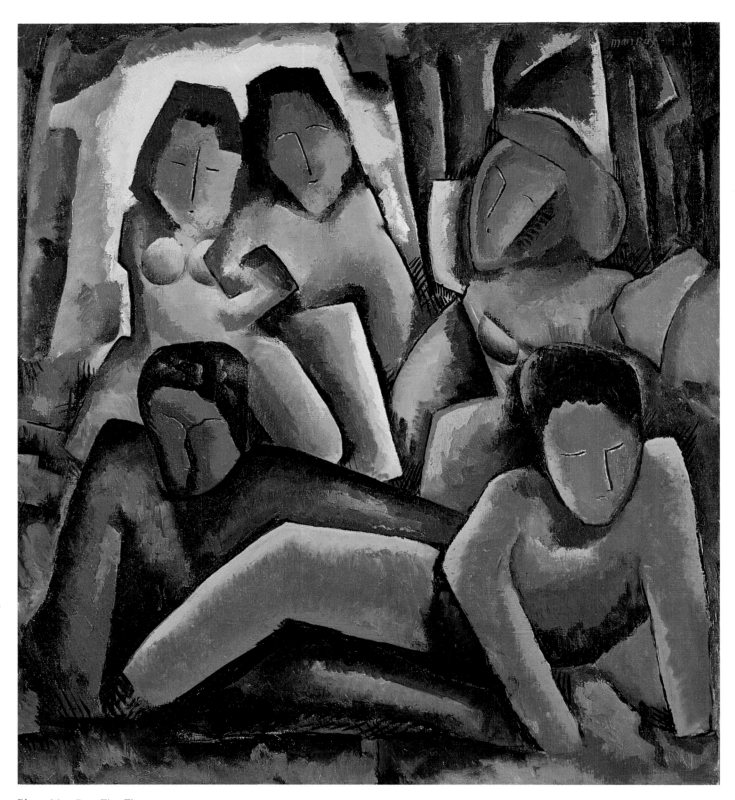

Pl. 4. Man Ray. Five Figures, *1914.*

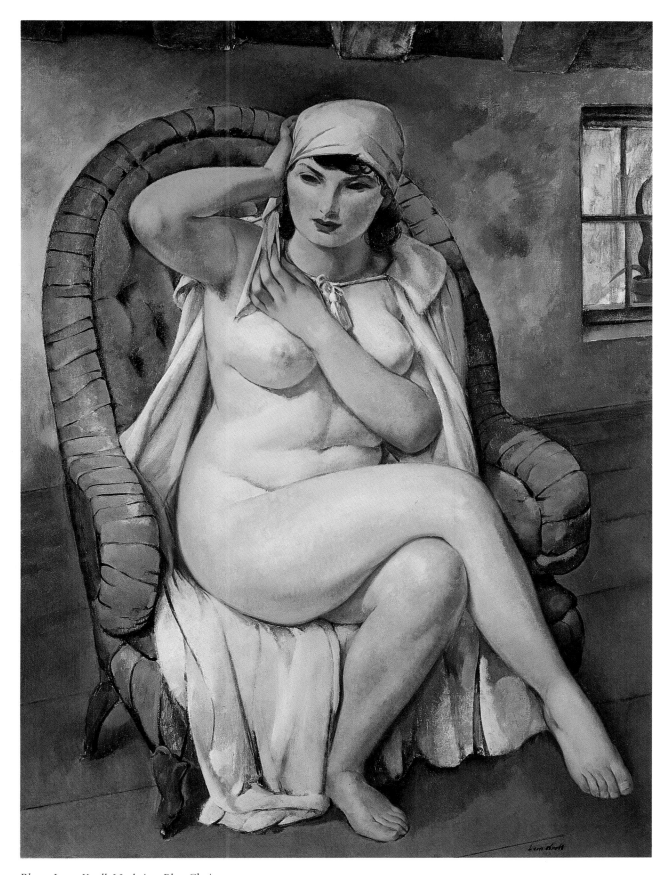

Pl. 5. Leon Kroll. Nude in a Blue Chair, *1930.*

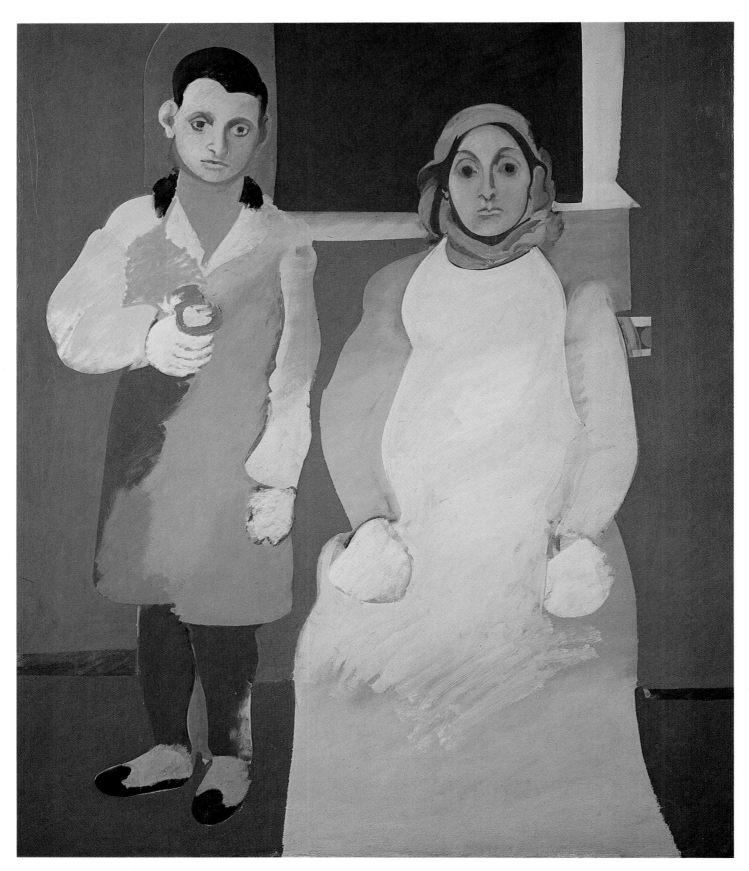

Pl. 6. Arshile Gorky. The Artist and His Mother, *1926-29.*

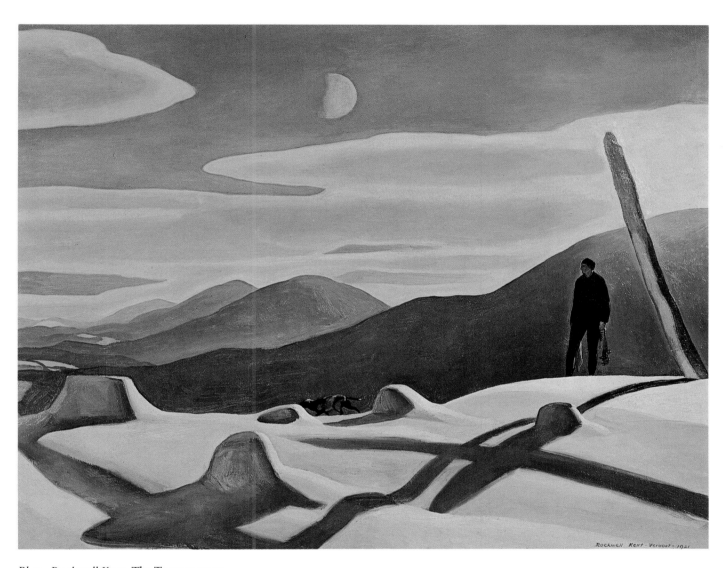

Pl. 7. Rockwell Kent. The Trapper, *1921.*

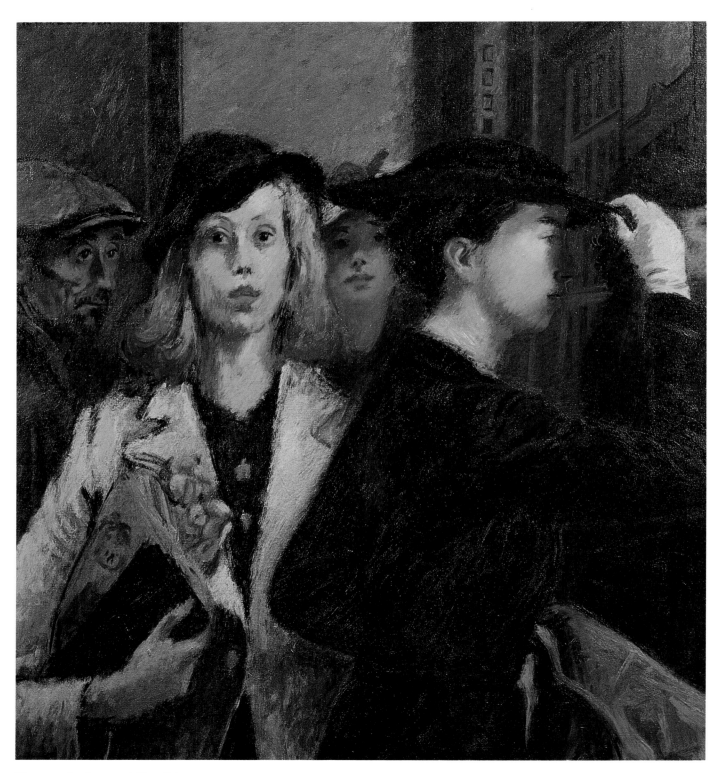

Pl. 8. Raphael Soyer. Office Girls, *1936.*

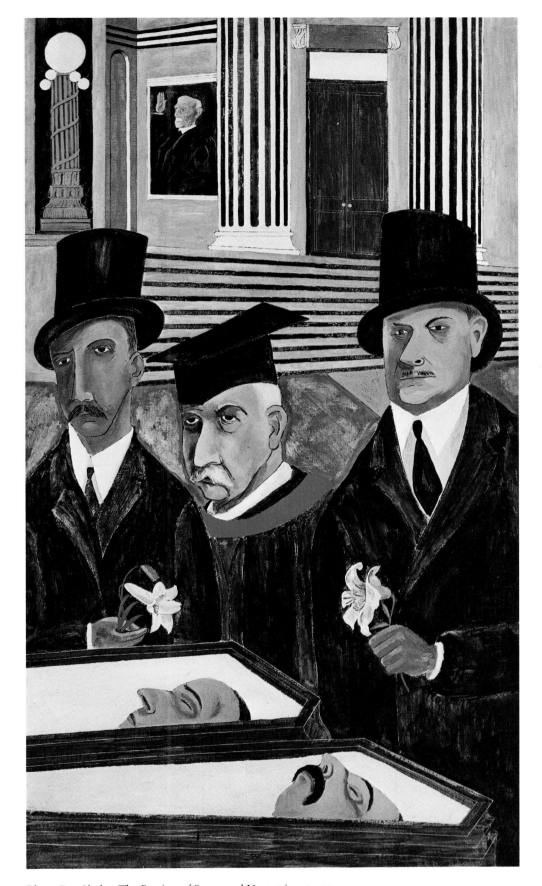

Pl. 9. Ben Shahn. The Passion of Sacco and Vanzetti, *1931-32.*

Pl. 10. Philip Evergood. Lily and the Sparrows, *1939.*

Pl. 11. Louis Guglielmi. Terror in Brooklyn, *1941.*

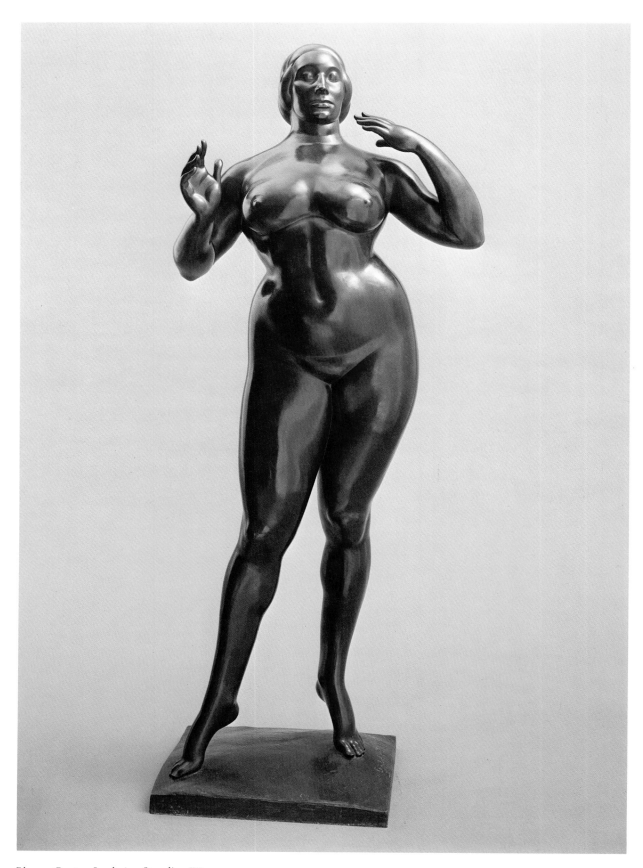

Pl. 12. Gaston Lachaise. Standing Woman, *1912-27.*

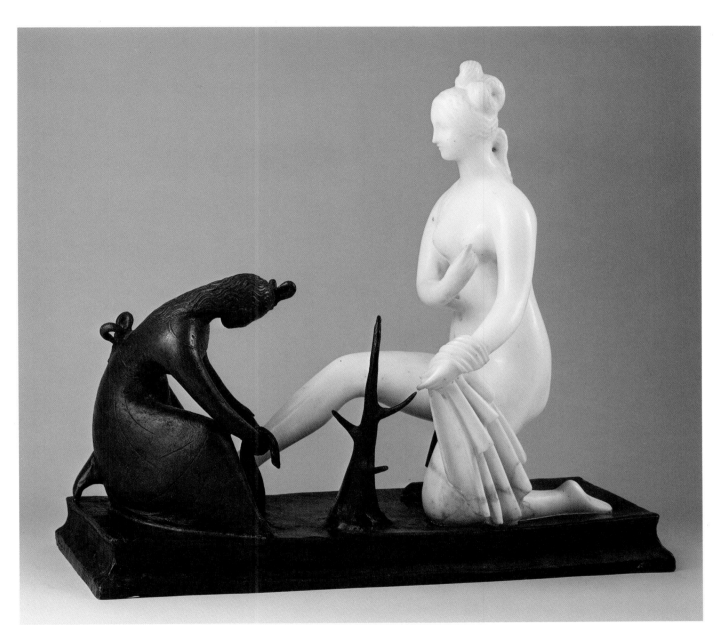

Pl. 13. Elie Nadelman. Sur la Plage, *1916.*

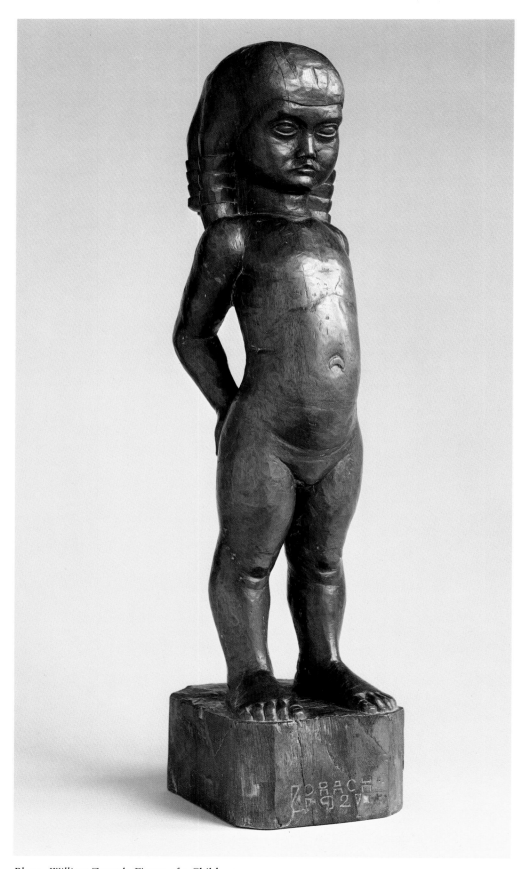

Pl. 14. William Zorach. Figure of a Child, *1921.*

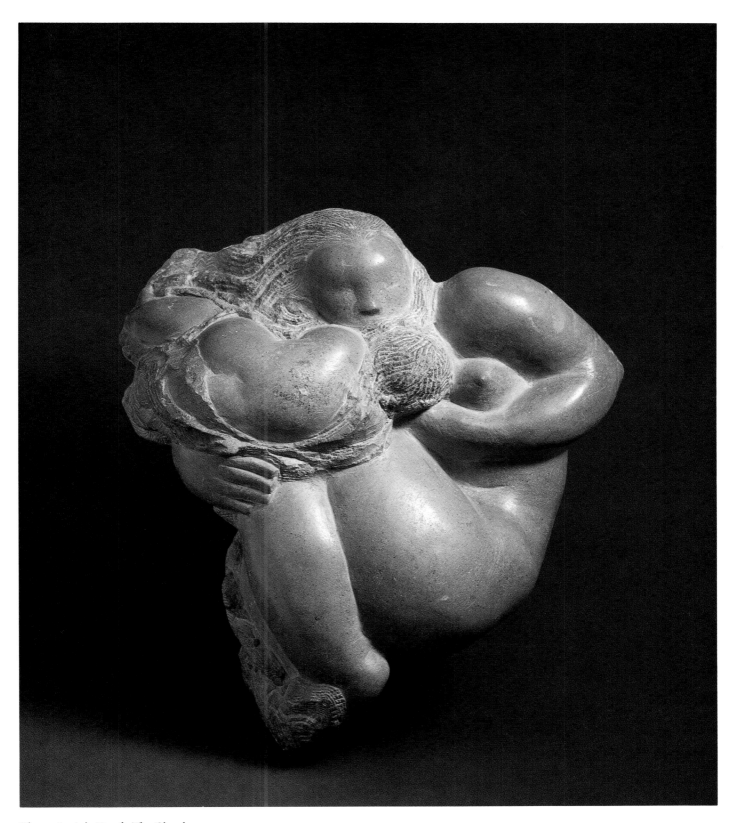

Pl. 15. José de Creeft. The Cloud, *1939.*

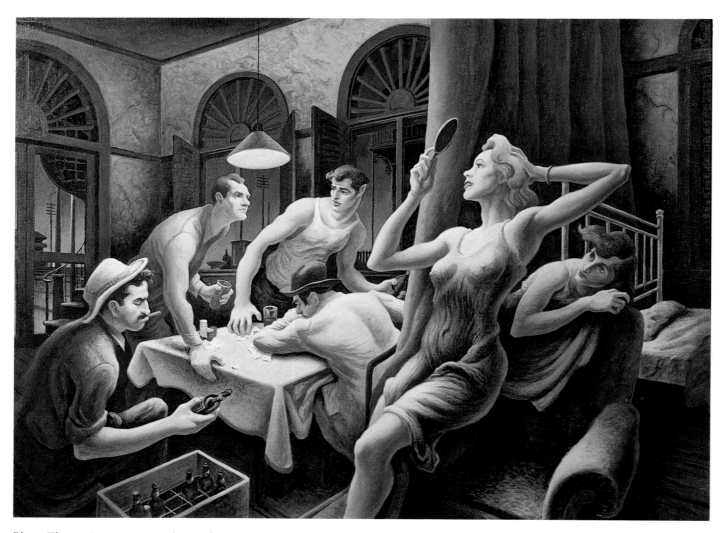

Pl. 16 Thomas Hart Benton. Poker Night (From "A Streetcar Named Desire"), *1948.*

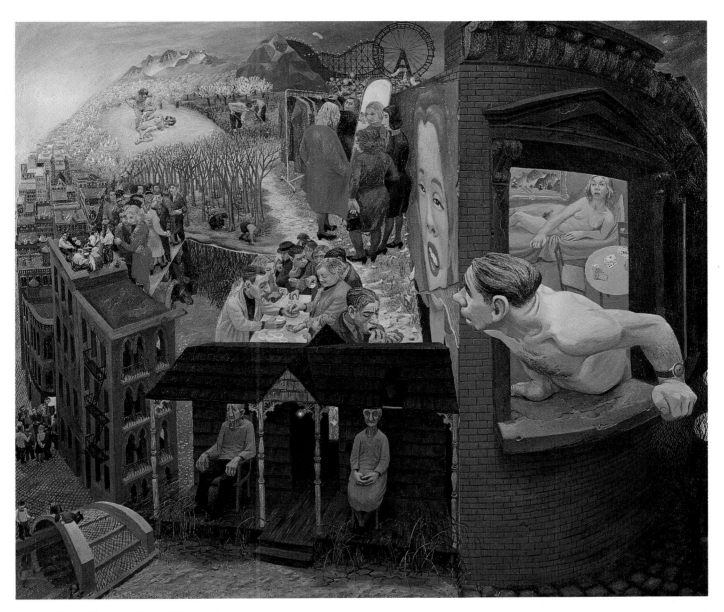

Pl. 17. Henry Koerner. Vanity Fair, *1946.*

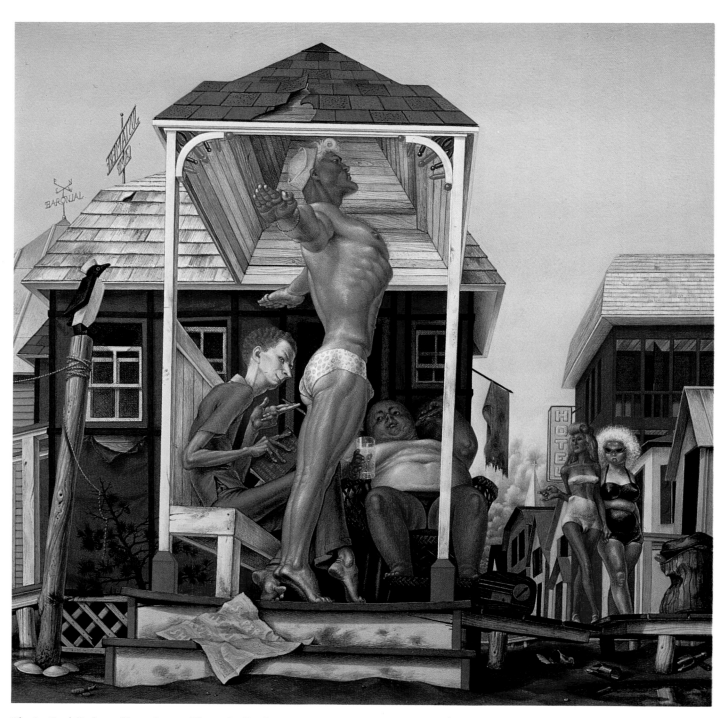

Pl. 18. Paul Cadmus. Fantasia on a Theme by Dr. S, *1946.*

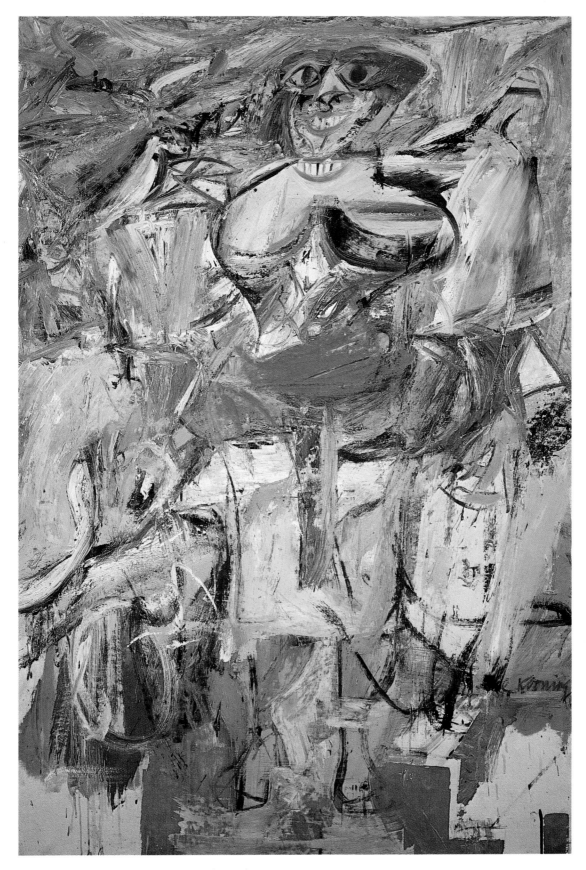

Pl. 19. Willem de Kooning. Woman and Bicycle, *1952-53.*

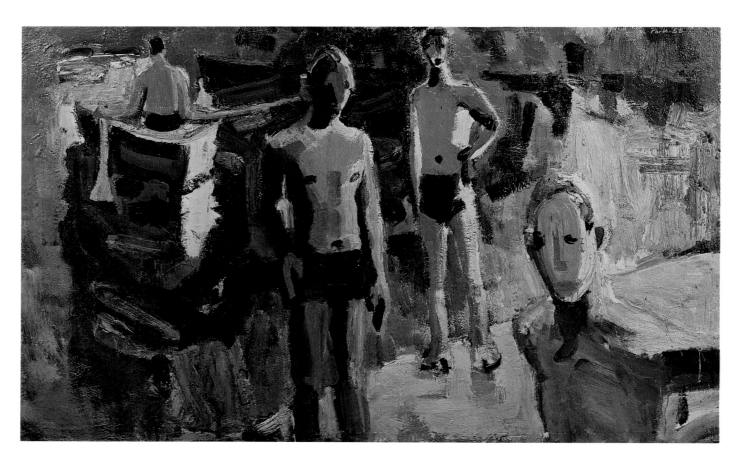

Pl. 20. David Park. Four Men, *1958.*

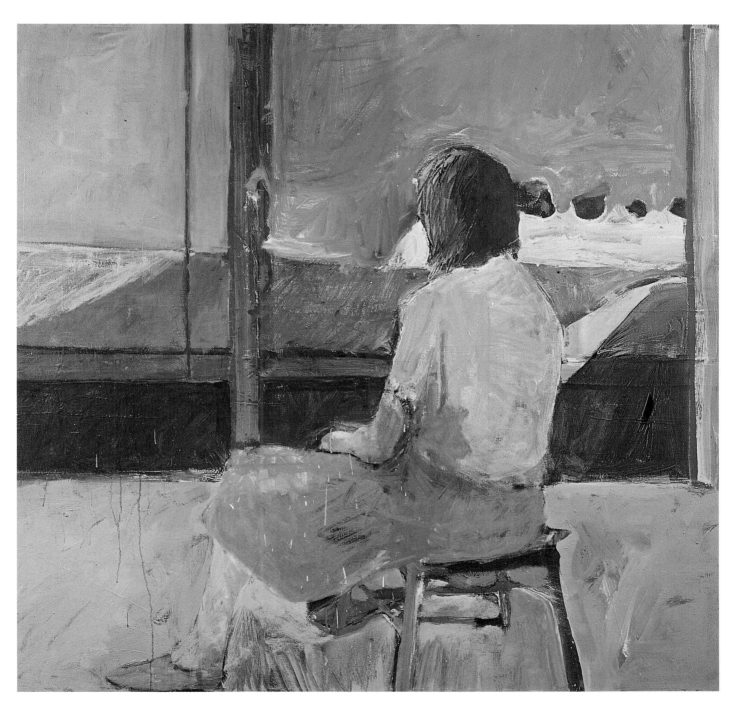

Pl. 21. Richard Diebenkorn. Girl Looking at Landscape, *1957.*

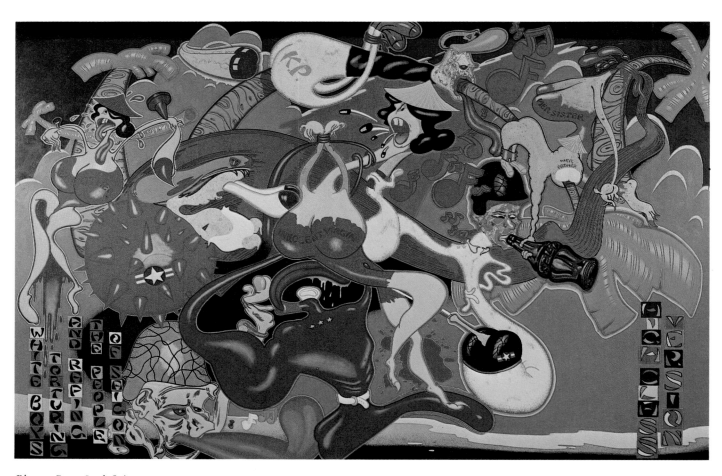

Pl. 22. *Peter Saul.* Saigon, 1967.

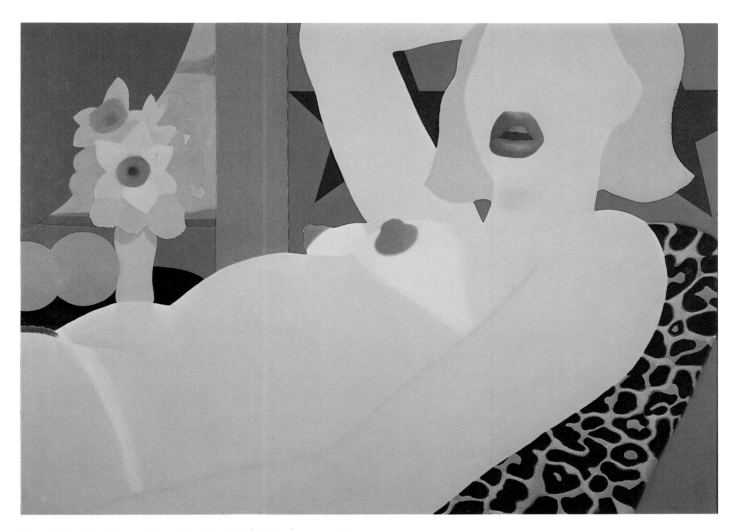

Pl. 23. Tom Wesselmann. Great American Nude, Number 57, *1964.*

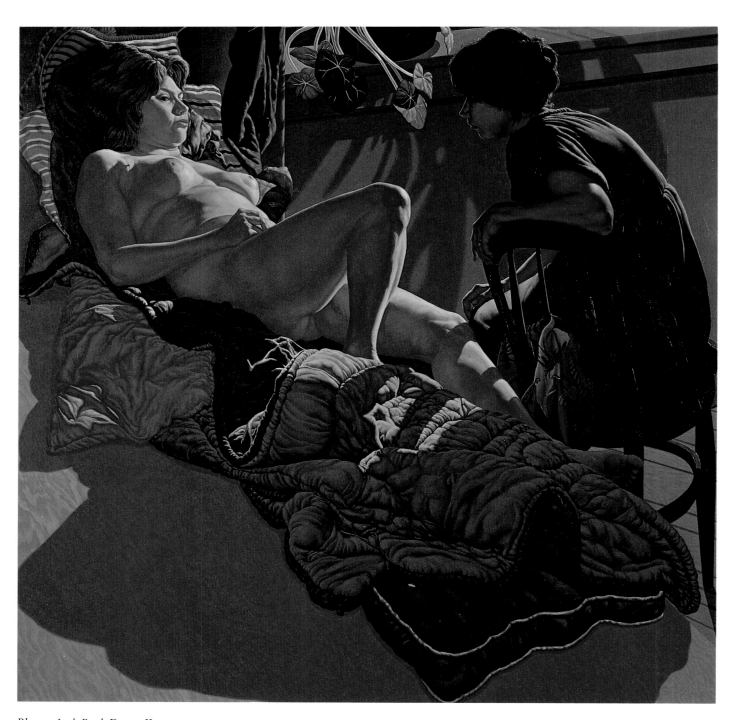

Pl. 24. Jack Beal. Danae II, *1972.*

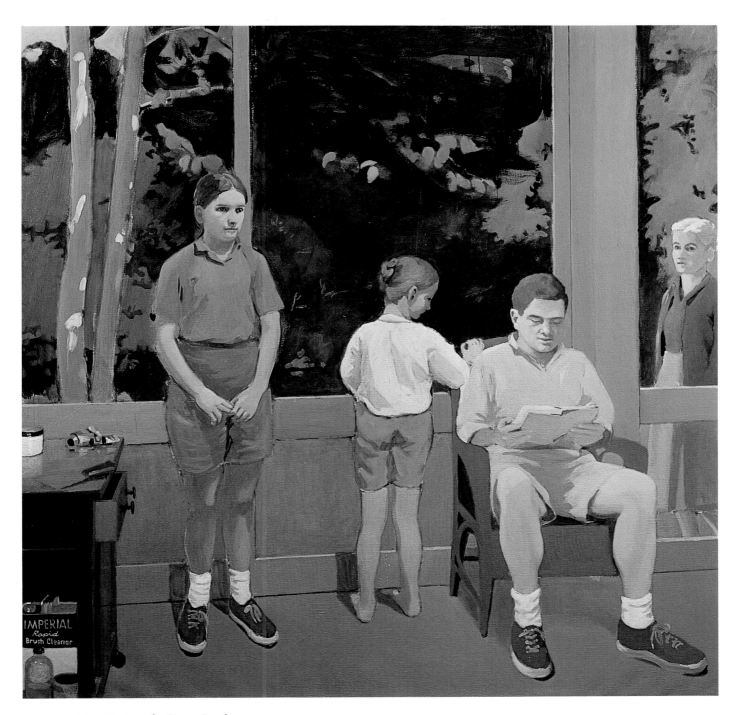

Pl. 25. Fairfield Porter. The Screen Porch, *1964.*

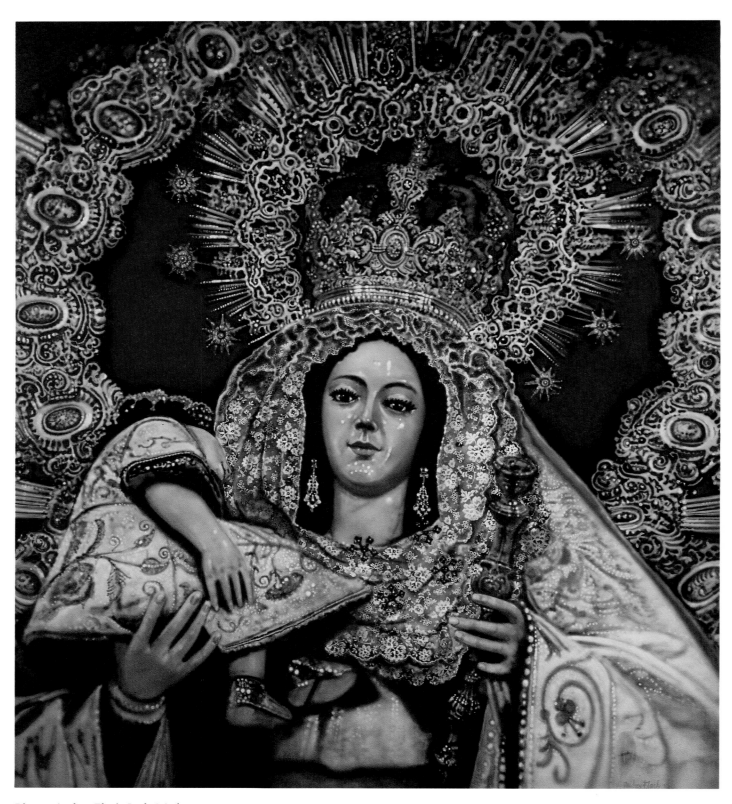

Pl. 26. Audrey Flack. Lady Madonna, *1972*.

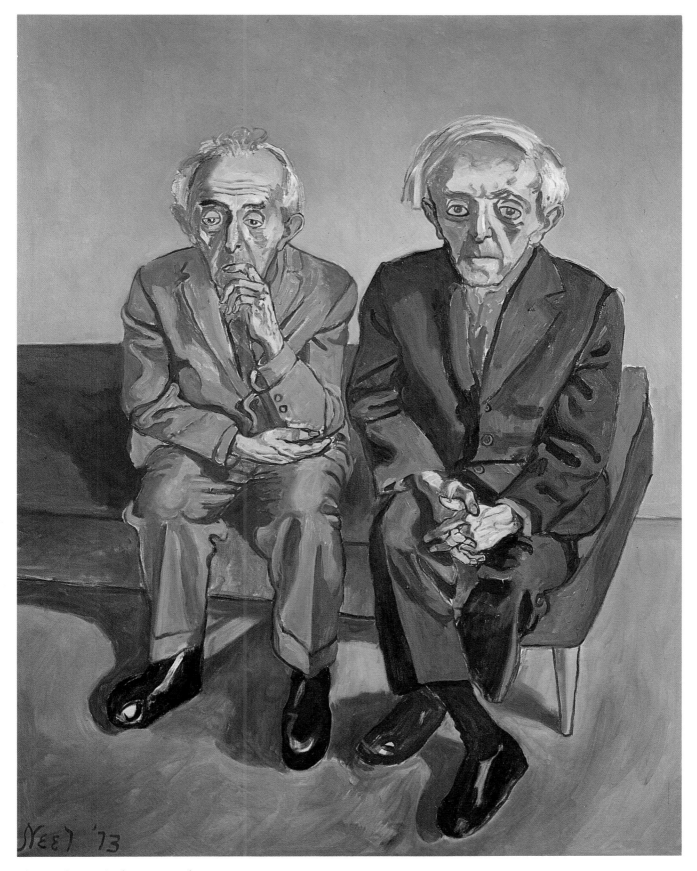

Pl. 27. Alice Neel. The Soyer Brothers, *1973.*

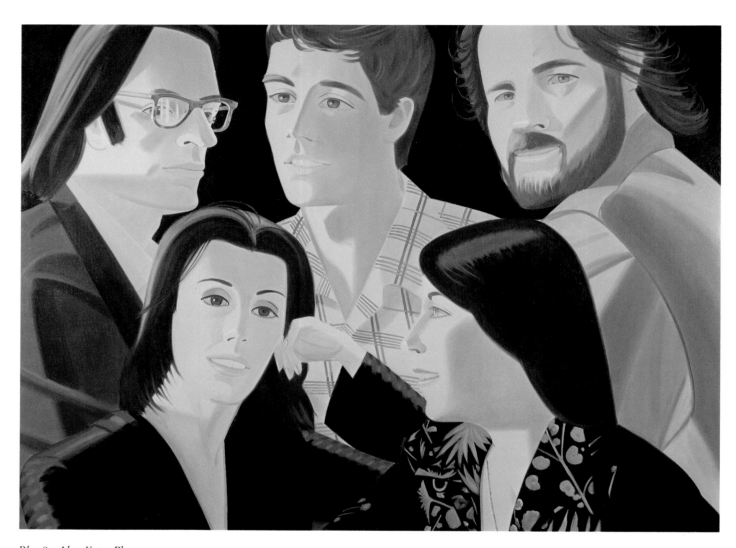

Pl. 28. Alex Katz. Place, *1977.*

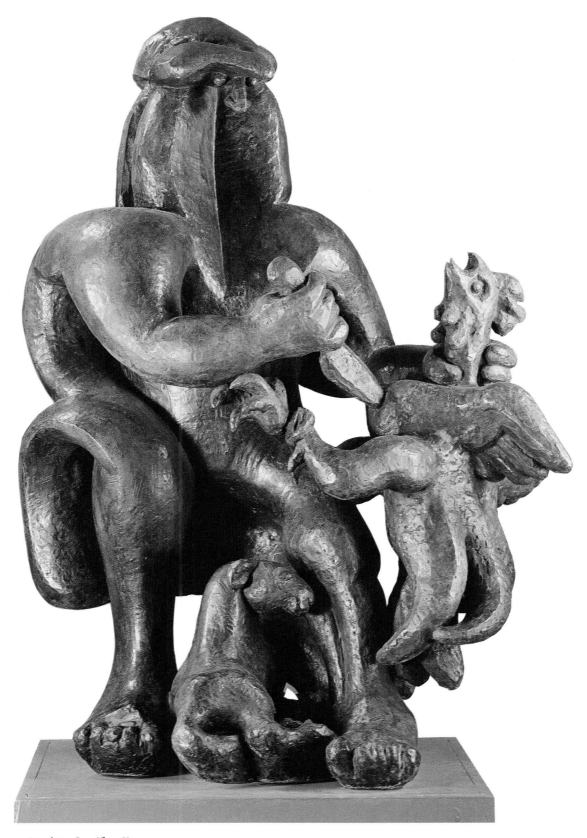

Pl. 29. *Jacques Lipchitz. Sacrifice, II, 1948/52.*

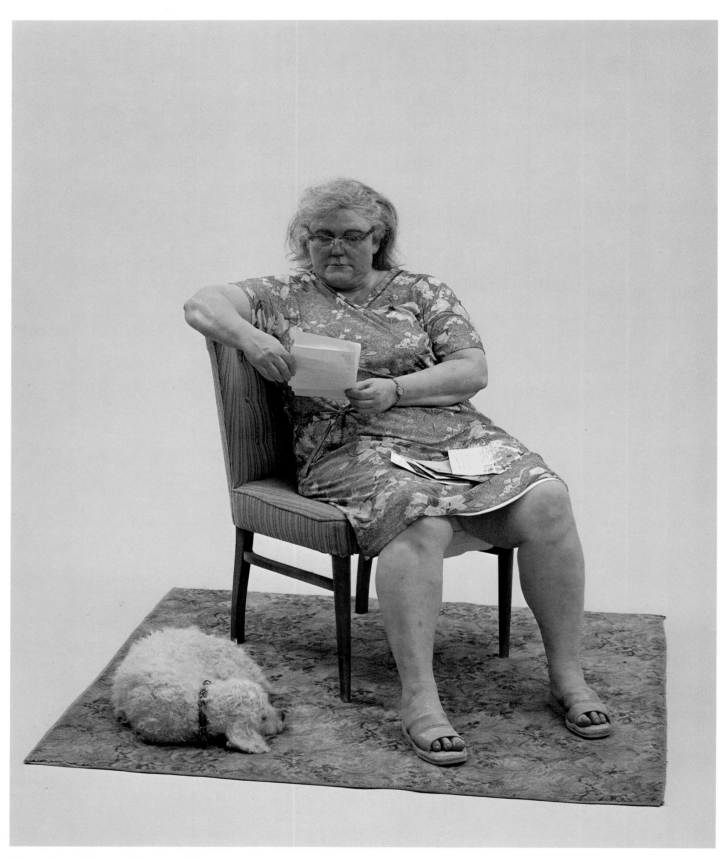

Pl. 30. Duane Hanson. Woman and Dog, *1977.*

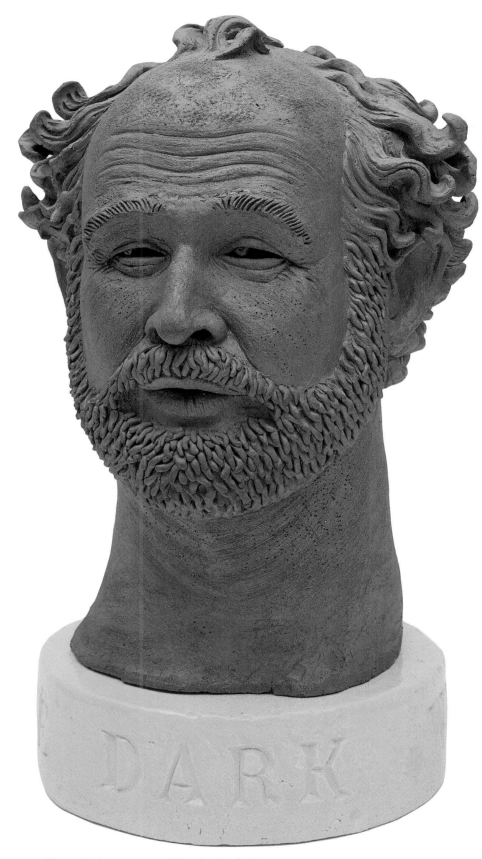

Pl. 31. Robert Arneson. Whistling in the Dark, *1976.*

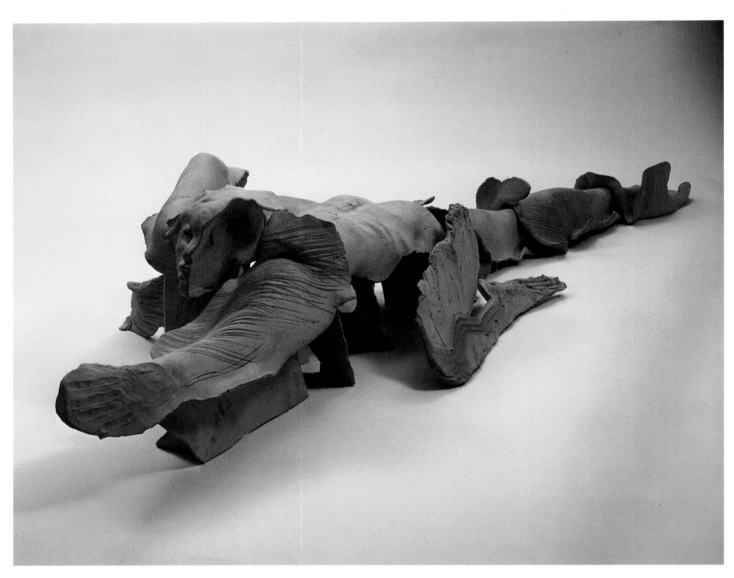

Pl. 32. Mary Frank. Swimmer, *1978.*

Color Plates

Pl. 1. John Sloan. The Hawk (Yolande in Large Hat), 1910. Oil on canvas, 26 × 32 inches. Promised 50th Anniversary Gift of the John Sloan Memorial Foundation, P.22.79.

Pl. 2. Robert Henri. Gertrude Vanderbilt Whitney, 1916. Oil on canvas, 50 × 72 inches. Promised gift of Flora Whitney Miller, 30.77.

Pl. 3. George Luks. Mrs. Gamley, 1930. Oil on canvas, 66 × 48 inches. Gift of Gertrude Vanderbilt Whitney, 31.289.

Pl. 4. Man Ray. Five Figures, 1914. Oil on canvas, 36 × 32 inches. Gift of Mrs. Katharine Kuh, 56.36.

Pl. 5. Leon Kroll. Nude in a Blue Chair, 1930. Oil on canvas, 48¼ × 36¼ inches. Gift of Gertrude Vanderbilt Whitney, 31.264.

Pl. 6. Arshile Gorky. The Artist and His Mother, 1926-29. Oil on canvas, 60 × 50 inches. Gift of Julien Levy for Maro and Natasha Gorky in memory of their father, 50.17.

Pl. 7. Rockwell Kent. The Trapper, 1921. Oil on canvas, 34 × 44 inches. Gift of Gertrude Vanderbilt Whitney, 31.258.

Pl. 8. Raphael Soyer. Office Girls, 1936. Oil on canvas, 26 × 24 inches. Purchase, 36.149.

Pl. 9. Ben Shahn. The Passion of Sacco and Vanzetti, 1931-32. Tempera on canvas, 84½ × 48 inches. Gift of Edith and Milton Lowenthal in memory of Juliana Force, 49.22.

Pl. 10. Philip Evergood. Lily and the Sparrows, 1939. Oil on composition board, 30 × 24 inches. Purchase, 41.42.

Pl. 11. Louis Guglielmi. Terror in Brooklyn, 1941. Oil on canvas, 34 × 30 inches. Purchase, 42.5.

Pl. 12. Gaston Lachaise. Standing Woman, 1912-27. Bronze, 70 × 28 × 16 inches. Purchase, 36.91.

Pl. 13. Elie Nadelman. Sur la Plage, 1916. Marble and bronze, 23 × 26¼ × 7½ inches. Promised 50th Anniversary Gift of the Sara Roby Foundation in honor of Lloyd Goodrich, P.3.79.

Pl. 14. William Zorach. Figure of a Child, 1921. Mahogany, 24 × 5½ × 6¼ inches. Gift of Dr. and Mrs. Edward J. Kempf, 70.61.

Pl. 15. José de Creeft. The Cloud, 1939. Greenstone, 13½ × 12½ × 8½ inches. Purchase, 41.17.

Pl. 16 Thomas Hart Benton. Poker Night (From "A Streetcar Named Desire"), 1948. Tempera and oil on panel, 36 × 48 inches. Promised gift of Mrs. Percy Uris, 5.77.

Pl. 17. Henry Koerner. Vanity Fair, 1946. Oil on composition board, 36 × 42 inches. Purchase, 48.2.

Pl. 18. Paul Cadmus. Fantasia on a Theme by Dr. S., 1946. Egg tempera on composition board, 13 × 13 inches. Purchase, 47.1.

Pl. 19. Willem de Kooning. Woman and Bicycle, 1952-53. Oil on canvas, 76½ × 48 inches. Purchase, 55.35.

Pl. 20. David Park. Four Men, 1958. Oil on canvas, 57 × 92 inches. Gift of an anonymous foundation, 59.27.

Pl. 21. Richard Diebenkorn. Girl Looking at Landscape, 1957. Oil on canvas, 59 × 60¼ inches. Gift of Mr. and Mrs. Alan H. Temple, 61.49.

Pl. 22. Peter Saul. Saigon, 1967. Oil on canvas, 92¾ × 142 inches. Gift of the Friends of the Whitney Museum of American Art, 69.103.

Pl. 23. Tom Wesselmann. Great American Nude, Number 57, 1964. Synthetic polymer on composition board, 48 × 65 inches. Gift of the Friends of the Whitney Museum of American Art, 65.10.

Pl. 24. Jack Beal. Danae II, 1972. Oil on canvas, 68 × 68 inches. Gift of Charles Simon, anonymous donor (and purchase), 74.82.

Pl. 25. Fairfield Porter. The Screen Porch, 1964. Oil on canvas, 79½ × 79½ inches. Lawrence H. Bloedel Bequest, 77.1.41.

Pl. 26. Audrey Flack. Lady Madonna, 1972. Oil on canvas, 78 × 69 inches. Gift of Martin J. Zimet, 72.42.

Pl. 27. Alice Neel. The Soyer Brothers, 1973. Oil on canvas, 60 × 46 inches. Gift of Arthur M. Bullowa, Sydney Duffy, Stewart R. Mott, Edward Rosenthal (and purchase), 74.77.

Pl. 28. Alex Katz. Place, 1977. Oil on canvas, 108 × 144 inches. Gift of Frances and Sydney Lewis, 78.23.

Pl. 29. Jacques Lipchitz. Sacrifice, II, 1948/52. Bronze, 49¼ × 33 × 22 inches. Purchase, 52.27.

Pl. 30. Duane Hanson. Woman and Dog, 1977. Polychromed polyvinyl, life-size. Gift of Frances and Sydney Lewis, 78.6.

Pl. 31. Robert Arneson. Whistling in the Dark, 1976. Terracotta and glazed ceramic, 36¼ × 20 × 20 inches. Gift of Frances and Sydney Lewis, 77.37.

Pl. 32. Mary Frank. Swimmer, 1978. Ceramic, 17 × 94 × 32 inches. Gift of Mrs. Robert M. Benjamin, Mrs. Oscar Kolin, and Mrs. Nicholas Millhouse, 79.31.

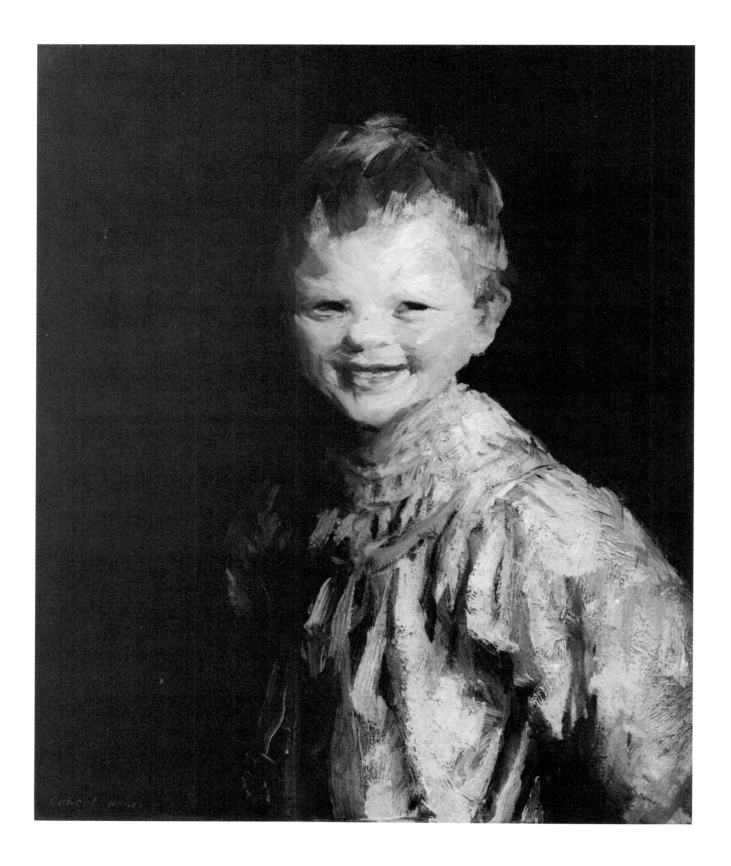

CHAPTER II

Painting, 1900–1940

PATRICIA HILLS

At the turn of the century, Robert Henri and the first wave of twentieth-century American realists, who made New York City their home, became aware that movements within urban society were changing the course of history. The tides of immigration and the shifts of population in the United States were creating overcrowded cities. The growth of trade unionism and the rise of the socialist movement were forcing progressive legislation. The rapid advances in technology and the transportation explosion were transforming the work and leisure habits of all classes. Henri and the realists found inspiration in the poetry of Walt Whitman, who had celebrated both individualism and the common man, as they developed a characteristically American form of humanism — optimistic, liberal, and democratic.[1]

Although humanism as a concept has been changing from the Renaissance to the present, it has generally referred to the study of or concern for man and his accomplishments rather than to theological matters. In 1938, a date which nearly coincides with the midpoint of our period, art historian Erwin Panofsky defined *humanism* in terms which could have been the credo of Henri and his realist friends: "the conviction of the dignity of man, based on both the insistence on human

values (rationality and freedom) and the acceptance of human limitations (fallibility and frailty)."[2] What the definition means in the outlook of these artists is that human dignity is a universal quality — all men, women, and children of all classes, ages, races, creeds, and nationalities have dignity. To insist on human values means to encourage the principles and moral standards which are generated by a society of free and equal people who respect each other's liberty and equality; but to Henri and his followers it also meant cherishing the altruistic emotions. To accept human limitations means to have compassion for psychological and physical frailties and imperfections; but it also means acknowledging that ordinary people, and not just a special and elite group, have possibilities for heroism, and that profound emotional, aesthetic, and social responses are potentially available to everybody.[3]

These artists, therefore, came to believe, as had Whitman, that *individualism*, the belief in the primacy of individual states and interests,[4] was not the exclusive province of the upper classes, creative artists, and "men of genius," but was manifest in each unique individual of whatever sex, race, or class. They were fascinated not only by specific, physical body types, as opposed to an idealized composite based on classical norms, but also were devoted to recording the life-styles, social activities, dreams (and later even nightmares) of individuals.

This outlook, then, explains these artists' rejection of the genteel subject matter of the late nineteenth

Fig. 19. Robert Henri, Laughing Child, *1907. Oil on canvas, 24 × 20 inches. Gift of Gertrude Vanderbilt Whitney, 31.240.*

century — the leisure-class domestic scenes of Frank Benson and Edmund Tarbell, the elegant and sophisticated portraits of John Singer Sargent, and the moody, sentimental figure pieces of George B. Fuller. All had disregarded the full and varied range of human possibilities.

While the realist artists maintained that the genteel tradition ignored human limitations, they were equally critical of the art-for-art's-sake movement. The art produced by this movement offered a necessary antidote to Victorian sentimentality. But because of its preoccupation with the aesthetic design of line, form, and color, it dismissed what it considered literary values, namely the representation of human emotions and behavior. Its concern was the nature of beauty rather than the nature of man. Charles Caffin, writing in 1907, expressed the critical attitude of the realists who opposed art for art's sake:

> [Art for art's sake] had, as other such rallying cries, a modicum of sanity and much extravagance. It was in its best sense a protest against the dependence of painting upon literature, and against the tendency to consider the subject of more importance than the method of representation. It was an assertion never out of place, that the quality of the artistic form must be the final test of a work of art. But it ran to extravagance in assuming that the artistic form was the only test; that what it might embody was of no account at all; that the method of presentation was the first, last, and only important concern of the artist. It put asunder the twain that should be one flesh — the form and the expression. The result was for a time, sterility; much cry and little wool; plenty of good workmanship, but a poverty of emotional or spiritual significance.[5]

Moreover, to realists the term called to mind the dandified and aristocratic types such as Whistler.

Sometime in the early twentieth century, the term *art for art's sake* changed to *Post-Impressionism* and then was modified to *modernism* as critics witnessed the movement expanding, shedding its effete associations, and allying itself with twentieth-century technology.[6] African, Oceanic, and pre-Columbian art, which seemed rhythmically dynamic and bold, as well as machine forms, replaced the sensuously sublime Oriental art that had appealed to Whistler's generation. The good workmanship, qualified by Caffin above, gave

way to "significant form," championed by Clive Bell, who may not have invented the term, but who gave it popular currency in his critical writings of 1911 and 1912:

> *Like all sound revolutions, Post-Impressionism is nothing more than a return to first principles. Into a world where the painter was expected to be either a photographer or an acrobat burst the Post-Impressionist, claiming that, above all things, he should be an artist. Never mind, said he, about representation or accomplishment — mind about creating significant form, mind about art. . . . Post-Impressionism is nothing but the reassertion of the first commandment of art — Thou shalt create form.[7]*

To Bell, the subject was unimportant. However, the creation and manipulation of form was not for its own sake, but for the sake of provoking an aesthetic response: "The important thing about a picture, however, is not how it is painted, but whether it provokes aesthetic emotion."[8] That emotion, unlike the human emotions of sympathy or empathy, was the response to form. Although many early abstract artists such as Kandinsky and later Mondrian were concerned with empathetic expression or the search for essences and universals, too often their work has been interpreted as a preoccupation with formal values only. Indeed, where *Post-Impressionism* today suggests certain forms of expressionism, such as the works of van Gogh and Gauguin, *modernism* as it has evolved has come to suggest the manipulation of form alone solely for aesthetic ends.[9]

Bell, as he was evolving his aesthetic theory, had in mind such artists as Cézanne, Matisse, and Picasso, whose work was not publicly exhibited in America until the end of the first decade. It was then that Alfred Stieglitz, with the enthusiastic help of Edward Steichen, began to show the work of the European moderns in January 1908 when he exhibited Rodin drawings at his Little Galleries of the Photo-Secession at 291 Fifth Avenue in New York. By 1913 he had also mounted shows of the works on paper by Matisse, Picasso, and Cézanne; however, the audience who viewed these exhibitions was relatively small. It was not until February 1913 that the general public was introduced to the modern tendencies in French art when the mammoth *International Exhibition of Modern Art* opened at the Sixty-ninth Regiment Armory in New York. The

exhibition contained about 1,600 works including sculpture, paintings, drawings, and prints of which one-third were late nineteenth-century and early twentieth-century European art. The artists included Cézanne, van Gogh, Gauguin, Matisse, Derain, Picasso, Braque, Duchamp, Gleizes, Léger, Picabia, Villon, Delaunay, Munch, Kandinsky, Kirchner, and the sculptors Archipenko, Duchamp-Villon, Manolo, Lehmbruck, Maillol, and Brancusi. Although the press ridiculed the exhibition, which traveled on to Chicago and Boston, many young American artists were overwhelmed by the energy and vitality of what they saw.[10]

Whatever its name, *modernism* — the concern with form — left its mark on almost all aspects of twentieth-century art. However, even though American figure painters from 1900 to 1940 experimented with the various European modernist styles (Fauvism, analytic cubism, collage cubism, and Constructivism), they ended by considerably modifying those styles because of their own insistence on the unique, the individual, and often the "American." This commitment to the worth of the individual overrode all other ideological commitments even during the tumultuous 1930s when artists were challenged by socialist ideas. With the hindsight of history, we can today see that Gertrude Vanderbilt Whitney and later Juliana Force, as patrons to a great number of early twentieth-century figurative artists, helped liberal humanism to flourish in the arts. The Whitney Museum's collection of figurative paintings charts that humanist current in American art in the decades before World War II.

Early Twentieth-Century American Realists

When the twentieth century arrived the academic and mural painters such as Kenyon Cox, Edwin Blashfield, and their friends dominated figure painting in America. Because they influenced the juries and hanging committees of the National Academy of Design, the Society of American Artists, the Pennsylvania Academy of the Fine Arts, and other art institutions, younger artists of less conventional subject matter or more modern styles found that recognition in the art community was difficult to achieve. In 1898, a group of ten New York and Boston impressionist and figurative artists organized their own exhibition in order to show their

work to its best advantage. In their styles and subject matter these artists, who came to be called The Ten, hardly seem innovative to today's viewer. Their styles ranged from the tasteful impressionism of Frederick Childe Hassam, Willard Leroy Metcalf, John Henry Twachtman, and Julian Alden Weir to the fashionable figure styles (with echoes of Vermeer) of Frank Benson, William Merritt Chase, Joseph Rodefer De Camp, Thomas Dewing, Robert Reid, Edward Simmons, and Edmund Tarbell.[11] Their subject matter included garden landscapes, quiet forest interiors, and languid ladies of the leisure class flitting through green meadows or performing bourgeois social rituals such as writing letters, visiting at tea time, and supervising the servants.

In time, The Ten and their friends also became part of the establishment, resisting the efforts of newcomers such as the New York realists. John Sloan's comment in his diary, when he heard the names of the jury members for the Pennsylvania Academy of the Fine Arts annual exhibition of 1906, characterizes the resentment of a younger generation:

> *The Penn. Academy Jury has Glackens on it, which is fine, but oh, the rest of the list is out today. Redfield, chairman, De Camp of Boston, Benson of Boston. Oh the poor Boston Brand of American Art! Childe Hassam, who owes debts of kindness to last year's Juries, Julian Story the temporary Philadelphian. Oh sad outlook! Redfield on the Hanging Committee!! S'death.*[12]

To the figure painters in the early years of the century, such as Robert Henri and Sloan, neither the academic, the genteel impressionist, nor the Post-Impressionist styles could communicate their enthusiasm for the American urban scene and the spirited people who inhabited it.

To show their work to a public they knew was interested, Henri along with John Sloan organized an exhibition of eight painters, which was held at the Macbeth Gallery in February 1908. Gertrude Vanderbilt Whitney, who had herself organized in 1907 an exhibition of the paintings of Arthur B. Davies, Ernest Lawson, and Jerome Myers,[13] selected four paintings to purchase before the opening of the Macbeth Gallery showing: Henri's *Laughing Child*, George Luks's *Woman with Goose*, Everett Shinn's *Revue*, and Ernest Lawson's *Winter on the River*. By then she was firmly committed to the patronage of living American figurative and realist artists. Of the others in the group —

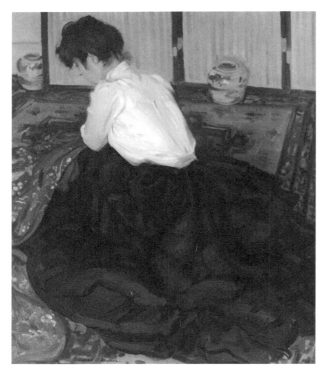

Fig. 20. Alfred H. Maurer. An Arrangement, *1901. Oil on cardboard, 36 × 31 ¾ inches. Gift of Mr. and Mrs. Hudson D. Walker, 50.13.*

Sloan, Davies, Maurice Prendergast, and William Glackens — Mrs. Whitney extended her support in numerous ways. Sloan had a one-man exhibition at the Whitney Studio in 1916; Mrs. Whitney purchased works by the others so that in the inaugural exhibition of the Whitney Museum of American Art in November 1931 they were all represented.

The figurative realism of Henri and his younger friends and students, in contrast to turn-of-the-century aestheticism, finds an appropriate paradigm in his *Laughing Child* of 1907 (Fig. 19) when compared with Alfred Maurer's *An Arrangement* of 1901 (Fig. 20). Maurer at that time was influenced by both Art Nouveau and Whistler in his choice of title, composition, and motifs. The woman who bends down to sew or repair a piece of fabric is less the subject than the occasion for Maurer's artistic creation. The billowing mass of her crumpled skirt, the white shape of her blouse, and the soft oval of her head set off a pattern created by the Chinese rug which, as it recedes into space, tilts upward to meet the carefully placed background screen and Oriental vases.

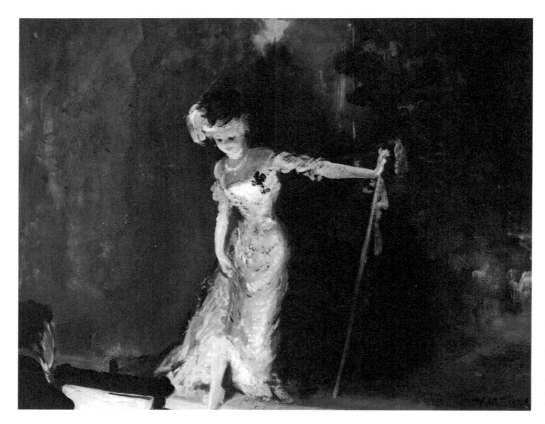

Fig. 21. Everett Shinn. Revue, *1908. Oil on canvas, 18 × 24 inches. Gift of Gertrude Vanderbilt Whitney, 31.346.*

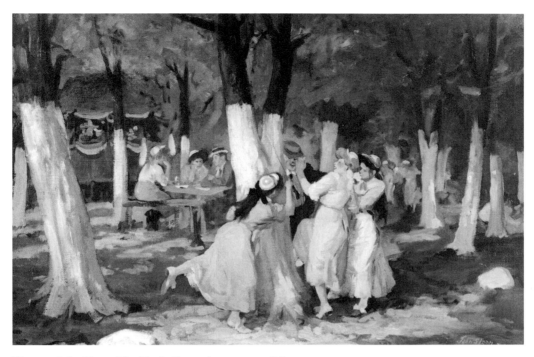

Fig. 22. John Sloan. The Picnic Grounds, *1906-07. Oil on canvas, 24 × 36 inches. Purchase, 41.34.*

Henri, in contrast, focused on the impish face of the laughing blond boy by using a free and loose brushstroke that recalls the bravura style of Frans Hals. Henri and his group were attracted to the spontaneity and life of children. In fact, to see life as if through the eyes of a child was desirable, and Henri admired Renoir for his reverence of children.[14]

Through Henri's teaching and exhortations he encouraged a generation of younger artists to value the urban scene and the working classes as subject matter and to disdain aestheticism and art for art's sake. To Rockwell Kent, recalling in 1955 his own student years at the New York School of Art, "Henri as an instructor, Henri as a leader of revolt against Academic sterility, Henri as an inspirational influence in American art, is possibly the most important figure of our cultural history."[15] Guy Pène du Bois, in his autobiography, remembered the young students who emulated Henri: "They were natural men, liking life enough to want to tear off the veil thrown so modestly or priggishly over it by the prevailing good taste."[16] Rebelling against the genteel tradition and, according to du Bois, taking their cues from Whitman, Dreiser, and the literary realists, they found the most vital subject matter in the cities:

Here, before their eyes, was the untouched panorama of life, an unlimited field, an art bonanza. Here in the Alligator Cafe on the Bowery, the Haymarket on Sixth Avenue, the ferryboats, the lower East Side, in any number of cheap red-ink restaurants, one found subjects as undefiled by good taste or etiquette or behavior — that national hypocrisy — as a new-born babe. Here was life in the raw or nearly so, life anyway not trying to pretend through a crooked finger or repelled nostrils to the possession of the better sort of breeding.[17]

The other figurative artists, Shinn, Glackens, Luks, and Sloan, all former newspaper illustrators from Philadelphia, were encouraged by Henri's example to paint. Everett Shinn specialized in vaudeville entertainers (see Fig. 21); Glackens painted café habitués; and Sloan depicted city parks, beaches, and picnic grounds brimming with exuberant men and women such as the "young girls of the healthy lusty type," depicted in his *Picnic Grounds* of 1906–07 (Fig. 22).[18] In a diary he kept during these years, Sloan recorded his impressions of the city; the entry for February 13, 1906, reads:

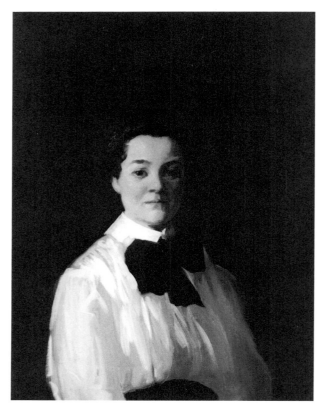

Fig. 23. John Sloan. Dolly with a Black Bow, *1907. Oil on canvas, 32 × 26 inches. Gift of Miss Amelia Elizabeth White, 59.28.*

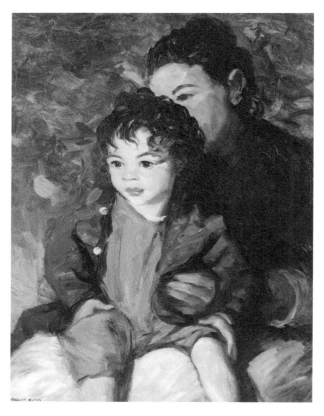

Fig. 24. Robert Henri. Sammy and His Mother, *1915. Oil on canvas, 32 × 26 inches. Promised gift of Mrs. Percy Uris, 16.77.*

Walked through the interesting streets on the East Side. Saw a boy spit on a passing hearse, a shabby old hearse. Doorways of tenement houses, grimy and greasy door frames looking as though huge hogs covered with filth had worn the paint away and replaced it with matted dirt in going in and out. Healthy faced children, solid-legged, rich full color to their hair. Happiness rather than misery in the whole life. Fifth Avenue faces are unhappy in comparison.[19]

In his painting *The Hawk (Yolande in Large Hat)* of 1910 (Pl. 1), Sloan attempted to capture the qualities of the "very bright nervous bird-like young lady of seventeen years"[20] — the same qualities of spontaneity as Henri's *Laughing Child.* Although Sloan was drawn deeply into the politics of the Socialist Party for a period of seven or eight years before the country entered World War I, he kept his paintings unpolitical, believing that

art and politics do not mix. Instead, he gave us joyous genre scenes of the camaraderie of working-class men and women.[21]

As they entered the second decade of the twentieth century, some of the New York realists tended toward expressions of elegance. Glackens, particularly, began to abandon the urban naturalism of the group and to fall more and more under the influence of French art. He visited France in 1906 and his *Reclining Nude* of 1910 (Fig. 25) is more softly sensuous than the earlier works. In 1912 Glackens returned to Paris on a buying trip for Albert Barnes, and was introduced to the works of Renoir and Cézanne in the collections of Gertrude and Leo Stein.[22] Renoir, particularly, was to be a lasting influence on him. In his *Girl in Black and White* of 1914 (Fig. 26), with its green tones in the shadowed part of the figure's face, Glackens has also attempted to model with color rather than tone as had the Fauve painters, whose works were exhibited at the Armory Show.

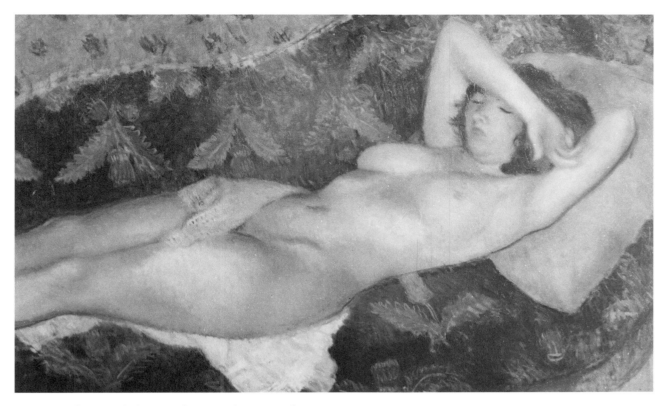

Fig. 25. William J. Glackens. Reclining Nude, *1910. Oil on canvas, 32¾ × 54 inches. Gift of Charles Simon, 78.104.*

Henri in his portrait *Gertrude Vanderbilt Whitney* of 1916 (Pl. 2) captures the art patron and sculptor reclining on a deep purple spread dressed in pale turquoise pantaloons and a loosely fitted royal blue and yellow jacket. The pose and the vibrant colors along with Henri's fluid elegance of brushwork reinforce an image of feminine modernity and sophistication disdaining the conventional roles of an upper-class matron.

Within a few years after the 1913 Armory Show, Sloan also moved away from working-class subjects toward a self-conscious and idiosyncratic form of modernism which emphasized color.[23] George Luks, however, never broke his ties with New York urban subject matter. In private life a boisterous and heavy-drinking man, Luks painted characters who matched his own pugnacious vitality. In his *Old Woman with White Pitcher* of 1926 (Fig. 27), he applied paint directly and thickly; in his life-size painting *Mrs. Gamley* done in 1930 (Pl. 3), the subject firmly controls her rooster, dominates her tidy kitchen, and challenges the viewer's notions of good taste. In Luks's paintings, personality rather than form manipulates the viewer's responses.

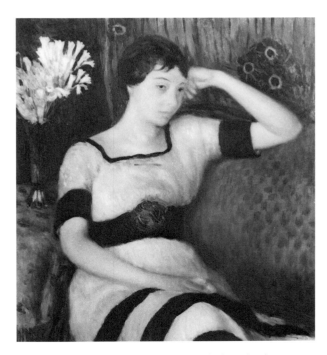

Fig. 26. William J. Glackens. Girl in Black and White, *1914. Oil on canvas, 32 × 26 inches. Gift of the Glackens Family, 38.53.*

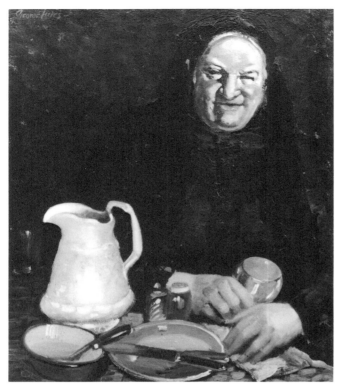

Edward Hopper studied with Henri and then made three long visits to Europe between 1906 and 1910, which strongly affected his subsequent development in art. Of the early realists he seems most concerned with problems of form, light, and design in the paintings done both in Paris and upon his return. In 1909 he painted *Summer Interior* (Fig. 28), a study of a nude seated on the floor staring at a patch of sunshine which falls next to her. The representation of light — including daylight falling into an interior or indoor illumination shining out into the darkness of the night — would become a major concern for Hopper and at times would shape the content of his realism, a tendency rarely characteristic of the Henri group.[24] Moreover, his figures, neither epic nor comic, would come to symbolize the pathos of the lonely existence of individuals in motels, all-night restaurants, and small town boarding houses. Yet, whatever the subject, the viewer is always aware of Hopper's manipulation of form and light to create strong designs.

Fig. 27. George Luks. Old Woman with White Pitcher, *1926. Oil on canvas, 30 × 25 inches. Gift of Mr. and Mrs. Lesley G. Sheafer, 55.45.*

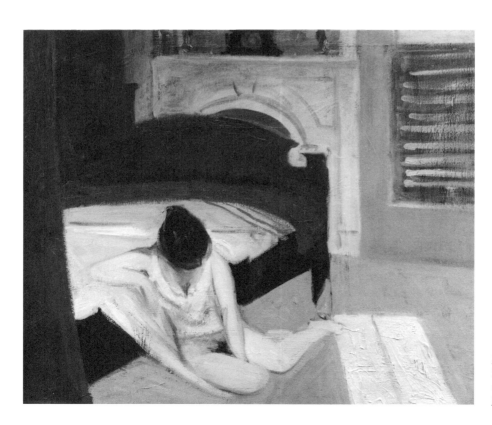

Fig. 28. Edward Hopper. Summer Interior, *1909. Oil on canvas, 24 × 29 inches. Bequest of Josephine N. Hopper, 70.1197*

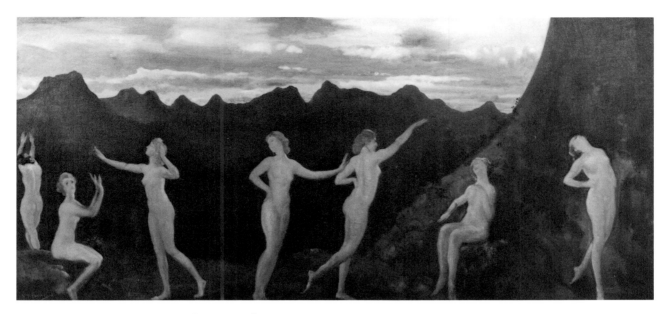

Fig. 29. Arthur B. Davies. Crescendo, 1910. Oil on canvas, 18 × 40 inches. Gift of Gertrude Vanderbilt Whitney, 31.166.

Early Twentieth-Century American Modernists

In the first five years of the century, the modernist trends were barely known in America. Bernard Karfiol noted that when he returned home from Europe in 1903, "Art seemed dormant. The new movements were unknown or laughed at. A few Impressionists slipped through into American consciousness, but generally it was desert land. Once again I escaped to Paris, seething with activities, discussions and ideas."[25] But by 1908, however, Fauvism and Cubism were becoming known in the art circles of New York. Stieglitz, whose role was crucial in introducing the French artists at his gallery, also exhibited the experimental work of younger American painters John Marin, Max Weber, Arthur G. Dove, Arthur B. Carles, Marsden Hartley, Oscar Bluemner, Georgia O'Keeffe, and Abraham Walkowitz between 1909 and 1917.[26] Except for Walkowitz and Weber, none of the Stieglitz group of American painters during the time of their association with Stieglitz developed a figurative style, preferring to explore modernism within the modes of still life, landscape, and nature painting.

The transition from late nineteenth-century academic art to twentieth-century modernism can be traced in paintings of the nude in the landscape, a theme which in Europe includes Puvis de Chavannes's murals as well as easel paintings by Cézanne, Derain, and Matisse.[27] Americans made their own transition, less radically than the Europeans. In Arthur B. Davies's Crescendo of 1910 (Fig. 29), lithe female nudes move across a narrow ledge of meadow as twilight darkens the backdrop of mountains. Arcadian creatures only vaguely aware of each other's presence, they invoke a mood of elegiac reverie. Their limbs move randomly and lack purpose as their bodies form a frieze of artificial poses.

Maurice Prendergast's The Promenade of 1913 (Fig. 30) contains nude and clothed figures in a painting that combines decorative qualities — the tapestry-like

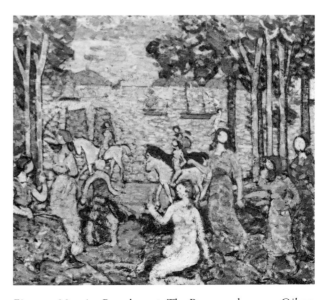

Fig. 30. Maurice Prendergast. The Promenade, 1913. Oil on canvas, 30 × 34 inches. Bequest of Alexander M. Bing, 60.10

Fig. 31. *Arthur Crisp.* Adam and Eve, *c. 1918. Oil on plaster, 22 × 30 inches. Gift of Gertrude Vanderbilt Whitney, 31.156.*

Fig. 32. *Bernard Karfiol.* Boy Bathers, *1916. Oil on canvas, 28 × 36 inches. Purchase (and exchange), 54.19.*

patterning of the entire surface — with the mood of arcadia. In its simplification of form, tentative or unfinished quality of line, flattening of space, and patches of pure color, *The Promenade* finds its European counterpart, and perhaps even source, in the outdoor nudes by Fauves Derain, Vlaminck, and Matisse of the previous decade.

Arthur Crisp's *Adam and Eve* of about 1918 (Fig. 31) is a decorative oil on plaster with incised lines creating a linear style based on Greek vase painting. The subject evokes a mood of peaceful interlude with the couple fondling the apples from the tree of knowledge in disbelief of the cautionary gesture of the angel. Bernard Karfiol's painterly *Boy Bathers* of 1916 (Fig. 32) suggests a similar simplicity in its conscious awkwardness of anatomy, perspective, and paint handling. Studying in Paris right after the turn of the century, Karfiol exhibited several of his canvases at the Salon d'Automne of 1904. In Paris until 1906, he met Picasso, Matisse, and other leading avant-garde painters in the homes of Gertrude and Leo Stein. He was thus aware of radical possibilities for handling the figure, but chose a less extreme style — a consciously artless style suggestive of innocence.

What all four artists — Davies, Prendergast, Crisp, and Karfiol — share is their preoccupation with a figural and idealist subject matter denying the materialism of the modern age, including the buildup of World War I. They sought, then, sylphlike female nudes, summer promenades, Adam and Eve before knowledge and sin, and pubescent boys — boys too young for the responsibilities of an ever more complicated technological world.

Cubism provided the structural grid by which Davies and Man Ray carried the nude form a further step toward decorative modernism. The new French

Cubist styles he saw at the Armory Show were "to mark a new departure" in the work of Man Ray,[28] who regularized and simplified the limbs, torsos, and heads of the nude forms in *Five Figures* of 1914 (Pl. 4). Recalling Léger's early twentieth-century experiments with tubular figures, the languorous nudes in *Five Figures* tumble and roll toward the spectator; the color, however, is distinctly Man Ray's, with purples, oranges, and greens radiating multiple halos of color within and without the forms of the figures. Davies, by then also under the spell of Cubism, used faceted planes of pure color to define the over life-size figures in a large mural he completed in 1915 called *Dances* (Detroit Institute of Arts).[29] The Whitney Museum's smaller version, called *Day of Good Fortune* (Fig. 33), was painted for Mrs. Lillie P. Bliss, later co-founder of the Museum of Modern Art. The romantic mood of Davies's earlier *Crescendo* has been replaced by an exuberant pattern of color wedges evoking the joyousness of pure dance. Whereas the twentieth-century American realists used a radical subject matter (urban, working-class life) in styles that were traditional (the painterly realism of Gustave Courbet and Wilhelm Leibl), Man Ray and Davies used a traditional subject (nudes) in styles that were boldly new.

Traditional genre scenes were subjected to a modernist approach. William Zorach absorbed some of the Post-Impressionist styles when he studied in France. *The Roof Playground*, painted in 1917 (Fig. 34), represents a "cubist" boy, girl, and dog in the center of a witty composite of specific images of urban life, including the laundry billowing on a foreground clothesline. Max Weber went a step further and splintered facial features into shifting dynamic designs with Futurist overtones. Weber's *Chinese Restaurant* of 1915 (Fig. 35) has lost almost all claims as a figurative genre painting, and yet

Fig. 33. Arthur B. Davies. Day of Good Fortune, 1920. Oil on canvas, 18 × 30 inches. Gift of Mr. and Mrs. Arthur G. Altschul, 71.228.

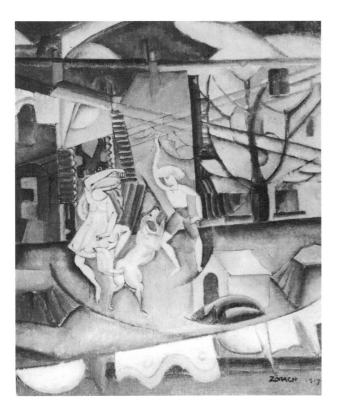

the fractured and refracted bits of eyes, brows, and noses which glimmer through the rich pattern of Chinese red, black, and gold (the decor of the restaurant) give movement and a touch of humor to what everyone would recognize as a distinctly American scene.[30]

Fig. 34. William Zorach. The Roof Playground, 1917. Oil on canvas, 29 × 23 ¾ inches. Gift of Mr. and Mrs. Arthur G. Altschul, 71.231.

Fig. 35. Max Weber. Chinese Restaurant, 1915. Oil on canvas, 40 × 48 inches. Gift of Gertrude Vanderbilt Whitney, 31.382.

New York Teaching Academies in the Post–World War I Years

The majority of American art students in the immediate postwar years could not afford the expenses of a trip abroad, nor were they drawn to Paris and the art movements there. With a goal of achieving mastery in rendering the human form and control of the various techniques, most felt that the art training available in the New York art schools was perfectly adequate. Many therefore attended art classes at the National Academy of Design, the Art Students League, as well as the New York School of Art until its demise in 1911, where they learned the basic rules of proportion, anatomy, perspective, chiaroscuro, and the judicious layering of paint on a canvas surface.

Of the three, most young artists considered the National Academy of Design the most conservative in terms of the styles of the instructors and teaching methods. Moreover, its reputation for turning down promising artists at its annual exhibitions gave it a bad name. Raphael Soyer, who attended the academy while working full time, vividly recalled the teachers on the faculty — Charles C. Curran, Francis C. Jones, and George W. Maynard — who used to visit the painting studios once or twice a week, but he "did not take their criticism seriously."[31] Young artists wanted not just instruction but sympathetic and vital mentors to serve as role models. They turned then to the New York School of Art, the Art Students League, and after 1917 the Educational Alliance Art School on the lower East Side.[32] The New York School of Art, reorganized in 1898, was the continuation of a school William Merritt Chase had established in 1896 and which he continued to head for the following eleven years. Robert Henri taught there from 1902 to the end of 1908, and Kenneth Hayes Miller taught from 1899 to 1911.[33] Chase was a man of the nineteenth century; Henri inspired the early twentieth-century realists; Miller, including the years he taught at the Art Students League, influenced many artists right up through the 1940s. Rockwell Kent, in his autobiography, characterized the differences among the three teachers:

As Chase had taught us just to use our eyes, and Henri to enlist our hearts, now Miller called on us to use our heads. Utterly disregardful of the emotional values which Henri was so insistent upon, and contemptuous of both the surface

realism and virtuosity of Chase, Miller, an Artist in a far more precious sense than either, exacted a recognition of the tactile qualities of paint and of the elements of composition — line and mass — not as a means toward the re-creation of life but as the fulfillment of an end, aesthetic pleasure. To translate this into terms of literature, he stressed the sound of words, the cadence and the rhythm of a line, as though regardless of their meaning or their truth. . . . Yet the importance of style as intrinsic to the expression of thought is undeniable; and Miller's emphasis upon some of its elements was of value to me if for no reason but as a corrective of Henri's disregard of it.[34]

At the Art Students League, which he joined in 1911, Miller found the atmosphere congenial. He taught there from 1911 until 1931, again from 1932 to 1936, and from 1944 to 1951. Instructors then, as now, could work in any style and had complete freedom in terms of teaching method. Students could sign up for study at any time during the year, paying tuition on a monthly basis. There were no attendance records, no grades, no entrance requirements.[35] Miller's students at the New York School and at the League included these, all represented in the collection of the Whitney Museum: Edmund Archer, Peggy Bacon, George Bellows, Isabel Bishop, Arnold Blanch, Alexander Brook, Adolf Dehn, John Graham, Marsden Hartley, Edward Hopper, Rockwell Kent, Yasuo Kuniyoshi, Edward Laning, Reginald Marsh, Katherine Schmidt, Henry Schnakenberg, and Robert Vickrey. Paul Cadmus was not a student but an admirer who shared with Miller a fondness for the tempera technique.[36]

What appealed to Miller's students was his sense of mission "to keep Art alive," because Miller shared with the modernists a concern for form. Lloyd Goodrich, a former student, described the basis of Miller's art:

To Miller the basis of all enduring art was the creation of three-dimensional design by the physical means of form, space, color and texture. In his austere concentration of these essentials, he was never diverted by superficial qualities. In a painting by him all the forms are round, realized from every side as by a sculptor, and situated in deep space; but they are the forms of art, and not imitated natural forms; the integrity of the picture plane is preserved, and the painting speaks in a purely sensuous language. Color, while having its own value, is

an instrument to create form and space. Every part of the picture has a conscious relation to every other part; and dominating all is a deeply felt and pondered conception of the harmony of the whole. . . . His art is essentially classic in its order, balance and sense of solidarity with the past. His peculiar combination of naturalism and classicism will, I believe, be valued more and more as the years pass. [37]

However, Miller's "peculiar combination of naturalism and classicism" characteristic of the 1920s has not yet been revived; nor are critics today as generous to Miller's art and to Miller's modernism as Goodrich was in 1953. Nevertheless, Miller does seem to have the distinction of being one of the last of the great teachers who, by emulating the Old Masters, tried to bridge the gap between the Renaissance and Baroque masters and the moderns. [38]

Other painters who taught at the League and who were among those closely associated with Mrs. Whitney, Mrs. Force, the Whitney Studio Galleries, the Whitney Studio Club, and later the Whitney Museum of American Art were Eugene Speicher, teaching from 1908 to 1913 and 1919 to 1920; Robert Henri from 1916 to 1928; John Sloan from 1916 to 1924, from 1926 to 1930, and again from 1935 to 1938; Allen Tucker, from 1921 to 1928; Guy Pène du Bois from 1920 to 1924, from 1930 to 1932, and 1935 to 1936; Henry Schnakenberg from 1923 to 1925; Thomas Hart Benton from 1926 to 1935; Yasuo Kuniyoshi from 1933 to 1953;[39] and Peggy Bacon in 1935 and again from 1949 to 1951. [40]

The Studio Picture

During the 1920s and 1930s many of the artists associated with Mrs. Whitney's endeavors chose as their principal genre "studio pictures" — either still lifes containing studio props, or figure compositions of posed nude or clothed figures. In the late nineteenth and early twentieth century John Sloan, like Degas and Forain, had done "slice of life" close-up views of a person (usually a working-class woman) caught unawares in the act of bathing, dressing, or undertaking a domestic chore. The studio picture, however, depicts models, either friends or hired professionals, represented *as models*, with their heads turned and limbs

arranged to make a pleasing composition. There is no pretense that the figures are acting out a life situation other than the reading and daydreaming which posed models do as an antidote to boredom. It is, in fact, an art school situation re-created in the painter's own studio. Milton W. Brown in *American Painting from the Armory Show to the Depression* refers to the "studio group" painters as "middle-of-the-road" artists, for as a group they neither embraced the extreme styles of modernism nor were they drawn to depict the typical situations of American life. Brown has singled out Jules Pascin, Bernard Karfiol, Alexander Brook, Emil Ganso, and Yasuo Kuniyoshi for mention.[41] Other studio figure artists in the Whitney Museum's collection would include Arnold Blanch, Lucile Blanch, Adolphe Borie, Leon Kroll, Henry Schnakenberg, Eugene Speicher, and Moses, Raphael, and Isaac Soyer.

Jules Pascin, a Bulgarian-born, German-trained Francophile of cosmopolitan ways but eccentric behavior, made a strong impression on the studio group.[42] From 1914 to 1920 he lived in the United States with trips to the South, Cuba, and the Caribbean, even acquiring U.S. citizenship before leaving for Paris. When he returned to New York for a stay which lasted from August 1927 to June 1928, his style in his oil paintings had matured to one which combined nervous and wispy lines with large patches of softly modulated and barely modeled color. His favorite subjects were lounging female figures — neither totally nude nor dressed, neither girls nor quite women, but softly erotic creatures suggesting the demimonde world which fascinated Pascin. Raphael Soyer recalls that Pascin was then very popular among younger artists; Peggy Bacon, Alexander Brook, Yasuo Kuniyoshi, and Walt Kuhn "were all taken by Pascin." Although Soyer never met Pascin, he was influenced by Pascin's work to hire his first model.[43]

Both Emil Ganso's *Gertie* of about 1928 (Fig. 36) and Alexander Brook's *Girl with Flower* of 1930 (Fig. 37) reveal the influence of Pascin's style, where the tentative qualities of individual draftsmanship and modeling are less relevant than the overall harmonious effect and the romantic mood of reverie. By comparison, Henry Schnakenberg's painterly naturalism in his *Conversation* of 1930 (Fig. 38) has little of Pascin's poetry; and Leon Kroll's *Nude in a Blue Chair*, also of 1930 (Pl. 5), presents a solidly rendered, sculpturesque form.

Yasuo Kuniyoshi's change of style after his encounter with Pascin is probably the most dramatic.

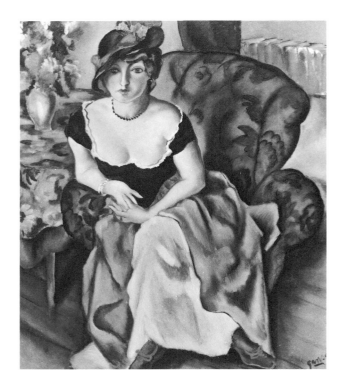

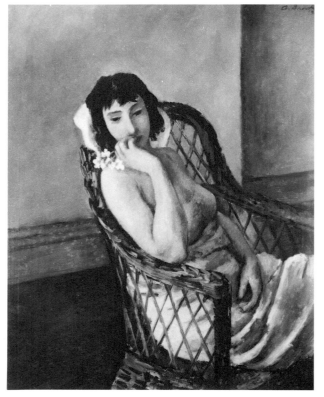

Kuniyoshi's *Child* of 1923 (Fig. 40) was doubtless painted from imagination and inspired by folk art, not yet a vogue among American collectors. The painting has both a naive and a cubist quality: earth tones, an archaizing emphasis on discrete parts, clarity of outline, arbitrary modeling, and depth barely suggested by overlapping forms rather than linear perspective. In his *I'm Tired* of 1938 (Fig. 41) the style has shifted to a painterly mode with indefinite contours, a gray-toned

counterclockwise starting upper left:

Fig. 36. Emil Ganso. Gertie, *c. 1928. Oil on canvas, 40 × 34 inches. Gift of Gertrude Vanderbilt Whitney, 31.205.*

Fig. 37. Alexander Brook. Girl with Flower, *1930. Oil on canvas, 34 × 26 inches. Gift of Gertrude Vanderbilt Whitney, 31.124.*

Fig. 38. Henry Schnakenberg. Conversation, *1930. Oil on canvas, 50¼ × 36 inches. Gift of Gertrude Vanderbilt Whitney, 31.338.*

pallor, and a scumbled background; the mood has changed from the humor of the aged child holding a woman's hat to the ennui of the frowsy female, listlessly reading her newspaper. Similar in tone and mood to *I'm Tired* is Isabel Bishop's *Nude*, a studio work of 1934 (Fig. 42). Brown has pointed out that "the studio picture in its modern form had its origin in the nineteenth century as one reflection of the artist's increasing isolation from normal social relationships."[44] Perhaps, then, the pale colors and indefinite

counterclockwise starting upper left:

Fig. 39. Eugene Speicher. Fira Barchak, *1929. Oil on canvas, 64 × 42 inches. Gift of Gertrude Vanderbilt Whitney, 31.358.*

Fig. 40. Yasuo Kuniyoshi. Child, *1923. Oil on canvas, 30 × 24 inches. Gift of Mrs. Edith Gregor Halpert, 55.1.*

Fig. 41. Yasuo Kuniyoshi. I'm Tired, *1938. Oil on canvas, 40¼ × 31 inches. Purchase, 39.12.*

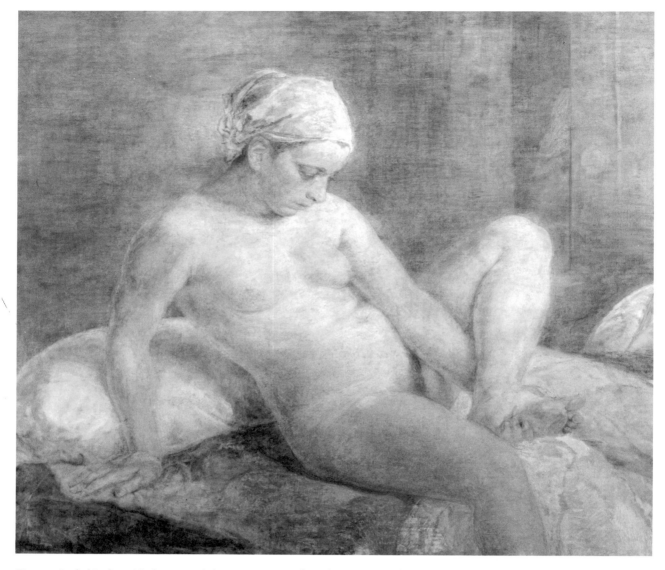

Fig. 42. Isabel Bishop. Nude, *1934. Oil on composition board, 33 × 40 inches. Purchase, 34.11.*

contours in these paintings by Kuniyoshi and Bishop reflect the absence of dynamic social interaction of the studio life.

Portraits in the 1920s and 1930s

From our vantage point, we can see that from the mid-1920s to the 1930s a general change of style occurred, which can be seen not only in the studio picture but in portraiture and American Scene painting as well. The 1920s figure compositions of John Graham and Arshile Gorky, who have usually been studied in terms of the history of modernist art, share certain style qualities with those of Kuniyoshi's early paintings, as well as with each other. In both Graham's *Head of a*

Woman of 1926 (Fig. 43) and Gorky's *The Artist and His Mother* of 1926– 29 (Pl. 6), the dark-haired, white-skinned figures have definitely demarcated facial features; overall, black predominates, patterns are emphatic, and shaded areas are sensed as shapes rather than as space definers. In short — and this was the legacy of modernism (and more immediately perhaps the influence of Picasso) — the individuality in 1920s figurative art is conveyed through clarity of shape and patterns, and it is the artist's individual design that counts.

During the 1930s, however, many artists rebelled against the formal values of modernism. Subject became primary over style, and naturalism rather than design became the preoccupation of artists. This describes the figurative painting in the Whitney Museum's

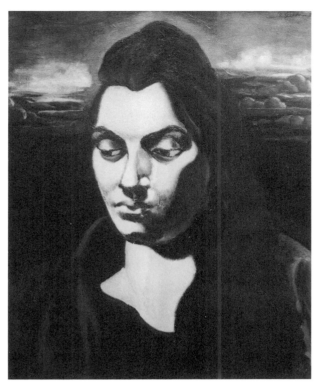

Fig. 43. *John D. Graham. Head of a Woman, 1926. Oil on canvas, 22 × 18 inches. Gift of Gertrude Vanderbilt Whitney, 31.228.*

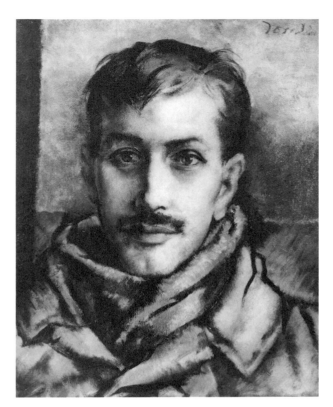

Fig. 45. *Bradley Walker Tomlin. Self-Portrait, 1932. Oil on canvas, 17 × 14 inches. Gift of Henry Ittleson, Jr., 55.28.*

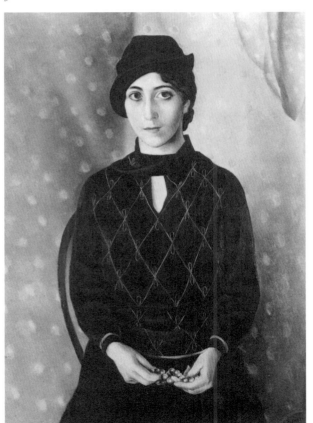

collection, including the portraits; compare, for instance, Ernest Fiene's stunningly designed *Concetta* of 1926 (Fig. 44) or Luigi Lucioni's *Jo* of 1939, with Bradley Walker Tomlin's pleasantly naturalistic *Self-Portrait* of 1932 (Fig. 45) or Edmund Archer's *Howard Patterson of the "Harlem Yankees"* of 1940. In general, the artists' palettes in the 1930s make use of the full range of the color wheel with browns used for shadows; the concern for full three-dimensional illusionism sometimes sacrifices two-dimensional design, and the touch is a dry painterly one with none of the wet into wet strokes of the earlier realists. It may be that in the 1930s figure artists who wanted to express their concern for humanity found naturalism more appropriate than stylization. Indeed, naturalism became the "styleless" style.

Fig. 44. *Ernest Fiene. Concetta, 1926. Oil on canvas, 40¼ × 30¼ inches. Gift of Gertrude Vanderbilt Whitney, 31.193.*

American Scene Painting

During the 1920s and 1930s many figurative artists, not satisfied with the limited repertory of nudes and studio subjects, began to search for rural and urban subjects which would express their feelings about living in America. The motives were mixed: some were in reaction to the modernism of Europe; others were probing the American past for subjects and an iconography they could use in the present. Back at their easels they painted from memory, from sketches, and sometimes even hired models as an aid for the poses. The term "American Scene" has been given to these genre paintings that capture the daily lives of rural or urban Americans without bearing a message of protest against the economic and social condition of these "ordinary" Americans. In other words, American Scene painters assumed a neutrality toward social mores and economic values; when the painters' values do emerge, they tend to emphasize the positive qualities of living on the American land or within American society. In contrast, Social Realism was critical of the sources and causes of social and economic inequalities. If the term "American Scene" as a catchall definition has usefulness, it is in distinguishing the optimistic genre scenes from the moralizing, partisan painting called Social Realism.[45]

In terms of style, remarks can be made similar to those made about the studio pictures and portraits. Many American Scene figurative paintings of the 1920s have the mannered look of an aesthetic based on machine forms, with smoothly brushed, tubular limbs and regularized oval heads, and with props and furnishings decoratively and repetitively patterned, similar to the Art Deco architectural decoration which came into vogue in the late 1920s. Although many mural artists continued this mannered style into the late 1930s, when they found inspiration in the simplified, monumental forms of Diego Rivera, or even Giotto, the majority of 1930s easel painters turned to a more painterly naturalist style which at times even verged on calligraphic caricature. In terms of generalizations (which run the risk of being oversimplifications), if Guy Pène du Bois and Kenneth Hayes Miller characterize the 1920s, then Raphael Soyer and Reginald Marsh would represent the 1930s.

Guy Pène du Bois spent the late 1920s in France, where he painted *Opera Box* (Fig. 47), a recollection of his frequent attendance as a music critic at Metropolitan Opera performances.[46] Du Bois emphasized less the nationality than the haughty attitude of the sleek

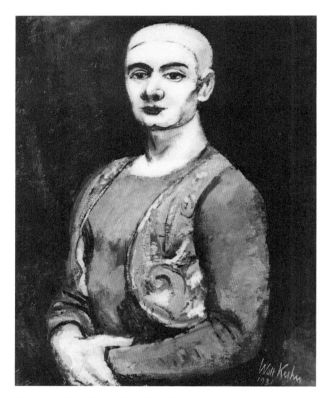

Fig. 46. Walt Kuhn. The Blue Clown, *1931. Oil on canvas, 30 × 25 inches. Purchase, 32.25.*

short-coiffed, wealthy matron who looks down at the performance from her box. Du Bois could appreciate the patrons of culture, as he did Mrs. Whitney, with whom he had a close relationship, but he could also satirize them as in his *Woman with Cigarette* of 1929 (Fig. 48).

A contrast to du Bois's cultured matrons are Miller's passive, dumpy, Fourteenth Street urban consumers. Miller's 1928 painting *Shopper* (Fig. 49) depicts an overweight cloche-hatted matron in sale-day specials, fondling the head of her umbrella. Miller admired the Italian Quattrocento with its rounded, idealized monumental forms, and he himself carefully constructed a bas-relief space within his paintings. To today's viewer, however, the historically inspired style seems inappropriate, perhaps absurd, not because of the shopper's ordinariness, but because Miller has made her pathetically passive toward the merchandizing environment which communicates mercantile rather than spiritual or humanist values.[47] On the other hand, the same monumentalizing style, used in Daniel Celen-

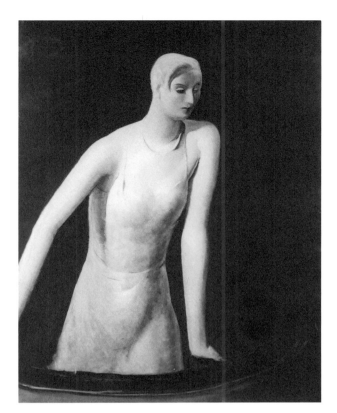

Fig. 47. *Guy Pène du Bois.* Opera Box, *1926. Oil on canvas, 57½ × 45¼ inches. Gift of Gertrude Vanderbilt Whitney, 31.184.*

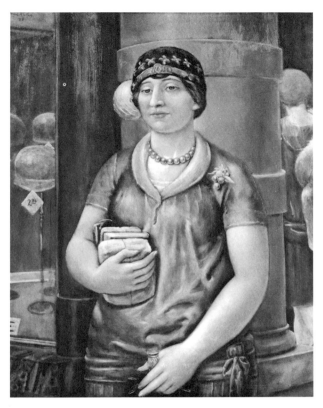

Fig. 49. *Kenneth Hayes Miller.* Shopper, *1928. Oil on canvas, 41 × 33 inches. Gift of Gertrude Vanderbilt Whitney, 31.305.*

tano's much later painting of 1937, *The First Born* (Fig. 50), seems suited to a message affirming family values, with overtones that are religious as well. In Celentano's work, the young parents present their first male child to his grandmother, thereby confirming the continuity of the generations.

Thomas Hart Benton's *The Lord Is My Shepherd* of 1926 (Fig. 51), depicting an elderly couple quietly finishing their meal, also reaffirms traditional religious values. The artist's neo-Baroque style magnifies the large hands of the pair, their furrowed faces and ill-fitting clothes. Work, rest, and prayer form the cycle of the couple's daily routine. The framed motto on the wall, from which the title comes, is the first line of the

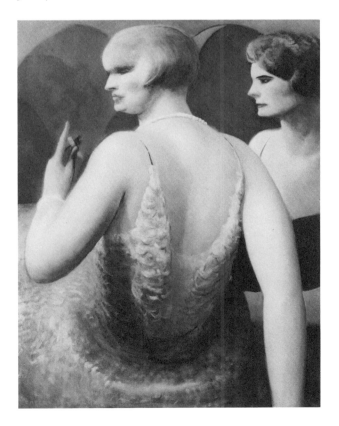

Fig. 48. *Guy Pène du Bois.* Woman with Cigarette, *1929. Oil on canvas, 36¼ × 28¾ inches. Gift of Gertrude Vanderbilt Whitney, 31.187.*

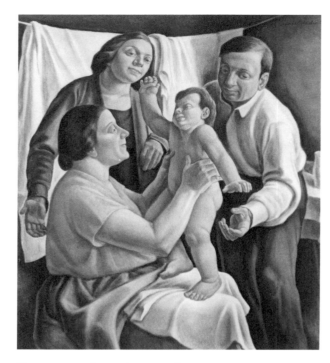

Fig. 50. Daniel R. Celentano. The First Born, 1937. Oil on canvas, 26 × 24 inches. Purchase, 37.38.

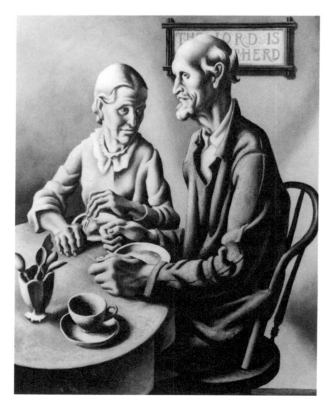

Fig. 51. Thomas Hart Benton. The Lord Is My Shepherd, 1926. Tempera on canvas, 34¼ × 27¼ inches. Gift of Gertrude Vanderbilt Whitney, 31.100.

popular Twenty-third Psalm, a song of faith in a world of potential adversity and corrupting values.

Artists with widely divergent political and social philosophies painted the American scene. Rockwell Kent, an outspoken artist with socialist leanings, painted *The Trapper* in 1921 (Pl. 7), representing the solitary work of a trapper when the winter light transforms the snow-covered mountains into an eerie landscape of isolated forms. Gifford Beal, whose approach was less lyrical, focused on the harpoonist in *Fisherman* of 1928 (Fig. 52), tensely poised for the downward thrust of his weapon. The individual heroism of these men is Emersonian, consisting of their ability to wage lonely battles to capture the bounty of nature.

George Bellows painted a topical scene, *Dempsey and Firpo*, in 1924 (Fig. 53), based on the famous title fight between Jack Dempsey and Luis Firpo of Argentina on September 14, 1923. His style is here more linear and monumental than his boxing pictures of the first decade, such as *Stag at Sharkeys* of 1906 (The Cleveland Museum of Art). The smoothly painted forms stand starkly silhouetted against the darkened room. Luis Firpo's powerful triangular form controls the composition; the ropes of the ring give definition to the space and stabilize the sudden movement of Dempsey falling into the audience. Unlike the earlier versions of fighters, which stressed the raw physicality of both the boxers and paint, Firpo has control and cunning as well as physical strength. In the actual fight, Dempsey returned to the ring to beat the Argentinean.[48]

As the 1920s turned into the 1930s the clarity of the forms of Miller, Bellows, and du Bois gave way to the more painterly mode of American Scene naturalism. John Steuart Curry finished *Baptism in Kansas* of 1928 (Fig. 54) in time to be exhibited at the Corcoran Gallery's Biennial. The painting has a congested composition and an almost haphazard patterning of the faces in the crowd — qualities reminding us of early Sloan or Luks. Reviewing the Corcoran show, *New York Times* art critic Edward Alden Jewell praised what he interpreted as social satire:

> *His "Baptism in Kansas" is a gorgeous piece of satire, and . . . admirably composed. Religious fanaticism of the hinterlands saturates the scene, only inanimate nature looking on as with a smile of cynical coolness. Yonder are some big barns and an impartial windmill. In the centre foreground is one of those circular watering troughs, consecrated*

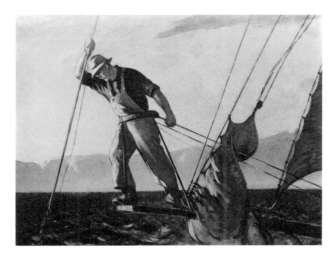

Fig. 52. *Gifford Beal.* Fisherman, *1928. Oil on canvas,*
36½ × 48½ inches. Gift of Gertrude Vanderbilt Whitney,
31.92.

now to the ceremonies attaching to immersion.
Knee-deep stand the parson and his trembling
neophyte, a woman with rather wild eyes, who
knows full well that the mystical waters will soon
cover her. A stirred company surrounds this
impending climax, its more musically inclined

members singing a hymn. Overhead clouds seem
stricken with ontological portent, and two other-
wise quite ordinary farmyard doves swoop like
symbols straight from the Apocalypse. Finally, on
all sides spread the flat Kansas prairies. . . .[49]

Although Jewell saw the work as satire, it has not
always been interpreted as such.

Thomas Craven was the most vigorous critic
promoting American Scene naturalism and castigating
those artists who looked to Europe for their styles. In his
book *Modern Art* of 1934 he cited the artists working in
the art colonies of Woodstock, Provincetown, and
Santa Fe as negative examples:

Working in typically American — in unique
environments — but working servilely from Eu-
ropean forms and without organic interest in their
subjects, these rustic Bohemians produce only
imitations. Even the local color escapes them. The
American scene is perverted into a technical pat-
tern. Instead of surrendering to the scene and
allowing it to modify the pattern, they impose an

Fig. 53. *George Bellows.* Dempsey and Firpo, *1924. Oil*
on canvas, 51 × 63¼ inches. Gift of Gertrude Vanderbilt Whitney, 31.95.

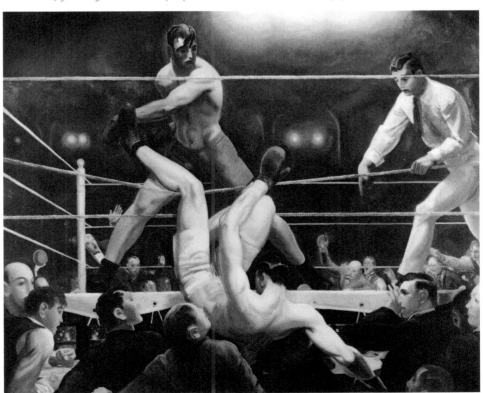

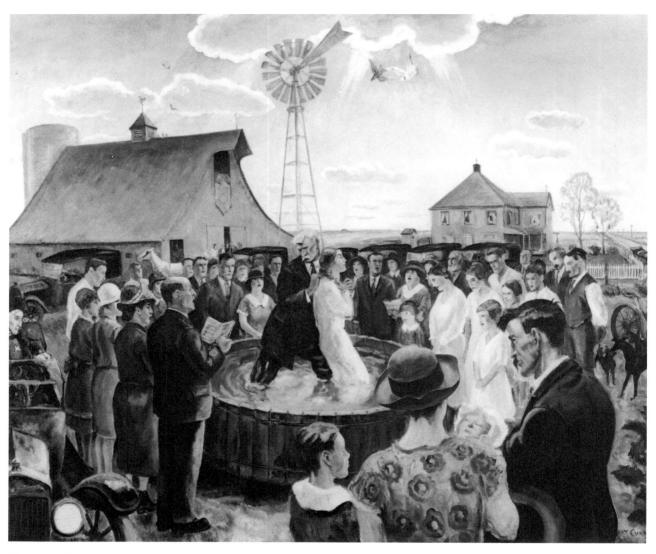

Fig. 54. John Steuart Curry. Baptism in Kansas, *1928. Oil on canvas, 40 × 50 inches. Gift of Gertrude Vanderbilt Whitney, 31.159.*

imported pattern on indigenous materials, with the result that the New Mexican desert resembles the Provençal landscape of Cézanne, and the Indian is chopped into the cubes and cones of Paris.[50]

To Craven, then, form was secondary to subject matter and content, as he advocated a distinctly nationalistic art. To him, only "when life, American life, develops in painters, interests stronger than the interests aroused by canonized art, we may hope for a native American school."[51]

In the 1930s, many artists considered style differences of less importance than social and political

attitudes. Some artists were drawn to the camp of the Regionalists, such as Benton, Curry, and Grant Wood, who focused on farm and small town living; others were attracted to the ideas of the Social Realists who painted the urban environment, with its scenes of workers and their camaraderie and hardships. To the first group, nationalism was esteemed; to the second, nationalism was a distraction — diverting the attention of people away from the class struggle. The polarization was brought about by the conditions of the Great Depression, which tended to politicize artists toward a mixture of populism, Jeffersonian agrarianism, and traditional individualism, as in the case of Benton,[52] or toward the Left (Socialism and Communism).

The Depression and the Government Art Projects

Times were indeed hard. Artists who had previously enjoyed a steady patronage from galleries and private collectors could no longer sell their paintings; other artists, particularly younger ones who had pieced together a subsistence wage from odd jobs, found themselves out of work. Although the unemployed in early 1930 was still less than ten percent of the work force, by 1933 it was over twenty-five percent, or roughly fifteen million people.[53] Norman Barr, an artist who lived through it, recently recalled the period:

> To understand fully the meaning of the "Great Depression" of the thirties, one must go beyond the statistics. . . . To recall the "Hoovervilles," shanties built of cardboard, pieces of tin, wooden planks, etc. all along the Hudson, Harlem and East Rivers, housing thousands of ill-clad, half-starving people is to relive a nightmare. Especially, if you were one of them.[54]

By the end of 1932 two projects had been established in New York State to give work and relief to artists: The Temporary Emergency Relief Administration (TERA) began by employing fifteen artists as teachers in thirteen arts centers in New York City; the program expanded to help 393 artists throughout the state. Meanwhile, the College Art Association established its own modest work relief program under the direction of Audrey McMahon and her assistant Francis Pollak. Both projects lasted until 1935 when they were consolidated under the Works Progress Administration.[55]

In December 1933, the Public Works of Art Project was inaugurated as part of the U.S. Treasury Department under the direction of Edward Bruce. In its brief seven months of operation, the PWAP national program employed 3,749 persons. In New York, the Whitney Museum's Juliana Force was the Regional Director of the PWAP, guided by a committee of other museum directors including Alfred Barr of the Museum of Modern Art. In 1934 Edward Bruce headed the newly created Treasury Section of Painting and Sculpture which awarded commissions for murals and sculpture in post offices and public buildings. The Section, which lasted until 1943, was not primarily a relief organization, and mural commissions were

awarded on the basis of merit rather than need. The Treasury Department also created the Treasury Relief Art Project (TRAP), which operated between 1935 and 1938 and did require a percentage of its artists to be certified for relief.

The most important project, the Works Progress Administration, however, did base its employee rolls on need. Set up in 1935 as an independent organization with four cultural projects — Art, Music, Theater, and Writers — it lasted until 1943 with Holger Cahill as National Director. In New York City Audrey McMahon became Regional Director for the Federal Art Project in charge of easel paintings, graphics, the Index of American Design, motion pictures, murals, photographs, posters, and sculptures. In 1936, the WPA/FAP was employing some five thousand artists across the country.

With all this activity of artists being employed, laid off, shifted to other agencies and projects, and reemployed, the more militant left-wing artists found it necessary to organize themselves collectively. In September 1933, twenty-five artists formed the Emergency Work Bureau Artists Group; their group grew into the Artists' Union by May 1934, which led to a number of demonstrations, sit-down strikes, and protests regarding the periodic bureaucratic cutbacks which continuously threatened the relief programs.[56] In the fall of 1934, the Artists' Union along with the militant Artists Committee of Action jointly began publishing *Art Front*, a feisty left-wing monthly magazine that ran through December 1937.[57]

The articles in *Art Front*, regularly written by people as diverse as Clarence Weinstock, Stuart Davis, Louis Lozowick, Moses Soyer, Meyer Schapiro, Charmion Von Wiegand, and Elizabeth McCausland (using the pseudonym Elizabeth Noble), often addressed social issues and appealed to artists to respond to the worker's needs. Paintings should not only be about the lives of the working classes but be *for* them as well. They argued also for a municipal art center to be available to all groups for teaching and exhibitions.

When *Time* magazine, in its December 24, 1934, issue, declared that the American Scene painters Benton, Wood, Curry, Charles Burchfield, and Reginald Marsh were "destined to turn the tide of artistic taste in the U.S.,"[58] Stuart Davis, then editor-in-chief of *Art Front*, reacted in the January 1935 issue with outraged hostility toward American Scene painting which he felt sentimentalized poverty or glorified rural and urban stereotypes. To socially concerned artists the phrase

"American Scene" became anathema. Moses Soyer, in a January 1935 review of the *Second Biennial Exhibition* at the Whitney Museum (November 27, 1934 – January 10, 1935), spoke for many when he implored:

> *Artists, therefore, should not be misled by the chauvinism of the "Paint America" slogan. Yes, paint America, but with your eyes open. Do not glorify Main Street. Paint it as it is — mean, dirty, avaricious. Self-glorification is artistic suicide. Witness Nazi Germany.*[59]

Soyer asserted that in the Whitney Museum's exhibition the paintings with social content "dominated the more conventional paintings that surround them. Laning's rather obvious composition of a worker bearing upon his shoulders a priest, a capitalist and a militarist — figures symbolizing the ruling class — Shahn's seedy 'Pillars of Society,' Curry's dramatic 'Lynching,' Hoffman's poignant 'Death of a Miner' and Cikovsky's sad 'Homeless Men' stand out." Soyer ended the review by concluding that "a spirit of youth and vigor" marked the show.[60]

In an April 1936 review of a Whitney Museum exhibition, Joe Solman was less charitable: "We can only conclude that, for continued allegiance to stale Americana and to old museum favorites, it was a typical Whitney show."[61]

Solman's remark characterizes a continuous series of swipes at the Whitney Museum regarding its Annual or Biennial offerings. However, *Third Biennial Exhibition* (November 10 – December 10, 1936) included Raphael Soyer's *Office Girls* (Pl. 8). Soyer rendered a slice of the city's life with three young women clutching their handbags and hurrying along a busy sidewalk. One wide-eyed blond woman looks directly at the viewer, while an older man looks over her shoulder. The figures are not distant from us, as in Sloan's *Picnic Grounds*, but placed close to the picture plane. They inhabit the artist's world in a real sense — figures he knew, neither passive and depressed nor idealized as spontaneous and childlike, but as firmly resolved to get on with the work of their lives. Raphael Soyer used a Ben Shahn photograph for the background (the Bowery eating house with the day's menu on display) in his painting *Reading from Left to Right* of 1938 (Fig. 55). Inspired by the captions of newspaper society photographs, Soyer found the title ironic, for these men, the unemployed of 1930s American society, would not be found on the "society page" of a newspaper.[62] In these

Fig. 55. Raphael Soyer. Reading from Left to Right, 1938. Oil on canvas, 26¼ × 20¼ inches. Gift of Mrs. Emil J. Arnold in memory of Emil J. Arnold and in honor of Lloyd Goodrich, 74.3.

Fig. 56. Isaac Soyer. Employment Agency, 1937. Oil on canvas, 34¼ × 45 inches. Purchase, 37.44.

two works, Soyer moves beyond the pathos of individuals living in hard times to make a statement about society at large, about a class of people affected by the specific circumstances of their time.

Fig. 57. *Katherine Schmidt.* Broe and McDonald Listen In, *1937. Oil on canvas, 30 × 24 inches. Purchase (and exchange), 50.15.*

Fig. 58. *Reginald Marsh.* Twenty Cent Movie, *1936. Egg tempera on composition board, 30 × 40 inches. Purchase, 37.43.*

Fig. 59. *Reginald Marsh.* Why Not Use the "L"? *1930. Egg tempera on canvas, 36 × 48 inches. Gift of Gertrude Vanderbilt Whitney, 31.293.*

Isaac Soyer, Raphael's brother, painted *Employment Agency* in 1937 (Fig. 56). A black woman and two white men patiently but dejectedly await their interview or news of a job, while another reads the daily newspaper. They have no place to go. Isaac Soyer tells us that unemployment is a condition with neither sex nor race bias. Katherine Schmidt's *Broe and McDonald Listen In*, also of 1937 (Fig. 57), depicts alert and concerned working-class men sitting in a diner. The painting calls to mind Clifford Odets's topical one-act play *Waiting for Lefty* of 1935, about men whose lives are sketched on the stage while they wait for their leader, the labor organizer. The styles of all three artists — Raphael Soyer, Isaac Soyer, and Katherine Schmidt — are painterly but solid; inhabiting a convincing three-dimensional space, the figures are pushed to the front of the picture plane to impress upon the viewer their immediacy and personal relevance.

Reginald Marsh, an illustrator and an admirer of Kenneth Hayes Miller, worked more eclectically. Many of his works are similar to *Twenty Cent Movie* of 1936 (Fig. 58), with a nervous calligraphic line creating a busy surface to the tempera painting; other Marsh paintings, such as *Why Not Use the "L"?* of 1930 (Fig. 59), have the solid rendering of form similar to the Soyers' naturalist style.

Many American figure paintings had specific references to the imperialism of the Fascist movement in Europe. Paul Cadmus's *Sailors and Floosies*, painted in 1938 (Fig. 60) and shown in the Whitney Museum Annual that year, was criticized for its bawdiness by Navy officials when exhibited during the summer of 1940 at the Treasure Island Palace of Fine Arts at the Golden Gate Exposition.[63] Cadmus, a self-conscious moralist, defended his satire:

Fig. 60. Paul Cadmus. Sailors and Floosies, *1938. Oil and tempera on composition board, 25 × 39½ inches. Anonymous gift (subject to life interest), 64.42.*

I believe that art is not only more true but also more living and vital if it derives its immediate inspiration and its outward form from contemporary life. The actual contact with human beings who are living and dying, working and playing, exercising all their functions and passions, demonstrating the heights and depths of man's nature, gives results of far greater significance than those gained by isolation, introspection or subjective contemplation of inanimate objects. Entering the world of human beings plunges one immediately into a mixture of emotions, thoughts and actions, some pleasant, some disturbing; but whether uplifting or disgusting, these reactions spring from a vital source.[64]

The painting portrays the desperately hedonistic revels of sailors and a marine in Riverside Park, while reminding us, by including the front page of the *Daily News,* that Mussolini's aggressive war policies had resulted in three thousand killed in an air raid. The scene becomes more poignant in retrospect when we realize that the lusty sailors would be shipped off within a few years.

Social Realism

Social Realism emerged in the mid-1930s not as a style but as an attitude toward the role of art in life. In 1925, Louis Lozowick stated his humanist belief that "the function of art, before it disappears, is not to decorate

or beautify life but to transform and organize it."[65] Like Lozowick, the Social Realists were vociferously left wing; they did not want to settle for a mere portrayal of the individual lives of working people with their dignity and limitations, but hoped in their art to promote class consciousness and social change.[66] To them, collective goals and collective betterment were more important than individual goals. As a group, their works were not pretty. They did not indiscriminately glorify either individual labor or collective work, and in this respect they differed from both the American Regionalists and the advocates of Socialist Realism as it was developing in the Soviet Union.[67]

Louis Ribak's *Home Relief Station* of 1935–36 (Fig. 61) depicts a huddled mass of people of all races and ages sitting on wooden benches in a large room while they wait their turn for their interviews. The scene is grim; the joking policemen are grotesquely rendered caricatures. Julius Bloch's *The Lynching* of 1932 (Fig. 62) represents a black man crucified on a tree, while a cluster of evil faces surround the base of the tree.[68] These paintings were well-intentioned attempts to arouse feelings of outrage against a demeaning welfare establishment and racist society, and yet both works have a timidity which makes them less successful than the social protest paintings by Philip Evergood, Ben Shahn, and Jack Levine or the forceful graphics of Robert Minor and William Gropper. Indeed, many well-intentioned liberal humanists focused on the individual oppression or on the pathos of the "suffering masses." While Communist Party ideologues argued for an art that would show workers as a class fighting back

Fig. 61. *Louis Ribak.* Home Relief Station, *1935-36. Oil on canvas, 28 × 36 inches. Purchase, 36.148.*

against their capitalist oppressors, few artists, for fear of indulging in "propaganda," produced a revolutionary painting. To most artists with strong feelings against oppression it was enough of a challenge to make a visual statement that would carry punch; their goal was to make an effective contrast between rich and poor, between the powerful and the powerless, between a vision of freedom and the reality of bondage, between the promise of equality and the raw facts of racism, bigotry, and oppression.

Ben Shahn found a politically relevant subject in the saga of Nicola Sacco and Bartolomeo Vanzetti, Italian immigrants arrested for robbing and killing a paymaster and his guard at a shoe company in South Braintree, Massachusetts, on April 15, 1920.[69] Evidence against the two was largely circumstantial, but it was a period of anti-radical hysteria, both Sacco and Vanzetti were anarchists, and they were carrying firearms when arrested. The presiding judge, Webster Thayer, seemed unduly biased; evidence appeared to be flimsy and Felix Frankfurter was moved to write critically of the proceedings in the *Atlantic Monthly* in March 1927. When public outcries demanded a new trial, Massachusetts Governor Alvan T. Fuller appointed Harvard President A. Lawrence Lowell, M.I.T. President Samuel W. Stratton, and Judge Robert Grant to advise him on the matter. The Lowell Committee ruled against the accused; they were executed on August 22, 1927. In April 1932 Ben Shahn exhibited twenty-three gouaches called *The Passion of Sacco and Vanzetti* (Pl. 9) at the Downtown Gallery. The final work, of Sacco and Vanzetti lying in their coffins, sometimes called *That Agony Is Our Triumph*, refers to a phrase of Vanzetti's in a last interview with Phil Stong, who published the remarks in the *New York World* on May 13, 1927:

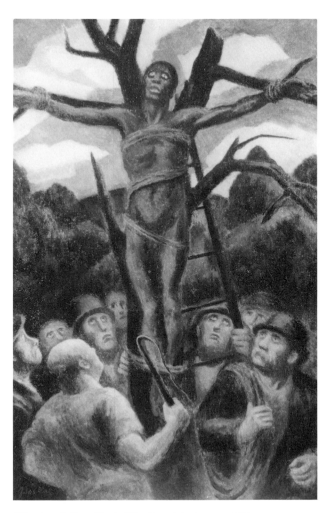

Fig. 62. *Julius Bloch.* The Lynching, *1932. Oil on canvas, 19 × 12 inches. Purchase, 33.28.*

"Our words — our lives — our pains nothing! The taking of our lives — lives of a good shoemaker and a poor fish peddler — all! That last moment belongs to us — that agony is our triumph."[70]

Shahn, in his painting, felt the need to communicate the hypocrisy of the three Lowell Committee members, who are shown carrying lilies to the open caskets. The element of caricature in the faces of the three living men conveys a brittle grimness to the proceedings. The steps and the columns of a hall of justice, with a portrait of Judge Thayer pledging to uphold the law, form the background. Shahn has used a carefully composed collage cubist style in which the forms and the spaces between look like pieces of cut-up paper, so that the whole surface has movement. In short, Shahn has used modernism to manipulate the images of power and powerlessness.

Philip Evergood, working on the WPA as well as deeply involved in the politics of the Artists' Union (he

was President in 1937), felt the need to communicate his feelings about the courageous working class. In a painting such as *American Tragedy* of 1937 (private collection) he showed an interracial couple defying the guns and billy clubs of the police breaking up a rally of striking Republic Steel Corporation picketers on Memorial Day of 1937. This painting is perhaps the quintessential partisan Social Realist painting, for its theme of working-class solidarity and militant resistance was meant to inspire the viewer to political action.[71]

Often, however, Evergood's paintings were vignettes of city life, remembered from his walks through the ghettos of New York. Regarding *Lily and the Sparrows* of 1939 (Pl. 10) Evergood recalled:

> *I was walking along [that section under the old El, between Sixth Street and West Broadway] in a sort of dream, thinking of something else, . . . and I happened to stop at the curb, just dreaming, . . . and I looked up, and here was an amazing sight. A little, bald-headed, white, beautiful white little face was in a window with her little bits of crumbs — alone. She could have fallen out and been killed — leaning out of the window there with her little crumbs, looking up, and there were a couple of little sparrows flying around in the air. I thought to myself, my God, this is the chance of a lifetime. . . . This tells the story and I've been given this just for standing here.[72]*

Invited to submit a work to the Whitney Museum Annual, Evergood, on the eve of sending it, scraped out the many layers painted onto the face of Lily, and one emerged — with a beatific, mysterious smile. When the Annual closed in mid-February 1940, the curatorial staff decided to purchase this image of individual innocence and squalid neglect.

Fantasy and American Surrealism

Evergood's style and sensibility in the late 1930s and 1940s often verged on the fantastic or the good-natured grotesque. At that time there were a number of artists working in modes described as fanciful, fantastic, or surrealist. Some of these artists worked in relative isolation in art colonies far from New York; others were involved with the social issues of the day.

Edwin Dickinson's art belongs to no easy category. He studied at the Art Students League under William Merritt Chase and then with Charles Hawthorne in Provincetown; after a stint in the Navy during World War I, he lived in Europe, painting in Paris, St.-Tropez, and Spain. From 1921 to 1937 Dickinson returned to Provincetown, where his figure style evolved away from the monumental and painterly realism of Hawthorne toward a private and mysterious symbolism. From 1945 to 1966 he taught in New York at the Art Students League and at Cooper Union.[73] His painting *The Fossil Hunters* of 1926–28 (Fig. 63) depicts a mad or irrational reality closer to the terrors of dreams than to everyday life. The ambiguous setting contains heavy dark blue-green drapery cascading over three figures who are carelessly dressed and inclined precipitously toward the viewer. In the lower left a grindstone anchors the dizzying spatial flow; a reclining cadaverous man stretches a divining rod toward the grindstone. Near his hand rest pieces of stone and a stick, as well as a clay mask with a grimace frozen on its features — features more clearly delineated that those of the three figures. The dark, elegiac disorder suggests a violence less of the present than of an indistinct memory or a barely recalled nightmare. The space, the dark bluegreen and lavender colors, and the forms together create an anxiety — all the more so because of the ambiguity, mystery, and inexplicitness. Dickinson's originality commanded the respect of a broad range of artists; because of contemporaneous concerns his paintings had particular appeal during the 1950s and 1960s.

Other figure painters closely allied to the realism of the American Scene painters, but influenced by the European movements of Surrealism in France and the Neue Sachlichkeit in Germany, evolved styles which have been called naturalistic surrealism, magic realism, and/or social surrealism, labels that even the artists found inadequate. Louis Guglielmi said of his own work: "My painting has been called surreal, magic realist, romantic, and expressionist. I do not know what to call it. It has the elements of all these classifications. I try to create in each picture an atmosphere and sense of its own reality."[74] What French Surrealism offered was a liberation from both naturalistically rendered form and Renaissance, perspectival space. Figures and props could be combined and juxtaposed without heed to rational and naturalistic ordering in order to convey a complex content. Indeed, the very juxtapositions could suggest insights into psychological truth.

Fig. 63. *Edwin Dickinson.* The Fossil Hunters, *1926-28. Oil on canvas, 96½ × 73¾ inches. Purchase, 58.29.*

Analytic cubism had also released artists from the obligation to scientifically plotted illusionism, but it had destroyed the holistic integrity of the figure. However, with synthetic or collage cubism (also montage), artists could retain the figure, either wholly or synecdochically, as well as take advantage of telling juxtapositions.

There were major differences between French Surrealism and its American variety. The French Surrealists, including Dali (who represented French Surrealism to most Americans), were often preoccupied with Freudian interpretations of sexuality, particularly with sexual nightmares and the anxieties arising from the unconscious. But Americans during the 1930s were often preoccupied more with the violence of social institutions (lynchings in the South, the growth of Fascism in Europe) than with the violence of repressed sexual urges. Therefore, in many of their works — including those of Blume and Guglielmi — the references are less to inner private anxieties than to collective, environmental, and social problems, including the role of the family and of spiritual values in an era of profit-producing technology and warfare. Grace Clement, in an article "New Content — New Form," for the March 1936 issue of *Art Front* discussed the possibilities of both surrealist styles and montage for a socially relevant art. Citing the subject of men standing

on a bread line, Clement argued that mere naturalism (verisimilitude) cannot satisfactorily deal with the contradictions of capitalism which are responsible for the bread line. The significance of the surrealists lay in "their use of psychological phenomena, especially through their use of associative ideas."[75] Therefore, Clement reasoned, juxtapositions of associative ideas could suggest insights into political, economic, and social truths as well as psychological truth. Indeed, a social surrealism did develop in America — a hybrid form of Surrealism which continued through the 1940s.

One social surrealist was Peter Blume, who came to prominence during the controversy surrounding his winning the First Prize at the Carnegie International in 1934 for his painting *South of Scranton* of 1931 (The Metropolitan Museum of Art), a composition of meticulously rendered forms and images recalled from an automobile trip made from New York to Charleston in 1930. At the time critics deplored the arbitrary placement of figures and the destruction of the Aristotelian unities of time and space. In *Light of the World*, painted in 1932 (Fig. 64) and included in the Whitney Museum's first Biennial, four figures on an outdoor patio worriedly stare up at an elaborate electrical light terminal, held up by cross-sections of classical entablatures. Wedged into the middle ground is a diminutive nineteenth-century copy of a Gothic church which represents faith based on belief rather than reason. Further in the background are a farm on the right and a factory on the left, two areas of employment for working Americans. The title phrase "Light of the World" has traditionally referred to Christ, but the object of their awe, and perhaps worship, is the light terminal symbolizing technology, which is the end product of the classical tradition based on reason.[76]

Louis Guglielmi painted *The Various Spring* in 1937 (Fig. 65). In this painting budding trees and factory houses take up the middle ground, toward which a worker wends his way. In the foreground and repeated twice again in the composition is an image of a man climbing a Maypole which holds a tray of fish, meat, fruits, vegetables, and a wine bottle in the midst of which is nestled an unconscious or dead child wearing the number 29. Above the tray is what appears to be a lacy handkerchief placed in an embroidery hoop from which hang streamers and a bomb. In the distance a small boy flies a kite. In the foreground at the right is a part of a building with a sign which spells out only the first three letters of "Hotel." A small snake is perched at the right on a ledge with a sprig of grass growing up

through a crack. The child with its number 29, the bomb, the desperate attempt of the man to climb the Maypole, the letters "HOT," and the fact that the painting was done in 1937, combine to suggest that the symbolism might refer to the saturation bombing by the Nazis of the Spanish town of Guernica — a three-hour ordeal of April 26, five days before May Day, which took the lives of hundreds of civilians including children.[77] The kite flown by the child might then refer to the airplanes; the homecoming worker, disproportionately large, might refer to the workers who made up the partisan cause; the "HOT" might refer to the heat of the

Fig. 64. Peter Blume. Light of the World, *1932. Oil on composition board, 18 × 20¼ inches. Purchase, 33.5.*

Fig. 65. Louis Guglielmi. The Various Spring, *1937. Oil on canvas, 15¼ × 19¼ inches. Promised gift of Flora Whitney Miller, 69.78.*

Fig. 66. *Federico Castellón.* The Dark Figure, *1938. Oil on canvas, 17 × 26 inches. Purchase, 42.3.*

saturation bombing or to wars in general, which transform homes into infernos. The snake could have any number of symbolic references — including death and regeneration. While this conjecture is specific, it does not negate a general interpretation of the effects of war on civilian life. The painting is moralizing, a comment on the value of human life, but there is no message of optimism.

In the 1941 Whitney Museum Annual, which ran from November 12 through December 30, Guglielmi exhibited *Terror in Brooklyn* of 1941 (Pl. 11), and Federico Castellón, another American surrealist, exhibited *The Dark Figure*, painted in 1938 (Fig. 66). In *Terror in Brooklyn* three matrons dressed in black, probably of the Italian neighborhoods with which Guglielmi was familiar, huddle under a bell jar placed in the middle of the street, with expressions of horror on their faces. Desolate houses and store fronts in the distant background repeat in mirror image those buildings in the middle ground.[78] A lamppost is without a lamp; on the side wall are bones hung up with ribbons and a diner is at the right. The pink and blue colors, because they seem inappropriate to the occasion, grate on our sensibilities. The object of the terror of these women eludes us, as the painter invites us to puzzle a meaning from the situation.

Federico Castellón, born in Spain, exhibited in Paris when he was nineteen years old, along with other Spanish artists including Picasso, Miró, and Dali. The latter with his meticulous and detailed draftsmanship was a lasting influence on Castellón. Castellón's dreamlike image *The Dark Figure* combines a middle-ground frieze of willowy arms caressing human fragments propped against a plastered wall. Three large and misshapen hoops and one small hoop are held up by the fingers, wrists, and backs of the fragmented figures. In the foreground at the right is a peasant woman, hooded and clothed in black, who grasps one hand with the long and muscular fingers of the other hand. *The Dark Figure* is ominous, perhaps a memory imaginatively reconstructed from Castellón's Spanish past, but one that portends an ominous future. In fact, while the 1941 Annual was on view the Japanese bombed Pearl Harbor, Scofield Barracks, and a number of U.S. Army Air Corps installations at Oahu on December 7, 1941. Both the Guglielmi and Castellón paintings seemed to represent a sensibility of apprehension, and it was not inappropriate that the Whitney Museum chose these works to purchase from that Annual.

American artists in the first forty years of this century, by and large, felt optimistic about the future of American society: they went to the polls, organized art schools, and believed that they could hold on to what was usable in the past, could humanize bureaucracy, and could reform the bad aspects of the free-enterprise system. In spite of the left-wing rhetoric of the 1930s few artists had in mind a social upheaval as violent as a revolution. To the majority of liberal, humanist figurative artists, the goal of artmaking was to communicate their personal expression, never doubting its compatability with the collective goals of enlightened political leadership and of the democratic masses. All through the 1930s, a period of great camaraderie among artists, this optimism prevailed, until 1939 when Fascism seemed to triumph and a period of disillusionment and introspection set in.[79] With the European abstractionists and Surrealists arriving in New York in the late 1930s, many American painters were encouraged to reconsider modernism — the art of turning in, of self-referentiality, of escape into formal values. At that same time, other painters began to turn away from naturalism, from the single view "slice of life," as not being adequate to render their own complex psychological and political responses to contemporary events.

Sculpture, 1900–1940

ROBERTA K. TARBELL

Figurative art has been more persistent in sculpture than it has in painting because a vertical three-dimensional form appears to represent man no matter how abstract the artist's interpretation. Before the twentieth century, sculptors rendered representations of human and animal figures almost exclusively. Nineteenth-century intellectuals believed that accurate perception and close recording of physical facts revealed the transcendental purpose of God. In 1802 William Paley, a master of this kind of teleological argument, enumerated in *Natural Theology* detailed physical facts to demonstrate the overall purpose of creation.[1] Such varied critics as Sir Joshua Reynolds, James Jackson Jarves, and John Ruskin agreed that figures radiated transcendental meaning — the more accurately the phenomenal world was reproduced, the more forcefully its spiritual significance would shine through. In addition, throughout the history of American art, the mercantile class has exhibited a strong preference for representation and naturalism.

The continuing desire to create the figure in the twentieth century is, in part, a wish to oppose the chaos of modern life, to create a self-contained recognizable body symbolizing the wholeness of the mind. Man has a compelling need to confront his own image in art, part of his search for his own identity. Even dreams, a tremendous source of imagery during our century, are only rarely non-figurative.

Clay Modeling for Bronze Casts

For the most part American sculptors between 1900 and 1940 carved or modeled their figures. John Storrs, Alexander Calder, Theodore Roszak, and others had pioneered constructivist techniques in their non-objective sculptures during these years, but this phenomenon had little to do with the development of figurative sculpture. Except for Calder's wire portraits, the emphasis was on monolithic mass, tactile surface qualities, and unity of material. Figurative sculptors tended to be academically trained romantic humanists who amalgamated some anti-classical concepts with the classical preference for the human figure as subject. Most of them encountered modernism during the second decade of the twentieth century, thus increasing their experimentation with abstraction, expressive anatomical distortion, primitivism, sensuality, or at the very least Rodin-inspired, roughly modeled surfaces.

Major shifts in style and technique have occurred in American sculpture during the past century. Late nineteenth-century American sculptors were modelers

Fig. 67. Elie Nadelman. Dancing Figure, *1916-18. Bronze, 29½ × 12 × 11½ inches. Promised gift of an anonymous donor, 7.75.*

Fig. 68. Gertrude Vanderbilt Whitney. Fountain, *1913. Bronze, 42 × 36 × 29 inches. Gift of the artist, 31.78.*

Fig. 69. Gertrude Vanderbilt Whitney. Study of Soldiers, *1919. Bronze. Collection of Flora Whitney Miller.*

who studied, for the most part, at the Ecole des Beaux-Arts and other academies in Paris and the United States. They accepted the academic emphasis on the human figure, emulation of antique, Renaissance, and Baroque masterpieces, and the aesthetic goals of harmony and beauty. The designs of the maquettes which they modeled in clay were usually transferred to marble or bronze by assistants or apprentices. Traditional late nineteenth-century metal and stone sculpture was figurative and was characterized by idealized form, didactic content, and softly modulated surface planes juxtaposed with finely articulated details. In 1900, when Mrs. Whitney, then twenty-five years old, decided that she wanted to model monumental works, she chose to study with either Augustus Saint-Gaudens or Daniel Chester French, the two leading American Beaux-Arts sculptors at that time. Neither was able to take her on as a pupil, and she studied instead with Hendrik C. Andersen, James Earle Fraser, and Andrew O'Connor, who also reflected the academic-classical tradition. She exhibited a male nude figure in the Pan-American Exposition in Buffalo in 1901 and a sculpture of an athlete in the St. Louis Exposition of 1904. During the spring of 1904 Gertrude Whitney, Malvina Hoffman, and Anna Hyatt all studied sculpture for a few months at the Art Students League.[2] Gertrude Whitney was one of the few sculptors included in the *Exhibition of*

Independent Artists in 1910.[3] She was profoundly impressed by Rodin, whom she met in 1911 at his atélier in the Hôtel Biron in Paris. The powerful modeling and the interest in the play of light across animated surfaces of the studies for the male figures supporting the bowl in *Fountain* (Fig. 68) reflect Rodin's influence. Her strong commitment to academic-classical forms is more evident in the finished fountain. She was a member of both the National Sculpture Society and the National Academy of Design, and the study for the fountain was awarded honorable mention at the Paris Salon in 1913. A replica of this bronze model is in working condition in the formal gardens surrounding the artist's studio in Old Westbury, Long Island.[4] After World War I, Gertrude Whitney modeled a series of more realistic studies of soldiers, based upon her observations at the hospital she established at the front in France, which reflected the aesthetic philosophy of some of her colleagues, especially Jo Davidson (Fig. 69).[5]

Davidson was one of the more imaginative American emulators of Rodin. Soon after he arrived in Paris in 1907 he visited the Salon des Artistes Indépendants and proclaimed "And here I saw the work of artists — individuals . . . painting and sculpting as they liked, expressing themselves. To me it was an open door to freedom."[6] His modernism was more of an attitude of

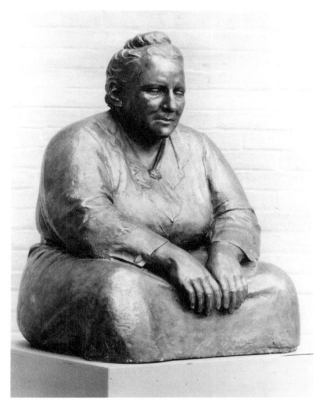

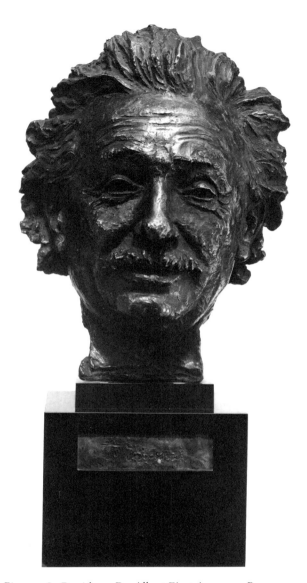

Fig. 70. Jo Davidson. Gertrude Stein, 1920. Bronze, 31 ¼ × 23 ¼ × 24 ½ inches. Purchase, 54.10.

acute observation than a thrust toward abstraction, and Davidson became one of the most sensitive traditional portraitists of our century. Davidson revealed that he became interested in portraiture as a student in Paris and that

> *gradually, portraiture became an obsession. I avidly made portraits of people in whatever surroundings I happened to find myself.*
>
> *It requires great discipline to see your sitter and to realize the wonder of the uniqueness of the face — that it is not a mask but a sensitive instrument by which man reveals himself. To look at your sitter with humility and accept him as he is with sympathy and understanding and express the living, talking, breathing man as I saw him — that was my objective.*[7]

For some sculptors, making portraits was a practical necessity because there were more patrons for likenes-

Fig. 71. Jo Davidson. Dr. Albert Einstein, 1934. Bronze, 13 ¾ × 10 × 11 inches. Purchase, 34.31.

ses than there were for more imaginative or abstract works. Davidson, however, enjoyed discovering and recording in clay the particularity of each person. There were romantically inclined sculptors, as well as painters, who were fascinated with a Whitman-inspired emphasis on the unique qualities of the individual and portraiture continues throughout the twentieth century to be an inventive and important aspect of the figurative tradition. Monroe Wheeler, in his introduction to *20th Century Portraits*, an exhibition held at the Museum of Modern Art in 1942, defined portraiture in terms similar to Davidson's, as "any representation of an individual known to the artist personally in which the appearance and character of that individual have been an important factor in his mind as he worked."

The Whitney Museum owns an impressive range

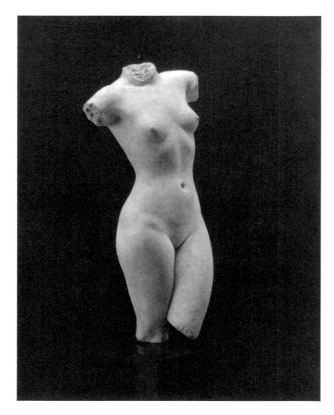

Fig. 72. Jo Davidson. Female Torso, 1927. Terra-cotta, 22½ × 10½ × 6½ inches. Purchase, 33.55.

The rough, kneaded surfaces of Michael Brenner's modeled head of *Gertrude Stein* (private collection, New York) expresses more of the emotional depth of his sitter than Davidson's portrait with its contemplative demeanor. With *Portrait of a Man* (Fig. 73), Brenner achieved an even greater range of chiaroscuro than with *Gertrude Stein* by undercutting the depressions that he gouged out for eyes. Brenner was born in Lithuania in 1885 and emigrated during the 1890s to New York City where, later in the decade, he studied with Augustus Saint-Gaudens at the Art Students League. On Saint-Gaudens's recommendation, Brenner traveled to Paris to study sculpture at the Ecole des Beaux-Arts. Although he excelled in academic drawing and modeling (winning a prize in competition), he preferred the freer, more modern attitudes of the Académie Julian. The abstracted figurative drawings in Brenner's undated

of Davidson's portraits including *Gertrude Stein* (Fig. 70), *Dr. Albert Einstein* (Fig. 71), and three of Mrs. Whitney (see Fig. 13). The bronze sculptures of *Gertrude Vanderbilt Whitney*, about 1917, and *Gertrude Stein*, 1920, are as different as the sitters. Gertrude Whitney stands tall, regal, elegant, and fashionably dressed. Davidson articulated the details of her costume with the same care she expended in selecting it. In contrast, Gertrude Stein sits stolidly in plainer garb, a mountain of sculpture. Both of these patrons of the arts were interpreted by Davidson as serious and deeply reflective figures of importance. For his bronze portrait head of Dr. Albert Einstein of 1934, Davidson chose a rougher surface treatment. With a greater range of chiaroscuro than the portraits of the two Gertrudes, it is reminiscent of Davidson's powerful and imaginative portrait bust of John Marin, completed in 1908. Its style and surface treatment are also similar to Jacob Epstein's 1933 portrait of Dr. Einstein.

Davidson was not exclusively a portraitist, and his refined abstracted terra-cotta *Female Torso* (Fig. 72) exhibits a little-known aspect of his oeuvre. The intentional creation of a partial human figure is an innovation of the last hundred years and can be considered a form of abstraction — that is, using a part to represent the whole.

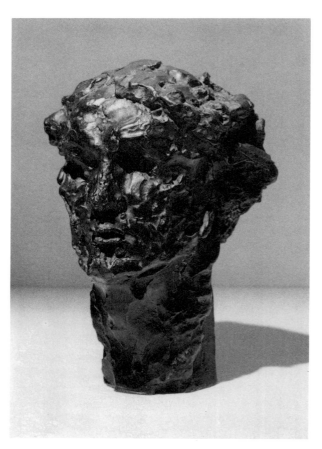

Fig. 73. Michael Brenner. Portrait of a Man, *before 1930. Bronze, 13 × 9¼ × 7¾ inches. Gift of Mrs. Michael Brenner, 74.8.*

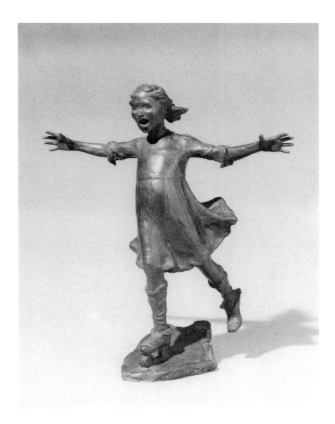

Fig. 74. *Abastenia St. Leger Eberle.* Roller Skating, *before 1909. Bronze, 13 × 11 ¾ × 6 ¼ inches. Gift of Gertrude Vanderbilt Whitney, 31.15.*

Fig. 75. *Mahonri M. Young.* Groggy, *1926. Bronze, 14 ¼ × 8 ¼ × 9 ½ inches. Gift of Gertrude Vanderbilt Whitney, 31.82.*

sketchbooks (University of Delaware Gallery) exhibit a modernist's interest in the shorthand signification of form — very few lines indicate the complexity of the whole figure, a style probably influenced by the contour, single-line drawings of Henri Matisse. Brenner was somewhat of a recluse but was befriended by and received the patronage of Gertrude Stein, who in turn introduced him to Gertrude Whitney.[8]

Some early twentieth-century figurative sculptors were involved in an acutely observed realism. Just as portraiture was embraced by both academic and avant-garde artists, so genre sculpture of the early twentieth century was accepted by the juries of annual exhibitions of the academies and paradoxically was also considered an independent alternative to classicism. Abastenia St. Leger Eberle's genre sculptures parallel the aesthetic philosophy and the paintings of The Eight. Like the realist painters, she stressed observation of life around her. Other realist American sculptors like Mahonri M. Young, Chester Beach, and Charles Haag glorified the common laborer. Paul Troubetskoy and Ethel Myers depicted, sometimes in caricature, New York's grandes dames. Eberle studied at the Art Students League from 1899 to 1902 and shared a studio with Anna Hyatt in 1904. Eberle said in

1913: "While in Italy, . . . I had steeped myself in the classic arts and I was filled with the past and seemed to lose hold on the present, but when I landed in New York I began to sense the modern spirit, and to live in the present work-a-day world with all its common places. . . ."[9] Her obsession with reflecting the contemporary world is typical of the independent artists surrounding Gertrude Whitney. Eberle studied and immersed herself in the life of the lower East Side which she interpreted in her statuettes as happy figures in motion without implying the need for social or political change. Far from spurning her interest in unidealistic genre figures of immigrants, the National Academy of Design awarded her the Burnett Prize in 1910 for her sculpture *The Windy Doorstep*, which she had modeled during her stay in Woodstock, New York.[10] *Roller Skating* (Fig. 74) expresses the gleeful abandon of a child at play, propelled by her own power.[11]

Mahonri Young was another master of genre sculpture. Mrs. Whitney purchased his bronze *Workman with Wheelbarrow* from the 1915 National Academy of Design exhibition, and by the time the Whitney Museum opened she had purchased two bronze sculptures — *Groggy*, 1926 (Fig. 75), and *The Ouessantine Shepherdess*, a Breton peasant women — which

Fig. 76. Maurice Sterne. The Bomb Thrower, *1910/14. Bronze, 12 × 7½ × 9½ inches. Bequest of Mrs. Sam A. Lewisohn, 54.51.*

Young had modeled on his fourth trip to France from 1923 to 1927. Young first exhibited at the Whitney Studio in 1918, and a one-man show of his drawings was on view at the Whitney Studio Club in 1919. He had studied at the Art Students League in 1899 and was close to Leo and Gertrude Stein in Paris during the pivotal years of their support of avant-garde art. Young's métier, however, was a style based on his close observations of the compositional and anatomical

Fig. 77. Gaston Lachaise. Standing Figure, *1927. Bronze, 11¼ × 4¼ × 3¼ inches. Given in memory of Edith Gregor Halpert by the Halpert Foundation, 75.14.*

structures of athletes and laboring men in motion. Young did not like excessively modeled projections and depressions; for him the focus of sculpture was anatomy, not lumpy surfaces, abstractions, or "truth to materials."

Maurice Sterne's first sculpture, *The Bomb Thrower* (Fig. 76),[12] which he dated 1910, is a very early example of modern American sculpture and shows the simplicity, directness, and power that characterized some European avant-garde sculpture contemporary to it. Sterne reduced natural shapes in this portrait of his Italian friend Pasquale to simple planes and silhouettes — he stressed form rather than content, and thus aligned himself with the mainstream of modern art. One immediately thinks of Raymond Duchamp-Villon's *Baudelaire*, and of Brancusi's work, like Sterne's reduced to the simplest natural elements.[13] Sterne acknowledged the profound impact he felt from Cézanne's paintings exhibited at the Salon d'Automne

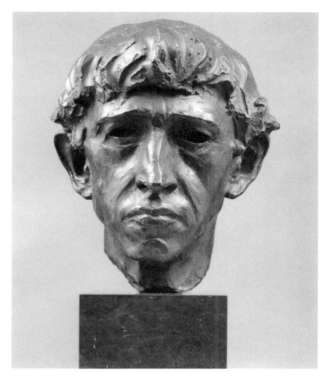

Fig. 78. Gaston Lachaise. John Marin, *1928. Bronze,
12 ¼ × 9 ⅝ × 9-15/16 inches. Promised 50th Anniversary
Gift of Seth and Gertrude W. Dennis, P.12.80.*

in Paris in October 1907. Whereas Eberle's and Young's
sculptures did not have political symbolism, Sterne's
Bomb Thrower does. This is a grim and decisively
determined expression of one of the many young
anarchists participating in the labor strikes prevalent in
Rome in 1910 and 1911.

　　Gaston Lachaise created some of the most strongly
personal sculptures in America during the early years of
this century. *The Lovers*, an intertwined male/female
group modeled between 1908 and 1910, was modern in
its depiction of an erotic theme.[14] After his emigration
from France to Boston in January 1906, Lachaise
supported himself by making belt buckles and other
accessories for war monuments like Henry Hudson
Kitson's *Minute Man* in Lexington, Massachusetts. On
his own, however, Lachaise modeled erotic sculptures
inspired by an intense relationship with his mistress,
Isabel Dutaud Nagle, who later became his wife. He
discarded the rules of classicism that he had learned
during eleven years of study in French academies to
begin his unusual hymns to the human female form.

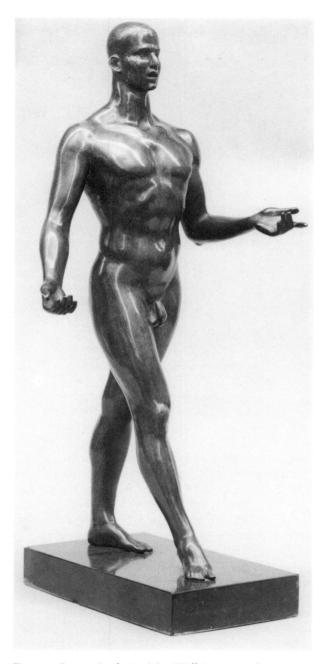

Fig. 79. Gaston Lachaise. Man Walking, *1933. Bronze,
23 × 11 ¼ × 8 ½ inches. Purchase, 33.58.*

The subjects of passion and sensuality, the tactile
kneaded surfaces, and the belief in the beauty of
distortion of the human form for design purposes are
the legacy of Rodin, but the interpretation is uniquely
Lachaise's. One can view the raw energy of Lachaise's
sculpture — so different from the grand or genteel-
tradition sculpture on which he labored for Kitson — as
an indication of broad cultural changes in America.

　　During the 1910s Lachaise developed a series of
reclining and standing women, small simple closed

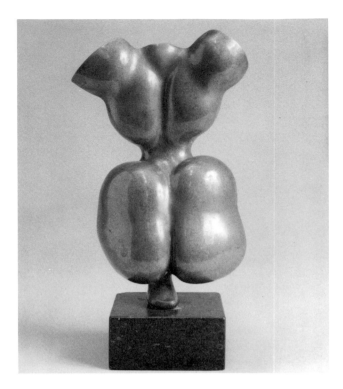

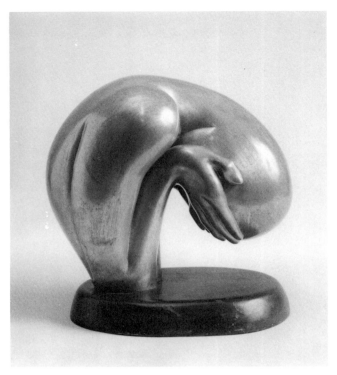

Fig. 80. Gaston Lachaise. Torso, *1930. Bronze,*
11½ × 7 × 2¼ inches. Purchase, 58.4.

Fig. 81. Hugo Robus. Despair, *1927. Bronze, 12¾ × 10 × 13*
inches. Purchase, 40.23.

forms culminating in the monumental *La Montagne*
(1934) and *Standing Woman* of 1912– 27 (Pl. 12). His
sculptured women of the 1920s were larger in scale and
more dramatically distorted than his earlier works.

Lachaise's French Beaux-Arts training emerged in
his facility in rendering portraiture in a wide variety of
modes.[15] Like Davidson, and most other fine por-
traitists, Lachaise enjoyed modeling portraits of people
he admired, as was the case with his *John
Marin* of 1928 (Fig. 78). Quite different from the
smooth-surfaced elegant portrait heads of Mme.
Lachaise in bronze, of Georgia O'Keeffe in alabaster
(1923, The Metropolitan Museum of Art) or Antoinette
Kraushaar in marble (1923, private collection, New
York), the head of Marin was modeled with an
expressionistic boldness which explores the suffering
and emotional breadth of the sitter. Davidson and
Lachaise both selected a roughly modeled surface and
down-turned composition lines for the eyebrows, eyes,
and mouth for their portraits of Marin.

During the 1930s Lachaise created several full-
length male nude portraits, an unusual genre for an
American sculptor. On one hand it antagonized the
strong puritanical strain of our national consciousness,
and on the other it ran counter to modern art's thrust
toward abstraction.[16] In some small statues Lachaise
harked back to early classical Greek sculptures of

athletes, as in *Boy with Tennis Racket*, 1933 (private
collection), and to statues of Egyptian Pharaohs, as in
Man Walking, 1933 (Fig. 79), which is a portrait of
Lincoln Kirstein. The *Man* (1930– 34) in the Chrysler
Museum in Norfolk, Virginia, however, is a
monumental, weighty earthbound pendant to the over
life-size women, Jungian archetypal symbols of the
female as a fecund earth mother, but both are more
universal interpretations of the human figure than the
specific portraits.

Lachaise's late fragments are the most dramatically
sexual sculptures produced by an American at the time.
After 1928, with *Seated Torso*, Lachaise left his
idealization and smooth surfaces to emphasize
the genital area, flesh, and musculature. With *Torso*
(Fig. 80), he arbitrarily decreased the size of the waist to
emphasize the breasts and the thighs — so different
from the chaste *Torso* by Jo Davidson. The dynamism
and explicit sexual joy expressed by Lachaise's late
series of sculptures were rare during the 1930s.

Hugo Robus is another figurative sculptor who
amalgamated his academic schooling with modern
tendencies.[17] He received his early training at the
Cleveland School of Art and the National Academy of
Design in New York. In Paris from 1912 to 1914 Robus
studied modeling with Antoine Bourdelle, and dis-
cussed aesthetic philosophy with Stanton

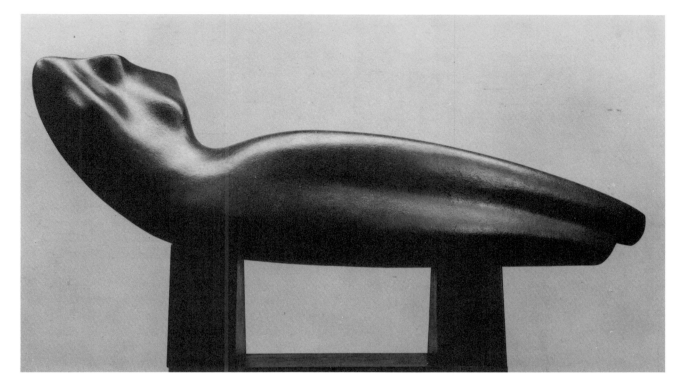

Fig. 82. *Alexander Archipenko.* Torso in Space, *1936. Metalized terra-cotta,*
21 × 60 × 13 inches. Gift of Mr. and Mrs. Peter Rubel, 58.24.

Macdonald-Wright, Morgan Russell, and František
Kupka. *Despair* (Fig. 81) exhibits the hallmarks of
Robus's mature and individual style of sculpture:
simplicity, curved smooth planes, serpentine contour
lines, volumetric forms, and human themes. Like other
figurative artists, Robus perceived that abstraction and
representation are not necessarily polarities of style and
that they could be found simultaneously in one work.

Many of Robus's mature works express the ex-
tremes of human emotions, from laughter to brooding
despair and anguish. In his search for new content
Robus also dealt with personal imagery and symbolism,
evoking mystery, ambiguity, and contradiction. He used
the human form freely, detaching the face and placing it
on the ground in front of a kneeling figure or decapitat-
ing a standing female figure and hanging the smiling
head from her finger (*Vase*, 1928, private collection).
Robus and many other twentieth-century artists re-
leased their figures from ordinary visual reality, dis-
locating them from conventional logic and com-
monplace causality.

Alexander Archipenko, one of the progenitors of
Cubism, emigrated to the United States in 1923.
Through his widespread teaching in his own art schools
in New York City and Woodstock and at various
college campuses, and by means of the dynamic forces
of his personality and art, Archipenko exerted a

tremendous impact on American sculpture. His art had
preceded him — Archipenko's sculptures were ex-
hibited in the Armory Show in 1913 and in 1921 at the
Société Anonyme. Most of Archipenko's distinctive
sculptural motifs and breakthroughs were established
during his European years. Even for the reclining female
torso, which he refined in this country in 1935, there are
precedents from his Parisian period. Archipenko
created *Torso in Space* (Fig. 82) in terra-cotta, in
chromium-plated metal, and in bronze versions as part
of his development of the image, which is the quintes-
sence of the slender floating female torso. Whereas
Lachaise's reclining females are voluptuous, Zorach's
sensuous, and Baizerman's rhythmically articulated,
Archipenko's are abstracted to a few sweeping curved
lines and flat planes.

Some of Lachaise's, Archipenko's, and Robus's
streamlined planar sculptures emphasized geometric
simplification and decorative stylization, a manner that
has been labeled Art Deco. The term is derived from the
*Exposition Internationale des Arts Décoratifs et Indus-
triels Modernes* held in Paris in 1925. Paul Manship,
some of whose sculptures share similar characteristics,
used the classical subjects that appealed to his academic
colleagues, but his figurative sculptures are more linear,
decorative, stylized, and ornamental than theirs.
Whereas Art Deco is closely associated with machine

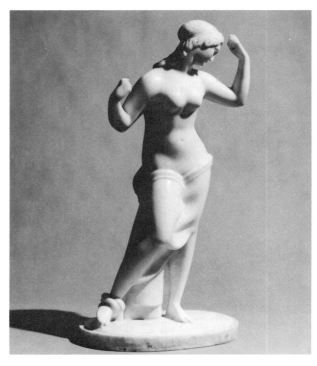

Fig. 83. *Elie Nadelman.* Draped Standing Female Figure, *1908. Marble, 22 ¾ × 11 × 8 inches. Promised gift of an anonymous donor, 8.75.*

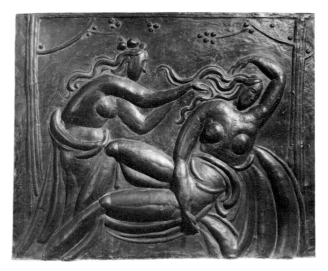

Fig. 84. *Elie Nadelman.* Spring, *c. 1911, cast 1966. Bronze relief, 47 × 57 × 1 ½ inches. Gift of Charles Simon, 69.140.*

technology and functional design, the parallel incised lines of Manship's works were inspired by archaic Greek sculpture and the figurative style of Greek vases which Manship studied during his three years, 1909–12, at the American Academy in Rome, and during a journey to Greece in 1912. The sleek lines and abstraction of both archaistic and Art Deco sculpture were prevalent in American figurative sculpture during the 1920s and 1930s, though these style characteristics are not represented in sculpture in the collection of the Whitney Museum.

Elie Nadelman's one-man exhibition at the Scott and Fowles Gallery in New York in 1925 elicited the comment from Henry McBride that the sculptures "point two ways at once, backward and forward."[18] Alongside the "caricatures in wood of modern society" were highly polished white marble classicized heads. Nadelman's presence in New York after 1914 was seminal, not only for the impact of his sculpture's qualities, especially his abstracted curvilinear system, but also for the importance of his theories of plasticity, beauty, and significant form. His reduction of figures to geometric curved volumes and spaces and the refinement of his ideas and execution appealed to and were echoed in the works of Lachaise, Robus, Zorach, Laurent, and many other important American sculptors.

Nadelman's marble *Draped Standing Female Fig-*

ure of 1908 (Fig. 83) is similar in size and composition to two bronze sculptures of the same year and title.[19] They are all of classical inspiration but the bronze sculptures are more stylized — the locks of hair are flatter and more schematic, the planes which are soft and round in the marble version end sharply in the bronze versions which have additional drapery over the head and across the shoulders. Nadelman borrowed freely from a wide range of Greek and Roman prototypes without any thought to archaeological correctness, adding his personal fluidity of serpentine lines, elegance, and decorative design. His own title for all three sculptures — *Recherches des Formes* — suggests an aesthetic philosophy best explained in the notes he wrote for an exhibition of his drawings at Stieglitz's "291" gallery:

> *I employ no other line than the curve, which possesses freshness and force. . . . The subject of any work of art is for me nothing but a pretext for creating significant form, relations of forms which create a new life that has nothing to do with life in nature, a life from which art is born, and from which spring style and unity.*
>
> *From significant form comes style, from relations of form, i.e., the necessity of playing one form against another, comes unity.*
>
> *I leave it to others to judge of the importance of so radical a change in the means used to create a work of art.*[20]

Kirstein argues convincingly that Picasso's visit in 1908 to Nadelman's studio, where he saw Nadelman's "researches in form" based on the curve, led to Picasso's analytical cubist sculptures based on angles and faceted

surfaces. Nadelman was the first to use the term "significant form," which was popularized by Clive Bell and became an essential goal for early twentieth-century modern sculptors.

Spring (Fig. 84) is one of several reliefs Nadelman designed in 1911 and 1912. The distinctive surface elevation of the relief was built up by arranging linear patterns of cylinders of clay. According to Kirstein, Nadelman's innovation of "drawing" with thin rolls of clay was imitated for twenty years in decorative, commercial, and fashion art but that its source in Nadelman was either forgotten or ignored.[21] Nadelman traveled to London from Paris in 1911 for his comprehensive one-man exhibition at Paterson's Gallery on Bond Street. Mme. Helena Rubinstein purchased the entire exhibition and commissioned Nadelman to decorate the billiard room of her house in Putney Park Lane; *Spring* and *Autumn* were two of the several terra-cotta plaques installed. Nadelman depicted Spring as an elaborately draped reclining female nude, with Botticellian flowing hair, being awakened by a partially draped standing female figure.

The Whitney Museum's recently acquired *Sur la Plage* ("On the Beach," 1916, Pl. 13) is an unusual combination of polished marble and bronze figures in a single work.[22] Such a mingling of traditional materials is characteristic of Baroque sculpture but not of modern. The mannered bronze seated maid, with archaistic flat-patterned wavy hair, uses a bronze towel to dry the feet of an elegantly coiffed aristocratic marble lady. Design, finish, expression, hairstyle, and silhouette of the head of the exquisite marble figure are similar to Nadelman's marble *Goddess* created the same year (The Cleveland Museum of Art).

According to Kirstein, Nadelman felt close to Mrs. Whitney, particularly because of her efforts to provide an atmosphere in which patronage might further innovation. He improvised an *Indigenous Sculpture* for a show at the Whitney Studio. When his partially nude figures, on view in an exhibition titled *Allies of Sculpture* on the roof garden of the Ritz-Carlton Hotel in 1917, caused a scandal, Mrs. Whitney came to his defense.[23]

Nadelman created many interpretations of the dance, an important subject for figurative sculptors, who feel an inherent affinity for such "sculpture" in motion. Noguchi wrote that the theater of the dance adds movement of bodies in relation to form, space, and music. He also commented on the joy of seeing "sculpture come to life on the stage."[24] Degas's and

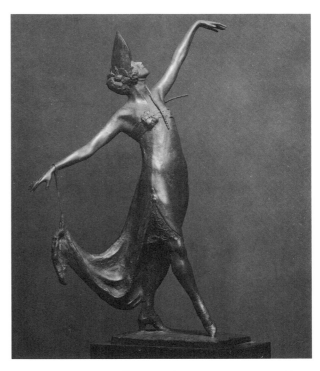

Fig. 85. Malvina Hoffman. Pavlova, *1915. Bronze, 13 ¾ inches high. Gift of Gertrude Vanderbilt Whitney, 31.36.*

Rodin's interpretations of the dance are legendary, as is Calder's *Josephine Baker*. Malvina Hoffman knew Pavlova and other members of the Russian ballet in Paris between 1910 and 1914, and her bronze statuette *Pavlova* (Fig. 85) has been part of the Whitney Museum's collection since its inception. In 1925 Robus modeled a gyrating rubbery figure which he cast in plaster (Forum Gallery). Nadelman's *Dancing Figure*, about 1916–18 (Fig. 67), is one of six bronze casts of a sculpture originally carved in marble for the garden of William G. Loew's estate in Old Westbury.[25] Like the marble bather of *Sur la Plage*, Nadelman's dancer poses with one leg bent beneath the body and the other bent out in front. It is unlike many sculptures of dancers, though, for Nadelman did not attempt to re-create the dynamism of motion in *Dancing Figure* but selected a moment of arrested motion at the end of a Greek dance. In both of these sculptures he was less interested in his signature arabesque and the serpentine curves than in harmonious angles of arms and legs in relation to the torsos.

Directly Carved Wood and Stone Sculptures

Of the Whitney Museum's collection of early twentieth-century American sculpture, a large propor-

tion is directly carved. The direct carver's respect for the innate qualities of material was different from the exaggerated emphasis on modeling and disregard for the intrinsic properties of medium of the preceding generation. Yet the direct carver's use of stone and wood was relatively traditional in view of the innovative use of materials advocated by the Futurists and the Bauhaus, to name only two groups. For example, collage provocatively juxtaposes unorthodox materials, and constructivist sculptors fastened together materials that had so far been considered unsculptural. Direct carvers' concern for materials was modern, but their use of them was traditional. Many European vanguard artists had carved directly: Aristide Maillol, Paul Gauguin, and George Lacombe had carved wood figures during the 1890s, André Derain and Joseph Bernard began in 1906, Pablo Picasso and Constantin Brancusi in 1907, Modigliani in 1909, and José de Creeft in 1917. Robert Laurent was the first to introduce *taille directe* to America with his dramatic primitivist relief *Negress* (Collection of Paul Laurent) in 1911. Between 1908 and 1917 the German Expressionists progressed from carving woodcuts that were self-consciously African to carving wood relief sculptures just as the American William Zorach did in 1917.[26]

Influenced by theories of modern art, direct carvers employed abstraction and expressive distortion of form which they combined with the traditional subject of the human figure. They expressed in their works a romantic orientation and an optimistic philosophy full of the deepest and finest qualities of human feeling and love. In the United States, the early direct carvers — Zorach, Laurent, Flannagan, Gross, and de Creeft — were influential in changing the dominant style of sculpture away from academic classicism. They shared an involvement with the entire creative process and the respect for the unique qualities of each material. The concept of "truth to materials," whether wood, stone, ceramic, or metal, had a strong hold upon American artists in the 1920s and 1930s.

The dreamy reflective quality inherent in the slow process of carving hard materials was a respite from the machines and speed so characteristic of our century. Stones are metamorphosed over the centuries, and their contemplation encouraged the ontological orientation of the American carvers. Somehow the rocks and trees with which they worked sustained their poetic nature and their romantic urge to return to primordial methods and forms. Sculptors who carved repeatedly expressed in words the existence of a universal being or quality in all living things in such phrases as "universal truth" or "essence of life." Artists, philosophers, and theologians grapple with the ultimate concerns of man and the essential meaning of life — with the spirit that transcends nature and man. Carvers invariably preferred natural (human or animal) forms carved of natural materials by means of the human hand. Carvers also believed in a kind of Michelangelesque reanimation — "a real artist touches a piece of material and under his touch it becomes a thing of life" is the way that Zorach described it.[27]

Zorach recorded the inception of a pair of carved wood statuettes recently reunited at the Whitney Museum:

> *In Provincetown I bought two pieces of mahogany, each of them about twenty inches high, which a sea captain had brought back from Africa many years ago. Dahlov was three and a half and Tessim six. I carved a figure of each child standing, chunky and compact figures. . . . I held the wood between my knees and used small carpenter chisels and a penknife. The children played around the room nude so I could study them and watch the forms move.*[28]

Zorach acknowledged that *The Young Boy* was influenced by African carvings.[29] The single axis, rigid stance, frontality, segmented parts, exaggerated hips, blank eyes, and stylized navel and knee caps link *The Young Boy* particularly to Fang statues, such as the one included in Charles Sheeler's folio of photographs of the Negro sculptures at Marius de Zayas's Modern Gallery, a book Zorach purchased around 1919.[30] *Figure of a Child*, companion to *The Young Boy*, is softer and less overtly primitive; the personality of the small girl overpowered Zorach's primitivist tendencies (Pl. 14, Figs. 86, 87).

John B. Flannagan, whose figurative works are not represented in the Permanent Collection of the Whitney Museum, created some of the outstanding examples of directly carved American sculpture. He exhibited at the Whitney Studio Club in a group show in December 1925, and Alexander Brook and Juliana Force organized his first one-man exhibition anywhere at the Whitney Studio Galleries in January 1929. Flannagan seemingly did little to transform the ellipsoidal blocks of granite or sandstone to the recognizable forms of animals or non-personalized images of people. A few months before his death, he wrote of images waiting to

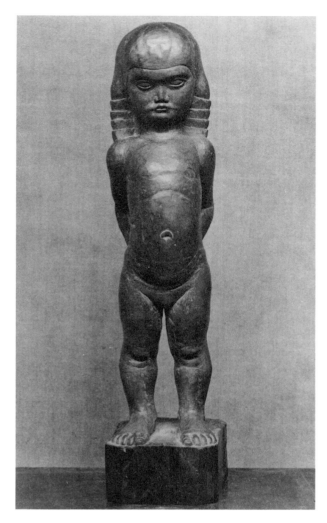 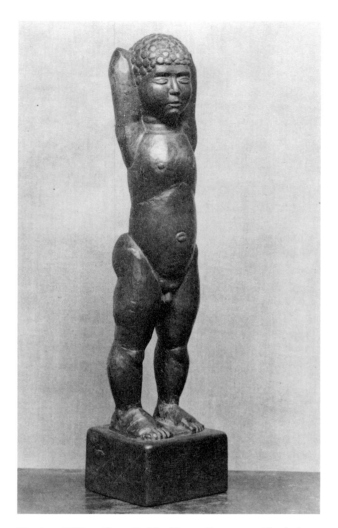

Fig. 86. *William Zorach*. Figure of a Child, *1921. Mahogany,*
24 × 5½ × 6¼ inches. Gift of Dr. and Mrs. Edward J.
Kempf, 70.61. Photograph by Charles Sheeler, 1921. Gift of
Mr. and Mrs. Tessim Zorach, 79.85 (see Pl. 14).

Fig. 87. *William Zorach*. The Young Boy, *1921. Maple (or*
mahogany ?), 22½ × 5¼ × 5 inches. Promised 50th An-
niversary Gift of Mr. and Mrs. Tessim Zorach, P. 14.79.
Photograph by Charles Sheeler, 1921. Gift of Mr. and Mrs.
Tessim Zorach, 79.84.

be released from the rock and the "occult attraction in
the very shape of a rock as sheer abstract form." [31] Both
Flannagan and Zorach, in his contemplative stone
heads carved between 1955 and 1962, were exploring
subtle differences between stone as rock and stone as
representation of a living being. [32] The sculptors were
attempting to see how little the artist needed to alter the
stone to transform it into a symbol of human life which
they hoped would remain for eternity.

The Spaniard José de Creeft was a pioneering
direct carver in Paris, from 1905 to 1928, before coming
to the United States in 1929. He learned the craftsman-
ship of carving, beginning in 1911, by translating clay
portraits to stone with pointing machines. In 1917 he
began to follow the philosophy of direct carving,
conceiving his designs as he chiseled the block of stone.

Through eighty years of creating sculpture de Creeft has
retained his conviction that the human figure is the
finest subject. In his carvings he favors romantic
interpretations such as his apparently light and airy
Cloud of greenstone (Pl. 15). De Creeft wrote that clay
seemed essentially dead to him and that it "had no will
of its own — no resistence. . . . It is soft and too quick to
bend to your will. . . . The only live thing about a
modeled form is its armature, which you cover up." [33]

Although Seymour Lipton is best known as an
innovative fabricator of abstract metal sculptures, he
began by carving wood figures during the 1930s. These
stand apart from the mainstream of American direct
carvings because of their inventiveness. From the
beginning Lipton, a self-taught sculptor, found neither
non-objective nor realistic sculpture completely satisfy-

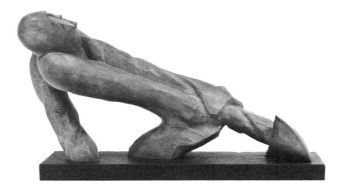

Fig. 88. Seymour Lipton. Sailor, *1936. Oak, 18 × 36 × 9 inches. Gift of the artist, 79.80.*

ing, and he chose to invent partial figures intertwined with man-made objects and punctured with voids.[34] Instead of softly rounded, compact, closed forms, Lipton composed with thrusting diagonals, angles, and curves offset by clearly demarcated volumes of space. Reflecting on *Sailor* (Fig. 88), he wrote that it illustrated his "early preoccupation with the fusion of human and non-human elements. Although realistic, there is a formal unity of the rope and the person in the *Sailor*, an architectonic structuring which produced a metaphysical activity."[35] Lipton also expressed goals more in line with the credo of direct carving — organizing the color of the wood, the grain, the shape of the forms, the mood of the subject, and the ideas implied in the work to suit one another for the greatest impact and intensity.[36] The formal solutions he chose and the concepts he expressed in his carvings were advanced and unusual, foreshadowing the power and complexity of his later direct metal non-figurative works.

Several design motifs and technical devices typical of American direct carvings of the 1930s and 1940s are evident in Concetta Scaravaglione's *Group* (Fig. 89). The block is unpierced by voids, and smooth polished surfaces which represent human skin contrast with textured areas patterned with curved-chisel marks which represent hair or the block seat. Softly rounded or squarish limbs and forms were used, and jagged or sharply angular angry forms were excluded. Scaravaglione learned to carve from Robert Laurent in 1924 and continued to carve until 1960. She disseminated her feeling for the medium to students at Vassar College during the 1930s and again from 1952 until 1967.[37] Like many other figurative sculptors represented in the Whitney Museum collection, she studied at the National Academy of Design and the Art Students League (1916–23), participated in the WPA projects and the 1939 World's Fair, and exhibited most frequently in the Sculptors Guild and the Whitney Museum and Pennsylvania Academy annuals. Like Laurent, Herbert

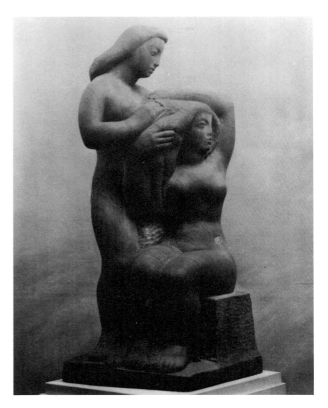

Fig. 89. Concetta Scaravaglione. Group, *1935. Mahogany, 24 ¼ × 10 ½ × 10 inches. Purchase, 36.4.*

Ferber, Lipton, Gross, and Calder, Scaravaglione found carving too confining for her total artistic expression and began constructing additive metal sculptures. She and Roszak experimented together with welding techniques in 1946, and during the ensuing decades she fabricated many metal figurative sculptures, enjoying the greater freedom and variety of contours, shapes, and void/volume interchanges.

Robert Laurent, who introduced the concepts of direct carving to American sculpture, was inspired by the primitivist carvings of African Negroes, Gauguin, and Picasso which he had seen in Paris in 1907. His direct carvings of the 1910s ranged from Art Nouveau and realism to strongly primitivist and completely abstract works.[38] Until 1927 he carved exclusively, and throughout his life he continued to cut alabaster and mahogany figurative works sensitive to the special qualities of each material. During the 1930s Laurent began casting metal works, creating some maquettes by carving blocks of plaster and some by modeling clay. *Kneeling Figure* (Fig. 90), which was modeled, is characterized by relatively smooth planes, blocky forms, heaviness of limbs, and a general abstraction of design elements that we associate with carved works. *Kneeling Figure* epitomizes the kind of figurative work favored during the 1930s, and indeed it was awarded

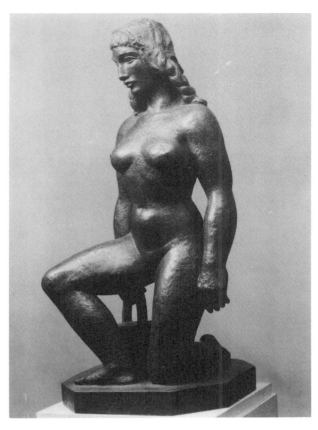

Fig. 90. Robert Laurent. Kneeling Figure, *1935. Bronze, 23 ½ × 11 ¼ × 12 inches. Purchase, 36.2.*

the Logan Medal at the Art Institute of Chicago in 1938 and the Brooklyn Museum Sculpture Prize in 1942.

Alexander Calder carved more than fifty wood sculptures between 1926 and 1931; *Woman* (Fig. 91) is one. Chaim Gross recalls Calder approaching him at an exhibition of the Society of Independent Artists, and asking him where he found his unusual woods. Gross recommended the J. H. Monteath Company in New York where he and Zorach had been purchasing their tropical woods. Calder took his advice.[39]

Calder's Wire Sculptures

Calder began constructing wire drawings in space in 1925, before his first trip to Paris in 1926. Such works as his monumental wire *Brass Family* (Fig. 92), which are at once sculptural and pictorial, are an extension of single-line drawings he had created between 1923 and 1925, and were inspired, perhaps, by Jean Crotti's wire portrait of Marcel Duchamp of 1915 or Giacomo Balla's wire *Pas de Deux*. The circus theme is prominent not only in the oeuvre of Calder but also of Walt

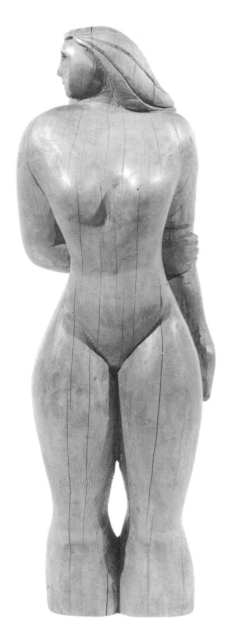

Fig. 91. Alexander Calder. Woman, *c. 1926. Elm, 24 × 6 ½ × 6 inches. Gift of Howard and Jean Lipman, 75.27.*

Kuhn, Louis Bouché, Chaim Gross, and many other artists. Calder made linear drawings of the Ringling Brothers and Barnum & Bailey Circus during a two-week assignment as a reporter for the *National Police Gazette*, which published some of the drawings on May 23, 1925. The next year he began to devise his famous mechanized circus.[40]

Calder's *Belt Buckle* (Fig. 93) is very similar to his several wire portraits of Josephine Baker. Looped curly hair, arms flung in a dancer's gestural motion, and tightly wound spirals for abdomen and breasts characterize both his first *Josephine Baker* of 1927 and the brass-wire figurative *Belt Buckle* of 1935.

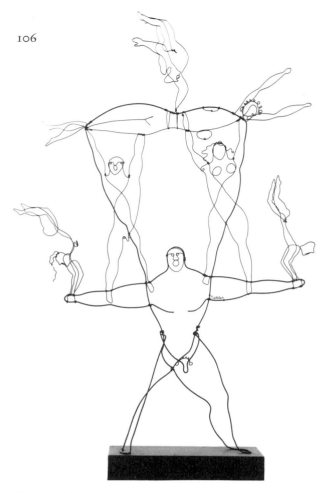

Fig. 92. Alexander Calder. The Brass Family, *1929. Brass wire, 64 × 41 × 8½ inches. Gift of the artist, 69.255.*

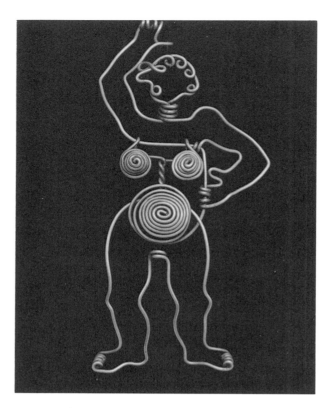

Fig. 93. Alexander Calder. Belt Buckle (Wire Female Figure), *1935. Brass, 8 × 5 × ½ inches. Gift of Mrs. Marcel Duchamp in memory of the artist, 77.21.*

Terra-cotta and Ceramic Sculpture

Materials and techniques are the most important determinants of style for twentieth-century American sculpture, and ceramic sculpture is a more dominant part of this art than is generally realized. The particular qualities of the ceramic medium have generated unusual figurative works, with significant contributions from Alexander Archipenko, Jo Davidson, Elie Nadelman, Isamu Noguchi, Kenneth Noland, John Storrs, Reuben Nakian, and later Louise Nevelson, Robert Arneson, David Smith, Helen Frankenthaler, and Mary Frank. Garth Clark suggests that the austerity of the 1930s brought attention to and encouraged the use of cheaper materials.[41] While this may have been true for Nadelman, whose fortune was abruptly wiped out with the collapse of the stock market in 1929, it is not a sufficient explanation for the appeal of the ceramic

medium to the others. Noguchi, for example, spent part of the years 1931 and 1932 in Japan learning traditional methods and forms and was especially influenced by Japanese Haniwa figures and Bizen and Shigaraki wares.[42] Haniwa literally means clay circles and Noguchi's *The Queen* (Fig. 94) is assembled of various circular terra-cotta forms. Noguchi wrote of his discovery of the Haniwa grave figures in the Kyoto Museum in 1931, "Simpler, more primitive than Tang figurines, they were in a sense modern, they spoke to me and were closer to my feeling for earth."[43] *The Queen*, created during that "lonely self-incarceration" in Kyoto, is quite unlike the other figures he created there which are more overtly oriental. Although Noguchi was "transfixed by [the] vision" of his mentor Brancusi, for whom he had worked as a stonecutter in Paris in 1927, and *The Queen* is abstracted in the manner of Brancusi, its symmetrical regularity is different from the asymmetry of Brancusi's works.

Reuben Nakian interacted significantly with several of the first-generation modernist sculptors. He was an apprentice in Paul Manship's workshop from 1916 to 1920, trained there by Manship's assistant Gaston Lachaise. From 1920 to 1923 Nakian shared a studio with Lachaise on Sixth Avenue. He was given a monthly

Fig. 94. Isamu Noguchi. The Queen, 1931. Terra-cotta,
45½ × 16 × 16 inches. Gift of the artist, 69.107.

Fig. 95. Reuben Nakian. The Lap Dog, 1927. Terra-cotta,
6½ × 5 × 10½ inches. Gift of Gertrude Vanderbilt Whitney,
31.47.

stipend, studio space, and exhibitions by Mrs. Whitney
during the 1920s and was represented by the
Downtown Gallery after 1927. From 1923 and into the
1930s Nakian was a close friend of Zorach's and
created a delightful portrait in terra-cotta of Zorach's
daughter Dahlov entitled *The Lap Dog* (Fig. 95).
Ceramic was frequently the medium of choice for
Nakian, and during the 1940s he added significant
innovations to its use.

During the 1930s and 1940s the sculptors invited to
participate in the non-juried Annual exhibitions of the
Whitney Museum were predominantly direct carvers.
William Zorach, Heinz Warneke, Nathaniel Kaz,
Chaim Gross, Ahron Ben-Shmuel, John B. Flannagan,
Albino Cavallito, Margaret Bressler Kane, Concetta
Scaravaglione, Simon Moselsio, Richard Davis, and
José de Creeft were regular exhibitors. José de Rivera
exhibited carvings in 1938 and 1941 and Herbert Ferber
in 1938, 1940, and 1942. Jo Davidson and Arthur Lee
exhibited nude figures cast in bronze with rough surface
textures, and Robert Laurent submitted metal and
plaster figures instead of the direct carvings usually
associated with him.

Early twentieth-century figurative artists were re-
vitalizing and bringing up to date one of the most
important sculptural subjects throughout history.
Zorach, Lachaise, Brenner, Laurent, Baizerman, and
Robus were born during the 1880s, were trained in
respected academies of art, and retained their convic-
tion that the human figure was inspiring and that it was
the ultimate subject, worthy of a decade or even a
lifetime of effort. Robus, for one, stated that he did not
feel sufficiently god-like to create totally new (i.e.,
abstract) designs; he felt more comfortable creating
organic biological forms. American figurative artists
were not a cohesive group, but they found a congenial
atmosphere at the Whitney Museum. Hugo Robus
wrote to Lloyd Goodrich in 1959 that he considered the
Whitney Museum "a place with which I feel more
closely integrated than with any other institution." [44]
The strong empathy toward organic forms of early
twentieth-century figurative artists forced them to
retain recognizable natural forms in their sculpture to
satisfy their own inner convictions.

CHAPTER IV

Painting, 1941–1980

PATRICIA HILLS

In the early 1940s the dominant preoccupation of Americans centered on World War II. The country mobilized with urgency: factories converted to war production, and young men and women joined the armed forces or transferred to defense jobs. To those on the home front the war meant the emotional ordeal of missed fathers, sons, brothers, and loved ones as well as the inconvenience of overcrowded trains, rationed gasoline, and food scarcities. Some thought ideologically in terms of destroying the social system of Fascism, but most simply wanted the war over as soon as possible.

In their art, painters had a wide range of responses to the war and its immediate aftermath. Some of those at home, such as the American Scene painters and the Social Realists of the 1930s, continued a representational painting with occasional references to the war; other artists, influenced by the European Surrealists who had emigrated to New York in the late 1930s and early 1940s, began to transform figurative imagery into abstraction. To those who went overseas with the armed forces, opportunities to paint were naturally more limited, although some artists were assigned to graphic departments and made signs,

designed camouflage, and produced propaganda posters. To Jack Levine, who spent a year and a half as a soldier on a South Atlantic island, the "war was a void"; moreover, the tedium of the Army was "insulation against all the great issues of the war." To other artists, such as Philip Pearlstein who was in the Italian campaign, the war and the immediate postwar occupation by American troops provided the unexpected opportunity to see Old Master paintings in the galleries and museums of Europe.[1]

Reviewing the 1940s, we can see that it was a decade in transition. By its end, painting had polarized into representational painting and abstraction, and by the mid-1950s modernism had become the dominant mode. In the 1940s modernism meant to many artists the search for a personal form to express a personal content; the emphasis was on expression — of human and personal values by abstract means. Hence, when the New Yorker critic Robert Coates called this generation of modernists "Abstract Expressionists," the term caught on. Harold Rosenberg had his own term — "action painting" — which emphasized the gestural techniques the artists used. More recently the term "New York School" has gained currency.[2]

In discussing this nomenclature, what we must not forget is that these postwar abstractionists shared with the figurative artists a humanist bias. However, the concept of humanism — the belief in the dignity of man and in human values as well as the awareness of human

Fig. 96. *Philip Pearlstein*. Seated Nude on Green Drape, *1969. Oil on canvas, 60 × 48 inches. Gift of the Friends of the Whitney Museum of American Art, 70.2.*

Fig. 97. George Grosz. Peace, II, *1946. Oil on canvas,*
47 × 33 ¼ inches. Purchase, 47.2.

limitations — was also in the process of transformation.
Whereas the figurative artists in the 1900– 40 period
shared an optimistic belief in progress and social justice,
the mood of many humanist artists, including the
abstract painters, changed to one of pessimism, de-
featism, and individual alienation, a mood which lasted
well into the early 1960s and still lingers today.

World War II as Subject for Painting

During the war years, a number of the figure paintings
shown in Whitney Museum Annuals made reference to
the war and its immediate aftermath, although the
majority referred to other themes which will be dis-
cussed shortly. The Annual of 1942 included Joseph
Hirsch's *Together We Fight for the Right to Live*; that of
1943, William Gropper's *Partisans*, Anton Refregier's
Terror in Poland, and Mitchell Siporin's *Recruit's
Farewell*. In 1944, Philip Evergood's *Production for
Peace* and Isaac Soyer's *Refugee* were shown; and in
1945 Harry Sternberg's *No More War*, Sidney Gross's
Victory, and Ben Shahn's *Reconstruction*, the latter two
purchased by the Whitney Museum. The Annual of
1946 exhibited George Grosz's *Peace, II* (Fig. 97), also
purchased by the Whitney Museum.

Other works with war-related themes entered the
Museum collection later as gifts, such as Jacob Law-

Fig. 98. Jacob Lawrence. War Series: Another Patrol, 1946. Egg tempera on composition board, 16 × 20 inches. Gift of Mr. and Mrs. Roy R. Neuberger, 51.8.

Fig. 100. Jacob Lawrence. War Series: Beachhead, 1947. Egg tempera on composition board, 16 × 20 inches. Gift of Mr. and Mrs. Roy R. Neuberger, 51.13.

Fig. 99. Jacob Lawrence. War Series: Reported Missing, 1947. Egg tempera on composition board, 16 × 20 inches. Gift of Mr. and Mrs. Roy R. Neuberger, 51.18.

rence's series of fourteen small panel paintings entitled *War*, completed in 1947. Lawrence, a Harlem artist who had established a reputation for his narrative series based on the history and biographies of black people, joined the U.S. Coast Guard in October 1943. He served on a weather patrol boat, subsequently the troop carrier U.S.S. *General Richardson*, before his discharge in December 1945.[3]

Awarded a Guggenheim Fellowship in 1946, Lawrence embarked on the project to recapitulate his war experiences. The *War* series does not illustrate a continuous narrative, but consists of impressions or images, some remembered and some imagined. The style is not naturalistic, but derives from the aesthetic

qualities of collage cubism — painted as though colored papers were boldly arranged to give movement to the design. *Another Patrol* (Fig. 98) represents men ascending a gangplank, a scene Lawrence would have witnessed numerous times. *Reported Missing* (Fig. 99) depicts men standing behind barbed wire, a generalized view of the endless waiting characteristic of all wartime situations. *Beachhead* (Fig. 100) pictures soldiers with bayonets moving left against a backdrop of tanks, as medical orderlies move right carrying a wounded soldier. As a synthesis of the advance and retreat of battle, *Beachhead* functions as an incisive schema rather than a naturalistic view of a single episode.

As expressionism — the stylistic distortions and exaggerations of line, form, and color intended to reveal the artist's emotional response to life — was suitable for Social Realism, so, too, was it appropriate for the themes of war. George Grosz, the Berlin satirist who fled Germany when Hitler came to power, subsequently settled in New York and taught at the Art Students League. In his painting *Peace, II*, Grosz represented a grim survivor emerging from the rubble and twisted iron beams of a bombed-out structure. The colors of dark umber and ocher fit the mood of desolation.

Ben Shahn's tempera painting *Reconstruction* of 1945 (Fig. 101) projects a more hopeful image. The background Roman viaduct locates the scene in Europe, probably Italy; in the iconography of modern war, the pack of chewing gum held up by the helmeted American soldier in the background to the group of eager children symbolizes the soldiers' friendly teasing of the defeated civilian population. In the foreground, young European children balance themselves on blocks of stone which will soon be used by them in the reconstruction of their country. The colors are the gray

Fig. 101. Ben Shahn. Reconstruction, 1945. *Tempera on composition board, 26 × 39 inches. Purchase, 46.4.*

of old marble fragments, the browns of soiled cast-off coats, and the pale flesh tones of subsistence living. The style uses the simplified disjunctions of montage and the distortions of expressionism to reinforce the meaning of the painting — that in spite of the desperate humiliation of occupation and drawing on the strength of a centuries-old culture, Europe will rise again because of the energy of its children.

American Painting and the Cold War

By the end of the 1940s it had become clear that the end of the war had not brought a lessening of tensions, as the United States slid into the Cold War. The old antagonisms between the capitalist and Communist countries intensified. By 1947 the Russians had blockaded Berlin; by 1949 Mao Zedong and Communist forces had triumphed over Chiang Kai-shek in China; and in 1950 the Americans entered the Korean War, which was to last until 1953. These tensions were intensified on the home front. In October 1947 the House Committee on Un-American Activities opened public hearings on "communism" in the film industry. Ten writers who refused to testify were charged with contempt of Congress and sent to prison. Erik Barnouw, in his history *Tube of Plenty: The Evolution of American Television*, characterized the political climate, where talented people overnight lost their jobs and their friends: "Hollywood entered a period of fear. Political discussion tended to vanish, but silence itself could seem suspicious. The patrioteering speech was much in evidence. A blacklist developed."[4]

The Alger Hiss trials of 1949 and 1950 and then the Julius and Ethel Rosenberg trial and appeals from 1950 to 1953, in which the accused were adjudged guilty of wartime espionage on behalf of the Russians, only increased the campaigns against the "internal Red menace." "Treason" and "treachery" were indiscriminately applied to others who ideologically or idealistically were drawn to the ideals of communism or who even criticized the free-enterprise system. Artists, if they maintained the same feelings of intense social concern as they had in the 1930s, were automatically suspect.

At the same time, the literature of existentialism began to attract intellectuals to its view that man's existence precedes man's essence and that essence was "alienation," a condition common to all men. Dore Ashton, writing in 1972 on the background of the Abstract Expressionists in *The New York School: A Cultural Reckoning*, has drawn the connection between the flare-up of anti-communism and the attraction of existentialism:

> *As such sensational events as the Alger Hiss case swept the red scare into prominence, and as McCarthy easily destroyed the solidarity of the professionals he attacked, the malaise of the intellectuals deepened. Silence fell. Marxism, which had once been so vital to artistic discourse, faded into the background of new discussions of existentialism. The old conflict between individualism and the collective ethic was interiorized.*[5]

Social issues and collective goals were either too dangerous or they were rationalized into the background as less pressing than personal and psychological self-awareness. Freud, and to a lesser extent Jung, replaced Marx, and Sartre and Camus supplied the Western intelligentsia with a new rhetoric of despair.

Meanwhile, business and industry were booming, suburban tract homes sprang up, television stations spread across the country, and home appliances came off the assembly lines in increasing numbers. What seemed like a rising prosperity for everyone tended, however, further to alienate artists who saw a society reveling in philistinism. Mark Rothko voiced a common sentiment among the Abstract Expressionists when he declared in 1947 in the little magazine *Possibilities I*:

> *The unfriendliness of society to his activity is difficult for the artist to accept. Yet this very hostility can act as a lever for true liberation. Freed from a false sense of security and community, the artist can abandon his plastic bank-book, just as he has abandoned other forms of security. Both the sense of community and of security depend on the familiar. Free of them, transcendental experiences become possible.*[6]

Against this background — with the world caught up in suppressed antagonisms, conflicting ideologies, and ambiguous diplomacy and with the nation the scene of rising prosperity, imposed conformity, and oppressive and subtle censorship — artists formed their imagery.

Much has been written about the New York School and the development of Abstract Expressionism in the late 1940s and early 1950s. What should not be lost sight of are the connections with representational painting at the time. Rothko stated in his *Possibilities* article, "I do not believe that there was ever a question of being abstract or representational. It is really a matter of ending this silence and solitude, of breathing and stretching one's arms again."[7] Both representational and abstract art were concerned with the expression of feelings and human values. The language of existentialism permeated the writing of the artists and art critics. Painting became the "gratuitous act," and "ambiguity," "alienation," and "anxiety" became catch words to define the nuances of artistic endeavor.

Because of many factors, the new abstract painting had, by the mid-1950s, achieved a prominence in the art world. One factor was the sincere belief that only abstract art could adequately express the artist's feelings. Robert Motherwell voiced this attitude in 1951:

> *The emergence of abstract art is one sign that there are still men able to assert feeling in the world. Men who know how to respect and follow their inner feelings, no matter how irrational or absurd they may first appear. From their perspective, it is the social world that tends to appear irrational and absurd.*[8]

Even though many representational artists were also depicting the social world as irrational and absurd, and were in fact abandoning naturalism as inadequate to what they wanted to express, it was the abstract art that was being seen in the major galleries, bought by

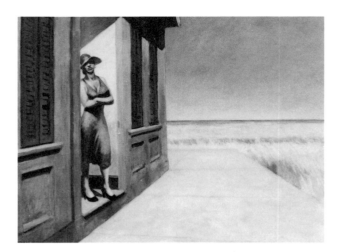

Fig. 102. *Edward Hopper.* Carolina Morning, *1955. Oil on canvas, 30 × 40 inches. Given in memory of Otto L. Spaeth by his family, 67.13.*

Fig. 103. *Robert Gwathmey.* Sowing, *1949. Oil on canvas, 36 × 40 inches. Purchase, 49.17.*

adventuresome collectors, written about by the major art critics, and sent abroad to influential international art shows.[9]

Although increasing numbers of artists abandoned representational painting and embraced the new painterly abstraction, a substantial minority of figurative artists weathered the changing art climate. Mature figurative artists such as Edward Hopper (Fig. 102), Thomas Hart Benton (Pl. 16), Robert Gwathmey, (Fig. 103), Isabel Bishop, and Raphael Soyer continued to paint either social themes, views of American life, or studio pictures as they had in the 1930s and 1940s.

But there was also a middle range of American artists — neither totally abstract nor traditional. Some responded to the postwar temper of anxiety, ambiguity, alienation, and even cynicism by probing themes that used the figure to express these moods or feelings — using styles that combined characteristics of naturalism, Cubism, expressionism, and Surrealism. Others explored the possibilities of the new painterly abstraction for investigating and pushing the human form to its formal and expressive limits. The first group, maintaining its commitment to content over form, stayed within the mainstream tradition of humanism, although they strained and deflected that tradition. The commitment of the second group was primarily to modernism, to exploring form and artistic process. These two groups defined the perimeters of the history of figurative painting through the mid-1960s.

Such artists as Evergood and Levine were direct in

satirizing those who (to them) were the agents of alienation — capitalists, gangsters, policemen, the military — although even they softened the bitter specificity of their earlier years. Younger artists, however, such as Stephen Greene, Robert Vickrey, and Joe Lasker, resorted to ambiguous metaphor and veiled allusion. To them the "human condition" was not specific to an individual or a group at a given time and place, as Marxists had said in the 1930s. To them the human condition was one of universal alienation in an irrational and absurd world. At best, humanity can merely endure and never prevail.

Postwar Figurative Themes: "The Human Condition"

The major postwar themes in figurative painting, which paralleled in chronology the rise of Abstract Expressionism during the late 1940s and 1950s, included the following: crucifixion themes, a single figure alone in a vast space or lost in a literal or symbolic labyrinth, and ambiguous rituals and sinister revelries of figures frequently masked. Sometimes the themes were pushed into the realm of satire on man's follies and vanities.

Right after the war, Rico Lebrun, Stephen Greene,

Peter Blume, and Philip Evergood probed Christian themes — particularly the image of the suffering or crucified Christ — to communicate their reaction to the war. Greene, who repeatedly alluded to the suffering Christ in the late 1940s, recalled his motivation in 1955:

In the forties I was obsessed in my life as well as my work (there is no separation) by the massacre of the Jews in Europe. This led me to reinterpret the story of Christ, particularly the events centering around the Crucifixion. Christ is no longer the central figure and torturers are equally involved and the tragedy was theirs as well. No one is saved.[10]

Peter Blume painted *Man of Sorrows* in 1951 (Fig. 104) after a trip to Mexico. The emaciated Christ figure bears a cross festooned with streamers, and dime-store religious amulets hang from his body. The garish greens, lavenders, and reds reinforce the repulsiveness of the images and the secular qualities of the figure. One is tempted to ask, "For what was he crucified?"

Philip Evergood's *The New Lazarus* (Fig. 105), begun in 1927 and completed in 1954, is overwhelmed

Fig. 104. Peter Blume. Man of Sorrows, *1951.* Tempera on canvas, 28 × 24 inches. Purchase, 51.5.

Fig. 105. Philip Evergood. The New Lazarus, *1927/54. Oil on plywood, 48 × 83 ¼ inches. Gift of Joseph H. Hirshhorn, 54.60.*

Fig. 106. *Siegfried Reinhardt.* Crucifixion, *1953. Oil on composition board, 28 × 45 ½ inches. Gift of William Benton, 55.2.*

Fig. 107. *Joe Lasker.* Naples, *1952. Oil on canvas, 34 ¾ × 51 inches. Purchase, 53.50.*

with a symbolism which refers to both the follies and the courage of mankind. The folly of passivity is personified by the three characters under the umbrella at the right in the poses of "Hear no evil, see no evil, speak no evil." The agony of sacrifice and war is personified by Christ and the soldiers, one of whom is stretched along the foreground. The eventual return of hope is symbolized by the flayed lamb, which approaches Christ with a burning cross, and Lazarus, who is raised from his coffin while his soul — a butterfly-winged woman — enters his body.

Life magazine, in its issue of March 13, 1950, reproduced the work of nineteen "exceptionally promising" American artists under the age of thirty-six who had been selected as the result of a poll of heads of museums, art schools, and college art departments. In the final selection, the questions posed by *Life*'s editors about the artists was: "Do they have anything worthwhile to express and do they get it across? Do they reflect feelings of hope, or are they harsh expressions of despair?"[11] In other words, expressions of strong human emotion were important considerations, but often the line between hope and despair was ambiguous.

One of the finalists was Siegfried Reinhardt, whose work both in oil and stained glass was religious in its imagery. His *Crucifixion* of 1953 (Fig. 106) depicts Christ and an anonymous man who fingers a drawstring from his shirt. Reinhardt explained the motif of the string, which recurs in other works: "It started as a thin form to relieve great masses and to create a sensation of space. Perhaps it has now psychological significance too. We're all conscious of the thread of life.

In some instances it becomes a symbol of the thin traces of the human spirit."[12]

Another of *Life*'s nineteen was Stephen Greene. A later *Life* issue, October 23, 1950, featured a spread of Greene's pictures, including *The Burial* of 1947 (Fig. 108). The article summed up Greene's work for a *Life* readership which ran into the millions:

> *Greene's canvases are not ingratiating. Peopled by sad, mannikinlike men, they have a strained and morbid cast. Many of them are based on religious subjects. Greene does not call himself a religious man but, because biblical stories are universally recognized and easily understood, he used them to communicate his own feelings on the state of modern man — a state Greene considers to be chaotic and insecure.*[13]

Greene's hairless and barely clothed cripples (two without legs and one without sight) in *The Burial* exist in a spatially ambiguous setting given compositional definition by the horizontals and verticals of coffin, coffin lid, candle, and gray wall. Their lives are an agony without contest, only futility. They are metaphors for, in the words of Greene, "man's final isolation, man suffering not so much for others but for himself and his own sense of incompleteness. My concept of man is essentially a tragic one. It is derived from the idea that man is inherently and originally good and that he subsequently falls into evil."[14] In the mid-1950s, the museum-going public, largely middle class and similarly affected by the cultural climate,

Fig. 108. Stephen Greene. The Burial, *1947. Oil on canvas, 42 × 55 inches. Purchase, 49.16.*

found such confessions authentic and the critical interpretations of the mass media persuasive.

In Boston, a strong strain of expressionism characterized the late 1940s and 1950s, a time when German-born Karl Zerbe was head of the Painting Department at the Museum School, and when Max Beckmann and Oscar Kokoschka also taught there for brief periods. The Institute of Modern Art (now the Institute of Contemporary Art) brought to Boston exhibitions of the work of Rouault in 1940, Ensor in 1944, and Soutine in 1945.[15] Hyman Bloom's brilliantly colored mature work of the 1940s included mystical and occult imagery as well as decaying corpses. The subject of his painting *The Anatomist* of 1953 (Fig. 109) shares a common theme with other expressionist paintings in its repre-

sentation (and here quite literally) of the search for understanding and knowledge within the corpse of violated and already destroyed man.

Reinhardt's style, inspired by the tradition of stained glass, drew upon the decorative design qualities of Cubism; Greene's style benefited from Surrealism's freedom to manipulate open space and scale; Bloom drew from sources as wide-ranging as Rembrandt and Jackson Pollock's *She-Wolf* of 1943 (The Museum of Modern Art). Naturalism, as practiced in the 1930s, could not adequately communicate their intense feelings about the tenuousness of human values. Humanism, the concern with man, seems to have taken a darker turn.[16] Indeed, by concentrating and absolutizing what we have described as one aspect of humanism,

Fig. 109. Hyman Bloom. The Anatomist, *1953. Oil on canvas, 70½ × 40½ inches. Purchase, 54.17.*

these artists moved out of the humanist tradition — or at least to its furthest margin.

As time passed from the late 1940s to the mid-1950s, the specific references to the war, to the Holocaust, to the grim reality of postwar reconstruction had given way to more generalized assessments. In the period of transition, artists, including Bloom and Greene, had swung from communicating a message of social concern to communicating feelings and intuitions. Evil became not the ruthless actions of men making wars and accumulating capital, but an insoluble mystery in which the victims were equally guilty.

Figures lost in maze-like environments were another common theme at this time. Robert Vickrey painted *The Labyrinth* in 1951 (Fig. 110), claiming that, "Beyond a sense of spiritual desolation, there is no attempt at any literary symbolism in the picture." Yet

the mere description creates a story: the nun, who perhaps symbolizes organized religion, has lost her way at night in a labyrinth papered with tattered circus posters; suddenly she shrieks in horror as she sees her image reflected in a warped, fun-house mirror. The dry medium such as casein, the illustrational technique, the preoccupation with textured surfaces (grass, old walls, etc.), the suggestion of a modern Gothic story also characterize the qualities of many of the tempera paintings of Andrew Wyeth.[17]

Mystery and frustration are also implied in Tooker's *The Subway* of 1950 (Fig. 111) whose terrified figures emerge from the long baroque perspectives of subway corridors to a center area enclosed by more barriers. In his use of the egg-tempera medium, Tooker followed the lead of Paul Cadmus. Jared French also worked in egg tempera on paper in his enigmatic *The Rope* of 1954 (Fig. 112), where three older men hold ropes attached to younger men. Fathers and sons become rescuers and swimmers; the theme of survival in an alien world of potentially drowning men and women had currency in other art forms of the time. Moreover, the highly disciplined and painstaking technique of egg tempera as used by Cadmus, Tooker, French, and Wyeth — the very opposite to the "action painting" of the contemporaneous New York School — infused their imagery of apprehension with the chilling quality of precalculation.

The themes of jesters and carnivals, of revelry without joy, of formal ritual without content were related themes that engaged figure painters in the late 1940s and 1950s. Henry Koerner, born in Austria of Jewish parents, fled to America upon graduating from

Fig. 110. Robert Vickrey. The Labyrinth, *1951. Casein on composition board, 32 × 48 inches. Juliana Force Purchase, 52.6.*

Fig. 111. *George Tooker.* The Subway, *1950. Egg tempera on composition board, 18 × 36 inches. Juliana Force Purchase, 50.23.*

the Vienna Academy of Design. Later, his wartime experience in Europe with the O.S.S. made a lasting impression on him:

> *In London I started to draw in earnest filling five sketch books of war-torn London. Since part of the veneer of civilization was bombed off, love, eating, sleeping, merrymaking, and the absurdity of Hyde Park speakers was going on right before my eyes. In 1945, we came to Germany . . . Berlin and the Nurenburg Trials. With all the tragedy in England, there had been still humor left. But Germany now was completely morbid. The whole veneer of civilization was torn off. You could see the raw flesh and bones. Through the hole made by a Russian gun, you could glimpse into the bedroom of a woman without a man. Reality had turned into surreality . . . "normal" life into existentialism. People with starved earthen faces and sores stood in the rubble . . . warriors coming home with feet wrapped in rags and newspapers . . . a faint memory had come to life again.*[18]

In Koerner's *Vanity Fair* of 1946 (Pl. 17), a man leans out a window while a nude woman reclines on a bed. He peers around the corner to see several urban vignettes: an elderly couple on a front porch, children listening to a street accordionist, dancers at a dance hall, women trying on coats from a sale rack, figures participating in a ritual of eating and drinking (com-

munion? taking pills in a mental institution?). In the distance men hoe a garden while a naked Cain triumphs over a bound Abel. In the distance a carnival with roller coaster and Ferris wheel lights up the sky; in the foreground rats scurry under a bridge. Koerner orders space and scale irrationally but contains the overall image in an oval composition (as if reflected in a

Fig. 112. *Jared French.* The Rope, *1954. Egg tempera on paper, 13½ × 14¼ inches. Charles F. Williams Fund, 56.3.*

Fig. 113. *Mitchell Siporin.* Dancers by the Clock, *1949. Oil on canvas, 40½ × 60 inches. Purchase, 50.22.*

Christmas tree ball), thereby strengthening the vanity-fair theme — the picaresque and episodic quality of a modern life without reason, morals, or goals.

The pathetic vanity of man is also the theme of Cadmus's beach scene, *Fantasia on a Theme by Dr. S.* of 1946 (Pl. 18). The thin ectomorph sitting on a hard bench looks up from his book, *Varieties of Physique & Temperament*, to admire the muscle-bound mesomorph going through his calisthenics while a bloated, hot-dog gorging endomorph, seated in a comfortable wicker chair, surveys the scene. On the steps of the porch is a crumpled paper, the letters of

which either headline an atomic explosion or banner the stories of a comic book — the motif seems sardonically unclear. Cadmus, too, has turned away from the humanist concern for the dignity of man and has absolutized human limitations as he picks at man's follies with a vengeance.

Mitchell Siporin's *Dancers by the Clock* of 1949 (Fig. 113) depicts the solemn festivities of tuxedoed men and gowned women interspersed with the brass section of a band. The background heads push forward, diminishing the figures in the foreground. A gray pallor deadens the New Year's Eve gaiety of the celebrants. More raucously boisterous is Philip Evergood's *The Jester* of 1950 (Fig. 114). Clowns, jesters, and carnival people had been the subject matter of Max Beckmann, whom Evergood admired; Alton Pickens and Karl Zerbe (see Fig. 115) also explored the theme. In Evergood's painting Death sits in a chair at the left and the artist sits at the right with palette, paintbrush, and canvas in his hands. Evergood catalogued his symbolism in an interview conducted by John Baur. To the far right is an Etruscan figure which represented "the war that has threatened us all our lives. . . . And then . . . the little rotund juggler of Wall Street juggling his

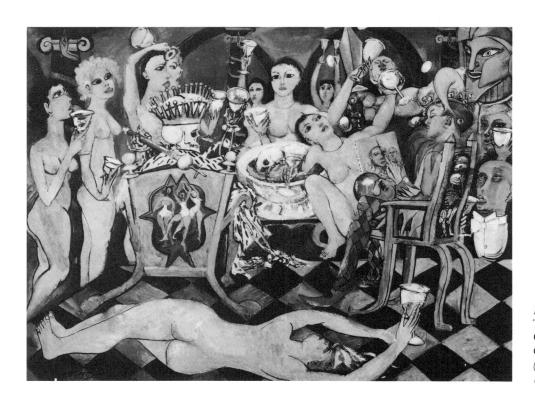

Fig. 114. *Philip Evergood.* The Jester, *1950. Oil on canvas, 72 × 96 inches. Gift of Sol Brody (subject to life interest), 64.36.*

Fig. 115. Karl Zerbe. Harlequin, *1943. Encaustic on canvas, 44 × 34 inches. Purchase, 45.8.*

Fig. 116. Jack Levine. Gangster Funeral, *1952-53. Oil on canvas, 63 × 72 inches. Purchase, 53.42.*

eggs and very content . . . and the big nudes that might symbolize the nations of the world, all prosperous and having a great time." The witches' brew with skull floating in it symbolized "the language of the politicians." Quite consciously, Evergood added the ironic touch of the three ballet dancers on the back of Death's chair, with the three skeletons on his own. He liked the reversal because "that's the way it is in life, very often."[19] Evergood's *Jester* is less specific than *Lily and the Sparrows* (Pl. 10), more a generalized idea of the follies of the time than a poignant rendering of a real ghetto child.

Jack Levine, whose earlier work falls under the rubric of Social Realism, painted *Gangster Funeral* in 1952–53 (Fig. 116), a ritual of the burial of a gangland boss. John Baur, writing in 1961, noted the change which occurred in the content of Levine's painting and that of the other Social Realists:

> *Today the distortions, which are the hallmark of expressionism, tend to be subtler and are generally aimed at a more profound analysis of human character, with its multiple shadings and paradoxes of virtue and frailty. The contrast is nowhere more apparent than in a comparison of*

> *Levine's early and late work. The cops, gangsters, and politicians who inhabit* The Feast of Pure Reason *of 1937 (Museum of Modern Art) are savagely caricatured "types"; they reappear in* Gangster Funeral *of 1952–53 as believable members of the human race, looking uncannily like people we remember. They are not more realistically painted, but the distortions spring from understanding rather than hate. They are used to plumb character rather than to create it in the image of the artist's indignation. To varying degrees a similar evolution may be traced in the work of Shahn, Evergood, and others. . . . It is a development which seems to correspond, on the stylistic plane, with the growing maturity of these artists and the altered climate of our times.*[20]

Whether or not the artists had indeed matured or whether they had simply changed, the climate had changed. Human limitations, which had become the major theme in representational painting, now included servility, venality, and corruptibility. As the anger in artists subsided, they began to tolerate with a certain amount of bitterness what they previously had condemned as the baser human motives, such as selfishness and avariciousness. At times they drifted toward otherworldliness and a preoccupation with fantasy, as Evergood did, or they turned to abstraction as a way out.

The 1950s New York Art Scene and the "Triumph" of Abstract Expressionism

One characteristic of the climate of the early 1950s seems to be the relative consensus of opinion among museum directors and curators in New York City. It seemed that, along with art journalists, critics, and dealers, they were all working in concert to promote the younger postwar artists, particularly the abstract artists. In 1952, Dorothy Miller and Alfred Barr, Curator and Director respectively of the Museum of Modern Art, organized *15 Americans*; in 1956, they organized *12 Americans*. Both exhibitions presented the painting and sculpture of a group of younger Americans whom Barr and Miller felt had promise. These two exhibitions emphasized abstract art, but there were works by figurative artists. In 1954 *Art in America* magazine, under the editorship of Jean Lipman, began an annual poll of leading museum directors and curators in order to ascertain and "present to the public a sampling of the many talented young or relatively unpublicized painters and sculptors working in various parts of the country."[21] The poll was conducted each year for ten years. The chairman for the first year was Lloyd Goodrich; other members of the panel included John Baur, who had recently joined the Whitney Museum staff as Curator, Dorothy Miller, and James Thrall Soby, also of the Museum of Modern Art. Of the artists whose names the panel submitted, the editors of *Art in America* selected twenty-seven artists, mostly abstract, but four were figurative painters whose work entered the Whitney Museum collection during the 1950s: Robert Vickrey, Herbert Katzman, David Park, and Grace Hartigan (then listed as George Hartigan). They were neither naturalist, Regionalist, nor Social Realist; "place" was not geographically but psychologically located, and social class was ignored or considered irrelevant.

The publicity afforded by art magazines and mass-market magazines, such as *Life*, or *Fortune*, which advocated selective investment in the new tendencies,[22] was not deprecated. Older realist artists might well have felt that a conspiracy existed on Fifty-seventh Street and in the art magazines to promote abstract art and formal values at the expense of realism and social commentary.

Figurative painting never disappeared, but it did have minority status. Although by the late 1950s the Museum of Modern Art overwhelmingly favored the abstract, non-figurative artists in their shows *Sixteen Americans* of 1959 and *The New American Painting*, sent abroad in 1958–59, the Whitney Museum in its Annuals and in its special exhibitions included a substantial number of representational artists. *The New Decade* exhibition held at the Whitney Museum in 1955 is a case in point: along with abstract artists Jackson Pollock, Ad Reinhardt, Richard Pousette-Dart, and Bradley Walker Tomlin (by then an abstract artist), there were the figurative artists Stephen Greene, Alton Pickens, George Tooker and Robert Vickrey as well as the abstract artists for whom the figure was central to their imagery, Willem de Kooning and Herbert Katzman. However, by the 1959 Annual, abstract art was dominating the presentations by a margin estimated at about three to one (107 out of 145 works),[23] which prompted a group of twenty-two figurative artists to write in protest to the Director, Lloyd Goodrich. Goodrich defended the selections in his reply to Joseph Hirsch, dated May 9, 1960:

> *We believe there is good art and bad art in both the figurative and abstract schools. As to the figurative school, the large academic exhibitions are filled with art which in our opinion has no more artistic merit than the run-of-the-mill abstract products. We believe that it is our responsibility to exhibit what we consider to be good in all tendencies. Our exhibitions are based on our judgment of quality, and not on "proportional representation."*[24]

The curatorial staff did not see naturalism and academic realism as coping with the central issues of the time — either aesthetic or humanist. However, the Whitney Museum did not ignore figure painting and continued to support and acquire it.

Much has been written about de Kooning's large paintings of women done from 1950 to 1953, including his *Woman and Bicycle* of 1952–53 (Pl. 19), and still their meaning eludes the viewer.[25] Some see the subject as a nasty, vulgar product of an arch misogynist; others see the women as joyful and loving excursions into the female form. Grace Hartigan, who interpreted the women as loving, but the paint as violent, related the following story to Cindy Nemser in 1975:

> *I saw most of these women being created in Bill's studio. When they were shown, I had a big argument with Jim Fitzsimmons who is now the*

editor of Art International. *He said that they were destructive; that it was hatred, Kali the blood goddess. He pointed to one painting that had big, palette-knife strokes slithering across the chest and he said, "Look, de Kooning is wounding her with blood." So I went to Bill and said, "Jim Fitzsimmons said you stabbed that woman and that is blood." Bill said, "Blood? I thought it was rubies."* [26]

De Kooning seems to have been ambivalent, with his own verbal responses often couched in riddles. Some ten years after he painted them, de Kooning remarked: "I look at them now and they seem vociferous and ferocious. I think it had to do with the idea of the idol, the oracle, and above all the hilariousness of it." [27]

Most critics and artists agree, however, that the importance of de Kooning for other painters lies in the energy of a style that suggests "painting situations" rather than studio pictures. [28] Accentuating painterly gesture and celebrating ambiguity, de Kooning's paintings suggest the search for a resolution to the interpenetration of form and space and for a synthesis of implicit feeling and explicit paint handling. To those who admired de Kooning, art was a *process* rather than a *product*, and it was important that he left naked the traces of his search — the abrupt stops and tentative or explosive starts, the erasures and the scrapings. [29] The end product, however, in each of the Woman paintings was an image of human energy — a dialectical synthesis of de Kooning's drive and his subject's latent potency — contained within the rectangular controls of the picture's edges.

De Kooning's unwavering example inspired a generation of painters. The figure in the carpet, the image caught in the dense and robust texture of paint with canvas surface a palpable reality — these became under de Kooning's influence the concerns of other artists as well.

The New York School

Like others of the younger generation of artists, Grace Hartigan began her career in the 1940s painting abstractions. At the time she intensely admired the work of Jackson Pollock, and then, partly influenced by de Kooning as well as her own need to find her roots in the Old Masters, she moved toward figuration. Critic

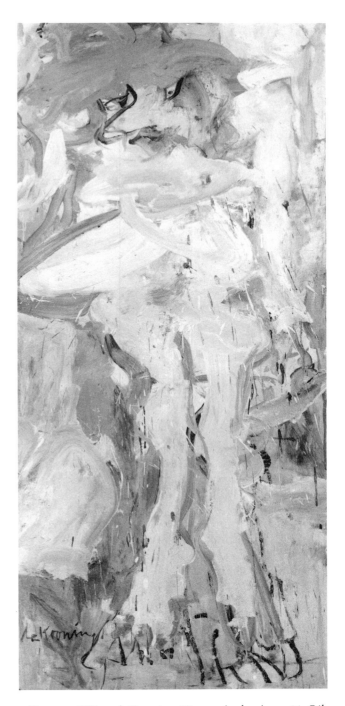

Fig. 117. *Willem de Kooning.* Woman Acabonic, 1966. *Oil on paper mounted on canvas, 80½ × 36 inches. Gift of Mrs. Bernard F. Gimbel, 67.75.*

Clement Greenberg and art historian Meyer Schapiro noticed her work and included her in the 1950 *New Talent* show at the Kootz Gallery. She was also included in the *Art in America* 1954 new talent issue, and subsequently included in the Museum of Modern Art's 1956 exhibition of *Twelve Americans.*

Fig. 118. *Grace Hartigan*. Grand Street Brides, 1954. *Oil on canvas, 72 × 102½ inches. Anonymous gift, 55.27.*

Hartigan's *Grand Street Brides* of 1954 (Fig. 118) represents her urge to reconcile style and subject. In 1975, Hartigan recalled the circumstances of the painting:

> *My studio was two blocks from Grand Street, where there's one bridal shop after another. I'm very interested in masks and charades — the face the world puts on to sell itself to the world — and in empty ritual. I thought of weddings as court scenes, like Goya and Velazquez — all the trappings, the gowns, the lace, and those blank, mad stares that the king, the queen, and the princes have on their faces. I posed the bridal party that way. I bought a bridal gown at a thrift shop and hung it in the studio. Every morning I'd go out and stare at the bridal shop windows and then come in and paint.* [30]

The preoccupation with "empty ritual" relates Hartigan to other figurative painters working in the early 1950s, such as Philip Evergood and Mitchell Siporin.

The difference is that in her work she struck a balance between the demands of subject — to be understood as metaphor — and the demands of the Abstract Expressionist gestural technique — to reveal the artist's process and search for form. Also, in Hartigan's *Grand Street Brides* the ritual involves women. [31]

Although de Kooning's influence was most important, Hans Hofmann was also an inspirational figure. According to the recent assessment of art historian Irving Sandler, "Hofmann's painting was not regarded as highly as de Kooning's, but he was widely considered to be America's greatest art teacher." [32]

In his classes in New York and in Provincetown during the summers, Hofmann set up still-life arrangements or hired models in order for the students to study the interrelationships between objects and space, between volumes and planes. He was famous for explaining composition in terms of the "push and pull" that was activated between the elements within the canvas. In Hofmann's paintings planes of warm and cool hues, with their properties of optical illusionism, seem to move forward or behind the picture plane. The goal was

Fig. 119. Lee Krasner. Imperfect Indicative, *1976. Collage on canvas, 78 × 72 inches. Gift of Frances and Sydney Lewis, 77.32.*

to achieve a balance of the "push and pull." Although Hofmann's finished work was abstract, the work of many of his students dealt with figures held in tension between illusionism and the flat picture plane. The younger generation of Hofmann students included Larry Rivers, Lee Krasner, Jan Müller, Jane Freilicher, Myron Stout, Nell Blaine, and Fritz Bultman. Krasner's *Imperfect Indicative* of 1976 (Fig. 119) consists of a collage of figure drawings done in Hofmann's classes. (The painting, however, also recalls de Kooning's incorporation of drawings into his series of Woman canvases.)

One of the most expressionist of Hofmann's students was Jan Müller, who painted *The Temptation of St. Anthony* in 1957 (Fig. 120). Müller left Hofmann's studio in 1950 and by the mid-1950s had evolved his own unique style that merged expressionist primitivism with a Matisse-like sensitivity to color and

Fig. 120. Jan Müller. The Temptation of St. Anthony, *1957. Oil on canvas, 79 × 120 ¾ inches. Purchase, 72.30.*

 

forms in space. More than any others, his works recall the intensity of Fauvism and German Expressionism. Sandler situates Müller's place as an expressionist abstract painter within the New York School:

> It was the seriousness of Müller's pictures that made them acceptable at the least to the New York School, and this despite their explicit, literary themes (anathema to "modernists"); their utter lack of irony, though not of touches of grim humor; and their relationship to German Expressionism, which was belittled as outworn and lacking in pictorial values. But it was clear that Müller's archetypal vision was his own and that it did not rely only on subject matter but was realized in the painting and design. [33]

Müller unfortunately died in 1958, before he had a chance to bring to fruition his talent and his promise. Similar to Müller's work in its emotional expressionism is the work of Robert Beauchamp, who has carried on expressionist portraiture in the tradition of Soutine, Dubuffet, and Karel Appel.

California Figure Painting

On the West Coast three painters, David Park, Richard Diebenkorn, and Elmer Bischoff, developed in the 1950s what has become known as Bay Area Figurative Painting, which centered first at the California School of Fine Arts in San Francisco. All three were teachers there at one time or another, and by the 1950s all three had adjusted Abstract Expressionism to the tradition of the studio picture, of the figure in a controlled or structured environment.

Throughout the 1940s, Park, influenced by Mark Rothko and Clyfford Still, who taught with him at the C.S.F.A., painted abstractly. At the end of 1949, however, he abruptly returned to the figure and unloaded his expressionist abstractions in the Berkeley dump. [34] In 1954 Park recalled his years of abstraction and his change to figurative concerns:

> During that time I was concerned with big abstract ideals like vitality, energy, profundity, warmth. They became my gods. They still are. I disciplined myself rigidly to work in ways I hoped might symbolize those ideals. I still hold to those ideals today, but I realize that those paintings practically never, even vaguely, approximated any achievement of my aims. Quite the opposite: what the paintings told me was that I was a hard-working guy trying to be important. . . . I have found that in accepting and immersing myself in subject matter I paint with more intensity and that the "hows" of painting are more inevitably determined by the "whats." I believe that my work has become freer of arbitrary mannerisms. . . . [35]

The figure types he evolved, such as the bathers in *Four Men* of 1958 (Pl. 20), are defined with large, flat brushstrokes which sweep around contours, playing off stark sunlit areas against warm brown shadows. The painterly surface of colored form and colored ground creates a dynamic tension with the spatial recession of overlapping forms and diminishing sizes. Park, an amateur pianist, preferred the jazz sessions with his friends but he played Mozart and Bach when by himself. [36] Analogously the free and improvisational quality of Park's paintings rests upon an essentially Cubist, formal structure.

Elmer Bischoff, after serving in an Army intelligence unit in England during the war, returned to California, and from 1946 to 1952 he taught at the California School of Fine Arts where he also developed as an abstract painter. In 1952, following Park's lead, he

Fig. 121. *Elmer Bischoff.* Seated Figure in Garden, *1958. Oil on canvas, 48 × 57 inches. Purchase, 59.2.*

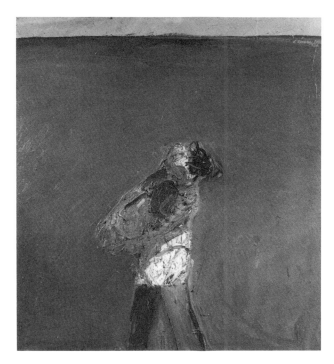

Fig. 122. Nathan Oliveira. Bather I, 1959. Oil on canvas, 52½ × 45 inches. Gift of Mrs. Iola S. Haverstick, 66.7.

and pale ochers accented by a sweeping band of soft orange or a wedge of lime-green, suggest the contradictory sensations of Bay Area weather: bright, sunny warmth and chilly shadows. For his coloration and the quality of his light, Diebenkorn is probably the most regional of the three.

Decorative Abstraction: The Figure in the Carpet

The figure as part of a decorative pattern, both less intensely expressionist than de Kooning's and less structured than Diebenkorn's but still abstract, found its way onto the canvases of other artists during the

turned to compositions in which ordinary figure subjects inhabit familiar domestic spaces.[37] Bischoff achieved an unaffected painterliness in his *Seated Figure in Garden* of 1958 (Fig. 121) by orchestrating with large brushstrokes form, color, style, and subject into a unified and intensely personal image. However, Bischoff allied himself with the first generation of Abstract Expressionists when he said in 1956: "What is most desired in the final outcome is a condition of form which dissolves all tangible facts into intangibles of feeling."[38]

Richard Diebenkorn, the youngest of the trio, attended C.S.F.A. right after the war, where he came under the influence of David Park and the other abstract painters working there. By the autumn of 1947, he himself was teaching at the institution. Working abstractly, by 1955 Diebenkorn began to feel uneasy about his facility, as he recalled: "It was almost as though I could do too much too easily. There was nothing hard to come up against. And suddenly the figure paintings furnished a lot of this."[39] He turned to representational painting, still life, and particularly landscape, often including a single figure to define the planes of the space. Diebenkorn's *Girl Looking at Landscape* of 1957 (Pl. 21) is a structured canvas recalling Matisse's compositions in which large horizontal and vertical rectangles and bars interlock into a flat patterned design. The color modulations in the paintings of this period, often dark blues, grayed pinks,

Fig. 123. Eugenie Baizerman. A Quiet Scene, c. 1947. Oil on canvas, 78 × 54 inches. Gift of Mr. and Mrs. Roy R. Neuberger (and purchase), 61.29.

Fig. 124. Abraham Rattner. Song of Esther, *1958. Oil on composition board, 60 × 48 inches. Gift of the Friends of the Whitney Museum of American Art, 58.36.*

Fig. 125. Herbert Katzman. Two Nudes Before Japanese Screen, *1952. Oil on composition board, 76 × 43 inches. Juliana Force Purchase, 53.5.*

1950s. By 1955 critics noted the "impressionist" quality of many Abstract Expressionist works. Canvases first assumed to be revelations of the artists' personal feelings became, to many, very lyrical, all-over designs of subtlety and beauty.[40] Eugenie Baizerman's *A Quiet Scene* of about 1947 (Fig. 123) at first glance impresses the viewer as an "abstract impressionist" mosaic of short choppy strokes of pink, yellow, blue, green, and purple hues. Gradually we become aware that strokes coalesce into a pink nude figure, flanked by two figures, one of whom holds a baby. The effort of seizing the central image in our minds, while we are distracted by the pictorial aggressiveness of the strokes which fill the negative spaces, creates a perceptual tension — but one which amuses rather than disturbs us.

Abraham Rattner used a similar artistic playfulness in his *Song of Esther* of 1958 (Fig. 124). Recalling Picasso's theme of artists painting models, the subject in Rattner's painting is an abstracted image of an artist, at the right, with palette in hand, next to an easel. The picture within the picture is equally abstract, presumably an abstract representation of "Esther." Once we recognize that it is a figure and begin to associate the inevitable hierarchy of values that attends the image of the human figure, the strokes around the image become mere decorative play of highly keyed color wedges and rectangles. We become aware not only of the unequal signification values of signs (acknowledging that the human figure tends to be more highly charged than other signs) but we also become aware of the interplay between perception and conception, and of our own activity in sorting them out.[41] Thus the spectator feels that his or her individual aesthetic response shares in the creative act which demands both an intuitive and intellectual grasp. As Marcel Duchamp said in a different context: "All in all, the creative act is not performed by the artist alone; the spectator brings the work in contact with the external world by deciphering and interpreting its inner qualifications and thus adds his contribution to the creative act."[42] To these artists there is no conflict between aesthetic values and the

humanist values that treasure the individual's participatory response with an art object.

If the figure can be neutralized, it then has the greatest potential for being treated decoratively. In the tradition of the desexualized nudes of Puvis de Chavannes and Matisse, the anonymous female has been assigned this position of neutral decorativeness. Herbert Katzman, included in the Museum of Modern Art's *15 Americans* exhibition of 1952 and the Whitney Museum's *New Decade* show of 1955, used the same bright, pure colors as Rattner, slightly limiting the number but not the range of the spectrum, in his *Two Nudes Before Japanese Screen* of 1952 (Fig. 125). We recognize the nudes, but they no more pull on our humanity than the other formal elements in the work. Katzman recalls that at that time he thought there was something sinful in not using color straight from the tube.[43] Early influenced by German and French Expressionist painters, specifically Soutine, he looked for a means to give organization to his painting and found it in the expressive deployment of color.

Compared with the outpouring of abstract and decorative nudes in the 1950s, de Kooning's paintings of women were indeed radically different. He reminds us of Picasso who, when he painted *Les Demoiselles d'Avignon*, declared that the nude was not neutral. The messy vigor of de Kooning's paint handling and the potential viciousness of his females are far from the decorativeness of Katzman. Unlike the perceptual tension of Baizerman's nudes, de Kooning's *Woman and Bicycle* operates on the level of conceptual tension — vacillating between contradictory views of the nature of art (process or product), as well as of figure/ground relationships.

But the question remains: Is de Kooning concerned with human values? Art historian Meyer Schapiro, in his essay "On the Humanity of Abstract Painting" of 1960, attempted to reconcile humanism and abstraction: "It is the painter's constructive activity, his power of impressing a work with feeling and the qualities of thought that gives humanity to art; and this humanity may be realized with an unlimited range of themes or elements of form."[44] Furthermore, Schapiro may well have had de Kooning in mind when he described the humanity of abstract art: "What we see on the canvas belongs there and nowhere else. But it calls up more intensely than ever before the painter at work, his touch, his vitality and mood, the drama of decision in the ongoing process of art."[45] Although Schapiro was writing at the time about Cézanne and abstract painting

in general, during the 1950s he was close to de Kooning; indeed, it was Schapiro who encouraged de Kooning to finish *Woman I*, at a time when de Kooning had abandoned it. Although Schapiro's net is cast so wide as to encompass practically all art, there were differences in the "humanity" depicted in late-1950s painting. Peter Selz, Curator of Exhibitions for the Museum of Modern Art, singled out a distinctive strain, or sensibility, of humanism in his *New Images of Man* exhibition held in 1959, a show which included de Kooning.

The "New-Image-of-Man" Sensibility

The *New Images of Man* exhibition included both American and European painting and sculpture, of which the American painters were Richard Diebenkorn, Leon Golub, Balcomb Greene, Willem de Kooning, Rico Lebrun, James McGarrell, Jan Müller, Nathan Oliveira, and Jackson Pollock.[46] What the exhibition did was to give a name — "new image of man" — to the direction which the pessimistic side of humanist painting had taken since the war. It was less a style, a technique, or an iconography than it was a sensibility — a sensibility projected by the paintings themselves which were interpreted (and even over-interpreted) in a special way by writers, critics and the gallery-going public throughout the 1950s and early 1960s.

In the introduction to Selz's catalogue theologian Paul Tillich blamed the continuing Cold War for polarizing artists into two groups: those who ignore dehumanizing world situations and those who resist by publicly despairing or rebelling:

> *One need only look at the dehumanizing structure of the totalitarian systems in one half of the world, and the dehumanizing consequences of technical mass civilization in the other half. In addition, the conflict between them may lead to the annihilation of humanity. The impact of this predicament produces, on the one hand, adaptation to the necessities of present-day living and indifference to the question of the meaning of human existence, and on the other, anxiety, despair and revolt against this predicament. The first group resigns itself to becoming things amongst things, giving up*

its individual self. The second group tries desparately to resist this danger.[47]

Part of the resistance of the second, *engaged* group, to Tillich and to Selz, was to regain the image of man as a powerful symbol of protest. Tillich continued: "They fight desparately over the image of man, and by producing shock and fascination in the observer, they communicate their own concern for threatened and struggling humanity."[48] Tillich's rhetoric, similar to that of many Christian existentialists, had a romantic ring, with its gloomy prediction that ultimately the problem rested on the demonic and irrational forces within each of us:

There are demonic forces in every man which try to take possession of him, and the new image of man shows faces in which the state of being possessed is shockingly manifest. In others the fear of such possession or the anxiety at the thought of living is predominant, and again in others there are feelings of emptiness, meaninglessness and despair. But there are also courage, longing and hope, a reaching out into the unknown.[49]

To Selz, too, the original premise, that the Cold War — the economic and diplomatic struggles of the United States and the Soviet Union for world hegemony — had created the uneasiness and despair, seemed to get lost in his existentialist interpretation of the artists' intentions:

Like Kierkegaard, Heidegger, Camus, these artists are aware of anguish and dread, of life in which man — precarious and vulnerable — confronts the precipice, is aware of dying as well as living. . . . Like the more abstract artists of the period, these imagists take the human situation, indeed the human predicament rather than formal structure, as their starting point. Existence rather than essence is of the greatest concern to them.[50]

Selz's show was controversial; the paintings were neither sensuously beautiful designs nor naturalism but aggressively ugly. Many artists and critics questioned the merit of the art, the validity of the premises, and the grouping of artists who seemed strikingly dissimilar. Manny Farber, writing in *Art News*, called it a "side show": "Included are some insectile women, a full female torso swinging on an iron spit, several Franken-

stein figures and some terribly swollen heads, in all of which the outstanding feature is a notably rough skin texture suggesting leprosy in late stages."[51] Fairfield Porter declared in *The Nation* that "the common superficial look of the exhibition is that it collects monsters of mutilation, death and decay. It is less an exhibition for people interested in painting and sculpture than an entertainment for moralists."[52] Porter questioned the motivation of the new-image-of-man artists and the violence of their imagery. He speculated that they were artists in crisis because they really wanted to be needed as moralists in a secular society which rejected moralists. To Porter, however, it was not the business of artists to supply such a lack; referring to Tillich's condemnation of the disengaged painter, Porter concluded: "The fate to become a thing may not be so terrible as the pressure to become a seer."[53]

Underlying the critical response was the issue of whether painting and sculpture could or should deal with issues of human experience, either psychological or sociological. Modernist critics and writers declared that art forms must "not mean but be," and that the province of modernist painting was the flat surface of the canvas covered with forms and colors. Clement Greenberg, writing for *The Nation* in 1944, had postulated: "Let painting confine itself to the disposition pure and simple of color and line, and not intrigue us by associations with things we can experience more authentically elsewhere."[54] The moralist, humanist tradition, however, from John Ruskin to the present, has argued that the purpose of art was the communication of ideas, with color and line merely the means to express that end. Writing in *Encounter* in 1963, Kenneth Clark reviewed the art currents of the time:

We now believe [art] should aim at producing a kind of exalted happiness: this really means that art becomes an end in itself. Now it is an incontrovertible fact of history that the greatest art has always been about something, a means of communicating some truth which is assumed to be more important than the art itself. The truths which art has been able to communicate have been of a kind which could not have been put in any other way. They have been ultimate truths, stated symbolically.[55]

To communicate ideas about man's condition and fate in ways which could not be conveyed by other art forms was indeed the goal of the new-image-of-man

painters, as it had been the goal of many Abstract Expressionists in the late 1940s and early 1950s. Leon Golub could have been speaking for many of the late 1950s figurative painters when he recalled that at the time he was "trying to explore a vulnerable psychic situation which has some relationship to social or political situations." [56] In other words, to Golub, personal despair had a basis in the material world.

However, without our knowledge of history and of the artists' own verbal explanations, most paintings of the new-image-of-man sensibility do not compel us today to make those connections to the social or political world. Indeed, in their attempt to make universal statements, the artists avoided those concrete and topical references which would locate their art in history. By the late 1950s specifically Christian images, such as those of Blume or Evergood, or genre-like scenes, such as Koerner's *Vanity Fair* (Pl. 17), were rejected. (Recall that Stephen Greene used Christian references because he wanted to be easily understood.) [57] Instead, we were presented with symbols and situations so obscure and ambiguous as to be ineffective as a form of communication. Indeed, too often they seemed to reach a point of morbid sentimentality — emotion in excess of facts, hysteria for its own sake. As such, the works appealed to that university educated, middle-class audience who had read Jean-Paul Sartre's *No Exit* (1944), David Riesman's *The Lonely Crowd* (1953), and Colin Wilson's *The Outsider* (1956). To many in this audience, personal guilt and alienation had become a badge of culture. The humanism of the new-image-of-man painters was not only pessimistic, but anti-democratic as well, for they made no attempt to reach out to "the people" or to depict the daily concerns of the working classes. Common Man and Existential Man inhabited two different worlds. [58]

Whether we today respond positively or negatively to these late 1950s and early 1960s figurative paintings, museums across the country acquired and exhibited them. The Whitney Museum's collection, in paintings by artists as diverse as Hyman Bloom, Umberto Romano, Hiram Williams, Robert Beauchamp, James Strombotne, James Kearns, Morris Broderson, James McGarrell, Robert Barnes, Jules Kirschenbaum, Keith Finch, Sidney Goodman, and Gregory Gillespie, contains a strong representation of the new-image-of-man sensibility.

James Kearns's *Cat's Cradle* of 1959 (Fig. 126) characterizes some of the stylistic qualities of the new-image-of-man painting with its awkward

Fig. 126. James Kearns. Cat's Cradle, *1959. Oil on composition board, 60 × 48 inches. Neysa McMein Purchase Award, 60.18.*

foreshortening, grayed colors, tentative but scrubbed brushwork, and obsessive details. Kearns's life seemed appropriately and romantically on the existential precipice, for after graduation from the Art Institute of Chicago, he worked for nine years as an explosives operator at the Picatinny Arsenal in Dover, New Jersey.

Kearns's painting, like other new-image-of-man paintings, was involved with emotion — but the cause and effects of the emotion were ambiguous. Was it psychological, philosophical, or sociological? In these paintings the action, if there is any, is ambiguous, the forms are unclear, and the spatial illusionism is vague. Colors are drained except for accent, such as an eerie yellow, a dull red or green, and the paint is often dragged across an acned surface.

The anxiety we experience confronting the canvases of Kearns, Broderson, McGarrell, Goodman, and Gillespie is less a response to the subject than the tension we feel in trying to read clarity into ambiguity, to find rational order where things have fallen apart, to hope for wholeness where only fragments remain. Like the

Fig. 128. James McGarrell. Service, 1962. Oil on canvas, 75 × 68 inches. Sumner Foundation Purchase Award, 62.52.

Fig. 127. Robert Broderson. Memory of Childhood, 1961. Oil on canvas, 65 ½ × 57 ½ inches. Gift under the Ford Foundation Purchase Program, 62.2.

theater of the absurd, these anti-sensuous and ugly paintings ask disturbing questions to which the answers can only be inexact and subjective: What is the meaning of the reclining figure in Broderson's painting *Memory of Childhood* of 1961 (Fig. 127)? Is the creature walking on him a hyena, a devourer of human carrion? What sinister actions are about to take place in the haunted, shaded arbor of James McGarrell's *Service* of 1962 (Fig. 128)? What is the nature of the carnage in Sidney Goodman's *The Walk* of 1963– 64 (Fig. 129)? Are the women, one naked and one robed, in Gregory Gillespie's *Two Women* of 1965 (Fig. 130), prostitutes cornered in hermetic rooms from which there is no escape?

Even Joseph Hirsch, whose work was Social Realist in the late 1930s and 1940s, moved close to the content of the new-image-of-man painting, if not the style and technique, with his *Interior with Figures* of 1962 (Fig. 131). John Canaday, art critic for the *New York Times*, saw Hirsch's work as an important metaphor when it was exhibited in New York at the Forum Gallery:

> Mr. Hirsch's Interior with Figures . . . is as technically brilliant a painting as is on exhibition in New York at this moment. More important, it is a

Fig. 129. Sidney Goodman. The Walk, 1963-64. Oil on canvas, 83 ½ × 65 ¼ inches. Gift of Dr. and Mrs. Abraham Melamed, 78.80.

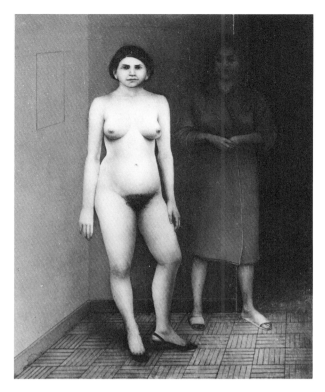

Fig. 130. Gregory Gillespie. Two Women, *1965. Oil, synthetic polymer, tempera, and collage on wood, 14 × 11 inches. Gift of the Friends of the Whitney Museum of American Art, 66.79.*

sinister fantasy expressed in a deceptively realistic vocabulary. The organization men bisected and immobilized at their desks, dominated by a gigantic face hardly visible in the background, seem captured within a new circle of hell invented for a brand of sinner we have invented in our century.[59]

Because Hirsch painted within the tradition of realism — without the brushwork of the Abstract Expressionists or the distracting compulsiveness of some of the new-image-of-man painters — his subject is perhaps more easily understood by a general audience as a comment on the climate of "the organization man," about which William H. Whyte had written in 1956.

In general, the difference between the new-image-of-man painting and 1930s social commentary, which also protested against conditions, is that the 1930s paintings were pointed and specific; artists then recognized that "alienation" was not intrinsic but extrinsic, that "the human condition" was not just determined by

Fig. 131. Joseph Hirsch. Interior with Figures, *1962. Oil on canvas, 45 × 72 inches. Gift of Rita and Daniel Fraad, Jr., 62.57.*

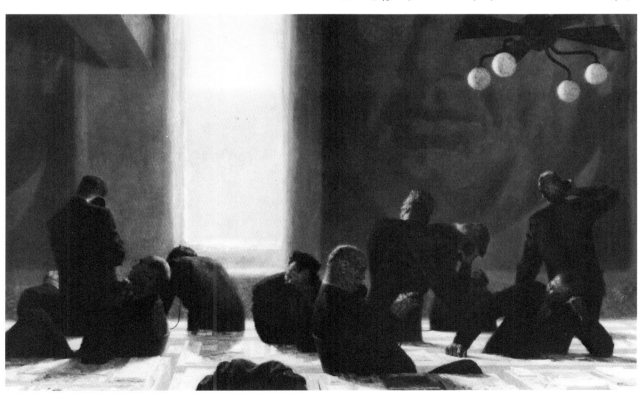

universally shared psychological factors, but that social and economic forces largely determined those psychological forces. Job cutbacks created unemployment, which in turn created poverty and individual anxiety and depression. But in the early 1960s, there seemed to be no specific villains; not American capitalism but original sin and man's hubris were blamed for his inability to find happiness; man's "innate selfishness" was blamed for his inability to share in communal values.

Protest and Violence in 1960s Painting

Before the decade of the 1960s had passed, the new-image-of-man sensibility was modified and changed as artists became more specific in their references to topical events. The Whitney Museum exhibition *Human Concern/Personal Torment* reflected a changed climate. Compared with Peter Selz's exhibition of the previous decade, Robert Doty's show was more eclectic and without the same existential intensity. The works were often boisterous and vulgar; they often had an earthy relevance quite different in spirit from those in Selz's show.

What intervened in the ten-year period from 1959 to 1969 were the international and domestic political events of the 1960s that acted upon the changing attitudes of artists. Early in the 1960s, the Cuban missile crisis, the belief that the big cities were all "ground zero" for atomic attack, and the campaign of Nelson Rockefeller, then Governor of New York, to build family bomb shelters (with debates as to whether or not one killed one's bomb-shelterless neighbor demanding refuge) — events such as these had an almost calculated effect of making the individual feel impotent or absurd. "Catch 22," coined from the title of Joseph Heller's 1961 war novel, meant that whatever the choices, one always lost.

As the 1960s wore on, three assassinations — John F. Kennedy in November 1963, and Martin Luther King, Jr., and Robert Kennedy in the spring of 1968 — affected the consciousness of many artists and writers and drew them to a preoccupation with the theme of violent death.[60] Television coverage of the carnage in Southeast Asia provided daily reminders of violence, which some anthropologists and psychologists maintained was ingrained in the American psyche or part of

the "human condition" and inevitable.[61] Others insisted that violence was symptomatic of an unjust social structure and a means of social control.

At the same time, the civil rights movement, the ghetto rebellions and later the antiwar movement led many to the conclusion that personal action (violent or non-violent) on behalf of collective goals could be effective in bringing about better political and social conditions. The economy was doing well and there was no reason, many argued, why poverty could not be eradicated. Consequently, many artists began to believe again, as Social Realists had in the 1930s, that art could be an instrument for social change. Many figurative artists became politically "radicalized," in the actual, etymological sense of the word, in that they looked to the social and political roots of "the human condition." As a result many artists attained a greater sophistication about the political aspects of art and the art world; many joined together in the late 1960s and early 1970s in such groups as Artists and Writers Protest Against the War in Vietnam, the Art Workers' Coalition, the Black Emergency Cultural Coalition, Women Artists in Revolution, and the New Art Association.[62]

Some younger artists used a range of figurative, expressive styles and included in their work specific and literal references to the Vietnam War, to U.S. militarism, to repression of the student movement, to racism, to the ghetto rebellions, and to the inadequate health and dehumanizing welfare systems, among them Benny Andrews, Bernard Aptekar, Rudolf Baranik, Dana C. Chandler, Oyvind Fahlstrom, Duane Hanson, Edward Kienholz, Faith Ringgold, Peter Saul, Nancy Spero, and May Stevens. The feminists of the group were also aware of the status and roles of women in contemporary society and made references to sexism as well.[63]

Included in the Whitney Museum's *Human Concern/Personal Torment* exhibition, Peter Saul's *Saigon* (Pl. 22) is an exuberant and absurdist comment on the Vietnam War. Violence is the content; its cause is not vague and ambiguous (as was the theme of violence in much of the new-image-of-man painting) but specific. Lettering at the left spells out the message "White Boys Torturing and Raping the People of Saigon" and on the right, "High Class Version." In the center in vivid day-glow colors is the "Innocent Virgin," surrounded by "Her Mother," "Her Sister," and "Her Brother," all simultaneously violated by the outsized phalluses of coke-swilling GI's. Fat, cartoon musical quarter-notes punctuate the space. Meant to be disgustingly violent, the painting succeeds in reminding us that

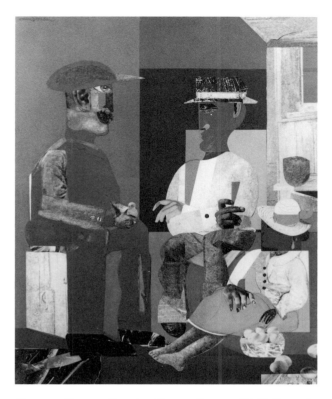

Fig. 132. Romare Bearden. Eastern Barn, *1968. Collage of glue, lacquer, oil, and paper on composition board, 55½ × 44 inches. Purchase, 69.14.*

Fig. 133. Charles White. Wanted Poster Number Four, *1969. Oil on board, 24 × 24 inches. Gift of The Hament Corporation (and purchase), 70.41.*

wars corrupt the pawns used to wage them.

During the 1960s the (largely white) art world became aware of the great numbers of black artists working in America. Romare Bearden's life is an example of an odyssey by a black artist drawn to formal concerns as well as to humanist content. He studied at the Art Students League with George Grosz, was associated with members of the Harlem Artists Guild and a neighbor of Jacob Lawrence and poet Claude McKay. A soldier during World War II, in the early 1950s Bearden lived in Paris, where his art turned toward abstraction. However, he returned to figure painting in his collages of the mid-1960s. His pasted papers — photographs and magazine illustrations of faces, dolls, and masks — took as their subject the lives and rituals of black people in America, such as his *Eastern Barn* of 1968 (Fig. 132). Bearden was naturally aware of the new-image-of-man painting, but required his own modification of the genre: "I work out of a response and need to redefine the image of man in terms of the Negro experience I know best."[64] John A. Williams in his introduction to a monograph on Bearden noted that black consciousness needs to be experienced by all Americans, if not in reality, then in art: "If the collective human experience of the people of this nation is to be truthfully described, it can no longer

be drawn as a totally white experience. It was never a completely white nation; it will never be a completely white nation."[65]

Rendering that black experience was debated among black artists such as Charles Alston, Norman Lewis, Romare Bearden, and others in the mid-1960s. When they met, in such groups as "Spiral," there was no unified consensus as to whether aesthetics and pictorial problems or politics and social statements should be the primary concern of black artists. Alston wondered whether most art expressed by black artists "might not be only reflections of a dominant culture and not truly indigenous."[66] While such debates were going on, two paintings by black artists entered the Whitney Museum's collection which were based on and reflective of the experience of blacks in America. Charles White's *Wanted Poster Number Four* of 1969 (Fig. 133) resulted from studies drawn from Civil War "wanted" posters of runaway slaves which included the name of the slaves as well as the reward sum. One might recall the targets of Jasper Johns, except that whereas Johns's works are oracular and mysterious, White's painting is unambiguous. To figurative artists such as White, from the awareness of specific oppression we can become aware of other oppressions today. In general, however, White's works project more positive images of black people, of which he has said:

My work strives to take shape around images and ideas that are centered within the vortex of the life experience of a Negro. I look to the life of my people as the fountainhead of challenging themes

Fig. 134. Malcolm Bailey. Untitled, *1969. Synthetic polymer on composition board, 48 × 72 inches. Larry Aldrich Foundation Fund, 69.77.*

and monumental concepts. I strive to create an image that all mankind can personally relate to and see his dreams and ideals mirrored with hope and dignity.[67]

Malcolm Bailey's *Untitled* of 1969 (Fig. 134) is based on diagrams of the holds of slave ships, which were originally published in the late 1780s by the Committee for Affecting the Abolition of the Slave Trade, an English group.[68] Bailey used white on a blue ground, the color of blueprints, to recapture the spirit of the calculated engineering used to oppress black peoples. Concerned with interpretation rather than realism, Bailey coolly presents the facts — the schematic hold, the cotton plant, and a detail of the hold. Human degradation in the form of slavery was based on an economic system founded on cotton. To Bailey, naturalism or realism was incapable of making that point as strongly and as unambiguously as the historic diagram. He was clear about his intentions:

I feel that too many black artists believe that by depicting an African design motif or painting an enraged black man with a raised clenched fist they are really saying something. It is a much more dynamic experience to see a live black cat raising his fist than it is to see a painting of one. Therefore, an artist's job should be more than one of just mirroring life; he must instead interpret life in a very subjective abstract way.[69]

Writers such as Larry Neal held out for revolutionary images "that go beyond the reflection of oppression and its preceding conditions."[70] In other words, if the humanism of black artists had a drawback to Neal and others, it was a too ready acceptance of the status quo. Nevertheless, the works which entered museums in the 1960s, done by socially conscious black artists, tended to be images of oppression rather than images of militant rebellion.

New York Pop Art

During the 1960s and 1970s, not all the responses of artists were expressions either of existential anguish or of civil rights awareness. Indeed, the majority of artists were neither philosophical nor political. They responded on a visceral level to the social and commercial activities which bustled around them, or they ignored them altogether. The figurative paintings done by these artists were often either satiric, straight, or decorative. The language of the humanists, with phrases such as "the dignity of man" or "human values," seemed to have little relevance for them.

New York artists Roy Lichtenstein, Andy Warhol, and Tom Wesselmann poked fun at white, middle-class mass culture with a deadpan irony by investigating and spoofing the media which transmit that mass culture — comic books, mass magazines, and calendar art. In the process, stereotypes became reality, clichés became startlingly unique and banality became chic.

In retrospect Jasper Johns and Robert Rauschenberg can be seen as transitional artists linking the New York School of the 1950s to the new movement which became known in the early 1960s as Pop Art. Johns drew from the ambiguity of de Kooning to make iconic images of flags, numbers, and targets — forms which are themselves flat, but also exist as signs; Rauschenberg emphasized process and gestural painterliness in

Fig. 136. *Richard Lindner. Ice, 1966. Oil on canvas, 70 × 60 inches. Gift of the Friends of the Whitney Museum of American Art, 67.17.*

his play of juxtaposed images drawn from the refuse heap of tired, popular images. Johns's concerns were often epistemological — he dealt with how we come to know the world which acculturates us — whereas Rauschenberg was immediate and sociological, with references to the Southeast Asian wars, art museum culture, street life, and to the myriad topical matters transmitted through newspapers, magazines, and television.

Andy Warhol, arriving in New York in 1949, spent over ten years as a commercial artist, illustrating magazines, designing shoes for I. Miller, and dressing windows for Bonwit Teller. Becoming serious as a painter in the early 1960s, he looked at the instruments of mass consumerism — supermarket displays and magazine advertisements — for his artistic sources. His *Before and After, 3* of 1962 (Fig. 135), based on advertisements for nose plastic surgery, comments on the American preoccupation with conventional prettiness.[71] Tom Wesselmann's *Great American Nude, Number 57* of 1964 (Pl. 23) depicts a flattened close-up image of a pinup object, details eliminated except for the erogenous components — puckered lips, full breasts, and taut, rubber-like nipples. There are no pretensions about the humanity of the pinup; she is pure object, like the silicone-injected breasts that shimmied through the sixties in the "topless" bars from San Francisco to Forty-second Street.

Fig. 135. *Andy Warhol. Before and After, 3, 1962. Synthetic polymer on canvas, 74 × 100 inches. Gift of Charles Simon (and purchase), 71.226.*

Richard Lindner's art superficially resembles Pop Art in its repeated allusions to the iconography of American popular culture — ice cream cones, stars, Indian heads — but the basis of his style lies in the German tradition.[72] The superimposition of lettering and images, the bilaterally symmetrical iconic designs, the mechanistic figures, the flattened space all refer back to the cubist-constructivist styles of Bauhaus Germany, whereas the erotically charged elements combining beauty and vulgarity, voluptuous aggressiveness and repressed confinement, recall the tradition of German Expressionism. In the painting *Ice* of 1966 (Fig. 136) the title refers to the cone the female is licking and to the letters which we see behind her form. But we also read the word "ice" as "love" by association of her lustful licking of the very phallic cone, and the tricks our mind plays if it fills in the circle for the "c" and reads the star behind the Indian profile as a "v." In Lindner's cool world of ironic joylessness, the significations of "ice" and "love" are interchangeable.

Chicago Imagism

Expressionism — the conscious expression of the artist's feelings in his/her art through distortion and exaggeration — forms the background of a younger generation of Chicago artists who combined an ironic attitude with fantastic, grotesque, and hilariously ugly forms. Called the "Chicago Imagists" or "Chicago Funk," almost all had studied at the school of the Art Institute of Chicago and all had been influenced by the Chicago metaphysical artists of the previous decade such as Leon Golub, George Cohen, and others. The difference between the Chicago Imagists and the New York Pop artists has been characterized by critic Joanna Frueh: "Pop depicts a cultural acceptance of commercialism, whereas Chicago's Funk imagism rebels against it. Both arts exaggerate, but Pop aggrandizes the gluttony of advertising, and imagism coarsens it."[73]

Not only did the Chicago painters rebel against commercialism, but they also rebelled against New York modernism, which New York Pop artists never did. Jim Nutt, along with Art Green, James Falconer, Gladys Nilsson, Suellen Rocca, and Karl Wirsum exhibited together as the "Harry Who," beginning in 1966. Ed Pascheke exhibited with the "Non-Plussed Some" and Philip Hanson, Roger Brown, and Christina Ramberg with the "False Image" group. Pop artists

Fig. 137. Jim Nutt. She's Hit, *1967. Synthetic polymer on plexiglas and enamel on wood, 36 ½ × 24 ½ inches. Larry Aldrich Foundation Fund, 69.101.*

used the figure in only some of their paintings, but the Chicago Imagists used the figure or a humanoid equivalent in almost all of their works.

The verbal and visual puns of pornographic comics as well as the Surrealist forms of Miró and Matta are the art-historical sources for the battered and bound, bounding and boisterous figures of Jim Nutt. The title of Nutt's *She's Hit* of 1967 (Fig. 137) becomes a scatological phrase if the letter division is shifted. The title may then define the next phase of the story of Miss Cast, whose mutilated, torn, stapled, and Band-Aided body stands before a wall, against which are thrown daggers by an unknown hand. Obsessive infantile doodles — on the level of a clever and "dirty" minded seven-year-old child — animate the surface. The bland, plastic colors — pastel lavender, lime, peach, and gold — and the inclusion of Phillips screws on the plexiglas surface reinforce the repulsive anti-sensuousness of the total image.

Christina Ramberg's *Istrian River Lady* of 1974 (Fig. 138), by comparison, is more subdued but no less

Fig. 138. Christina Ramberg. Istrian River Lady, *1974. Synthetic polymer on composition board, 34½ × 30 inches. Gift of Mr. and Mrs. Fredric M. Roberts in memory of their son, James Reed Roberts, 74.12.*

bizarre in its imagery. More recent work by Chicago artists Roger Brown and Nicholas Africano have lost the sexual exuberance but none of the obsessiveness of the Chicago school. The trivialization of spiritual values in our society is brilliantly parodied in Brown's *The Entry of Christ into Chicago in 1976* (Fig. 139), a modern Palm Sunday scene with a plaster doll Jesus blessing the scattered crowd of cardboard cutouts from a toy flatbed truck. About 370 of these cardboard figures can be counted, including the shadowed silhouettes in the windows. Where Brown's work may be a history painting (to a culture that believes even less in history than it does in religion), Africano's *An Argument* of 1977 (Fig. 140) is a genre painting in which doll-like people in an empty, neutrally colored space without environmental references argue without mutually confronting each other. Painting now with whimsy, now with locker room humor, which may have been the only way to counter New York

Fig. 139. Roger Brown. The Entry of Christ into Chicago in 1976, *1976. Oil on canvas, 72 × 120 inches. Gift of Mr. and Mrs. Joel S. Ehrenkranz (by exchange), Mr. and Mrs. Edwin A. Bergman, and the National Endowment for the Arts, 77.56.*

Fig. 140. *Nicholas Africano. An Argument, 1977. Oil, acrylic, and wax on canvas, 69 × 85½ inches. Gift of Mr. and Mrs. William A. Marsteller, 77.68.*

Fig. 142. *Bob Thompson. An Allegory, 1964. Oil on canvas, 48 × 48 inches. Gift of Thomas Bellinger, 72.137.*

Fig. 141. *Robert Gordy. Boxville Tangle, Number 1, 1968. Synthetic polymer on canvas, 90 × 60 inches. Larry Aldrich Foundation Fund, 68.49.*

Fig. 143. *Roy De Forest. Wise Horse's Dream, 1972. Synthetic polymer on canvas, 60 × 66¼ inches. Purchased with the aid of funds from the National Endowment for the Arts, 73.29.*

modernism, the Chicago school has maintained a moralist attitude towards the figure from the 1950s up to the present day.

Discounting the subject, if possible, we can delight in Brown's painting for its pattern as well as its naive quality. In the last twenty years painters have used the figure as part of a decorative pattern of color, which ranges from the sophisticated neo-Art Deco designs of Robert Gordy, such as his *Boxville Tangle, Number 1* of 1968 (Fig. 141), to the Fauve-like fantasy landscapes of Bob Thompson, such as his *An Allegory* of 1964 (Fig. 142). Like Jan Müller, whom he admired, Thompson in his decorative scenes sought to express a private vision of search and salvation.[74] A consciously childlike and colorful style is also used by Roy De Forest in his *Wise Horse's Dream* of 1972 (Fig. 143).

Studio Pictures of the 1960s and 1970s

During the 1940s and the 1950s the portrait and the studio nude — rendered either naturalistically or according to canons of ideal form — all but disappeared from the art world. The reemergence of these two forms — the portrait and the nude — without Pop overtones or sardonic manipulations characterizes one of the strong trends in the 1960s and 1970s. These two forms were central to the "new realism," exhibited in the Whitney Museum's 1970 *22 Realists*, a show which examined both realism and Photo-Realism of the late 1960s. James Monte, in his foreword to the catalogue, defined "realism" in simple terms, as a painting method "which employs a full pictorial illusionism to embody the artist's feelings."[75]

The figurative "new realists" look at the world of real people and specific situations. They differ from the new-image-of-man painters in that they are not concerned with visualizing in paint "the human condition" as a universal; their "feelings" generally mean their aesthetic convictions rather than their emotional or ethical feelings. Similar to studio painters of the 1920s and 1930s, they concern themselves with the same range of pictorial problems: light, color harmonies, and spatial definition, or topographical exactitude. Character delineation as revealed through the face and body is less a characteristic of the "new realists" than of the more traditional realists.

In discussing these examples of recent figure painting, we may find it useful to revive one of the traditional distinctions between *realism* and *naturalism*. Although the words have been used interchangeably, *realism* has gained acceptance as the term to categorize any art representing or imitating forms that exist or could exist in the world outside the artist's consciousness.[76] The distinction between realism and naturalism has been blurred, perhaps because the question of the artist's intentions — his or her personal stance — has been dismissed as irrelevant. But when historians and critics considered the differences (usually in connection with nineteenth-century French painting), the accepted definition went somewhat as follows: If the artist self-consciously proclaimed a political point of view, a social message, a concern with ethics or ideology, then the work was considered "realist." If, on the other hand, the artist eschewed moral and political commitment and claimed slice-of-life objectivity as the only validly modern response (to a life which we could hardly pretend to know, much less reform), then that art was called "naturalist." In terms of history, the realists such as Courbet — with their concerns for content — became part of the current of humanist art; whereas the naturalists, such as Monet — with their preoccupation with form and pattern neutrally viewed but almost always designed — have become part of the history of modernism.[77]

Since advocates of formalist art and criticism consider ethical or political intentions irrelevant to the aesthetic enterprise, when they do turn their attention to recent representational art, their bias operates to select those painters veering toward naturalism who, after all, seem primarily concerned with the deployment of forms, colors, and shapes across the canvas. The choice of subject, they can then argue, is adjusted to prior compositional necessities.

Many of the new realists and almost all of the Photo-Realists are naturalists in this precise sense. To call them naturalists might clear up some problems which Barry Schwartz had in his investigation of "new humanist" art:

> *Though the realists would like to be known, in Jack Beal's words, as "struggling Humanists," they, in fact, are generally cautious painters. They exist between two worlds — between loyalty to conventional notions of form, and a full-blown investigation of content. The new figurative art makes no value judgments. It claims to be an art of perception. But to perceive the human figure and to make no judgments about it, in the face of contemporary experience, is to make a significant judgment about it.*[78]

Schwartz has proposed a distinction which, in spite of its logic, confuses the issue. That is, if humanism in art means the investigation of content, and all figurative art has content (whether consciously intended or not by the artist), then it follows logically that all figurative art is humanist. This is to blur distinctions of intentions that many artists and critics would want to maintain. Indeed, Schwartz himself wants to reserve the term "new humanism" for "a form of empathetic figuration which requires the figure but never solely as form."[79] However, many figurative artists do not want to give up what they have learned from modernism; they do not want to sacrifice the sensuousness of form for message.

Returning to our distinction between realism and naturalism: the artists who claim to make no value

Fig. 144. *Philip Pearlstein.* Female Model on Oriental Rug with Mirror, *1968. Oil on canvas, 60 × 72 inches. Promised 50th Anniversary Gift of Mr. and Mrs. Leonard A. Lauder, P.10.80.*

Fig. 145. *Sidney Goodman.* Room 318, *1971-72. Oil on canvas, 75 × 97 inches. Purchased with the aid of funds from the National Endowment for the Arts (and exchange), 73.8.*

judgments might be called naturalists (even granted that such valueless decisions are impossible). Their naturalism can take the form of a sharply focused rendering of details and illusionistic modeling of forms, such as the works of Pearlstein, Chuck Close, and most of the Photo-Realists, or a painterly style which reduces details and focuses on light and composition, such as the works of Fairfield Porter and Alex Katz.

Philip Pearlstein is now a sharp focus naturalist. Once involved with the ethos and aesthetics of the New York School, he held his first show of figurative brush drawings in 1962, and by 1963 he had exhibited figure paintings. Also in 1962 he wrote "Figure Painters Today Are Not Made in Heaven,"[80] his manifesto for a new figurative realism. Pearlstein rejected what he thinks of as the pretentious intellectualism of the new-image-of-man painting and has traded the gestural messiness of Abstract Expressionism for a coolly objective rendering of exactly what he sees before his eyes: one or two nudes, seated or standing, with flesh shining from the three spotlights hanging from his studio ceiling. In his *Seated Nude on Green Drape* of 1969 (Fig. 96), Pearlstein has arranged the limbs of the model, the furniture and drapery to strengthen the two-dimensional design which counterbalances the diagonal thrust into space that comes from his point of view of looking down on the model. Pearlstein's nudes have been called ugly and ungainly with swollen feet,

prominently veined hands and furrowed flesh. Often their faces are averted or cut off by the canvas edge. They are neither erotically sensuous nor is there narrative content. Although they are specific, real people, whom Pearlstein admires because they are professional models who work for a living,[81] they are treated as studio objects. If one defines modernism as a concern for the new and experimental, as assumed by art historian H. H. Arnason,[82] Pearlstein's works would not qualify. If, on the other hand, modernism is defined as a concern with form, then they do. However, although Pearlstein claims that his figures are mere arrangements and that his intention is only to make arrangements, the viewer need not be intimidated from making an interpretation, if he or she is trying to probe the *content* of American painting in the 1960s and 1970s.[83]

Jack Beal's work, which makes allusions to art-historical tradition, seems to hover between naturalism and realism. The title of Beal's *Danae II* of 1972 (Pl. 24) draws its literary source from the classical myth of Zeus, who disguised as a shower of gold came to seduce Danae. However, the manipulations of light and space seem to be the real subject. The bright sunlight streaming in from the window at the top right bathes the reclining nude attended by her female friend. The secondary hues of orange, green and purple harmonize the foreground objects. However Beal, in his work of the mid-1970s, and Alfred Leslie, in his more recent work, have attempted to combine an ambitious narra-

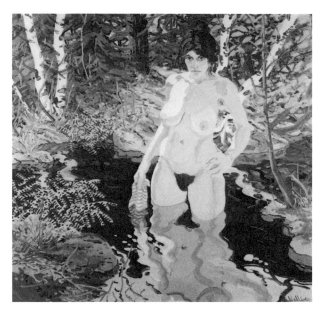

Fig. 146. Neil Welliver. Girl with Striped Washcloth, *1971. Oil on canvas, 60 × 60 inches. Gift of Charles Simon, 72.17.*

tion with almost mannerist effects of light and space which go beyond naturalism.[84]

Sidney Goodman's *Room 318* of 1971 – 72 (Fig. 145) is far removed in mood from the overt existential sensibility of his painting *The Walk* of 1963 – 64 (Fig. 129). Nonetheless, the image teases the viewer because of its ambiguity. The artist and the spectator are placed at a distance from the nude figure sitting on a cloth covered cabinet (examining table?) who stares inscrutably at us. Aware of being a model in that studio space, she confronts us with that fact. The dark foreground is articulated by spots of sunlight on the floor and a large black cat. Space and light compete with the nude for our attention, yet she has a presence which controls and gives tension to the tableau. The harshness of the light and the starkness of the forms maintain the painting as a forthright, unromantic image.

Fairfield Porter represents the painterly current of figurative naturalism in his paintings which also follow the tradition of the studio picture. Porter's *The Screen Porch* of 1964 (Pl. 25) represents the slow pace of a summertime scene of his children and a friend on a screened-in porch. Porter's painterly, dry brush flattens and simplifies detail to a surface of pastel tones offset by darker greens. Like Pearlstein and like Hopper earlier, Porter does not probe the character of the figures or

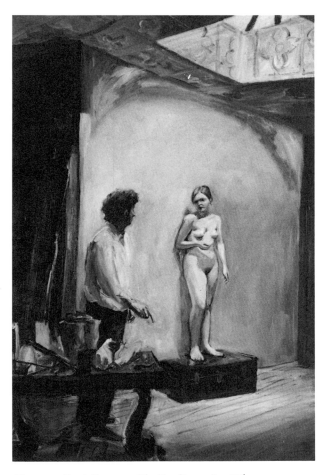

Fig. 147. Paul Georges. The Studio, *1965. Oil on canvas, 120½ × 79½ inches. Neysa McMein Purchase Award, 66.12.*

their social relationships. On the other hand, the nude in Paul Georges's *The Studio* of 1965 (Fig. 147) is shown engaged in a relationship with the artist as she concentrates on the artist's hand signal gesturing her instructions. The studio picture in the 1960s and 1970s shows a slice of life of the artist's world — his craft, his friends, family, and models — undisturbed by urban distractions and international events. In fact with many painters, studio pictures merge with portraiture, but there is a cautious neutrality to them.

By the late 1960s many painters of the nude figure had developed an imagery which was frankly romantic in its appeal. These artists, then, did have intentions, but those intentions related to the creation of sensuous and even erotic forms.[85] Elusive in meaning and in mood is Paul Wiesenfeld's *Secrets II* of 1968 – 69 (Fig. 149), which was exhibited in the Whitney Museum's *22 Realists* show. Wiesenfeld has painted a neat and orderly room containing a nude young woman lying on a Victorian sofa. A rosy glow suffuses the interior in which each object has its own discrete place in the

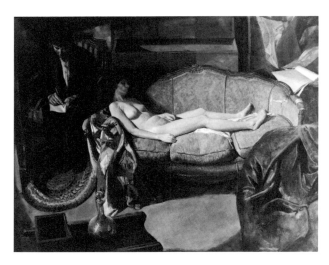

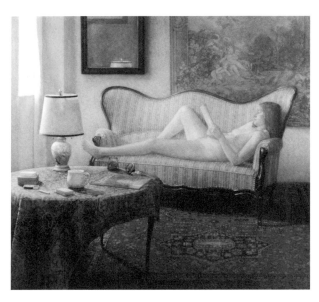

Fig. 149. Paul Wiesenfeld. Secrets II, *1968-69. Oil on canvas, 63 × 66½ inches. Richard and Dorothy Rodgers Fund, 70.15.*

Fig. 148. Ben Kamihira. The Couch, *1960. Oil on canvas, 63 × 79¼ inches. Sumner Foundation Purchase Award, 60.49.*

composition. The mystery suggested by the title becomes less important than the medley of patterns, including the striped upholstery of the Victorian sofa,

an eighteenth-century tapestry of cupids, Oriental rugs, and the nude herself. William Bailey's nude in his *"N" (Female Nude)* of about 1965 (Fig. 150) is by contrast sparse — a gentle still life of cream white against the brown and tan tones which support her. The repetition of forms — leg against leg, bent elbow against pillow, against pillow — gives us a clue to his primary concern for making an arrangement of harmonious and rhythmical forms silhouetted against a dark background.

Fig. 150. William Bailey. "N" (Female Nude), *c. 1965. Oil on canvas, 48 × 72 inches. Gift of Mrs. Louis Sosland, 76.39.*

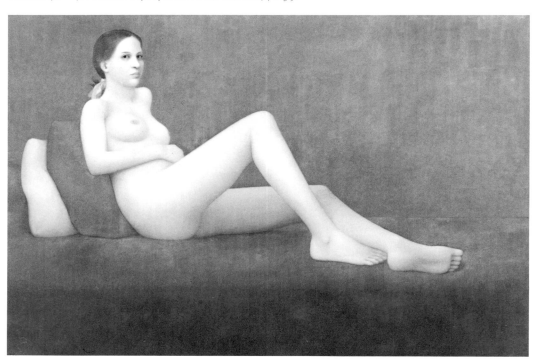

Photo-Realism

The Photo-Realists — realists who worked directly from a photographic image or a slide — also emerged in the early 1960s and a number were included in *22 Realists*. The Photo-Realists share with most other recent realists and naturalists a concern with the specific, ordinary, and familiar forms before them, rather than remembered or imagined forms. Some Photo-Realists are obsessed with detail; others simplify form the way bright sunlight eliminates detail in a snapshot. Although the painters *not* working from photographs disparage the efforts of those who do, the Photo-Realists do not have the limitation of the studio situation. Since Photo-Realist paintings are based on photographs, slides, and postcards, they can choose a broader range of subject matter including views of city sidewalks or vacation activities and sights. The photographic visual aids function as the preliminary on-site sketches had for nineteenth-century painters. On the other hand, the visual aid (photograph, slide or postcard) by acting as an intermediary step, insulates the Photo-Realist from the reality of a situation (whether contrived or objective) which he or she may not have personally witnessed. Thus, Photo-Realists, in relying on preprocessed images, operate similarly to the New York Pop artists.

The figure painters among the Photo-Realists hold a position analogous to traditional genre painters who did scenes of typical everyday life, with the difference that to these realists specific people are engaged in those typical pursuits. Howard Kanovitz in *New Yorkers I* (Fig. 151) represents poets, artists, and other art-world personalities whom he has brought together for their group portrait, with art-historical references all the way back to Frans Hals. On the other hand, the group portraits of Robert Bechtle and Richard McLean have the quality of informal snapshots. Robert Bechtle's *'61 Pontiac* of 1968–69 (Fig. 152) presents the artist and his family standing in the bright California sunlight in front of their station wagon. In the tradition of eighteenth-century British equestrian portraiture, Richard McLean's *Still Life with Black Jockey* of 1969 (Fig. 153) depicts a race-winning horse with a mounted jockey and the trainer holding the bridle. McLean based his paintings on black-and-white photographs and advertisements found in journals devoted to horse raising, such as *The Thoroughbred of California*, *The Quarter Horse Journal*, and *Appaloosa News*.[86]

Whereas the works of Kanovitz, Bechtle, and McLean are subdued in the intensity of the colors, Audrey Flack used the Photo-Realist technique in *Lady Madonna* of 1972 (Pl. 26) to achieve unexcelled brilliance. Working from slides projected onto a white primed canvas, Flack used a brush for underpainting and then used an air brush to spray pure primary colors identical to the gels of the slide onto limited areas of the canvas separated by masking tape and butcher paper.

Fig. 151. Howard Kanovitz. New Yorkers I, 1965. Synthetic polymer on canvas, 70 × 93½ inches. Gift of the artist, 69.172.

Fig. 152. *Robert Bechtle. '61 Pontiac, 1968-69. Oil on canvas, 60 × 84 inches. Richard and Dorothy Rodgers Fund, 70.16.*

The patient build-up of red, blue, and yellow achieved a rainbow brilliance as the painting progressed. On a trip to Spain Flack saw and was moved by the emotional qualities of the painted sculptures done by the seventeenth-century sculptress Luisa Roldan, as well as other Baroque sculptures. Although Roldan did not create the subject of *Lady Madonna*, the crowned Virgin holding the Christ child in one hand and a scepter in another, the sculpture, to Flack, had the same emotional quality that Flack saw in Roldan's work. Most Photo-Realists approach their subjects coolly, but Flack, whose preferred genre is the studio still life, includes objects that project an intensely personal meaning. Particularly in her recent work, these objects appear as retrospective symbols or archetypes standing in isolation, not as things which function or have an effect on the events of the world. Lawrence Alloway has referred to Flack's recent work as combining the "genre of still life with the humanist tradition of art as the vehicle of ambitious meaning." [87] Indeed, as distinctions blur as to which of the new realists and Photo-Realists are "humanists," one might say that "ambitious meaning" has come to be the major criterion, although the "meaning" rarely goes beyond the studio situation.

Fig. 153. *Richard McLean. Still Life with Black Jockey, 1969. Oil on canvas, 60 × 60 inches. Purchase, 70.17.*

Portraits of the Last Two Decades

When realism and naturalism reappeared so did portraits. Some of the recent portraits are based on photographs and slides while others are painted in the presence of the sitter. Some claim to be straight, "objective" renderings of the surface appearances of a face at a given moment, while others have expressive, emotional qualities suggesting the character of a person who has developed through time and place. Larry Rivers, who shifted in and out of gestural figure painting and Pop imagery during the 1950s, painted a number of poignant portraits of friends and relatives. His *Double Portrait of Berdie* of 1955 (Fig. 154) represents two poses of his mother-in-law, an aging woman whose indomitable spirit shines through the sagging flesh and venerable wrinkles of a human being who has lived and endured for many years.

Qualities of human vulnerability and fragility and the human values of tenderness also haunt Moses Soyer's *Julia Evergood* of 1962 (Fig. 155) and Alice

Neel's *The Soyer Brothers* of 1973 (Pl. 27). In both portraits the character of the sitters is revealed through expression, body pose, and positioning of the hands. Neel's *Andy Warhol* of 1970 (Fig. 156) is a portrait of an art-world personality, hailed as the greatest impressario of our time, at a particularly vulnerable moment. Disrobed to reveal the scars inflicted on him in the summer of 1968 by a former admirer, Warhol sits in beatific self-composure. Neel refers to herself as a modern Balzac and indeed her *John Perreault* of 1972 (Fig. 157) depicts a frankly sensuous but curiously passive nude whose genitalia relax in a bed of furry pubic hair. Neel's portrait satirizes the "openness" of the late 1960s when "humanistic psychology" emphasized body awareness and the freely communicated expression of emotions. Indeed, in the early 1970s in many circles "humanism" had come to mean self-development and self-perfection. To Neel, realism meant representing her subjects not only as personalities but as types who embody attitudes and styles very much of our time.

This same directness — "letting it all hang out" —

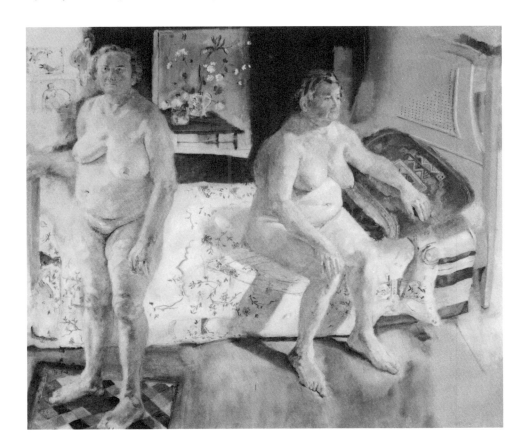

Fig. 154. Larry Rivers.
Double Portrait of Berdie,
1955. Oil on canvas,
70¾ × 82½ inches.
Anonymous gift, 56.9.

Fig. 155. Moses Soyer. Julia Evergood, *1962. Oil on canvas, 36 × 30 inches. Gift of Mr. and Mrs. Percy Uris, 63.4.*

Fig. 156. Alice Neel. Andy Warhol, *1970. Oil on canvas, 60 × 40 inches. Promised gift of Timothy Collins, 1.71.*

is the theme of Alfred Leslie's over life-size self-portrait, *Alfred Leslie* of 1966– 67 (Fig. 158), done in black and white tones. Leslie, who before the mid-1960s was an Abstract Expressionist, depicts himself: the uncombed hair, the paint-splattered trousers with broken fly zipper, the flaccid belly present an image of the artist as neither an elegant professional nor a deeply brooding outsider. The artist is simply a person who has the talent to make a likeness and the candor not to idealize the portrait into a conventional image.

Transmitting information rather than probing human psychology is the goal of Chuck Close in his *Phil* of 1969 (Fig. 159). In his portraits in the late 1960s and 1970s Close used a camera to make photographs of his subjects. Close adjusted the focal plane of the lens to the plane of the subject's eyes; in the resulting photograph, that plane is scrupulously detailed while the tip of the nose and the hair blur out of focus. Squaring off the photograph, he transferred the image to an outsized canvas by copying each detail of hair follicle and skin wrinkle as well as the blurred areas. The image becomes a literal and optical "slice of life." Close's ambition is

identical with his technique — to "use frontal formal poses that are lit to present the greatest information about that particular face in that particular situation," with the goal being "to see a familiar image in a new way."[88] Emphasizing seeing and perception rather than understanding and conception, Close's intensely

Fig. 157. Alice Neel. John Perreault, *1972. Oil on canvas, 38 × 63½ inches. Gift of anonymous donors, 76.26.*

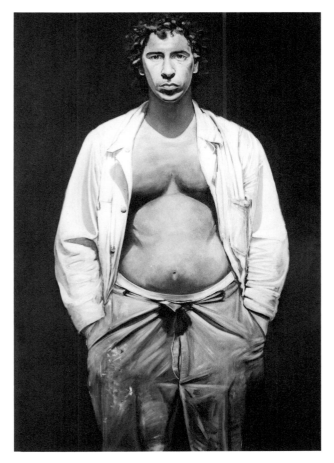

Fig. 158. *Alfred Leslie.* Alfred Leslie, *1966-67. Oil on canvas, 108 × 72 inches. Gift of the Friends of the Whitney Museum of American Art, 67.30.*

Fig. 159. *Chuck Close.* Phil, 1969. *Synthetic polymer on canvas, 108 × 84 inches. Gift of Mrs. Robert M. Benjamin, 69.102.*

naturalist portraits are processed into formalist images of overwhelming presence.

In Alex Katz's portraits individual character is irrelevant. The three men and two women — Michael Brownstein, Gerrit Henry, Doug Ohlson, Paula Cooper, and Jennifer Bartlett — of almost billboard proportions in *Place* of 1977 (Pl. 28) smile down at the viewer with great self-assurance. They are idealized images of the types one meets on a sunny day in the gallery district south of Houston Street in New York City. They have none of the qualities of the smug but vulnerable petty bourgeois so mischievously and rawly satirized by Neel. They are artists, dealers, and writers — types who come and go, talking of art in SoHo. Katz, who was affected by the dynamic tenor of New York School painting and who still admires the "quick light" in Pollock's paintings, is himself attempting to restructure the elusive quality of light.[89] The results are subjects transformed into images of spontaneous freedom. Regarding the new trends in figurative art, Katz has recently said: "For me, figurative painting is a whole new ball game. Reality is a variable — what things appear to be is

something that changes every 20 years. The most interesting painters are the ones in contact with the world they're living in and they're making new pictures."[90] The world Katz chooses to live in and concern himself with is primarily circumscribed by the perimeters of the chic art galleries and museums of New York.[91] Moreover, his naturalism harmonizes a concern for modernity with a preoccupation with the optical sensations that flatten and reduce form. As such he comes closest to the goals of the Impressionists working a hundred years ago who sought to synthesize the optical reality of appearances with the content of contemporaneity, of "being of one's time."

Close and Katz chose the human face because it is the form perhaps most deeply established in our consciousness, but they are not interested in making statements about human values *per se*. It may be that to them humanism — the secular religion — has lost its edge, its relevance in a world in which information, chic, and optimistic cool have become the best defenses to withstand the cynicism and pessimism which continually threaten artists.

Other Figurative Options

In the 1940s Philip Guston was a realist whose themes paralleled those of Siporin, Lasker, and Shahn. By the 1950s he had become an Abstract Expressionist — a mode he pursued until the early 1970s when he abruptly returned to the figure. His figures, however, are neither naturalistic nor chicly stylized, but rather large, clumsy forms with hooded faces and feet which could have been drawn by the satirist R. Crumb. Guston's *Cabal* of 1977 (Fig. 160) strikes an ominous note. The Random House *Dictionary of the English Language* (1966) defines the noun "cabal" as "1. a small group of secret plotters, as against a government or person in authority. 2. the plots and schemes of such a group; intrigue. 3. a clique, as in the artistic, literary, or theatrical fields." In these post-Watergate years, the intriguer draws our contempt, although we may have a different attitude toward the artificers who plot against art-world authorities. However, these pathetic creatures of Guston, painted in cadmium reds, dirty pinks, and brownblack — all vulnerable eyes and ears — are lost souls who may just drown in their own passivity.

The most recent figurative paintings in the Whitney Museum's collection range from the disarmingly simple and optimistic images of Katz to the complex and synecdochic, pessimistic creatures of Guston. Inverting conventional notions of the appropriate content to match style, the naturalistic images of Katz conjure up a carefree paradise whereas the abstracted images of Guston suggest a purgatory of lost souls, and the paintings of Roger Brown and Nicholas Africano fall somewhere in between.[92]

As of this writing, critics and artists speak of "postmodernism," applying the term not only to architecture but to painting and sculpture.[93] Critic Kim Levin, as recently as October 1979, has suggested that the distinguishing characteristic of the decade of the 1970s was that modernism "had gone out of style":

The question of imitation, the gestural look of Abstract Expressionism, and all the words that had been hurled as insults for as long as we could remember — illusionistic, theatrical, decorative, literary — were resurrected, as art became once again ornamental or moral, grandiose or miniaturized, anthropological, archeological, ecological, autobiographical or fictional. It was defying all the proscriptions of modernist purity.

The mainstream trickled on, minimalizing and conceptualizing itself into oblivion, but we were finally bored with all that arctic purity.[94]

Clement Greenberg, writing at about the same time, has defended modernism, not by reiterating the primacy of formal preoccupations, but by redefining it in terms of its contemporary mission. To Greenberg, there is a war waging:

So I come at last to what I offer as an embracing and perdurable definition of Modernism: that it consists in the continuing endeavor to stem the decline of aesthetic standards threatened by the relative democratization of culture under industrialism; that the overriding and innermost logic of Modernism is to maintain the levels of the past in the face of an opposition that hadn't been present in the past. Thus the whole enterprise of Modernism, for all its outward aspects, can be seen as backward-looking.[95]

To Greenberg, the post-modernist trends spring from the "urge to relax" the aesthetic standards of the past. In his view the advocate critics of post-modernism "bring philistine taste up to date by disguising it as its opposite, wrapping it in high-flown art jargon. . . . Underneath it all lies the defective eye of the people concerned; their bad taste in visual art."[96]

This is not the occasion to raise the issue of *whose* aesthetic standards are the measure, or to remind us, as did Leo Steinberg almost thirty years ago, that the eye is a part of the mind.[97] Nor is this the place to predict what figurative paintings, if any, curators will select for their art museums for the future.

It is appropriate, however, to acknowledge the fact that many younger, and not so young, artists produce figurative art today out of an inner psychological or a social necessity to express what they see in the world and what they think and feel. "Aesthetic standards" to them are too ambiguous, too much tied to conditions of privilege, too often the subterfuge for dismissing their ideas — whether those ideas be aesthetic or political.

While figurative painters such as Philip Pearlstein and Alex Katz have approached their subjects with formal concerns primary, others such as Alice Neel and Philip Guston consider the formal structuring of the parts (as important as it is for visual impact) to be at the service of the meaning which they wish to reveal and

*Fig. 160. Philip Guston. Cabal, 1977. Oil on canvas,
68 × 116 inches. Promised 50th Anniversary Gift of Mr. and
Mrs. Raymond J. Learsy, P.8.79.*

with the thoughts and feelings they wish to provoke in the viewer. Figurative artists intent on communicating a view of humanity — human values and human limitations within a context of recent history and established mores — have relied less on mimesis (imitation of the forms of the outside world) than on styles which allow a juxtaposition of forms and motifs compelling the viewer to synthesize implicit and explicit ideas. Collage, expressionism, and Surrealism have offered stylistic possibilities for appeasing the requirements of form as well as offering solutions for the handling of a more ambitious and conscious content.

The debate goes on, often with polemical shrillness, as to whether painting finds its analogue in music or in literature or whether modernism, with its stress on form, has been pre-empted by a post-modernism rigorously committed to a content extrinsic to the art itself. Against the background of such polemics, does the term *humanism* serve any further purpose in our discussions of art?

Implicit in the concept of humanism, right from its beginning in ancient Greek culture, was the notion of standards (ethical, aesthetic or athletic) sanctioned and upheld by an elite group to distinguish itself from the ways and modes of slaves, women, non-citizens and barbarian outsiders. At the time, Greek civilization, given its low level of technology and productivity, could not have incorporated the "others" into their democracy. Therefore, only the elite group was capable of fully realizing its humanity. However, from the Renaissance to the present time, the humanist ideal of individual self-development of mind and body has become ever more inclusive.

In the late twentieth century, with advanced industrialization and the tremendous increase in productivity, such opportunities are potentially available to everyone. Now, more than ever, standards are necessary; indeed, the elimination of standards would invite chaos. But in this modern age, standards need not be instruments for exclusionary strategies; rather they should help the individual measure her or his self-development.

In the meantime, the definitions of art historians are less important than the variety, extent, directions, and latent possibilities of figurative painting being produced by artists today, some of whom are working out a viable and dynamic form for a content truly democratic and universal in its appeal. Artists should take comfort in the knowledge that the often inflexible stances of art critics, and the power they wield in the media and art market, are in the long run less relevant and germane than the artist's search for human meaning in today's restless and apprehensive world.

CHAPTER V

Sculpture, 1941–1980

ROBERTA K. TARBELL

After World War II abstract art predominated over mimetic art. However, some American sculptors found that interpretations of the human figure could be individual and modern. Certain aesthetic approaches elucidate the continuing selection of the human figure by some mid-twentieth-century artists:

1. Philosophical and Psychological Awareness: Sculptors accepted the validity of their unconscious interior worlds and their dream worlds, invariably figurative, which evolved from their interest in the teachings of Freud and Jung. They emerged in sculptural terms as mystery, fantasy, illusion, irony, metamorphosis, and anatomical distortion. Not all art stemming from the unconscious or dreams is surrealist — some is more aptly described as expressionist, motivated by deeply personal feelings and imagery. Just as the academic sculptor was exploring an ideal world and the realist sculptor the physical world, so the expressive sculptor sought to re-create the metaphysical realm with distortions of the human anatomy. Sculpture by Lipchitz,

Fig. 161. George Segal. Walk, Don't Walk, *1976. Plaster, cement, metal, paint, and electric light, 104 × 72 × 72 inches. Gift of the Louis and Bessie Adler Foundation, Seymour M. Klein, President; the Gilman Foundation, Inc.; the Howard and Jean Lipman Foundation, Inc.; and the National Endowment for the Arts, 79.4.*

Grippe, Caesar, Baskin, and Rivers falls into this category.

One aspect of twentieth-century psychological awareness (in contrast to public denial by the Victorian age) is the explicit expression and vivid depiction of human sexuality, erotic fantasies, and passion. Heralded by Lachaise's figural fragments of the 1930s, this subject matter has continued to be important for Nakian, De Andrea, Graham, and Wesselmann, and for other American sculptors over the last fifty years.

The dominant mood of artists changed, as mid-century neared, from optimism to pessimism. Instead of man as hero, as a symbol of life, wholeness, serenity, and harmony, it was defeated, despairing, fearful man and the death of the individual that later sculptors, including Kienholz, Baskin, Hanson, and Conner, tended to depict. Instead of a classical belief in rational man they accepted man's irrationality. As Irving Sandler points out, the intellectual matrix of vanguard art was existentialism in which man does not have a fixed essence but is molded by his surroundings, by his existence.[1]

2. Formalism: Gross, de Creeft, Zorach, Hague, Laurent, and other direct carvers continued to view natural objects as geometric or crystallized shapes, a deliberate simplification of organic morphology, and a search for the essential, the salient formal characteristics of living beings. Trova's and Tovish's interpretations are

Fig. 162. William Zorach. The Future Generation, *1942-47. Botticini marble, 40 × 19 × 14¼ inches. Purchase (and exchange), 51.32.*

mechanistic reductions. The use of the partial figure is a form of abstraction — by decreasing the identity of the subject and removing gesture, fragments of the anatomy (the *pars pro toto*) are less representational and more abstract. Baizerman's torso, Von Huene's hands, Wesselmann's foot, and Arneson's and Conner's heads are examples of such fragments.

3. *Invention and Originality*: For most of this century creative genius, artistic intuition, and innovation were venerated. Sculptors felt free to employ the human figure in whatever manner they wished, often evoking eccentric scale, proportion, anatomy, subject, composition, and assemblage of human parts. Figurative artists felt a compulsion to invent "new images of man," to use Peter Selz's phrase. It is such a pervasive intellectual conviction of our age, and especially of American culture, that it is difficult to understand the reverence of previous generations and centuries for accepted and traditional classical standards. Thus, anatomical distortions were motivated by both psychological insights and the desire to be avant-garde. During the 1970s, however, interest in mimetic realism has increased.

4. *New Materials*: Assembling and fabricating figures from myriad new man-made materials updated and suggested new forms for figurative sculpture. Whereas early twentieth-century sculptors felt they should express the qualities inherent in stone and wood, mid-twentieth-century American sculptors exploited polyester resin, epoxy, new metal alloys, and the infinite variety of found objects, as well as the traditional bronze, terra-cotta, plaster, and wood (but very little stone).

Direct Carving

Some of the concepts, techniques, and traditions of the period 1900–40 continued during 1940–80 in the face of the spiraling New York School. William Zorach and José de Creeft, of the generation born during the 1880s and 1890s, remained convinced of the figure's essential qualities as a subject. Younger artists such as David Smith, Seymour Lipton, Isamu Noguchi, Ibram Lassaw, and Herbert Ferber, born during the early years of the

twentieth century, found that figurative sculpture did not fully express their evolving aesthetic philosophy' and began creating biomorphic or geometric abstractions. Figurative artists who were born during the 1920s had more difficult experiences during the late 1940s and 1950s. They were either castigated or ignored for their interest in an illusionistic third dimension, representation of any sort, and the subject of the human figure. George Segal, for example, was frustrated in his art classes at New York University in 1948 and 1949 because his teachers tried to jolt him out of his admiration for the German Expressionists and to increase his appreciation for complete abstraction.[2]

Zorach carved *The Future Generation* (Fig. 162) during 1942–47 in Maine. He wrote to Edith Halpert in 1943 that he had established a fine composition, but the brittleness of the Botticini marble made it extremely difficult to carve.[3] Zorach's large two-figure groups express what he considered the most emotionally significant relationships in life — the love between mother and child, man and woman, or child and animal. Although vanguard artists during the 1940s were becoming increasingly cynical, carvers of Zorach's generation and the young artists they inspired through their teachings at the Art Students League and elsewhere, retained their interest in positive emotions. A farmer asked Zorach why he carved a mother and child rather than a "real" subject like war and peace. Zorach replied, "Without a mother and child, there would be neither war nor peace."[4] *The Future Generation* has the solidity, massiveness, and density characteristic of Zorach's carved sculptures and is the most literal interpretation of any of his carved multi-figure groups.[5]

Chaim Gross had cut his first two figures in wood in 1926, in Robert Laurent's class at the Art Students League. *Acrobatic Dancers* (Fig. 163) was carved in 1942 from ebony, a material Gross described as a black or brownish-black, extremely hard and smooth wood which "takes a polish beautifully."[6] Gross was not interested in personal qualities of individual acrobats but "in a combination of the two or three figures which allows him to combine and interlock forms, permitting the flow of one form into another."[7] He continued to devise acrobats in wood through the 1950s, after which, through the 1960s, he proceeded to working directly in plaster for subsequent casts in bronze. In 1976 he noted that his philosophy of sculpture had also changed: "I could not go back and carve wood as I was doing in 1940. Right now, I could not go through another acrobat in a ring or a mother and child."[8] Currently

Fig. 163. Chaim Gross. Acrobatic Dancers, 1942. Ebony, 40 ½ × 10 ½ × 7 inches. Purchase, 42.28.

Gross is employing Old Testament patriarchs to symbolize such universal ideals as peace and the striving of man for eternal qualities.

Like other American sculptors of his generation Raoul Hague, born in 1905, evolved from figurative carvings to abstractions during the 1940s. He is a relatively reclusive sculptor of the highest integrity, like Hugo Robus, and he has had only four one-man exhibitions, including a recent one at Xavier Fourcade which was well received.[9] Born and educated in Constantinople, Hague moved to Ames, Iowa, in 1921, to New York City in 1925, and has been a resident of Woodstock, New York, since 1941. Hague learned direct carving from William Zorach at the Art Students League in 1927 and 1928, and more informally from John Flannagan and Chaim Gross. Even more so than his colleagues, Hague seems to have immersed himself in the particular qualities of each material he has carved and, during the thirties and forties, included the name of the material in the title (e.g., *Blue Stone Figure, Figure in Black Walnut*, or *Torso in Chestnut* — sculptures exhibited in the Whitney Museum Annuals of 1946, 1947, and 1948, respectively). Hague's *Figure in Elm* of 1948 (Fig. 164) is severely abstracted for a carving and, also unusual, assembled of two parts. While the figure is not static (it twists and strides buoyantly forward), the emphasis is on the concentric annular rings of the surface of the elmwood. Thomas B. Hess perceptively noted that Hague's sculptures "are individual personalities," and that "their humanity is specific and becomes general by the very strength of its unique, human quality," adding that "the fact that they are beautiful is what makes this quality so moving."[10] That same year, in a rare statement, Hague wrote, "In the last thirty years, of all the artists I have known, there have been only three whose eyes I could trust — Gorky, Tomlin and Guston — and I have used them in my own development."[11] The analogy in Hague's carvings to Arshile Gorky's biomorphic abstractions is clear, but to Bradley Walker Tomlin's ribbon-like forms or to Philip Guston's painterly Abstract Expressionism, less so. Hague and de Creeft, pioneers of *taille directe*, continue to carve to the present day.

Fig. 164. Raoul Hague. Figure in Elm, *1948. Elm, 48½ × 14 × 14 inches. Gift of the Howard and Jean Lipman Foundation, Inc., 66.26.*

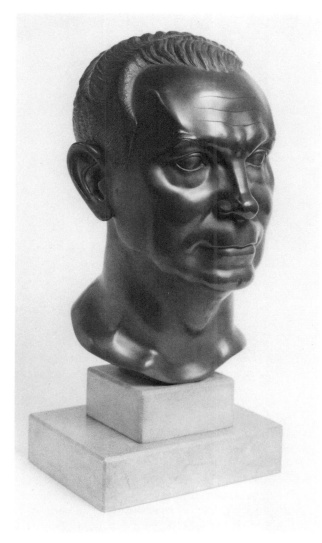

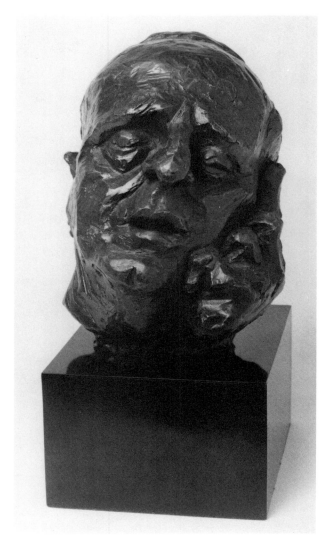

Fig. 165. Paul Fiene. Bust of Grant Wood, *c. 1942. Bronze, 17¼ × 7½ × 8 inches. Promised gift of Mr. and Mrs. George D.Stoddard, 1.77.*

Fig. 166. Jacques Lipchitz. Marsden Hartley Sleeping, *1942. Bronze, 10¼ × 7¾ × 10 inches. Gift of Benjamin Sonnenberg, 76.41.*

Portraiture

Portraiture is a traditional form of figurative sculpture which continues to be executed by conservative and experimental artists alike. Two bronze portrait heads of American artists created in 1942, *Bust of Grant Wood* by Paul Fiene and *Marsden Hartley Sleeping* by Jacques Lipchitz, exhibit two approaches to interpretive yet representational three-dimensional likenesses. Fiene's hard, gleaming, smooth surfaces contrast to Lipchitz's softer, blurred, rough modeling. The unique cast of *Bust of Grant Wood* (Fig. 165), like Duchamp-Villon's *Baudelaire* (1911) and Sterne's *Bomb Thrower* (1910), is reductive, planar, and geometric, powerful in its directness and simplicity. The polished unbroken sur-

faces of Fiene's portrait apparently carried over from his stone carvings of animals.

Jacques Lipchitz arrived in New York in June 1941. He immediately established contacts with dealers (Curt Valentin and Joseph Brummer), foundries (initially Roman Bronze Foundry but changing in 1942 to the Modern Art Foundry), collectors (Edgar J. Kaufmann, owner of Frank Lloyd Wright's "Falling Water" at Bear Run), and artists (Chaim Gross lent him modeling tools). Although Lipchitz was working on several versions of *Mother and Child*, he was having a difficult time earning a living and so decided to make a series of portraits. Lipchitz recalled his attendance at an opening of an exhibition at Helena Rubinstein's and his creation of portrait of *Marsden Hartley Sleeping* (Fig. 166):

In the crowd at the opening I saw a man who seemed to me to have a typical American face. . . . We were introduced (although I still did not know who he was), and he said he would be delighted to pose. I made three portraits of him, one in terra cotta, now in the Metropolitan Museum, New York. One time, when he came to my studio, he said, "Jacques, I have just seen an old man sleeping on a bench, like this," and he assumed the pose of the sleeping man in such a graphic manner that I immediately said, "Marsden, will you hold that pose so I can make a sketch of you like that?" I also made a third sketch, later cast in bronze in seven issues.[12]

Lipchitz stated that "Hartley was an interesting man of great sensitivity and, I think, an important American painter. He had a wonderful head, a very sensitive face, and I believe the portrait of him is a good one."[13] As it turned out Lipchitz did not model a series of portraits, modeling only one other in 1942 — of Curt Valentin. That year Monroe Wheeler selected all three portraits of Hartley for his exhibition at the Museum of Modern Art, *20th Century Portraits*, placing Lipchitz's portraits within the ambience of Rodin. Certainly the kneaded, nervous surface of *Marsden Hartley Sleeping* echoes the textural qualities of Rodin's.

The rich painterly qualities of Larry River's paintings are carried over to his sculpture of *Berdie Seated, Clothed* (Fig. 167). Rivers felt that he shared the interest in process and formalism of his teacher (Hans Hofmann) and of the Abstract Expressionists but that he was different from them in his realism.[14] Rivers began modeling such small sculptures as *Berdie Seated, Clothed* in 1951, part of a series of paintings, prints, and bronzes of his mother-in-law, Bertha "Berdie" Burger, who lived with Rivers and his sons from 1950 until her death in 1957. The blurry surface texture of the small sculpture of Berdie can also be found in Rivers's life-size plaster figures, also begun in 1951, not unlike the haunting archetypal presences of Baskin's standing figures, each a mythical unity. In 1957 Rivers began to work on welded sculptures and in 1965 on giant construction-paintings.

Expressionist Metal Works: Modeled and Hammered

In contrast to Lipchitz's portraits, which were likenesses, and to his geometric cubist works created be-

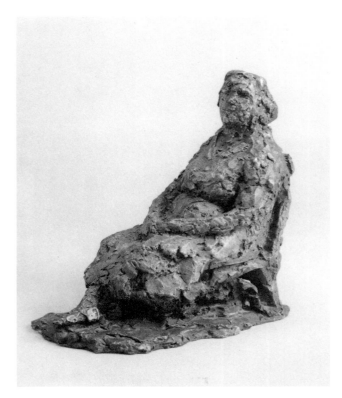

Fig. 167. *Larry Rivers. Berdie Seated, Clothed, 1953. Bronze, 10 × 6 ½ × 9 ¾ inches. Lawrence H. Bloedel Bequest, 77.1.45.*

tween 1915 and 1925, the swelling, organic forms of his mature figurative works were powerfully emotional. He recorded the history and iconography of *Sacrifice, II* (Pl. 29), a sculpture expressive of the anger he felt during the 1940s. In his autobiography, Lipchitz recalled that "the man holds the cock of expiation over his head, prepared for sacrifice," one of the earliest examples in his sculpture of a narrative or Jewish theme.[15] In the small study for *Sacrifice*, which he modeled in 1947–48,

the man (he is not actually a rabbi but an individual specially ordained to perform the sacrifice) is killing the cock. This is more massively conceived than the sketch. This subject fascinated me. . . . [In the second and third version] the figure becomes more upright and hieratical, the cock's wings and feathers more dramatically scattered, and a reclining lamb is introduced between the figure's legs. Why I should have done this I cannot recall, since the lamb is rather a Christian than a Jewish symbol and is definitely not a victim of the sacrifice. I may have been thinking of the continuity of the Judeo-Christian tradition, and I may, as well, have wanted something between the legs to lend stability to the entire composition. . . . The use of the dagger is deliberate, to heighten the sense of

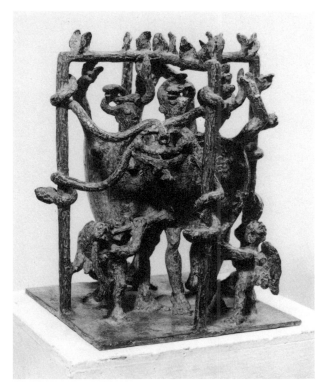

Fig. 169. Peter Grippe. Three Furies, II, *1955-56. Bronze, 14 × 11½ × 9¾ inches. Purchase, 57.44.*

drama. I think this is one of my major works. It certainly is strong and complete, but it unquestionably comes out of some continuing feeling of anger. I could not make it today because my mood is different, much happier, more optimistic. Sacrifice is heavy and enigmatic, even brutal, and now, in my present mood, I want my sculptures to be saturated with light.[16]

The mood is similar to that of contemporary painters.

The figure had always been central in the sculptural oeuvre of Jacques Lipchitz and Henry Moore and they had a profound impact upon American figurative artists during the 1940s. Lipchitz's one-man exhibition at Joseph Brummer's gallery in 1935 preceded his actual presence in New York. Curt Valentin organized one-man shows for Lipchitz at the Buchholz Gallery in 1942, 1943, 1946, 1948, and 1951, and Lipchitz's sculpture was regularly exhibited in the Whitney Museum Annuals. Little-known sculptor Robert Moir's limestone *Mother and Child* (Fig. 168) is quite unselfconsciously derived from both Moore and Lipchitz. The face of Moir's mother is partially solid and partially void in the manner of the man in Lipchitz's *Sacrifice* or the mother in his *Mother and Child* of 1949. In both Moir's and Lipchitz's *Mother and Child* cloth is draped over the head and arm. The massive doughy

flow of limbs, so obviously molded from clay in the Lipchitz, have become static, refined, and hard in the Moir. Moir's *Cumulus*, exhibited at the 1951 *Annual Exhibition of Contemporary American Sculpture* at the Whitney Museum, is also derivative of Lipchitz-like compositions and formal devices, and Moir's *Prometheus Unbound* (shown in the 1954 Whitney Museum Annual) derives its title from a masterpiece by Lipchitz.

The philosophical systems of artists who reached maturity during the 1940s continue to this day to be dependent on concepts of paradox, the dialectical, creative contradictions, and the tension between opposites whereby the grotesque is beautiful and ugliness is sublime. Figurative and abstract sculptures became a

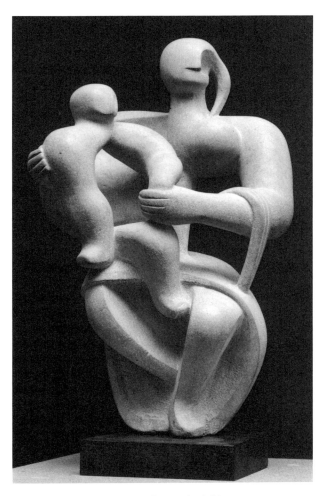

Fig. 168. Robert Moir. Mother and Child, *1950. Limestone, 22¼ × 13½ × 10 inches. Purchase, 52.18.*

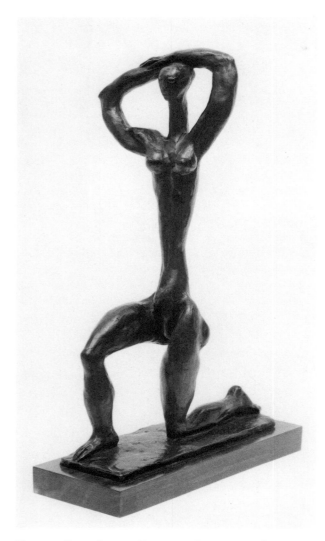

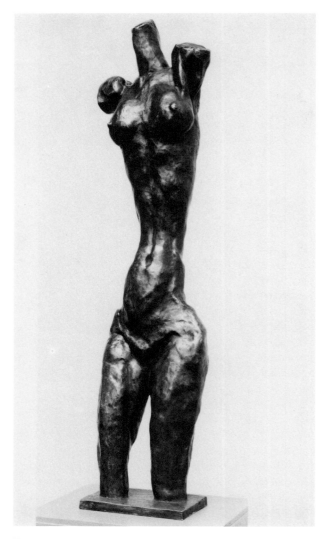

Fig. 170. *Doris Caesar.* Woman on One Knee, *n.d. Bronze,* *14½ × 4¾ × 8¾ inches. Lawrence H. Bloedel Bequest.*

Fig. 171. *Doris Caesar.* Torso, *1953. Bronze, 58 × 14¾ × 11* *inches. Purchase (and exchange), 54.30.*

complex interplay of polarities and also frequently reflected Gestalt theories. The major link between the New York artists and Gestalt psychology was Rudolf Arnheim, who taught at the New School for Social Research during the 1940s. Sculptors were concerned with a whole organism greater than the sum of its parts.

During the 1940s several sculptors changed from carving or modeling massive figures to welding linear airy designs. This led Ibram Lassaw and Herbert Ferber to creating sculptural drawings in space which were non-objective and Peter Grippe to placing figures in his open airy cages as he did in *Three Furies, II* (Fig. 169). Like Alberto Giacometti, Grippe after 1944 was more concerned with the impact of space than he was with the illusionistic reality of the figure.[17] Although Grippe's sculptures fall within the ambience of Lipchitz, whom he knew, the differences are major. Grippe's construc-

tions are more transparent, the forms are articulated more particularly and he is more interested in an architectural environment. There is a greater proliferation of lines, spaces, and surface configurations in Grippe's work, which is also more grotesque. Artists during the decade of World War II were obsessed with tormented, tortured figures reflecting the angst of their souls.

Born and trained in Buffalo, New York, Grippe taught in the Federal Arts Project in New York during the 1930s, used terra-cotta as his primary medium during the 1940s, and was on the faculty of Black Mountain College from 1946 to 1948, a time when Josef Albers, John Cage, Willem de Kooning, Buckminster Fuller, Merce Cunningham, and Richard Lippold were teaching there.

In 1959 Lloyd Goodrich and John I. H. Baur or-

ganized an exhibition entitled *Four American Expressionists*, which included Chaim Gross and Doris Caesar, two sculptors whose art is entirely concerned with the human figure. The authors maintained that expressionism was a style term and not an organized movement in America but concluded that expressionists freely distorted the human figure and other natural recognizable subject matter to impart emotional response to the experience.[18] Doris Caesar's early works were heavy and stolid (most of them destroyed), but during the 1940s and 1950s she modeled attenuated female figures like *Woman on One Knee* (Fig. 170) and *Torso* (Fig. 171) which were cast in bronze. She had studied painting at the Art Students League (1909) and sculpture with Alexander Archipenko and Rudolf Belling. She reduced her subject to the single theme of the nude female form and she poured out the aspirations and the pathos of her subjects in elongated shapes and fragile anatomical parts.[19]

Saul Baizerman's human figures are also expressively rendered, brought into twentieth-century terms by his choice of the partial figure and his unusual techniques of hammering his bronze casts (during the 1920s) or forcing copper sheets into a mold by the repoussé method (after 1926). Born in Russia in 1889, he studied at the National Academy of Design in 1911 and thereafter with Solon Borglum at the Beaux-Arts Institute of Design in New York.[20] His sculptures of the 1920s were modeled statuettes of laborers in action, e.g., *Two Men Lifting* (1922), *Cement Man*, and *Man with a Shovel* (or *The Digger*, 1924).[21] His large hammered-copper works of the 1930s required years to complete and were named for musical terms: *Sonata Primitive, Appassionata, Pastoral, Sculptured Symphony, Eroica, Crescendo, Elegy*. Musical analogizing is suggested by the tempo of rhythmic relief curves across the horizontal surface of the metal. Baizerman's monumental relief torsos like *Slumber* (Fig. 172) are abstracted, but retain the harmony of human curves and counter curves, adding the visual excitement of his direct-metal processes (no preliminary sketches).

Leonard Baskin's metaphysical sculptures are expressive of life/death paradoxes. Between 1952 and 1968 Baskin produced a series of monumental figures of recumbent dead men of walnut, limestone, and bronze.[22] They were not on a journey like an Egyptian Pharaoh, or asleep like a medieval lord, or a Christ triumphant in death, but just ordinary unheroic death — our death, but promising hope of life. Archetypal *Hephaestus* (Fig. 173), while vertical, appears

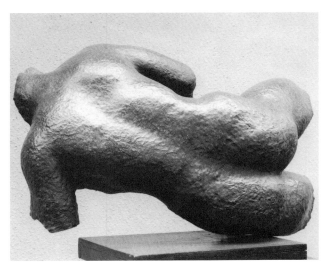

Fig. 172. *Saul Baizerman*. Slumber, 1948. *Hammered copper, 40 × 25 × 23 inches. Purchase, 48.20.*

scarcely more alive. The eyes are closed and hardly articulated. The chest is filled with life-giving breath but the rigid limbs, impossible stance, and absence of alertness render *Hephaestus* dead. The qualities of stillness and quiet in sculpture have impressed Baskin since his student years. Drawings by Baskin accompany the publication of books of Greek mythology and of Conrad Aiken's *Thee*, a stanza of which augments our understanding of Baskin's sculpture:

> *Where shall I abide*
> *cries the spirit*
> *mind changes*
> *and body changes with it*
> *body changes*
> *and mind changes with it.*[23]

Baskin labels himself a moral realist who finds the human frame "glorious" and regards man, though debauched, redemptible. He is not describing specific people, as Hanson does, but models, symbols of human destiny. Not only does Baskin retain a traditional belief in humanism but he also scorns technical innovations, preferring to create allegorical sculpture in age-old wood and bronze. There is a certain confraternity of images between Baskin's sculptured men and the figurative sculptures of the Frenchmen César [Baldaccini] and Jean Ipoustéguy, and with Pablo Picasso's *Man with Sheep* (1944) and *Pregnant Woman* (1950).[24]

Fig. 173. Leonard Baskin. Hephaestus, *1963. Bronze, 63 ¼ × 23 ½ × 23 ¾ inches. Gift of the Friends of the Whitney Museum of American Art, 64.16.*

Tableaux: Assemblage and Found Objects

Not since Gianlorenzo Bernini's *St. Theresa in Ecstasy* (Cornaro Chapel, Santa Maria della Vittoria, Rome, 1645–52) have sculptors produced tableaux so creatively, so dynamically reflecting the intellectual convictions of their age. Modern tableaux arose from new sculptural materials, from the theater, from photography, and especially from the "Happenings" by Allan Kaprow and others during the early 1960s. Two assembled sculpture/scenes created in 1964 demonstrate the range of materials, methods, and messages implicit in sculpture as tableau. Edward Kienholz's depressingly grotesque *The Wait* (Fig. 174) is very different from the fashionable beauty and optimism

expressed in Marisol's *Women and Dog* of 1964 (Fig. 175). Created the year after the assassination of the President, it recalls the Kennedy-Camelot age.[25] Satire, amusing in Marisol's work, is biting and bitter in Kienholz's. Who amongst us has not visited an elderly relative surrounded with the grayness of dust, dimming vision, and overflowing photographs, and determined that the repulsive condition would never happen to us? Kienholz jolts the viewer with the tragedy of growing old in America, a pervasive, unremedied social problem. Even the illusionistic presence of Hanson's *Old Woman* (1976) does not overwhelm us with the hideous social reality of Kienholz's. Although the calm, serene resignation of Hanson's sculpture does not jar us, it simultaneously evokes in the viewer feelings of superiority and the fear of recognition of self.

Robert Graham created tableaux on a smaller scale during the late 1960s, modeling tiny realistic human figures in wax surrounded by environments fabricated of found objects, cardboard, balsa wood, and metal, all enclosed in a clear plexiglas box. In *Untitled* (Fig. 176) a nude lies face down on a rumpled bed in an otherwise empty room (prefiguring John De Andrea's life-size resin *Sleeping Woman on Bed* of 1974.)[26] More recently, in *Lise* of 1977 and other pedestal sculptures, Graham enlarged the figures, rendered them with almost classical idealism, broke them into fragments, and cast them in bronze. He is concentrating on the human figure because he claims, "Everything is in it."[27] He recognizes technology in his use of videotapes of nude models in motion which he replays as he works the wax or clay.[28] Whereas the mimetic resin and wax figures of Hanson, De Andrea, and Graham are so lifelike that formalist considerations give way to discussion of subject, *Lise* and Graham's more recent works suggest analysis based on aesthetic criteria. Mary Frank, Frank Gallo, and Graham (especially in *Lise*) eschew solid massive structures. The chiaroscuro of their works is not the play of light across the surface but the interplay of dark interior hollows and light exteriors, another example of paradox in which sculptures of recent decades are rooted. Graham's collaboration with George Segal, Leonard Baskin, and Neil Estern on a fifty-foot-long wall of bas reliefs for the Franklin D. Roosevelt memorial in Washington, D.C., should change the direction of monumental sculpture in the capital city.

George Segal's classic tableaux consist of one or several people assembled in prosaic settings. Although his figures appear to be another form of emotional

Fig. 174. Edward Kienholz. The Wait, *1964-65. Tableau: epoxy, glass, wood, and found objects, 80 × 148 × 78 inches. Gift of the Howard and Jean Lipman Foundation, Inc., 66.49.*

narrative and realistic genre, the works also are allegorical and metaphysical, dealing with the human condition as well as a specific ordinary situation. Segal's plaster sculptures are yet another instance of antithetical elements operating simultaneously. His seemingly lifeless figures provoke questions about life and portray Segal's own psychic state. According to Martin Friedman, they are "frozen moments in real life [which] reveal the artist's overwhelming desire to give permanence to transitory events, thereby holding on to life. It seems Segal is reflecting on mortality."[29] Segal's own comments on *Cinema* (1963) apply to *Walk, Don't Walk* (Fig. 161) and to his sculpture in general: "I love to watch people. I'm interested in their gestures and I'm interested in their experiences and mine. In the early years I spent a lot of time trying to look as bluntly as I could at people in their environments. Very often I saw them against garish light, illuminated signs. I saw them against visually vivid objects that were considered low class, anti-art, un-art, kitsch, disreputable. . . ."[30] Thus, Segal's art is sometimes eternal and sometimes temporal.

Duane Hanson, like most of the first generation

American abstract constructivist sculptors, worked at carving during his formative years.[31] His first polyester-resin sculptures were fashioned between 1966 and 1968 while he was an instructor at Miami-Dade Community College and were then exhibited and known only in Florida. Ivan Karp, impressed by slides of Hanson's work, exhibited his sculptures in New York, originally at the Leo Castelli Gallery and then in 1969 at his own O.K. Harris Gallery. Robert Doty selected several of Hanson's life-size tableaux, *Riot, Accident*, and *Pieta*, for the Whitney Museum's *Human Concern/Personal Torment* exhibition which studied the sublimity of the grotesque and the social impact of the ugly. Violence was an important subject for artists during the Vietnam years.

Although Hanson claims that it is not his goal, his painfully perceptive social commentaries are startlingly illusionistic. The seated woman from *Woman and Dog* (Pl. 30) was cast from a live model. Hanson made negative molds in about six parts from which the resin positive mass is layered with fiberglass reinforcement. He added flesh-tinted "skin" and authentic clothing and apparatus. The dog was shaped by hand rather than

Fig. 175. Marisol. Women and Dog, *1964. Fur, leather, plaster, synthetic polymer, and wood, 72 × 82 × 16 inches. Gift of the Friends of the Whitney Museum of American Art, 64.17.*

cast from a mold, and Hanson meticulously applied hair clipped from a real dog. The completed figures resemble but do not replicate his models, and his sculptured figures may be a composite of several.

Although both Segal and Hanson cast from live models and group figures in life-size scenarios, their sculpture is quite different. With Segal one feels the intensity and the stillness of a quiet moment in urban daily life. Hanson's works of the 1970s focus on the archetypal common man who appears to him to be appalling in his banality and unaware of his absurdity. But how many enlightened perceptive geniuses can escape this ignoble dull vernacular of life? Hanson is aware of the dialectics of reality, of the bittersweet aspects of existence, and of the absurdity and the unremitting pressure of the commonplace and the prosaic.

Hanson's early reclining figures from tableaux such as *War* and *Riot* of 1967 and some of Segal's works echo the silhouettes and shapes of the plaster casts of the lava-covered panic-stricken bodies found at Pompeii in the nineteenth century. Baskin owned a portfolio of photographs of the plaster casts, Marino Marini acknowledged influence from them, and Hanson and Segal were obviously cognizant of them.

Fig. 176. Robert Graham. Untitled, *1968. Balsa wood, plexiglas, and wax, 12 × 30 × 15 inches. Gift of the Howard and Jean Lipman Foundation, Inc., 69.56.*

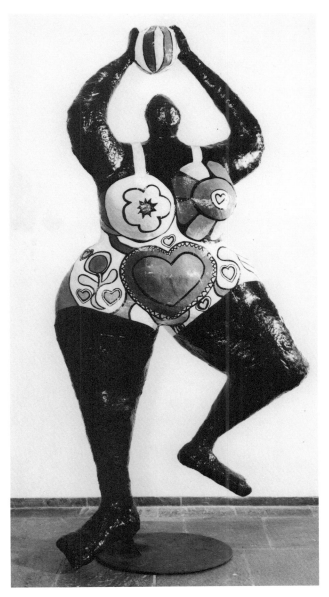

Fig. 177. *Niki de Saint Phalle.* Black Venus, 1967. *Painted polyester, 110 × 35 × 24 inches. Gift of the Howard and Jean Lipman Foundation, Inc., 68.73.*

Industrial and Innovative Sculptural Media

Niki de Saint Phalle's *Black Venus* (Fig. 177) and Frank Gallo's figures are more decorative and involved with playful activities. *Black Venus* is an odd juxtaposition of bright colorful pattern and the bulk of a twice life-size black-painted female figure.[32] Gallo's *The Swimmer* (Fig. 178) indicates his greater interest in svelte fashionable figures, popular imagery, and mild

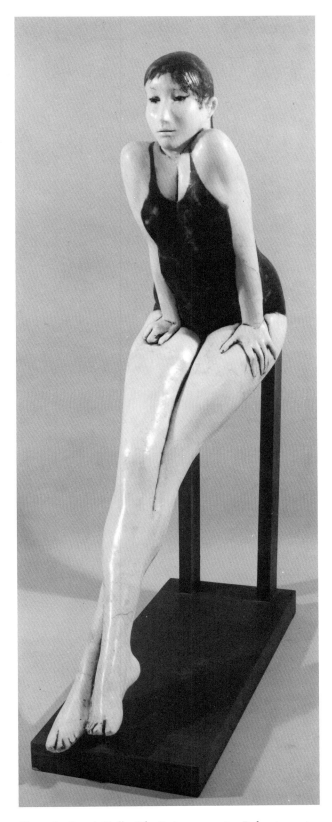

Fig. 178. *Frank Gallo.* The Swimmer, 1964. *Polyester resin, 65 × 16 × 41¼ inches. Gift of the Friends of the Whitney Museum of American Art and the artist, 65.25.*

Fig. 179. Richard Fleischner. Walking Figure, *1970. Bronze, copper, and silver, 7 ¼ × 12 ½ × 1 ¾ inches. Anonymous gift, 71.188.*

satire than in social realism. The illusionism of Gallo's sculptures is denied by the absence of a back — his epoxy people are relief-like hollow fragmented shells.

Richard Fleischner created both life-sized tableaux and microcosms on tiny reliefs. His *Walking Figure* of 1970 (Fig. 179) is a small cast-metal sculpture. Fleischner also made white plaster figures, polyester-resin life-size figures, environmental site-specific sculptures, and photographs.[33] His photograph *Handball Court Wall*, 1965, relates directly to his intimate hand-sized sculptures like *Walking Figure*. Both are organized as a plane (wall) of articulated bricks in front of which tiny figures move or play. The discrepancy in size between the hard-edged man-made objects and the minuscule human beings suggests a monumental size denied by the actual height of the relief sculpture (about eight inches.). In *Walking Figure*, Fleischner contrasted the regulated flat surface of the wall, with its exactly spaced incised lines, to the kneaded rough surface on which the tiny figure stands. The wall looks machine made but the modeler's nervous fingers are clear in the fingerprints which were pressed into the clay of the ground.

Fleischner stated that the major influence on his work during the late 1960s was the sculpture of Alberto Giacometti, especially *City Square* of 1948 (The Museum of Modern Art, New York). In both Fleischner's *Walking Figure* and Giacometti's *City Square*, the mood of the overwhelming loneliness and detachment of the people in modern society is evoked. In the post-World War II era, American sculptors exhibited an awareness of contemporary developments in European figurative sculpture but were not awed or overwhelmed by it. Picasso, Moore, Marini, Giacometti, and Richier

continued to improvise and discover creative potential in the human figure, but during the 1940s and 1950s European artists were probably more inspired by American abstract sculpture. The innovative work of the last twenty years has come particularly from American ceramic and resin figurative sculptors.

Manufactured and non-traditional materials and found objects have led to funky art, biting pessimism, and strange anthropomorphic distortions, especially during the 1960s. Assemblages like *Medusa* (Fig. 180) by Bruce Conner, a California artist, have been variously labeled neo-surrealist, funk, and a reflection of our junk culture.[34] Most of Peter Selz's descriptions of funk art apply to Conner's *Medusa*: antiform, bizarre, ugly, confident, defiant, and irrational.[35] Like some bloated creature washed up on the shore in a torn nylon bag, the sulptured wax head surrounded by junk is intentionally repulsive, a reminder of the grotesque qualities of our culture. Typical of avant-garde Bay Area artists, Conner did not care about public reactions or moralities and felt antipathy both toward permanence in sculpture and toward museums which cherished and sheltered objects.

The future of figurative sculpture depends upon the attitudes of new generations of artists. In 1968, after working in collage, painting, and other media, Nancy Grossman began to fabricate studded-leather heads over a wood core. Primarily images of fantasy, sculptures like *Head* (Fig. 181) are also real — the artist particularizes the nose for breathing and the mouth to project words. The zippers are closures, means of entry to the interior subconscious mind.[36] *Persistent Yet Unsuccessful Swordsman* (Fig. 182) by another eccen-

Fig. 180. Bruce Conner. Medusa, *1960. Cardboard, hair, nylon, wax, and wood, 10¾ × 11 × 22¼ inches. Gift of the Howard and Jean Lipman Foundation, Inc., 66.19.*

Fig. 181. Nancy Grossman. Head, *1968. Epoxy, leather, and wood, 16¼ × 6½ × 8½ inches. Gift of the Howard and Jean Lipman Foundation, Inc., 68.81.*

Fig. 182. Stephan Von Huene. Persistent Yet Unsuccessful Swordsman, *1965. Leather and wood, 28½ × 6¾ × 6½ inches. Gift of the Howard and Jean Lipman Foundation, Inc., 68.44.*

tric Californian, Stephan Von Huene, is an anatomical fragment (ostensibly a hand) and a double-entendre. The two-fingered hand can be analogized to two upraised female legs and the thumb to an out-of-scale penis. The lack of success of the man, suggested by the title, can be attributed to either the fixed yet distant position of the functioning parts or to the tightly laced corset encasing the arm (torso). His leather and wood *Hermaphroditic Horseback Rider* also has sexual connotations. Von Huene had a strong interest in sculpture as musical machine (e.g. *Pneumatic Music-Machine*, also called *Kaleidoscopic Dog*) as well as to figurative allusions.[37]

Mechanistic Man

The amalgamation of man and machine, the creation of humanoids in science fiction literature and films has echoes in sculpture. Ernest Trova invented a sleek, anthropomorphic, faceless, mock robot with his *Study/Falling Man 1966* (Fig. 183). Jan van der Marck described Trova's prostrate man as a frame of a rolling car from which valves protrude and a radiator grill becomes a crash helmet, a symbol of the paradox of modern man who is in control of his world yet controlled by it.[38] Just as one can view the human condition today optimistically or pessimistically, so Trova insists that, despite the ordeals he inflicts on his subject, the "Falling Man" image should be read in a

positive way. He claims to project man as master of his own fate, composed in defeat as well as in triumph, untouched by irrational panic, and cognizant of his coming and going on this planet as he is of time and eternity.[39]

Mechanistic man is also evoked by both the image and the title of Harold Tovish's *Vortex* of 1966 (Fig. 184). Vortex usually refers to the vacuum at the center of a liquid whirling in a circular motion. In contrast, the contour of Tovish's profile (self-portrait) appears to have been thrown by centrifugal force to the outer circumference of the circle while he remains solid, intact, and human within, at the core. The name and the interpretation may also have been inspired by vorticism which purported to relate art forms to the machine. In Tovish's bronze and wood *Interior, I,* 1962 (Hirshhorn Museum and Sculpture Garden), the relief sculpture of his face emerges from behind a board. Tovish credited Franz Kafka with teaching him that the comical and the sinister can be identical.[40]

Fig. 183. *Ernest Trova.* Study/Falling Man 1966, 1966. *Silicon bronze, 21 × 78½ × 31 inches. Gift of Howard and Jean Lipman, 67.12.*

Fig. 184. *Harold Tovish.* Vortex, 1966. *Bronze, 66 × 18 × 18 inches. Gift of an anonymous donor and purchase, 66.132.*

Ceramic Sculpture

While ceramic sculpture has been created throughout the century, there appears to be an upsurge of interest and innovation in recent years, notably by Robert Arneson and Mary Frank. Reuben Nakian has used the medium creatively for decades. Nakian's *Pastorale* of 1950 (Fig. 185) is a sculptor's drawing gouged out of and added to a small disc-like slab of terra-cotta similar

to the reliefs in the *Europa* series which he created between 1948 and 1965. The scratch relief plaques display a Rubenesque delight in voluptuous female sensuality, though *Pastorale* is not as erotic as the mythological figures of his *Europa* series.

A little-known aspect of Louise Nevelson's sculptural oeuvre is her early work which included terra-cotta figures.[41] The several individual units of *Moving — Static — Moving Figures* of about 1945 (Fig. 186) are solid blocky masses, cast and assembled vertically on dowel-like cores. Like Nakian's later intaglio reliefs, Nevelson incised design lines in the terra-cotta. For her, clear continuous lines indicate facial features and abstractions of other anatomical parts:

Life drawings by Nevelson dating from the 1930s in the Whitney Museum collection consist of sparse lines signifying abstracted, partial female figures. These lyrical curvilinear drawings, within the ambience of Matisse and Lachaise, are highly individual, exciting, and different from her early figurative sculptures composed of sharp, angular, blocky geometric masses.

Robert Arneson is a pioneering ceramicist from California who innovated in his own work a transition from Abstract Expressionist (1950s) to Pop and funk (1960s) to a highly personalized style (1970s) that defies labeling.[42] His recent monumental portrait heads are both heroes and clowns (the name given to an exhibition of his portraits at the Frumkin Gallery in New York last year). Although polychrome had been used early in the century by such American sculptors as Max Weber (1915) and John Storrs (1919), and ceramic was a natural medium for color in sculpture, Nakian, Noguchi, Frank, and Nevelson did not add paint or chromatic glazes to their ceramic sculptures, depending instead on a range of values to articulate forms. Arneson's sculptures are colorful but not overpainted like much of Abstract Expressionist and funk ceramic sculpture. *Whistling in the Dark* (Pl. 31) is for Arneson a relatively tame self-portrait.[43] It includes no gesture, antisocial or otherwise; the head is upright and intact (no one is swimming inside), and the face is not twisted or contorted, a twentieth-century version of the obsession with self-portraits of such artists as Rembrandt and van Gogh. Arneson initiated *Whistling in the Dark* as a self-portrait; the particular facial contortions were inspired by a magazine photograph. Arneson explained that when you do not know what you are doing you are "whistling in the dark" and that the sculpture is a symbol of capturing those places or qualities that do not

Fig. 185. Reuben Nakian. Pastorale, *1950. Terra-cotta, 15 × 20 × 9 inches. Gift of the artist in memory of Juliana Force, 63.47.*

exist, the gaps between assurances. He created the head in terra-cotta, closed the damper of the gas kiln more than usual, which reduced the iron in the clay to a metal and increased the amount of carbon in the clay and darkened it. When I asked him the significance of the yellow polychrome, Arneson answered, "What other color would you use for a whistler than canary yellow?"[44]

Like Arneson, Mary Frank brought dynamic inno-vations to her sculpture and to ceramics. Her torn-clay organic terra-cotta fragments are unprecedented — that is not to say that echoes of historical sculptural morphology cannot be cited. She is fascinated with fossils, natural living beings, and objects in the American Museum of Natural History. Metamorphosis, figures in motion, and process are critical to her, and some of her figurative sculptures like *Swimmer* (Pl. 32) seem infinite.[45] She does not work within a controlling contour line or framework. It is instead a dynamic assemblage of vital fragments. Working in clay is so much more tenuous than immediately casting a plaster positive of the form: "If it will survive the firing . . .," Mary Frank keeps saying about works in her studio still unbaked.[46] Several times a year she fires the kiln at her country house in the Catskills. Once they have been baked, the assemblages of terra-cotta parts are still fragile and will provide a challenge to curators. Fascinated with Nakian's free-form terra-cotta slabs incised with a stylus, Frank experimented with the process and in 1969 began working directly in terra-cotta figures. In 1974 she increased her scale to life-size figures like *Swimmer*. Eleanor Munro, who has interviewed Frank

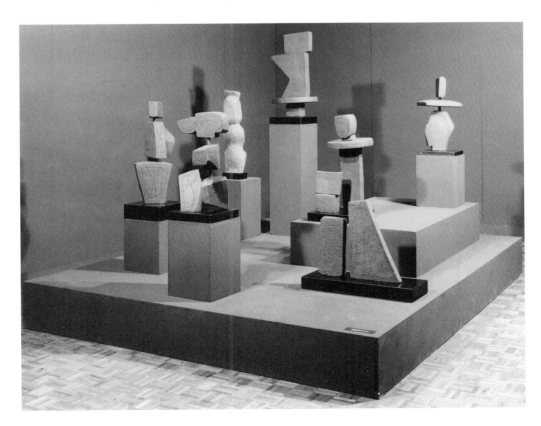

Fig. 186. Louise Nevelson. Moving — Static — Moving Fig-ures, *c. 1945. Terra-cotta; fifteen individual pieces, sizes vary. Gift of the artist, 69.159.*

Fig. 187. Bruno Lucchesi. Woman Undressing, *1964. Bronze relief, 27¾ × 17¾ inches. Gift of Mr. and Mrs. Haim Shwisha, 65.91.*

extensively, described them in her recent book, *Originals*, as "Hollow, all disconnections, empty space and impermanent manifestations of matter, the figures hovered somewhere between worlds, as living people standing in sea water with their arms bent seem to belong wholly to neither the land nor the air."[47]

The Persistence of Tradition

Frank's, Arneson's, and Stephen De Staebler's ceramic works suggest one dynamic new interpretation of the figure in the face of equally exciting developments in abstract and environmental sculpture. In 1961 David Smith stated that artists created abstractions because that was the valid direction of art: "Nor will we go back, in either sculpture or painting, to any form of representation."[48] Smith was expressing the philosophy dominant among abstract artists twenty years ago. In Clement Greenberg's terms, complete abstraction was historically determined to dominate the arts. He wrote

in 1948, "The human body is no longer postulated as the agent of space in either pictorial or sculptural art; now it is eyesight alone."[49] Greenberg was also perceptive enough to realize that by driving a tendency to its furthest extreme one finds one's self abruptly going in the opposite direction.[50] The more abstract and pure art became, the greater the urgency for its opposite (representational art) to re-emerge. For Greenberg, the whole history of art is a matter of dialectical fluctuation between abstraction and representation, a case of ironical conversion of opposites.[51]

The essence of post-modern realism is the acceptance of the validity of a wide range of styles. Fine, sensitive figurative sculptors like Richard Miller and Bruno Lucchesi (Fig. 187) are not ignored or castigated because they are working within the traditional vocabulary of modeled sculpture. The subject of the last frame of Lucchesi's bronze relief *Woman Undressing* is the same as Robert Graham's *Untitled* (Fig. 176) or John De Andrea's *Sleeping Woman on Bed*, but the means and mode are different. His fusion of motion and form is different from Trova's yet he convincingly depicts fluid graceful movement. Richard Miller's sculptures appeal to conservative and avant-garde connoisseurs alike.[52] His nude female figures are more realistic than their academic counterparts, and his interest in the transparency, framing potential, and abstract form and space of the bronze grids, which provide the environment for his figures, is modern. Lucchesi and Miller optimistically reaffirm the positive qualities inherent in human beings.

Recently there has been a revival of interest in a more personal set of symbols which includes individual unique figures or partial figures.[53] Few figurative sculptors perceive the creation of the human image as their only end product. There is usually significant spiritual content that may or may not be readily communicated to the viewer. A more pluralistic view of art, with its proliferation of accepted styles and media, is the direction of the immediate future. The feeling that it is necessary to be modern is waning.

At the onset of a new decade and of the beginning of the end of the twentieth century, one can safely predict that dynamic and exciting figurative sculptures will be created in ceramic and polyester resin, that the poetic beauty of traditional bronze casts of the nude or partially draped human figure will continue, and that the amalgamation of man and machine will provoke creative genius. The figure is a positive continuing mode of representation for artists.

Notes

Chapter I
Gertrude Vanderbilt Whitney as Patron

The most frequently consulted sources for this chapter are:

The chronological files of documentary material on and personal journals of Gertrude Vanderbilt Whitney, organized by Flora Miller Irving during the 1970s. All letters cited herein with no locus can be found in the Whitney Family Papers, formerly in Mrs. Whitney's studio in Old Westbury, Long Island, but recently donated to the Archives of American Art, Smithsonian Institution, Washington, D.C.

B. H. Friedman, *Gertrude Vanderbilt Whitney: A Biography* (Garden City, N.Y.: Doubleday, 1978) Many facts were found in the Whitney Family Papers and published verbatim in Friedman's biography.

Daty Healy, "A History of the Whitney Museum of American Art, 1930–54" (Ph.D. dissertation, New York University, 1960).

Juliana Force and American Art: A Memorial Exhibition, September 24–October 30, 1949, essays by Hermon More and Lloyd Goodrich, John Sloan, Guy Pène du Bois, Alexander Brook, and Forbes Watson, (New York: Whitney Museum of American Art, 1949).

1. Henry McBride, "Hail and Farewell," *New York Sun*, April 24, 1942.

2. John Sloan, in *Juliana Force and American Art*, pp. 35–36.

3. Malvina Hoffman, quoted in B. H. Friedman, *Gertrude Vanderbilt Whitney*, p. 246.

4. Letter, Eugene Speicher to the editor, *New York Herald Tribune*, April 20, 1942.

5. Letter, Arthur B. Davies to Mrs. Whitney, April 10, 1907.

6. "Objects of the Society," Article I of the *By-Laws of the Society of Independent Artists*, 1917.

7. The four works were *Floating Ice* (by 1916, exhibited as *Winter on the River*, the title that has been used ever since) by Ernest Lawson, *Laughing Child* by Robert Henri, *Woman with Goose* by George Luks, and *Girl in Blue* (now titled *Revue*) by Everett Shinn.

8. Edith DeShazo, *Everett Shinn, 1876–1953: A Figure in His Time* (New York: Clarkson N. Potter, 1974), p. 65.

9. Gertrude Vanderbilt Whitney's personal papers also include minutes of the February 14, 1906, the March 16, 1906, and the December 11, 1906, meetings of the National Sculpture Society (Karl Bitter presiding), letters from the National Sculpture Society Exhibition Committee (signed by Daniel Chester French, Chairman;

Thomas Hastings; Herbert Adams; Solon Borglum; and Karl Bitter), and news clippings. See also James M. Dennis, *Karl Bitter: Architectural Sculptor 1867–1915* (Madison, Milwaukee, and London: University of Wisconsin Press, 1967), pp. 246–47, and footnotes.

10. Letter, Daniel Chester French to Mrs. Whitney, April 19, 1907.

11. Dana H. Carroll, "Progress in the National Academy Exhibitions," *Arts and Decoration*, 3, no. 7 (1913), p. 227.

12. The other recipients were Harry Sternfeld (1914) and Ernest E. Weihe (1919).

13. John Sloan, in *Juliana Force and American Art*, p. 36.

14. Goodrich and More, in *Juliana Force and American Art*, p. 13.

15. Interview with Mrs. Whitney, reported with variations in *American Art News*, 15 (March 10, 1917); and the *New York Herald*, February 18, 1917; and partially quoted in *Juliana Force and American Art*, pp. 15–16; and Daty Healy, "History," pp. 46–47. Helen Foster Burnett, J. Sanford Salters, E. M. Gattle, Comm. J. Stuart Blackton, Otto H. Kahn, C. G. Charles, Paul G. Baumgarten, Gertrude V. Whitney, and the Society of Friends of Young Artists offered prizes to these competitions.

16. In May 1923 the Club was transferred to 10 West Eighth Street, adjacent to the Whitney Studio. During October 1925 the Club moved again, this time to 14 West Eighth Street, while Number 10 was being renovated, and returning to the new galleries at 10 West Eighth during December 1927.

17. Alexander Brook, in *Juliana Force and American Art*, p. 52.

18. Letter, Arthur Lee to Mrs. Whitney, September 18, 1907.

19. Letter, Hendrik C. Andersen to Mrs. Whitney, November 27, 1907.

20. Letter, Morgan Russell to Mrs. Whitney, April 1, 1910. See also Gail Levin, *Synchromism and American Color Abstraction, 1910–1925* (New York: George Braziller in association with the Whitney Museum of American Art, 1978).

21. Letter, Thomas Hart Benton to Juliana Force, late 1930s, Artists' Files, Whitney Museum of American Art.

22. The firm of Delano and Aldrich built a townhouse at 121 East Seventieth Street in 1910, built the residence of Willard and Dorothy Whitney Straight at the corner of Fifth Avenue and Ninety-fourth Street during 1913–15, restored the Bartow-Pell Mansion in 1914, and built Greenwich House (on Barrow Street between Fourth and Bleecker Streets) in 1917.

23. Paul Chalfin had decorated the interior of Vizcaya, the estate of James Deering in Miami, Florida, and during 1919–39 was curator of Japanese art at the Museum of Fine Arts, Boston. In 1936 he and Mrs. Whitney spent days designing the installation of her one-woman exhibition of sculpture at Knoedler.

24. Howard Cushing was a frequent escort during Gertrude's debutante years, and they resumed their friendship in Paris during the 1890s while he studied painting at the Académie Julian. Cushing nurtured Gertrude's interest in art during the late 1890s, a time when she was searching for a direction in her own life. In 1900 when she decided upon sculpture, he arranged for her to study modeling with Hendrik C. Andersen.

25. Robert Chanler was an artist with whom Mrs. Whitney frequently attended art exhibitions. Chanler had painted murals in Stanford White's Colony Club at Thirtieth Street and Madison Avenue, and his nine screens painted with exotic tropical plants and birds attracted considerable attention at the 1913 Armory Show.

26. Letter, Maxfield Parrish to Mrs. Whitney, July 19, 1912, quoted in Coy Ludwig, *Maxfield Parrish* (New York: Watson-Guptill, 1973), p. 160.

27. Ibid.

28. Forbes Watson, in *Juliana Force and American Art*, p. 59.

29. Mrs. Whitney quoted in the *New York Herald Tribune*, November 19, 1931.

30. Lloyd Goodrich, "The Whitney's Battle for U.S. Art," *Art News*, 53 (November 1954), pp. 70–71.

Chapter II
Painting, 1900–1940

1. See Joseph J. Kwiat, "Robert Henri and the Emerson-Whitman Tradition," *PMLA*, 71 (September 1956), pp. 617–36. Kwiat quotes Sloan, who said to the former in 1948: "Henri . . . was my father in Art. I got my Whitman through him. Whitman's love for all men, his beautiful attitude toward the physical, the absence of prudishness . . . all this represented a force of freedom. . . . I liked what resulted from his descriptive catalogues of life. They helped to interest me in the details of life around me."

2. Erwin Panofsky, "The History of Art as a Humanistic Discipline," in *Meaning in the Visual Arts* (New York: Anchor Books, 1955), p. 2, first published in *The Meaning of the Humanities*, ed. by T. M. Greene (Princeton, N.J.: Princeton University Press, 1938), pp. 91–118. Panofsky gives a historical definition of human values and human limitations; in short, human values are what distinguish man from the beasts; human limitations are what distinguish man from God.

3. The definition, the concept, and the philosophy as it is lived by humanists is not free from ambiguities and contradictions. For example, acceptance of human limitations also often means being tolerant of society's limitations, which because it has not yet eliminated economic and political injustices, does in practice deny the dignity of some of the population.

4. See Raymond Williams, *Keywords: A Vocabulary of Culture and Society* (New York: Oxford University Press, 1976), pp. 133–36, regarding the changing definition of *individual* and *individualism* through the centuries; see pp. 121–24 for a brief description of the changing definition of *humanity*, including *humanism*.

5. Charles H. Caffin, *The Story of American Painting* (New York: Frederick A. Stokes Co., 1907), pp. 258–61.

6. As of this writing I have not charted the relative frequencies of each term in each decade of the twentieth century. Clement Greenberg, in his essay "Modern and Post-Modern," *Arts Magazine*, 54 (February 1980), pp. 64–66 (first presented as a lecture on October 31, 1979), is unconcerned with the entrance of the term "modernism" into art history, but sees it as roughly equivalent to "art for art's sake." Greenberg states (p. 65): "But underneath all the invocations, the explanations and the rationalizations, there was the 'simple' aspiration to quality, to aesthetic value and excellence for its own sake, as end in itself. Art for art's sake. Modernism settled in in painting with Impressionism, and with that, art for art's sake." *Modernism*, whether used to define a historical period, a style, a mannerism, or a world view, can be deeply complex depending upon which country is being investigated and who is to be believed concerning the definition. Malcolm Bradbury and James McFarlane deal with this complexity in their introductory essay, "The Name and Nature of Modernism," in *Modernism*, ed. by Bradbury and McFarlane (London: Penguin Books, 1976). The authors even suggest *two* modernisms, one arcane, private, and conservative, and the second experimental and progressive. In my discussion, *modernism* will be defined as it has come to be understood by American artists and critics, particularly those under the influence of Clement Greenberg, as a "concern with form," although "self-definition" has also been advanced by Greenberg. Sam Hunter and H. H. Arnason, both of whom have written influential textbooks, would include "experimentalism" in their definition. See Chapter IV, note 77. See also various articles in *New Literary History* which have discussed modernism.

7. Clive Bell, "Aesthetics and Post-Impressionism," in *Art*, first published in 1913 (New York: Capricorn Books, 1958), p. 38. Roberta Tarbell reminds me that all of the early twentieth-century sculptors referred to the art which was concerned with form as "Post-Impressionist."

8. Ibid, pp. 38–39.

9. Bradbury and McFarlane, *Modernism*, p. 25, have pointed out that: "One of the word's associations is with the coming of a new era of high aesthetic self-consciousness and non-representationalism, in which art turns from realism and humanistic representation towards style, technique, and spatial form in pursuit of a deeper penetration of life." The "pursuit of a deeper penetration of life," however, suggests expressionism, which, according to Bradbury and McFarlane, does not characterize the Anglo-American tradition of modernism. They quote Graham Hough, *Image and Experience: Studies in a Literary Revolution* (London, 1960), p. 8: "Expressionism in art has Germanic connotations, and the literature we are considering is Anglo-American profoundly influenced by France. And Expressionism is a name for a kind of critical doctrine, a doctrine of personality and self-expression, that is precisely the one *not* held by our twentieth-century school." New York School Abstract Expressionism was indeed a form of Expressionism, recognized at the time as such, but later often discussed in terms of its formal qualities only. (See Chapter IV, "Painting, 1941–1980."

10. Milton W. Brown, *American Painting from the Armory Show to the Depression* (Princeton, N.J.: Princeton University Press, 1955), pp. 46–51. See also Milton W. Brown, *The Story of the Armory Show* (New York: Joseph H. Hirshhorn Foundation, 1963). For a list of exhibitions at Stieglitz's "291," see Dorothy Norman, *Alfred Stieglitz: An American Seer* (New York: Random House, 1973), pp. 232–33.

11. Chase joined the group in 1902 when Twachtman died. See Patricia Hills, *Turn-of-the-Century America: Paintings, Graphics, Photographs, 1890–1910* (New York: Whitney Museum of American Art, 1977), pp. 73–74.

12. Written November 8, 1906, *John Sloan's New York Scene*, ed. by Bruce St. John (New York: Harper & Row, 1965), p. 77.

13. See Chapter I, "Gertrude Vanderbilt Whitney as Patron," by Roberta K. Tarbell.

14. See Robert Henri, *The Art Spirit: Notes, Articles, Fragments of Letters and Talks to Students, Bearing on the Concept and Technique of Picture Making, and the Study of Art Generally, and on Appreciation,* compiled by Margery Ryerson (Philadelphia: J. B. Lippincott, 1951), pp. 138, 142.

15. Rockwell Kent, *It's Me O Lord: The Autobiography of Rockwell Kent* (New York: Dodd, Mead, 1955), p. 81.

16. Guy Pène du Bois, *Artists Say the Silliest Things* (New York: American Artists Group and Duell, Sloan and Pearce, 1940), p. 81.

17. Du Bois, *Artists Say the Silliest Things,* p. 82.

18. *John Sloan's New York Scene*, p. 38.

19. Ibid., p. 13.

20. Ibid., p. 349.

21. See Patricia Hills, "John Sloan's Images of Working-Class Women: A Case Study of the Roles and Interrelationships of Politics, Personality and Patrons in the Development of Sloan's Art, 1905–16," *Prospects*, 5 (1980), pp. 157–96.

22. Bennard B. Perlman, *The Immortal Eight: American Painting from Eakins to the Armory Show, 1870–1913* (Westport, Conn.: North Light Publishers, 1979), p. 205.

23. Both Henri and Sloan were influenced by the Maratta System of colors. Several references can be found in Sloan's diary published in *John Sloan's New York Scene*. See also William Innes Homer with the assistance of Violet Organ, *Robert Henri and His Circle*, (Ithaca, N.Y.: Cornell University Press, 1969).

24. See Barbara Christie Kaiser, "Edward Hopper: In Time, Out of Time" (M.A. thesis, Hunter College, City University of New York, 1968), for a discussion of the theme of light in Hopper's paintings.

25. Statement by Bernard Karfiol, p. 3, given to Lloyd Goodrich in 1946 when he was preparing the Whitney Museum *Pioneers of Modern Art in America* exhibition, Artists' Files, Whitney Museum of American Art.

26. Norman, *Alfred Stieglitz*, pp. 234–35.

27. See Robert Goldwater, *Primitivism in Modern Art*, rev. ed. (New York: Vintage Books, 1967), pp. 89–95.

28. Man Ray, *Self-Portrait* (Boston: Little, Brown, 1963), p. 30.

29. Reproduced in Nancy J. Rivard, "American Paintings at the Detroit Institute of Arts," *Antiques*, 114 (November 1978), p. 1054.

30. Morris Kantor's *Two Figure Arrangement* of 1923 (Whitney Museum of American Art) is a more sober, splintered figure study.

31. Interview by Patricia Hills with Raphael Soyer, December 11, 1979.

32. See Alfred Werner, "Ghetto Graduates," *The American Art Journal*, 5 (November 1973), pp. 76–77, regarding the Educational Alliance Art School. Other important teaching institutions were Cooper Union in lower Manhattan and Pratt Institute in Brooklyn.

33. Regarding Chase's teaching at the school, see Katherine Metcalf Roof, *The Life and Art of William Merritt Chase*, first published in 1917 (New York: Hacker Art Books, 1975), p. 171. Regarding Henri's

teaching there, see Perlman, *The Immortal Eight*, pp. 87–93, and p. 189. For the dates of Miller's tenure at the New York School of Art, see Lincoln Rothschild, *To Keep Art Alive: The Effort of Kenneth Hayes Miller, American Painter (1876–1952)* (Cranbury, N.J.: Associated University Presses, 1974), p. 25.

34. Kent, *It's Me O Lord*, p. 83.

35. Lawrence Campbell, "Foreword," in *The Hundredth Anniversary Exhibition of Paintings and Sculptures by 100 Artists Associated with the Art Students League of New York*, (New York: Kennedy Galleries, 1975), p. 16. See p. 168 for dates of Miller's teaching at the League.

36. See Rothschild, *To Keep Art Alive*, pp. 57–65, regarding students and followers.

37. Statement by Lloyd Goodrich in *Kenneth Hayes Miller*, catalogue of the memorial exhibition sponsored by the Art Students League held in the galleries of the National Academy of Design, September 23–October 11, 1953.

38. Thomas Hart Benton was also concerned with the tradition of composition in Western painting; see Mark Roskill, "Jackson Pollock, Thomas Hart Benton, and Cubism: A Note," *Arts Magazine*, 53 (March 1979), p. 144.

39. Culled from *The Hundredth Anniversary Exhibition of the Art Students League*.

40. See Roberta K. Tarbell, *Peggy Bacon: Personalities and Places* (Washington, D.C.: National Collection of Fine Arts, Smithsonian Institution, 1975), pp. 61–62.

41. Brown, *American Painting from the Armory Show to the Depression*, pp. 154–59.

42. See Alfred Werner, "Pascin's American Years," *The American Art Journal*, 4 (Spring 1972), pp. 87–101.

43. Interview by Patricia Hills with Raphael Soyer, December 11, 1979.

44. Brown, *American Painting from the Armory Show to the Depression*, p. 154.

45. See Matthew Baigell, *The American Scene: American Painting of the 1930s* (New York: Praeger, 1974), and David Shapiro, *Social Realism: Art as a Weapon* (New York: Frederick Ungar, 1973). Baigell (p. 18) maintains that "the first clear evidence of the movement known as the *American Scene* appeared during the exhibition season of 1931–32," in part the result of "an explosive hostility to European modernism" during the 1930–31 exhibition season. However, I am extending the time frame to include those paintings of the American scene done in the 1920s as well. Baigell includes Social Realism in his category of American Scene, whereas Shapiro treats Social Realism as a separate category, which is my own approach. Regionalism is the term often given to small town or rural American Scene painting, as opposed to the urban American Scene painting of artists such as Marsh.

46. Du Bois, *Artists Say the Silliest Things*, p. 128.

47. See Lawrence Alloway, "Art," *The Nation*, April 14, 1979, pp. 412–13.

48. See "Jack Dempsey," *Current Biography*, 6 (February 1945), p. 13.

49. Edward Alden Jewell, in the *New York Times*, November 4, 1928, section 8, p. 12, a reference noted in Laurence E. Schmeckebier, *John Steuart Curry's Pageant of America* (New York: American Artists Group, 1943), p. 41. Schmeckebier also notes, p. 42, that in the fall of 1928, Curry "became a member of the Whitney Studio Club of New York and was granted a weekly stipend of $50 by Mrs. Harry Payne Whitney to support him for the next two years."

50. Thomas Craven, *Modern Art: The Men, The Movements, The Meaning* (New York: Simon and Schuster, 1934), p. 271. The regionalist Grant Wood, who came closest to emulating Art Deco mannerisms (although his style has clear affinities to the Neue Sachlichkeit German painter Otto Dix) did not move in the direction of naturalism but maintained a schematic decorative style which included diminishing repetitive forms, clear outlines, and simplification and regularization of detail—traits to which Craven was opposed.

51. Ibid, p. 272.

52. Matthew Baigell and Allen Kaufman, "Missouri Murals: Another Look at Benton," *Art Journal*, 36 (Summer 1977), pp. 314–21.

53. Marlene Park and Gerald E. Markowitz, *New Deal for Art: The Government Art Projects of the 1930s with Examples from New York City & State* (Hamilton, N.Y.: Gallery Association of New York State, 1977), p. 1.

54. Norman Barr, "Statement," in *New York City WPA Art*, exhibition catalogue (New York: Parsons School of Design, 1977), p. xiii.

55. The information here and in the following paragraphs regarding the projects is drawn from Park and Markowitz, *New Deal for Art*, pp. xii–xiii, 1–6. See also Francis V. O'Connor, ed., *Art for the Millions: Essays from the 1930s by Artists and Administrators of the WPA Federal Art Project* (Greenwich, Conn.: New York Graphic Society, 1973), and Richard D. McKinzie, *The New Deal for Artists* (Princeton, N.J.: Princeton University Press, 1973).

56. Baigell, *The American Scene*, p. 46.

57. See Gerald M. Monroe, "Art Front," *Archives of American Art Journal*, 13, no. 3 (1973), pp. 13–19. A complete set of *Art Front* is on microfilm at the Archives of American Art.

58. "Art: U.S. Scene," *Time*, December 24, 1934, p. 24.

59. Moses Soyer, "Review of Whitney Biennial," *Art Front*, January 1935. In the same issue Soyer discussed his own painting: "The absence of paintings dealing with the working class should not be taken as a lack of class-consciousness on the part of Moses Soyer but rather as an uncertainty in his own powers, an almost unconscious reluctance to tackle such a serious theme."

60. Ibid.

61. *Art Front*, April 1936.

62. Interview by Patricia Hills with Raphael Soyer, December 11, 1979. The Shahn photograph titled *The Bowery, New York City* of about 1936 is reproduced in *The Photographic Eye of Ben Shahn*, ed. by Davis Pratt (Cambridge, Mass.: Harvard University Press, 1975), p. 22.

63. See "Paul Cadmus" in *Current Biography*, 3 (July 1942), p. 124. In 1934 Cadmus's painting *The Fleet's In* had stirred a similar controversy with the Navy department.

64. Paul Cadmus, "Credo," in exhibition catalogue, Midtown Galleries, New York, 1937.

65. Louis Lozowick, *Modern Russian Art* (New York: Societe Anonyme, Museum of Modern Art, 1925), p. 30. I am grateful to Susan E. Cohen for bringing this quotation to my attention.

66. David and Cecile Shapiro, "Abstract Expressionism: The Politics of Apolitical Painting," *Prospects*, 3 (1977), p. 209, have defined Social Realism as "programmatically critical of capitalism. Its stated aim, in fact, is to serve as an instrument in the social change that will disestablish capitalism."

67. Shapiro, *Social Realism: Art as a Weapon*, p. 28, note 1, makes the distinction clear between Social Realism and Socialist Realism: "Social Realism and Social*ist* Realism are different from each other. Social Realism, opposed to the ruling class and its mores, predominantly selects as its subject matter the negative aspects of life under capitalism: Labor conflicts, poverty, the greediness of capitalists, the nobility of long-suffering workers. Socialist Realism, as it has developed in the Soviet Union, supports the ruling class and the form of government. It selects as its subject matter the positive aspects of life under socialism: happy, cooperating workers, the beauty of factory and countryside, well-fed, healthy children, and so on. Mexican Social Realism, somewhere between these two, shows both the struggle of the people to gain control of the means of production and some of the fruits of that power."

68. Lynchings of black Americans and lynching parties in the South were a reality as well as the subject for artists during the 1930s. Seymour Lipton and Isamu Noguchi did sculptures on the theme; Arnold Blanch, John Steuart Curry, Paul Cadmus, and Louis Lozowick did paintings, drawings, and prints. Oliver W. Larkin, in *Art and Life in America*, revised and enlarged ed. (New York: Holt, Rinehart and Winston, 1960), p. 431, noted Herman Baron's remark that the social artist "seemed to concentrate on three themes: policemen beating strikers, lynchings, and bloated capitalists."

69. See Francis Russell, *Tragedy in Dedham: The Story of the Sacco-Vanzetti Case* (London: Longmans, Green and co., 1962).

70. Quoted in ibid., p. 388.

71. A notable exception is Philip Evergood's *American Tragedy* of 1937 (private collection). See Patricia Hills, "Philip Evergood's 'American Tragedy'; The Poetics of Ugliness, the Politics of Anger," *Arts Magazine*, 54 (February 1980), pp. 138–42.

72. Transcript 2, p. 52, of interview with Philip Evergood by John I. H. Baur, then preparing his catalogue for the Philip Evergood exhibition at the Whitney Museum of American Art, 1960.

73. See Lloyd Goodrich, *Edwin Dickinson* (New York: Whitney Museum of American Art, 1965).

74. Quoted in Jeffrey Wechsler, *Surrealism and American Art, 1931–1947* (New Brunswick, N.J.: Rutgers University, 1976), p. 39, from O. Louis Guglielmi, "I Hope To Sing Again," *Magazine of Art*, May 1944, pp. 175–76.

75. Grace Clement, "New Content—New Form," *Art Front*, March 1936, p. 9.

76. I am grateful to Amy Lighthill for informing me that Blume did not give titles to his paintings; his dealer did, but Blume seems not to have objected. Blume's most political painting was his depiction of Mussolini's Italy in *The Eternal City* of 1934–37, shown in the Whitney Museum Annual of 1940 and subsequently acquired by the Museum of Modern Art in 1942.

77. The significance of the number "29" is unclear. One searches the newspapers for relevant items. Articles with the dateline April 29, 1937, reported in the April 30 *New York Times*, chronicle that: 1) the air attack was now known to have been ordered by Goering, who "took the initiative in ordering that Guernica be bombed and destroyed. He intended to give a practical demonstration of what air warfare can achieve and vindicate some of his strategical and tactical conceptions;" and 2) there were food shortages in Bilbao, a city near Guernica.

78. Observed by Baur, in Lloyd Goodrich and John I. H. Baur, *American Art of Our Century* (New York: Praeger, 1961), p. 153.

79. Regarding the disillusionment, some artists and critics maintain that the Hitler-Stalin pact of 1939 was responsible for destroying the optimism in the art community about the Soviet Union and about the ideology of communism. Others, however, maintain that the negative reaction was short lived, ending when Hitler invaded Russia. A decisive split in the art community came in April 1940 in reaction to the Soviet Union's invasion of Finland, when a number of members of the American Artists Congress resigned in protest against the leadership of the Congress who refused to condemn the Soviet Union. Peyton Boswell, Jr., of *Art Digest* accused the leadership of being Stalinists (May 1, 1940 issue), while the *Daily Worker* called the break-away opposition Trotskyites. As of this writing no one has really wanted to untangle the political controversies, nor has the influence of Trotsky and his followers on the art of the 1940s and early 1950s been satisfactorily investigated. Such controversies are, however, but one aspect of the total picture.

Chapter III
Sculpture, 1900–1940

1. William Paley's *Natural Theology* was subtitled "Evidences of the Existence and Attributes of the Deity Collected from the Appearance of Nature" and was published in London in 1802.

2. B. H. Friedman's biography, *Gertrude Vanderbilt Whitney* (Garden City, N.Y.: Doubleday, 1978), provides chronological material on Mrs. Whitney's development as a sculptor; no definitive critical study of her art has been written. The catalogue *Memorial Exhibition: Gertrude Vanderbilt Whitney* (New York: Whitney Museum of American Art, 1943) lists and illustrates many of her sculptures.

3. The other sculptors included in the *Exhibition of Independent Artists*, held from April 1 to 27, 1910, were the animalier Albert Humphreys, James Earle Fraser, Robert Aitken, Gutzon Borglum, Louis Potter, and Dorothy Rice. See *The Fiftieth Anniversary of the Exhibition of Independent Artists in 1910* (Wilmington: Delaware Art Center, 1960).

4. The monumental marble fountain, commissioned by the Arlington Hotel in Washington, D.C., was given to McGill University, Montreal, Canada, in 1931, and it is still in situ. A bronze replica is located in Lima, Peru, and bronze casts of individual caryatid figures can be found in a private collection, New York, at Brookgreen Gardens, South Carolina, and in the Metropolitan Museum of Art. See Beatrice Gilman Proske, *Brookgreen Gardens Sculpture* (Brookgreen Gardens, 1968), pp. 206–208; and Albert TenEyck Gardner, *American Sculpture* (New York: Metropolitan Museum of Art, 1965), p. 130.

5. See Guy Pène du Bois, "Mrs. Whitney's Journey in Art," *International Studio*, 76 (January 1923), pp. 351–54. Mrs. Whitney's bronze studies of soldiers were exhibited at the Whitney Studio in 1919.

6. Jo Davidson Papers, Manuscript Division of the Library of Congress, Washington, D.C.; quoted in Dorothy V. Taylor, "Jo Davidson: the Paris Peace Conference Busts of June 1919" (M.A. thesis, University of Delaware, Newark, 1972), p. 6.

7. First draft of *Between Sittings* (subsequently published by Dial Press, 1951), Jo Davidson Papers, Library of Congress.

8. Interview by B. H. Friedman with Mrs. Michael Brenner, filed with Whitney Family Papers, and mentioned in Friedman, *Gertrude Vanderbilt Whitney*, p. 265. See also Catherine Turrill, "Michael Brenner (1885–1969)," in *Avant-Garde Painting & Sculpture in America 1910–25* (Wilmington: Delaware Art Museum and the University of Delaware, 1975), pp. 36–37.

9. R. G. McIntyre, "The Broad Vision of Abastenia Eberle," *Arts and Decoration*, 3 (August 1913), p. 136.

10. Casts of *The Windy Doorstep* are located at Brookgreen Gardens (see Proske, *Brookgreen Gardens Sculpture*, pp. 152–54), Baltimore Museum of Art, Newark Museum, Carnegie Institute, and Worcester Art Museum.

11. Also titled *Girl Skating, Roller Skater*, and *Girl with Roller Skate*. A signed and dated cast is in the Metropolitan Museum of Art (acquired 1909; see Gardner, *American Sculpture*, p. 136), and another of the eight casts is owned by the Rhode Island School of Design.

12. The first version of *The Bomb Thrower* was exhibited at the Berlin Photographic Co., New York, in 1912, under the title *Head — Pasquale*. Of three casts of the reworked version, one was purchased by the Metropolitan Museum of Art in 1922 (Gardner, *American Sculpture*, p. 133). The third cast is at the Worcester Art Museum.

13. William C. Agee and George Heard Hamilton, *Raymond Duchamp-Villon* (New York: Walker and Co., 1967), pp. 56–60, illus.

14. Gerald Nordland, *Gaston Lachaise: The Man and His Work* (New York: George Braziller, 1974), fig. 86. Several of Lachaise's other early statuettes are illustrated in figs. 2–5, 47, and 53.

15. Ibid., pp. 82–95.

16. William H. Gerdts, *The Great American Nude* (New York: Praeger, 1974), p. 185.

17. A biography, critical analysis of paintings and sculptures, and catalogue raisonné of Robus's sculpture, written by the author, is forthcoming from the Smithsonian Institution Press, Spring 1980.

18. Henry McBride, "Modern Art," *Dial*, 78 (June 1925), p. 528.

19. John I. H. Baur, *The Sculpture and Drawings of Elie Nadelman, 1882–1946* (New York: Whitney Museum of American Art, 1975), pls. 12 and 13; and Lincoln Kirstein, *Elie Nadelman* (New York: Eakins Press, 1973), cat. nos. 81 and 82, and pl. 38.

20. Elie Nadelman, "Notes for a Catalogue," *Camera Work*, no. 32 (October 1910), p. 41.

21. Lincoln Kirstein, *The Sculpture of Elie Nadelman* (New York: Museum of Modern Art, 1948), p. 60; and Kirstein, *Nadelman*, 1973, p. 193.

22. *Sur la Plage* was exhibited at Scott and Fowles Gallery in New York in 1917. Umberto Boccioni, in his *Technical Manifesto of Futurist Sculpture*, 1912, advocated a combination of materials in the construction of a sculptural whole.

23. Kirstein, *Nadelman*, 1973, pp. 209–11.

24. *Isamu Noguchi: A Sculptor's World* (New York and Evanston: Harper & Row, 1968), p. 123.

25. Two other bronze casts are in museum collections, the Brooklyn Museum and the Cleveland Museum of Art. See Kirstein, *Nadelman*, 1973, cat. nos. 120 (sculpture) and 114 (drawing). The larger marble *Dancing Figure*, also called *Artemis*, from Loew's estate (Parke-Bernet Sale No. 455, January 1951) is in the Chrysler Museum at Norfolk, Virginia, gift of Walter P. Chrysler, Jr.

26. See Roberta K. Tarbell, "Direct Carving," in *Vanguard American Sculpture 1913–1939* (New Brunswick, N.J.: Rutgers University, 1979), pp. 45–66, for a fuller account of its inception, philosophy, and practitioners in America.

27. William Zorach, "Direct Sculpture," typed lecture notes, February 1930, Zorach Papers, Archives of American Art, Smithsonian Institution, Washington, D.C., microfilm 59–2: 1980 ff [original papers deposited in the Manuscript Division of the Library of Congress].

28. William Zorach, *Art Is My Life* (Cleveland and New York: World Publishing Co., 1967), p. 66.

29. "Reminiscences of William Zorach," typescript of interviews by Louis M. Starr, Oral History Collection, Columbia University, 1957, 297.

30. Zorach's copy has been deposited at the National Collection of Fine Arts, Smithsonian Institution, Washington, D.C. Sheeler also photographed several of Zorach's early sculptures (see Figs. 86, 87).

31. John B. Flannagan, "The Image in the Rock," in *The Sculpture of John B. Flannagan* (New York: Museum of Modern Art, 1942), p. 7.

32. Zorach's late stone heads are catalogued in Roberta K. Tarbell, "Catalogue Raisonné of William Zorach's Carved Sculpture" (Ph.D. dissertation, University of Delaware, 1976), pp. 550–94.

33. José de Creeft, "Statement on Sculpture," *Seven Arts*, 2, ed. Fernando Puma (New York: Doubleday, 1954); reprinted in Jules Campos, *The Sculpture of José de Creeft* (New York: Kennedy Graphics and Da Capo Press, 1972), p. 12.

34. See Tarbell, "Direct Carving," pp. 57–58; and Tarbell, "Seymour Lipton's Carvings: A New Anthropology for Sculpture," *Arts Magazine*, 54 (October 1979), pp. 78–84.

35. Seymour Lipton, "Sailor and Flood," manuscript written May 23, 1979, collection of Roberta K. Tarbell.

36. Seymour Lipton, notes prepared for a public interview, 1943, Archives of American Art, microfilm D-386, frame 19; and interviews by Roberta K. Tarbell with Seymour Lipton, May 23 and July 5, 1979.

37. Interview by Roberta K. Tarbell with Concetta Scaravaglione, Kraushaar Galleries, New York, January 2, 1972.

38. Laurent's early carvings are illustrated in Peter V. Moak, *The Robert Laurent Memorial Exhibition* (Durham: University of New Hampshire, 1972).

39. Interview by Roberta K. Tarbell with Chaim Gross, November 13, 1976.

40. The *Circus* and the film *Calder's Circus* are on view at the Whitney Museum. *Calder's Circus*, ed. by Jean Lipman with Nancy Foote, (New York: E. P. Dutton and the Whitney Museum of American Art, 1972), provides visual, chronological, and text material on Calder and his relationship to the *Circus*.

41. Garth Clark, *A Century of Ceramics in the United States, 1878–1978: A Study of its Development* (New York: E. P. Dutton in association with the Everson Museum of Art, 1979), p. 94. Although Nadelman used the ceramic medium most frequently between 1930 and 1935 when he had his own kiln, he had made statuettes and relief sculptures in terra-cotta for Helena Rubinstein in 1911 and 1912.

42. Ibid., p. 314.

43. Isamu Noguchi, "1931," *A Sculptor's World*, pp. 20–21; and Joan M. Marter, "Interaction of American Sculptors with European Modernists: Alexander Calder and Isamu Noguchi," in *Vanguard American Sculpture*, p. 114.

44. Letter, Hugo Robus to Lloyd Goodrich, June 21, 1959, Artists' Files, Whitney Museum of American Art.

Chapter IV
Painting, 1941–1980

1. Interview by Patricia Hills with Jack Levine, September 22, 1979, and with Philip Pearlstein, December 11, 1979.

2. The term "abstract expressionism" was first used by Alfred H. Barr in *Cubism and Abstract Art* (New York: Museum of Modern Art, 1936), pp. 64–72, to describe the work of the German Expressionists.

3. See Milton W. Brown, *Jacob Lawrence* (New York: Whitney Museum of American Art, 1974).

4. Erik Barnouw, *Tube of Plenty: The Evolution of American Television* (New York: Oxford University Press, 1975), p. 109.

5. Dore Ashton, *The New York School: A Cultural Reckoning* (New York: Viking Press, 1972), p. 175. See also Irving Sandler, "1946–1960," in *The Hirshhorn Museum and Sculpture Garden* (New York: Harry N. Abrams, 1974), p. 379–480.

6. Mark Rothko, "The Romantics Were Prompted," *Possibilities I* (New York), Winter 1947/48, p. 84, reprinted in Herschel B. Chipp, *Theories of Modern Art: A Source Book by Artists and Critics* (Berkeley: University of California Press, 1968), p. 548. For quotations by other artists of the time see Chipp as well as Maurice Tuchman, *New York School: The First Generation* (Greenwich, Conn.: New York Graphic Society, 1965), and Barbara Rose, ed., *Readings in American Art 1900–1975* (New York: Holt, Rinehart and Winston, 1975).

7. Rothko, "The Romantics Were Prompted," p. 84.

8. Statement made by Robert Motherwell at a symposium held at the Museum of Modern Art, February 5, 1951, and subsequently printed in *What Abstract Art Means to Me, Bulletin of The Museum of Modern Art* (New York), 18, no. 3 (Spring 1951), reprinted in Chipp, *Theories of Modern Art*, p. 562.

9. An investigation of the social conditions (the extra-aesthetic conditions) which gave rise to Abstract Expressionism continues to engage writers today. See Max Kozloff, "American Painting During the Cold War," *Artforum*, 11 (May 1973), pp. 43–54; Eve Cockcroft, "Abstract Expressionism, Weapon of the Cold War," *Artforum*, 12

(June 1974), pp. 39–41; and David and Cecile Shapiro, "Abstract Expressionism: The Politics of Apolitical Painting," *Prospects: An Annual of American Cultural Studies*, 3 (1977), pp. 175–214.

10. Quoted in John I. H. Baur, *The New Decade* (New York: Whitney Museum of American Art, 1955), p. 38.

11. See *Life*, March 20, 1950, p. 82. The other artists were Franklin Boggs, Aleta Cornelius, Eldzier Cortor, Frank Duncan, Jr., Hazard Durfee, Dean Ellis, Stephen Greene, Joseph Lasker, Edward Melcarth, Kenneth Nack, Bernard Perlin, Alton Pickens, Hubert Raczka, Honoré Sharrer, Theodore Stamos, Hedda Sterne, Edward Stevens, Jr., Howard Warshaw. An exhibition of the works selected opened at the Metropolitan Museum of Art, March 24, 1950 with Robert Beverly Hale the curator.

12. Quoted in Dickson Terry, "Siegfried Reinhardt — Top Artist," *St. Louis Post-Dispatch*, February 7, 1954, clipping in Artists' Files, Whitney Museum of American Art.

13. *Life*, October 23, 1950, p. 64.

14. Quoted in Baur, *The New Decade*, p. 38.

15. Information on Bloom and the Boston Expressionists is drawn from *Boston Expressionism: Hyman Bloom, Jack Levine, Karl Zerbe*, essays by Gillian Levine, Stephen Prokopoff, and Elizabeth Sussman (Boston: Institute of Contemporary Art, 1979), including the reference to Pollock's *She-Wolf*.

16. Other paintings of the late 1940s in the Whitney Museum collection with religious themes include Weber's *Adoration of the Moon* of 1944 and Ben Zion's *Handwriting on the Wall* of 1948; Rico Lebrun's *Wood of the Holy Cross* of 1948 does not contain a figure, but the message is similar to Reinhardt's *Crucifixion*.

17. Quoted in Lloyd Goodrich, "Robert Vickrey," *Art in America*, 42 (Winter 1954), p. 25.
Wyeth's work, especially his most famous painting, *Christina's World* of 1947 (The Museum of Modern Art, New York), would fit in with the general theme of isolation. The model of Wyeth's painting, Christina Ohlson, had a real infirmity. But at a time when human limitations were not just one aspect of man's nature, but elevated to a major theme in art, the museum public would interpret her physical deformity as a metaphor for spiritual and emotional deficiencies.

18. Quoted from "A taped interview between Henry Koerner and Dr. Paul A. Chew," in the catalogue for the *Henry Koerner Retrospective Exhibition* (Greensburg, Pa.: Westmoreland County Museum of Art, 1971). In the last sentence, Koerner could have been describing the painting *Peace, II* by George Grosz.

19. Quotations from Transcript 2, pp. 71–72, of interview with Philip Evergood by John I. H. Baur, 1960, Artists' Files, Whitney Museum of American Art.

20. Baur, in Lloyd Goodrich and John I. H. Baur, *American Art of Our Century* (New York: Frederick A. Praeger, 1961), p. 165.

21. The Editor [Jean Lipman], "Foreword . . . Americans with a Future," *Art in America*, 42 (Winter 1954), p. 10. Jean Lipman informs me that the New Talent survey was dropped after 1963 because the art being produced was too diversified for a panel to come to a consensus.

22. The Fortune articles, running in the issues of September 1946 and December 1955, were noted by Leo Steinberg in a lecture at the Museum of Modern Art, March 1968. See also "Other Criteria," in *Other Criteria: Confrontations with Twentieth-Century Art* (New York: Oxford University Press, 1972), pp. 55–57.

23. Estimated by Joseph Hirsch in his letter of May 10, 1960, to Lloyd Goodrich. I am grateful to Mr. Hirsch for giving me copies of his correspondence with Lloyd Goodrich.

24. Letter from Lloyd Goodrich to Joseph Hirsch, May 9, 1960. In an article, "Form and Image," *Art in America*, 48, no. 1 (1960), p. 21, Goodrich confessed: "In our present-day concern with advanced trends, we are apt to forget that representational art is still very much alive, and has many exponents. . . . Non-academic creative representational art, which belongs to a tradition older than the Academy's, has shared in the plastic discoveries of our period. Fully conscious of plastic values, it nevertheless believes that there need be no more conflict between them and representational values than there was in the Renaissance. Its exponents today are in a difficult position: a minority, attacking some of the most complex pictorial problems, in the face of relative indifference or opposition from influential critics, museums and powers-that-be." Goodrich's concluding remarks have relevance today: "If the history of past successive schools has any bearing on the present situation, the current predominance of abstract art is not necessarily permanent. I say *predominance*: abstract art will of course continue to be widely practiced, and will produce its vital mutations and inventions. But there are increasing signs of other tendencies making themselves felt — some as outgrowths of abstraction, some as reactions from it. What further forms they will take, who can predict? We can be sure of only one thing: they will not be what we expect."

25. The most recent thorough analysis of de Kooning's *Woman* series is E. A. Carmean, Jr., "Willem de Kooning: The Women," in E. A. Carmean, Jr., and Eliza E. Rathbone with Thomas B. Hess, *American Art at Mid-Century: The Subjects of the Artist* (Washington, D.C.: National Gallery of Art, 1978). See also Thomas B. Hess, "De Kooning Paints a Picture," *Art News*, 52 (March 1953), pp. 29–32, 64–67; Leo Steinberg, "The Month in Review," *Arts Magazine* 30 (November 1955), pp. 46–48; Sally Yard, "Willem de Kooning's Women," *Arts Magazine*, 53 (November 1978), pp. 96–101, as well as Irving Sandler, *The Triumph of Abstract Expressionism* (New York: Praeger, 1970), p. 133–37.

26. Quoted in Cindy Nemser, "Grace Hartigan: Abstract Artist, Concrete Woman," *Ms.*, 3 (March 1975), p. 33.

27. Quoted in Thomas B. Hess, *Willem de Kooning* (New York: Museum of Modern Art, 1969), p. 149 (excerpts from an interview with David Sylvester for the BBC, reprinted from *Location*, 1 [Spring 1963]).

28. Ashton, *The New York School*, p. 178, has noted the preoccupation with "situations," by the European existentialist writers as well as artists and critics of the period: "Louis Finkelstein, himself a painter and friend of de Kooning, wrote of him in the October 1950 issue of the *Magazine of Art* that 'instead of painting objects he paints situations.' Such 'situations' were understood by most painters of that period to be unstable, difficult to define, fraught with imperceptible hazards, and in constant danger of being unsituated." See also Sandler, "1946–1960," *The Hirshhorn Museum and Sculpture Garden*, p. 436: "The gesture painters considered painting to be an existential process, an unpremeditated 'situation' (for they often used words borrowed from the terminology of Existentialism) in which a creatively 'committed' artist 'encountered' images of 'authentic' being."

29. De Kooning must have considered it important to make a record of the progress of process of the first painting *Woman I*, 1950–52 (The Museum of Modern Art), because he permitted Rudolf Burckhardt and Walter Auerbach to make six photographs of the painting in its stages of development from 1950 to 1952. See Carmean, "Willem de Kooning: The Women," pp. 158–59. Of *Woman I*, de Kooning said, "I didn't work on it with the idea of perfection, but to see how far one could go . . .," quoted in Hess, *Willem de Kooning*, 1969, p. 149.

In an interview with the author on December 11, 1979, Philip Pearlstein said that he was reacting to this very quality in de Kooning's work, and that although he admired de Kooning, he, Pearlstein, did *not* want to leave the traces of the search.

The emphasis placed on experimentation and on art as process rather than art as product was also the legacy from the WPA years. Francis V. O'Connor, in his "Introduction," to *Art for the Millions: Essays from the 1930s by Artists and Administrators of the WPA Federal Art Project*, (Greenwich, Conn.: New York Graphic Society, 1973), p. 17, has pointed out the debt of Holger Cahill, National Director of the WPA, to John Dewey: "Along with seeing art as a symbol of human life and solidarity, Dewey also saw it primarily as a process and only secondarily as a product. Masterpieces are not, therefore, the central goal of the artistic process and formal qualities are subordinate to human utility." O'Connor refers to Bertram Morris, "Dewey's Aesthetics: The Tragic Encounter with Nature," *Journal of Aesthetics and Art Criticism*, 30 (Winter 1971), p. 193.

30. Quoted in Nemser, "Grace Hartigan," p. 33.

31. Women's rituals were to become major themes for women artists in the 1970s. Muriel Magenta's film *Bride*, shown October 1978 at the University Galleries of the University of Southern California, was inspired by Hartigan's painting.

32. Irving Sandler, *The New York School: The Painters and Sculptors of the Fifties* (New York: Harper & Row, 1978), p. 2. Sandler is here practicing "consensus art history," which is explained in his article "The History of Contemporary Art: A Contradiction in Terms?" *Art Criticism*, 1 (Spring 1979), pp. 42–54. Regarding Hofmann's teaching, see Irving Sandler, "Hans Hofmann: The Pedagogical Master," *Art in America* (May/June 1973), pp. 48–55, and Cynthia Goodman, "Hans Hofmann as a Teacher," *Arts Magazine*, 55 (April 1979) pp. 120–125.

33. Sandler, *The New York School*, p. 125.

34. Betty Turnbull, "David Park: Unyielding Humanist," in *David Park* (Newport Beach, Calif.: Newport Harbor Art Museum). Clyfford Still taught at the C.S.F.A. from 1946 to 1950; Rothko, during the summers of 1947 and 1949.

35. Quoted in Alfred Frankenstein, "Northern California," *Art in America*, 42 (Winter 1954), p. 49.

36. See statement by David Park in *David Park: Recent Painting* (New York: Staempfli Gallery, 1959).

37. See Terry St. John, "Introduction," *Elmer Bischoff: Figurative Paintings 1957–1972* (Oakland, Calif.: Oakland Museum, 1975), pp. 5–8.

38. Artist's statement for *Elmer Bischoff* (San Francisco, Calif.: California School of Fine Arts, 1956).

39. Interview with Gail R. Scott, in *New Paintings by Richard Diebenkorn* (Los Angeles: Los Angeles County Museum of Art, 1969), p. 6, as quoted in Gerald Nordland, "The Figurative Works of Richard Diebenkorn," *Richard Diebenkorn: Paintings and Drawings, 1943–1976* (Buffalo, N.Y.: Albright-Knox Art Gallery, 1976), p. 26.

40. Sandler, *The New York School*, pp. 52 and 55, has pointed out that several critics and artists wrote between 1954 and 1956 about the affinities of French Impressionism with certain trends in Abstract Expressionism; those critics and artists include Sam Hunter, Robert Rosenblum, Clement Greenberg, Louis Finkelstein, and Elaine de Kooning.

41. A human figure is a sign, and no matter how abstracted, once recognized, the painting takes on a content not acknowledged in the precognition state, which would suggest that content (like beauty) is in the eye of the beholder. At this same time, Jasper Johns, with his white-on-white targets and numbers, was dealing with the same issues. See Lawrence Alloway, *American Pop Art* (New York: Collier Books in association with the Whitney Museum of American Art, 1974), pp. 66–71.

42. Marcel Duchamp, "The Creative Art" (from a paper presented to the Convention of the American Federation of Arts, Houston, April 1957), reprinted in *The New Art*, ed. by Gregory Battcock (New York: E. P. Dutton, 1966), p. 25–26, also quoted in Alloway, *American Pop Art*, p. 66. Other paintings in the Whitney Museum collection in which the figural image is almost unreadable include Robert Goodnough's *Pink Reclining Nude* of 1959, Carl Holty's *Bathers* of 1950, Charles Cajori's *Three Figures* of 1962–63, and Seong Moy's *Susanna and the Elders* of 1956.

43. Interview by Patricia Hills with Herbert Katzman, December 10, 1979.

44. Meyer Schapiro, "On the Humanity of Abstract Painting," reprinted in *Modern Art: 19th and 20th Centuries: Selected Papers* (New York: George Braziller, 1978), p. 228. Ortega y Gasset, in his influential essay "The Dehumanization of Art," first published in 1948, argued that the goal of modern art was becoming the elimination of the human elements.

45. Schapiro, "On the Humanity of Abstract Painting," p. 229.

46. The American sculptors were: Leonard Baskin, Cosmo Campoli, Theodore J. Roszak, and H. C. Westermann. The European artists were Karel Appel, Kenneth Armitage, Francis Bacon, Reg Butler, César, Jean Dubuffet, Alberto Giacometti, Eduardo Paolozzi, Germaine Richier, and Fritz Wotruba. All the figurative artists, however, do not seem to fit comfortably into Selz's thesis, such as de Kooning, Diebenkorn, and Oliveira.

47. Paul Tillich, "A Prefatory Note," in Peter Selz, *New Images of Man* (New York: Museum of Modern Art, 1959), p. 9.

48. Ibid.

49. Ibid., p. 10.

50. Selz, *New Images of Man*, p. 11.

51. Manny Farber, "New Images of (Ugh) Man," *Art News*, 58 (October 1959), p. 39. Philip Pearlstein, interview by Patricia Hills, December 11, 1979, referred to it as "the Buchenwald show."

52. Fairfield Porter, "New Images of Man," *The Nation*, October 24, 1959, reprinted in *Fairfield Porter: Art in Its Own Terms, Selected Criticism 1935–1975*, ed. by Rackstraw Downes (New York: Taplinger Publishing Co., 1979), p. 59.

53. Ibid., p. 61.

54. Clement Greenberg, "Abstract Art," *The Nation*, April 15, 1944, p. 451, also quoted in Barry Schwartz, *The New Humanism: Art in a Time of Change* (New York: Praeger, 1974), p. 28. Schwartz's book analyzes the new-image-of-man painting in terms of what he calls the New Humanism. Although this author has many disagreements with Schwartz's various theses, it is the only book to address the issue of content in the new-image-of-man painting. Greenberg's essay is in part about the inadequacy of naturalism: "Today we know that the question what a corporeal object is can be answered in many different ways, depending on the context, and that appearance is only one context among many, and perhaps one of the less important ones. To give the appearance of an object or a scene at a single moment in time is to shut out reference to too many of the other contexts in which it simultaneously exists."

55. Kenneth Clark, "The Blot and the Diagram," *Encounter*, 20 (January 1963), p. 36, partly quoted in Schwartz, *The New Humanism*, p. 32.

56. Interview by Patricia Hills with Leon Golub, September 22, 1979.

57. See above, p. 116.

58. See Schwartz, *The New Humanism*. Schwartz is in many ways uncritical of the new-image-of-man painters and does not refer to them as anti-democratic. Schwartz has a strong bias toward philosophical anarchism, a characteristic of many cultural critics of the late 1960s, e.g., Schwartz states, p. 20: "Today's Humanist is without dogma, without an encompassing ideology. . . . Although the Humanist may draw upon Social Realist art, he upholds human value against both the ideological collective and the corporate state. Still the absence of ideology in Humanist art does not imply any diminution of the demand for social change. However, the social change envisioned — divorced from imposed labels — is simply a demand that people be able to be free, and live lives that are healthy, satisfying, and free of manipulation."

59. John Canaday, "Welcome Variety," *New York Times*, November 25, 1962, section 2, p. 25.

60. The January/February 1969 issue of *Art in America* was devoted to the theme of crisis, violence, and reform. See particularly Dore Ashton, "Response to Crisis in American Art," pp. 24–33, and Charlotte Willard, "Violence and Art," pp. 36–47. Many "Happenings" in the 1960s dealt with the theme of violence, particularly those of the Guerilla Art Action Group. See also Allan Kaprow, *Assemblage, Environments, and Happenings* (New York: Harry N. Abrams, 1966).

61. Konrad Lorenz's theories, explicated in *On Aggression*, trans. by Marjorie Kerr Wilson (New York: Harcourt, Brace and World, 1966), were both promoted and attacked.

62. See Therese Schwartz, "The Politicalization of the Avant-Garde," *Art in America*, 59 (November/December 1971), pp. 96–105. Regarding the radical Art Workers' Coalition, see Lucy Lippard "The Art Workers Coalition," *Studio International*, 180 (November 1970), reprinted in Gregory Battcock, ed., *Idea Art: A Critical Anthology* (New York: E. P. Dutton, 1973), pp. 102–15.

63. See Schwartz, *The New Humanism*, particularly section on "Political Humanism," pp. 94–114. In the mid-1960s Jacob Landau, in his lithographic *The Holocaust Suite*, and Mauricio Lasansky, in his *Nazi Drawings*, made reference to World War II. Other artists, working out of a sensibility of an earlier generation, would include Joseph Hirsch, Robert Gwathmey, and Chaim Koppelman. Leon

Golub at the time made moving but more universalizing statements than the others listed in the text and here; he has since moved toward more literal images in his Mercenary paintings.

64. Quoted in John A. Williams, "Introduction," in M. Bunch Washington, *The Art of Romare Bearden: The Prevalence of Ritual* (New York: Harry N. Abrams, 1972), p. 9.

65. Ibid.

66. Quoted in Jeanne Siegel, "Why Spiral?" *Art News* (September 1966), p. 49. Abstract artist Norman Lewis, p. 49, stated that "Political and social aspects should not be the primary concern; esthetic ideas should have preference." In response to the exhibition *Afro-American Artists: New York and Boston*, Hilton Kramer wrote three articles questioning the compatability of aesthetics and politics (*New York Times*, May 22, 1970, p. 36; May 31, 1970, section 2, p. 17; and June 7, 1970, section 2, p. 19). Edmund B. Gaither and Benny Andrews responded to Kramer in the *New York Times*, June 21, 1970, section 2, pp. 21–22. See Walter Byron Young, "Black American Painters and the Civil Rights Movement: A Study of Relationships, 1955–1970" (D. Ed. dissertation, Pennsylvania State University, 1972).

67. Quoted in Elton C. Fax, *Seventeen Black Artists* (New York: Dodd, Mead, 1971), p. 78, quoted in Young, "Black American Painters," p. 99.

68. An American group, the Pennsylvania Society for Promoting the Abolition of Slavery, the Relief of Free Negroes Unlawfully Held in Bondage, and for Improving the Condition of the African Race, published the diagrams in *The American Museum* in 1789; see fig. 31 in Ellwood Parry, *The Image of the Indian and the Black Man in American Art, 1590–1900* (New York: George Braziller, 1974), p. 46.

69. Quoted in "Afro-American Art: Special Issue." *The Art Gallery Magazine*, 13 (April 1970), p. 32, as quoted in Young, "Black American Painters," p. 132.

70. Young, "Black American Painters," p. 145, summarizing Larry Neal, "Any Day Now: Black Art and Black Liberation," *Ebony* (August 1969).

71. See Alloway, *American Pop Art*, p. 107, for the visual source of Warhol's image. See also John Coplans, *Andy Warhol* (New York: New York Graphic Society, n.d.).

72. See Hilton Kramer, *Richard Lindner* (Boston: New York Graphic Society, 1975), p. 30. See also Dore Ashton, *Richard Lindner* (New York: Harry N. Abrams, 1969), p. 41, regarding the influence of the Bauhaus theater, particularly the work of Oscar Schlemmer, on his imagery.

73. Joanna Frueh, "Chicago's Emotional Realists," *Artforum*, 17 (September 1978), p. 42. See also Patrick T. Malone and Peter Selz, "Is There a New Chicago School?" *Art News*, 54 (October 1955), pp. 36–39, 58–59; Franz Schulze, *Fantastic Images: Chicago Art Since 1945* (Chicago: Follett Publishing Company, 1972); C. L. Morrison, "Chicago Dialectic," *Artforum*, 16 (February 1978), pp. 32–39; Max Kozloff, "Inwardness: Chicago Art Since 1945," *Artforum*, 11 (October 1972), pp. 51–55; and Carrie Rickey, "Chicago," *Art in America*, 67 (July/August 1979), pp. 47–56.

74. Gylbert Coker, *The World of Bob Thompson* (New York: Studio Museum in Harlem, 1978), p. 14.

75. James K. Monte, *22 Realists* (New York: Whitney Museum of American Art, 1970), p. 7. The exhibition was preceded by two

important non-commercial exhibitions: *Realism Now*, Vassar College Art Gallery, Poughkeepsie (May 8-June 12, 1968), and *Aspects of a New Realism*, Milwaukee Art Center (June 21-August 10, 1969), a show which traveled to the Contemporary Arts Museum, Houston, and the Akron Art Institute. Women artists have been at the forefront of the contemporary portrait and studio nude tendencies, although not often collected by museums. Aside from Alice Neel, there are also Sylvia Sleigh, Joan Semmel, June Blum, etc. See *Sons and Others: Women Artists See Men* (Flushing, N.Y.: Queens Museum, 1975) for reproductions of work by some thirty-nine women artists.

76. Linda Nochlin, "The Realist Criminal and the Abstract Law I," *Art in America*, 61 (September-October 1973), p. 54, includes under the rubric of realism "naturalism, social realism, Magic Realism, Neue Sachlichkeit, even some Surrealism, and the various New Realisms of the present." However, she adds: "Yet on the whole, realism implies a system of values involving close investigation of particulars, a taste for ordinary experience in a specific time, place and social context; and an art language that vividly transmits a sense of concreteness. Realism is more than and different from willful virtuosity, or the passive reflexivity of the mirror image, however much these may appear as ingredients in realist works." However, not all of the "realisms" she includes would be involved in the "close investigation of particulars." My own wish to make a distinction between realism and naturalism is motivated not by my desire to set up hard categories, but to come at recent figurative painting in a fresh way in order to distinguish the telling differences.

77. In spite of Barry Schwartz's attempt, a history of "humanist art" may well be impossible to write because of the changing definition of "humanism." A good example of *modernist* art history is H. H. Arnason's *History of Modern Art*, rev. and enlarged ed. (New York: Harry N. Abrams, 1977). For example, regarding the 1930s in America, Arnason writes (p. 433): "The decade, however, marked a détente in modern art in America. Although there were many artists of talent, and many interesting directions in American art, most of these lie outside the scope of this book. In this category may be included the so-termed American scene painters, the social realists, the regionalists. Whatever their qualities and virtues may be, their work, offering little that was new or experimental, is not in its essence germane to the evolution of modern art." To Arnason, then, modernism meant the "new or experimental" in terms of form only. In terms of subject matter artists in the 1930s such as Evergood were new and experimental by extending the themes of art way beyond the finite themes of previous decades.

78. Schwartz, *The New Humanism*, p. 26.

79. Ibid. Schwartz continues: "Humanism distinguishes itself from generally figurative art by the artist's conscious decision to judge, to permit self-disclosure. Unlike formalist art, abstract or figurative, Humanism sees beyond the face into the life of the person. It illuminates what other artistic intentions help us to hide. The present figuration would pretend to deal with surface realities of vision without evaluating what it is we see. At a time when society is fragmented and torn by mechanistic violence; at a time when two out of every three hospital beds are filled with the mentally ill; at a time when nature herself is dying the ecological death, the formalists would divorce the eye from the brain. If, in art, we cannot deal with our feelings, our maladies, our sicknesses, how will we ever find a vision of health? . . . What makes the new realism different from Humanism in art is that the Humanist is committed to the intention. . . ." However, at a time when "humanism" is being claimed for formalist art as well,

there are certain advantages in using historical terms, such as "naturalism" as a contrast to "realism" in an attempt to fathom the role of *content*.

80. Philip Pearlstein, "Figure Painters Today Are Not Made in Heaven," *Art News*, 61 (Summer 1962), pp. 39, 51– 52.

81. Interview by Patricia Hills with Philip Pearlstein, December 11, 1979.

82. See note 77.

83. To Erwin Panofsky, "The History of Art as a Humanistic Discipline," in *Meaning in the Visual Arts* (New York: Anchor Books, 1955), p. 14, "Content as opposed to subject matter, may be described as . . . that which a work betrays but does not parade. It is the basic attitude of a nation, a period, a class, a religious or philosophical persuasion — all this unconsciously qualified by one personality, and condensed into one work." In other words, "intentionless" art does contain a message. It comes down to whether or not we have the license or the privilege or the duty to interpret works of art over and against the wishes of the artist and the intimidating critics. An interesting interpretation has been offered by art historian Matthew Baigell in "Pearlstein's People," *Art Criticism*, 1 (Spring 1979), pp 3– 11. Baigell speculates, p. 7, "that the artist [Pearlstein] is describing modern alienation. His figures, in avoiding the appearance of a dialogue with each other, evade responsibility for their own lives and signal their refusal to face an oppressive reality."

84. As of this writing, Beal seems to be treading a thin line between naturalism and communicating an ambitious content, in such works as *The Farm*, 1979, and *Harvest*, 1979–80, exhibited at Allan Frumkin Gallery, February 1980.

85. They are, however, not realists in the historical sense of wanting to communicate an ethical or political point of view. Because of this Paul Wiesenfeld and William Bailey relate more closely to pre-Courbet painters, such as Ingres, or the later nineteenth-century French academic painters.

86. See William C. Seitz, "The Real and the Artificial," *Art in America*, 60 (November 1972), p. 71. See also "The Photo-Realists: 12 Interviews" in the same issue.

87. See Lawrence Alloway, "Audrey Flack — Vanitas," in *Audrey Flack: "Vanitas"* (New York: Louis K. Meisel Gallery, 1978), for Alloway's comment and for reproductions of Flack's recent paintings. Flack's comments on her work and Roldan were revealed in an interview with Patricia Hills, February 9, 1980.

88. Chuck Close, "I Translate From a Photo," *New York Times*, October 31, 1976.

89. Interview by Patricia Hills with Alex Katz, December 10, 1979. See also Ellen Schwartz, "Alex Katz: 'I See Something and Go Wow!'" *Art News*, 78 (Summer 1979), pp. 42– 47. The sunny images of Katz remind this author of Bruno Bettelheim's remark in *The Uses of Enchantment: The Meaning and Importance of Fairy Tales* (New York: Vintage Books, 1977), pp. 7– 8: "The dominant culture wishes to pretend, particularly where children are concerned, that the dark side of man does not exist, and professes a belief in an optimistic meliorism."

90. Quoted in Schwartz, "Alex Katz," p. 46.

91. Neel, on the other hand, does not identify with the New York art scene, and paints portraits of people from Spanish Harlem and street scenes of the unchic upper West Side.

92. The intensely narcissistic images prevalent in the 1970s have not appeared in the Whitney Museum collection of paintings, although the Autopolaroids of Lucas Samaras and the phenomenological art of Bruce Nauman in the form of casts of his body have been shown in retrospective exhibitions.

93. Gregory Battcock used the term "post-Modernist art" in 1973 in his introductory essay to *Idea Art: A Critical Anthology*, p. 9. To Battcock, "post-Modernist art" included Pop, Minimal, and Conceptual art. However, Minimalism is now considered by many critics to be "Late Modernist." See Douglas Davis, "Post-Everything," *Art in America*, 68 (February 1980), pp. 11, 13–14. Regarding literature, see Ihab Hassan, "POSTmodernISM: A Paracritical Bibliography," *New Literary History*, 3 (Autumn 1971), pp. 5–30. See also Malcolm Bradbury and James McFarlane, eds., *Modernism* (London: Penguin Books, 1976), pp. 19–55, particularly references listed in the notes.

94. Kim Levin, "Farewell to Modernism," *Arts Magazine*, 54 (October 1979), p. 90.

95. Clement Greenberg, "Modern and Post-Modern," *Arts Magazine*, 54 (February 1980), p. 66. For an analysis of Greenberg's criticism, see Donald B. Kuspit, *Clement Greenberg: Art Critic* (Madison: University of Wisconsin Press, 1979).

96. Ibid.

97. First published in *Partisan Review*, 20 (March-April 1953); revised and reprinted in Susanne K. Langer, ed., *Reflections on Art*, (Baltimore: Johns Hopkins, 1958); and included in Leo Steinberg, *Other Criteria*.

Chapter V
Sculpture, 1941–1980

1. Irving Sandler, "1946–1960," in *The Hirshhorn Museum and Sculpture Garden* (New York: Harry N. Abrams, 1974), pp. 379–480.

2. Jan van der Marck, *George Segal* (New York: Harry N. Abrams, 1975), pp. 17–18.

3. Letter, William Zorach to Edith Halpert, August 22, 1943, Downtown Gallery Papers, Archives of American Art, Smithsonian Institution, Washington, D.C.

4. William Zorach, *Art Is My Life* (Cleveland: World Publishing Co., 1967), p. 86.

5. See Roberta K. Tarbell, "Catalogue Raisonné of William Zorach's Carved Sculpture" (Ph.D. dissertation, University of Delaware, 1976), chap. 5 and cat. no. 42.

6. Chaim Gross, *The Technique of Wood Sculpture* (New York: Arco Publishing Co., 1957), p. 112.

7. *Chaim Gross*, exhibition catalogue (New York: Associated American Artists, 1942).

8. Interview, Roberta K. Tarbell with Chaim Gross, November 23, 1976.

9. The exhibition *Raoul Hague: Recent Sculpture* at Xavier Fourcade, New York, November 24, 1979-January 5, 1980, was reviewed: Hilton Kramer, "Sculpture: Big Show by an 'Unknown,' " *New York Times*, November 30, 1979, p.C-18; John G. Ittner, "Raoul Hague," *New York Post*, November 30, 1979; Walter Channing, "Raoul Hague's Wood: Sculptor Shows at Fourcade," *ART/WORLD*, December 20/January 15, 1980, pp. 1 and 9.

10. Thomas B. Hess, "Raoul Hague," in *12 Americans*, ed. by Dorothy C. Miller (New York: Museum of Modern Art, 1956), p. 44.

11. Ibid., artist's statement; see also p. 94 for biography and bibliography.

12. Jacques Lipchitz with H. H. Arnason, *My Life in Sculpture* (New York: Viking Press, 1972), pp. 151–52. Lipchitz related a similar story to Selden Rodman, who published it in *Conversations with Artists* (1957; New York: Capricorn Books, 1961), pp. 135–36.

13. Lipchitz and Arnason, *My Life in Sculpture*, p. 152.

14. See Sam Hunter, *Rivers* (New York: Harry N. Abrams Book for Meridian Books, 1971). Rivers was born in Brooklyn in 1923 and was a musician and in the army before starting to paint in 1945. He studied with Hans Hofmann in New York and Provincetown in 1947 and 1948.

15. Lipchitz and Arnason, *My Life in Sculpture*, pp. 82 and 85. The maquette of 1925 is illustrated on p. 84.

16. Ibid., pp. 180 and 183.

17. See Wayne Andersen, *American Sculpture in Process: 1930–1970* (Boston: New York Graphic Society, 1975), pp. 25, 39, 59, 60, 62–63, 77, 78, 86, 89, 90, 97, 100, and 242, for passages on Grippe.

18. *Four American Expressionists: Doris Caesar, Chaim Gross, Karl Knaths, Abraham Rattner* (New York: Frederick A. Praeger for the Whitney Museum of American Art, 1959), jacket flap of hardcover edition.

19. See John I. H. Baur, "Doris Caesar," in ibid., pp. 22–36.

20. See Julius Held's essay in the catalogue of the retrospective exhibition at the Walker Art Center, Minneapolis, in 1953, and Carl Goldstein, "The Sculpture of Saul Baizerman," *Arts*, 51 (September 1976), pp. 121–25.

21. Illustrated in Louise Cross, "Recent Sculpture Exhibitions," *Creative Art*, 12 (April 1933), pp. 300–302.

22. See *Figures of Dead Men by Leonard Baskin*, preface by Archibald Macleish (University of Massachusetts Press, 1968).

23. Conrad Aiken, *Thee*, drawings by Leonard Baskin (New York: George Braziller, 1967).

24. For Baskin's ideas see *Baskin: Sculpture, Drawings, & Prints* (New York: George Braziller, 1970), pp. 1–21. A good overview of European figurative sculpture can be found in Giuseppe Marchiori's "Figurative Sculpture from 1945 to the Present," in *Art Since Mid-Century, the New Internationalism 2: Figurative Art* (Greenwich, Conn.: New York Graphic Society, 1971), pp. 35–58.

25. Lucy Lippard includes Marisol [Escobar] in her monograph on Pop art (*Pop Art* [New York: Oxford University Press, 1966,] p. 101) but disclaims that she is really "Pop." Marisol is not a Pop artist because she does not work directly from two-dimensional mass-media images.

Two of Pablo Picasso's sculptures of 1953, both entitled *Standing Woman*, constructed board figures with flat straight scraps of lumber added on for limbs and clothed with paint, appear to be precedents for Marisol's figures.

26. Illustrated in Frank Goodyear, Jr., *Seven on the Figure* (Philadelphia: Pennsylvania Academy of the Fine Arts, 1979), p. 40.

27. Barbara Isenberg, "Robert Graham: Ignoring the Lessons of Modern Art," *Art News*, 78 (January 1979), p. 69.

28. Grace Glueck, "The Renaissance Sculptor for Roosevelt Memorial," *New York Times*, May 6, 1979, p. 71.

29. Martin Friedman and Graham W. J. Beal, *George Segal: Sculptures*, exhibition catalogue (Minneapolis, Minn.: Walker Art Center, 1978), p. 28. The exhibition was also shown at the Whitney Museum in 1979.

30. Ibid., p. 33.

31. See Martin H. Bush, *Duane Hanson*, exhibition catalogue (Wichita, Kans.: Edwin A. Ulrich Museum of Art, 1976). The exhibition traveled extensively, making its final stop at the Whitney Museum in 1978.

32. Born in Paris in 1930, Niki de Saint Phalle moved to New York in 1933 and returned to Europe in 1949. She was a painter during the early fifties, shot holes in plastic bags filled with paint in 1960 and 1961, and in 1965 began her series of anonymous black women which are sometimes labeled her "Nana" sculptures.

33. Hugh M. Davies has written the two most comprehensive analytical works on Fleischner: "Sculpture of the Last Decade," *Arts*, 51 (April 1977), pp. 118–23; and *Richard Fleischner* (Amherst: University of Massachusetts, 1977).

34. Andersen, *American Sculpture*, pp. 156–68, 180.

35. Peter Selz, *Funk* (Berkeley: University of California Press, 1967).

36. Excerpts from Vals Osborne's and Corinne Robins's unpublished articles on Grossman, 1973 and 1977 respectively, Artists' Files, Whitney Museum of American Art. Grossman has had solo shows at Cordier & Ekstrom in 1969, 1971, 1973, 1975, 1976, and 1977.

37. See Andersen, *American Sculpture*, pp. 175–76; and Maurice Tuchman, ed., *American Sculpture of the Sixties* (Los Angeles: Los Angeles County Museum of Art, 1967), pp. 211–12, 255.

38. Jan van der Marck, in *Eight Sculptors: The Ambiguous Image* (Minneapolis, Minn.: Walker Art Center, 1966), p. 30.
 Jack Burnham, in *Beyond Modern Sculpture: The Effects of Science and Technology on the Sculpture of This Century* (New York: George Braziller, 1968), analyzes a full range of changes in sculpture based on technology.

39. Van der Marck, in *Eight Sculptors*, p. 32.

40. Tovish, born in New York in 1921, studied under the WPA Art Project Teaching Program during the 1930s and at Columbia University and in Paris during the 1940s. See *Hirshhorn Museum and Sculpture Garden*, p. 755, and figs. 664, 816.

41. For further information on the early figurative work of Nevelson, see Dorothy Gees Seckler, "The Artist Speaks: Louise Nevelson," *Art in America*, 55 (January 1967), p. 38; Arnold B. Glimcher, *Louise Nevelson* (New York: E. P. Dutton, 1972, 1976); Jean Arp, "Louise Nevelson," *XXe Siecle*, 22, supp. 19 (June 1960); John Gordon, *Louise Nevelson* (New York: Whitney Museum of American Art, 1967); and Louise Nevelson and Diana MacKown, *Dawns & Dusks* (New York: Charles Scribner's Sons, 1976).

42. See *Robert Arneson*, essays by Stephen Prokopoff and Suzanne Foley (Chicago: Museum of Contemporary Art, 1974), and Garth Clark, *A Century of Ceramics in the United States, 1878–1978: A Study of its Development* (New York: E. P. Dutton in association with the Everson Museum of Art, 1979).

43. See *Robert Arneson: Self-Portraits* (Philadelphia: Moore College of Art, 1979), and Sarah McFadden, "Robert Arneson at Frumkin," *Art in America* 65 (July/August 1977), pp. 101 and 103.

44. Interview, Roberta K. Tarbell with Robert Arneson, January 19, 1980.

45. London-born and a student of the dance with Martha Graham in New York (1949), Mary Frank married the Swiss photographer Robert Frank in 1951. She studied briefly with Hans Hofmann in 1951 and carved free-form wood designs during the mid-1950s. During the 1960s she drew and made small figures in wax of swimmers and dancers to be cast in bronze, and her talent for swiftness and fleeting gesture began to assert itself.

46. Eleanor Munro, *Originals: American Women Artists* (New York: Simon & Schuster, 1979), p. 293.

47. Ibid., p. 304. For further information see Martica Sawin, "The Sculpture of Mary Frank," *Arts*, 51 (March 1977), pp. 130–32. Eight solo exhibitions of Frank's sculpture were held at the Zabriskie Gallery between 1968 and 1979.

48. See Rodman, *Conversations with Artists*, pp. 128–29.

49. Clement Greenberg, *Art and Culture: Critical Essays* (Boston: Beacon Press, 1961), p. 143.

50. Clement Greenberg, "Art," *Nation*, January 8, 1949, p. 51.

51. Donald B. Kuspit, *Clement Greenberg: Art Critic*, (Madison: University of Wisconsin Press, 1979), p. 23.

52. Miller's exhibitions and sculptures have been analyzed positively in such divergent periodicals as *Artforum, Art International, National Sculpture Review,* and *American Artist*. Richard Miller was born in 1922, spent his first forty years in Ohio, having graduated from the Cleveland Institute of Art in 1951. He moved to New York in 1962, persevering in his creation of realistic figures in the age of abstraction. His book *Figure Sculpture in Wax and Plaster* was published by Watson-Guptill in 1971.

53. Michele Cone, "The Question of Post-Modernism," *Women Artists News*, 4 (February 1979), p. 12.

Selected Bibliography

The following is a basic reading list. For monographs and material on specific topics, consult the individual essays. In addition, the major archival resources are: Archives of American Art, Smithsonian Institution, Washington, D.C.; the Gertrude Vanderbilt Whitney Papers and the Artists' Files, Whitney Museum of American Art, New York.

Allan Frumkin Gallery. "Kinds of Realism." *Newsletter*, Winter 1979. Statements by Alfred Leslie, William Beckman, Philip Pearlstein, Chuck Close, Jack Beal, Paul Georges, and Richard Estes; ed. by J. Martin.

Alloway, Lawrence. *American Pop Art*. New York and London: Collier Books and Collier Macmillan Publishers in association with the Whitney Museum of American Art, 1974.

————. "Art as Likeness." *Arts Magazine*, 41 (May 1967), pp. 34-39.

Andersen, Wayne. *American Sculpture in Process: 1930-1970*. Boston: New York Graphic Society, 1975.

Armstrong, Tom; Craven, Wayne; Feder, Norman; Haskell, Barbara; Krauss, Rosalind E.; Robbins, Daniel; Tucker, Marcia. *200 Years of American Sculpture*. New York: David R. Godine in association with the Whitney Museum of American Art, 1976.

Art Since Mid-Century: The New Internationalism. Vol. 2, *Figurative Art*. Greenwich, Conn.: New York Graphic Society, 1975.

Ashton, Dore. *The New York School: A Cultural Reckoning*. New York: Viking Press, 1972.

Baigell, Matthew. *The American Scene: American Painting of the 1930s*. New York: Praeger, 1974.

Battcock, Gregory, ed. *Super Realism: A Critical Anthology*. New York: E. P. Dutton, 1975.

Baur, John I. H. *The New Decade*. New York: Whitney Museum of American Art, 1955.

Boston Expressionism: Hyman Bloom, Jack Levine, Karl Zerbe. Essays by Gillian Levine, Stephen Prokopoff, and Elizabeth Sussman. Boston: Institute of Contemporary Art, 1979.

Brown, Milton W. *American Painting from the Armory Show to the Depression*. Princeton, N.J.: Princeton University Press, 1955.

Brummé, C. Ludwig. *Contemporary American Sculpture*. Foreword by William Zorach. New York: Crown Publishers, 1948.

Burnham, Jack. *Beyond Modern Sculpture: The Effects of Science and Technology on the Sculpture of This Century*. New York: George Braziller, 1968.

Butler, Ruth. *Western Sculpture: Definitions of Man*. Boston: New York Graphic Society, 1975.

Chipp, Herschel B. *Theories of Modern Art: A Source Book by Artists and Critics*. Berkeley: University of California Press, 1968.

Clark, Garth. *A Century of Ceramics in the United States, 1878-1978: A Study of its Development*. New York: E. P. Dutton, 1979.

Craven, Wayne. *Sculpture in America: From the Colonial Period to the Present*. New York: Thomas Y. Crowell, 1968.

Cummings, Paul. *A Dictionary of Contemporary American Artists*. New York: St. Martin's Press, 1966.

Doty, Robert M. *Human Concern/Personal Torment: The Grotesque in American Art*. New York: Whitney Museum of American Art, 1969.

Elsen, Albert E. *Origins of Modern Sculpture: Pioneers and Premises*. New York: George Braziller, 1974.

————. *The Partial Figure in Modern Sculpture: From Rodin to 1969*. Baltimore, Md.: Baltimore Museum of Art, 1969.

Fink, Lois Marie, and Taylor, Joshua C. *Academy: The Academic Tradition in American Art*. Washington, D.C.: Smithsonian Institution Press for the National Collection of Fine Arts, 1975.

Fogg Art Museum. *Recent Figure Sculpture*. Cambridge, Mass.: Harvard University Press, 1972.

Friedman, B. H., with the research collaboration of Flora Miller Irving. *Gertrude Vanderbilt Whitney: A Biography*. Garden City, N.Y.: Doubleday, 1978.

Friedman, Martin, and van der Marck, Jan. *Eight Sculptors: The Ambiguous Image*. Minneapolis, Minn.: Walker Art Center, 1966.

Gardner, Albert TenEyck. *American Sculpture: A Catalogue of the Collection of The Metropolitan Museum of Art*. New York: Metropolitan Museum of Art, 1965.

Gerdts, William H. *The Great American Nude: A History in Art*. New York: Praeger, 1974.

———. *A Survey of American Sculpture*. Newark, N.J.: Newark Museum, 1962.

Geske, Norman. *The Figurative Tradition in Recent American Art*. Washington, D.C.: Smithsonian Institution Press for the National Collection of Fine Arts, 1968.

Goodrich, Lloyd. *The Whitney Studio Club and American Art 1900-1932*. New York: Whitney Museum of American Art, 1975.

——— and Baur, John I. H. *American Art of Our Century*. New York: Frederick A. Praeger, 1961.

——— and Baur, John I. H. *Four American Expressionists: Doris Caesar, Chaim Gross, Karl Knaths, Abraham Rattner*. New York: Whitney Museum of American Art, 1959.

Goodyear, Frank, Jr. *Eight Contemporary American Realists*. Philadelphia: Pennsylvania Academy of the Fine Arts, 1977.

———. *Seven on the Figure*. Philadelphia: Pennsylvania Academy of the Fine Arts, 1979.

Henry, Gerrit. "The Artist and the Face: A Modern American Sampling." *Art in America*, 63 (January-February 1975), pp. 34-41.

Hills, Patricia. *Turn-of-the-Century America: Paintings, Graphics, Photographs, 1890-1910*. New York: Whitney Museum of American Art, 1977.

The Hirshhorn Museum and Sculpture Garden. Foreword by S. Dillon Ripley, ed. and with an introduction by Abram Lerner. New York: Harry N. Abrams, 1974.

Homer, William Innes, with the assistance of Violet Organ. *Robert Henri and His Circle*. Ithaca, N.Y.: Cornell University Press, 1969.

The Hundredth Anniversary Exhibition of Paintings and Sculptures by 100 Artists Associated with the Art Students League of New York. Foreword by Lawrence Campbell. New York: Kennedy Galleries, 1975.

Juliana Force and American Art: A Memorial Exhibition. Essays by Hermon More and Lloyd Goodrich, John Sloan, Guy Pène du Bois, Alexander Brook, and Forbes Watson. New York: Whitney Museum of American Art, 1949.

Kramer, Hilton. "Realists and Others." *Arts Magazine*, 38 (January 1964), pp. 18-22.

Laderman, Gabriel. "Unconventional Realists." *Artforum*, 6 (November 1967), pp. 42-46.

Marter, Joan; Tarbell, Roberta K.; and Wechsler, Jeffrey. *Vanguard American Sculpture*. New Brunswick, N.J.: Rutgers University Art Gallery, 1979.

Miller, Dorothy C., ed. *12 Americans*. New York: Museum of Modern Art, 1956.

Monte, James K. *22 Realists*. New York: Whitney Museum of American Art, 1970.

Munro, Eleanor. *Originals: American Women Artists*. New York: Simon and Schuster, 1979.

Nochlin, Linda. *Realism*. Baltimore, Md.: Penguin Books, 1971.

———. "Some Women Realists: Painters of the Figure." *Arts Magazine*, 48 (May 1974), pp. 29-33.

Pearlstein, Philip. "Figure Paintings Today Are Not Made in Heaven." *Art News*, 62 (Summer 1962), pp. 39, 51-52.

Perlman, Bennard B. *The Immortal Eight: American Painting from Eakins to the Armory Show, 1870-1913*. Westport, Conn.: North Light Publishers, 1979.

Pincus-Witten, Robert. *Postminimalism*. New York: Out of London Press, 1977.

Proske, Beatrice Gilman. *Brookgreen Gardens Sculpture*. Brookgreen Gardens, S.C.: Brookgreen Gardens, 1968.

Rodman, Selden. *Conversations with Artists*. Rev. ed. New York: Capricorn Books, 1961.

Sandler, Irving. *The New York School: The Painters and Sculptors of the Fifties*. New York: Harper & Row, 1978.

Schnier, Jacques. *Sculpture in Modern America*. Berkeley: University of California Press, 1948.

Schwartz, Barry. *The New Humanism: Art in a Time of Change*. New York: Praeger, 1974.

Seitz, William C. "The Real and the Artificial: Painting of the New Environment." *Art in America*, 60 (November 1972): pp. 58-72.

Selz, Peter. *Funk*. Berkeley: University of California Press, 1967.

———. *New Images of Man*. New York: Museum of Modern Art, 1959.

Shapiro, David, ed. *Social Realism: Art as a Weapon*. New York: Frederick Ungar, 1973.

Tillim, Sidney. "The Reception of Figurative Art: Notes on a General Misunderstanding." *Artforum*, 7 (February 1969), pp. 30-32.

Tuchman, Maurice, ed. *American Sculpture of the Sixties*. Los Angeles: Los Angeles County Museum of Art, 1967.

Varnedoe, J. Kirk T., et al. *Modern Portraits: The Self and Others*. New York: Columbia University, 1976.

Wechsler, Jeffrey. *Surrealism and American Art, 1931-1947*. New Brunswick, N.J.: Rutgers University Art Gallery, 1979.

Whitney Museum of American Art. *Catalogue of the Collection*. Introduction by John I. H. Baur. New York: Whitney Museum of American Art, 1974.

Young, Walter Byron. "Black American Painters and the Civil Rights Movement: A Study of Relationships, 1955-1970." D. Ed. dissertation, Pennsylvania State University, 1972.

Checklist of the Exhibition

Painting

Nicholas Africano (b. 1948)
An Argument, 1977
Acrylic, oil, and wax on canvas,
 69 × 85½ inches
Gift of Mr. and Mrs. William A.
 Marsteller, 77.68

Malcolm Bailey (b. 1947)
Untitled, 1969
Synthetic polymer on composition board,
 48 × 72 inches
Larry Aldrich Foundation Fund, 69.77

William Bailey (b. 1930)
"N" (Female Nude), c. 1965
Oil on canvas, 48 × 72 inches
Gift of Mrs. Louis Sosland, 76.39

Eugenie Baizerman (1899–1949)
A Quiet Scene, c. 1947
Oil on canvas, 78 × 54 inches
Gift of Mr. and Mrs. Roy R. Neuberger
 (and purchase), 61.29

Gifford Beal (1879–1956)
Fisherman, 1928
Oil on canvas 36½ × 48½ inches
Gift of Gertrude Vanderbilt Whitney,
 31.92

Jack Beal (b. 1931)
Danae II, 1972
Oil on canvas, 68 × 68 inches
Gift of Charles Simon, anonymous donor
 (and purchase), 74.82

Romare Bearden (b. 1914)
Eastern Barn, 1968
Collage of glue, lacquer, oil, and paper on
 composition board, 55½ × 44 inches
Purchase, 69.14

Robert Bechtle (b. 1932)
'61 Pontiac, 1968–69
Oil on canvas, 60 × 84 inches
Richard and Dorothy Rodgers Fund,
 70.16

George Bellows (1882–1925)
Dempsey and Firpo, 1924
Oil on canvas, 51 × 63¼ inches
Gift of Gertrude Vanderbilt Whitney,
 31.95

Thomas Hart Benton (1889–1975)
The Lord Is My Shepherd, 1926
Tempera on canvas, 33¼ × 27¼ inches
Gift of Gertrude Vanderbilt Whitney,
 31.100
*Poker Night (From "A Streetcar Named
 Desire")*, 1948
Tempera and oil on panel, 36 × 48 inches
Promised gift of Mrs. Percy Uris, 5.77

Elmer Bischoff (b. 1916)
Seated Figure in Garden, 1958
Oil on canvas, 48 × 57 inches
Purchase, 59.2

Isabel Bishop (b. 1902)
Nude, 1934
Oil on composition board, 33 × 40 inches
Purchase, 34.11

Peter Blume (b. 1906)
Light of the World, 1932
Oil on composition board, 18 × 20¼
 inches
Purchase, 33.5
Man of Sorrows, 1951
Tempera on canvas, 28 × 24 inches
Purchase, 51.5

Robert Broderson (b. 1920)
Memory of Childhood, 1961
Oil on canvas, 65½ × 57½ inches
Gift under the Ford Foundation Purchase
 Program, 62.2

Alexander Brook (1898–1980)
Girl with Flower, 1930
Oil on canvas, 34 × 26 inches
Gift of Gertrude Vanderbilt Whitney,
 31.124

Roger Brown (b. 1948)
The Entry of Christ into Chicago in 1976,
 1976
Oil on canvas, 72 × 120 inches
Gift of Mr. and Mrs. Joel S. Ehrenkranz
 (by exchange), Mr. and Mrs. Edwin A.
 Bergman, and the National Endowment
 for the Arts, 77.56

Paul Cadmus (b. 1904)
Sailors and Floosies, 1938
Oil and tempera on composition board,
 25 × 39½ inches
Anonymous gift (subject to life interest),
 64.42
Fantasia on a Theme by Dr. S., 1946
Egg tempera on composition board,
 13 × 13 inches
Purchase, 47.1

Federico Castellón (1914–1971)
The Dark Figure, 1938
Oil on canvas, 17 × 26 inches
Purchase, 42.3

Daniel R. Celentano (b. 1902)
The First Born, 1937
Oil on canvas, 26 × 24 inches
Purchase, 37.38

Chuck Close (b. 1940)
Phil, 1969
Synthetic polymer on canvas, 108 × 84
 inches
Gift of Mrs. Robert M. Benjamin, 69.102

Arthur Crisp (1881–?)
Adam and Eve, c. 1918
Oil on plaster, 22 × 30 inches
Gift of Gertrude Vanderbilt Whitney,
 31.156

John Steuart Curry (1897–1946)
Baptism in Kansas, 1928
Oil on canvas, 40 × 50 inches
Gift of Gertrude Vanderbilt Whitney, 31.159

Arthur B. Davies (1862–1928)
Crescendo, 1910
Oil on canvas, 18 × 40 inches
Gift of Gertrude Vanderbilt Whitney, 31.166
Day of Good Fortune, 1920
Oil on canvas, 18 × 30 inches
Gift of Mr. and Mrs. Arthur G. Altschul, 71.228

Willem de Kooning (b. 1904)
Woman and Bicycle, 1952–53
Oil on canvas, 76½ × 49 inches
Purchase, 55.35
Woman Acabonic, 1966
Oil on paper on canvas, 80½ × 36 inches
Gift of Mrs. Bernard F. Gimbel, 67.75

Edwin Dickinson (1891–1978)
The Fossil Hunters, 1926–28
Oil on canvas, 96½ × 73¾ inches
Purchase, 58.29

Richard Diebenkorn (b. 1922)
Girl Looking at Landscape, 1957
Oil on canvas, 59 × 60¼ inches
Gift of Mr. and Mrs. Alan H. Temple, 61.49

Guy Pène du Bois (1884–1958)
Opera Box, 1926
Oil on canvas, 57½ × 45¼ inches
Gift of Gertrude Vanderbilt Whitney, 31.184

Philip Evergood (1901–1973)
The New Lazarus, 1927/54
Oil on plywood, 48 × 83¼ inches
Gift of Joseph H. Hirshhorn, 54.60
Lily and the Sparrows, 1939
Oil on composition board, 30 × 24 inches
Purchase, 41.42
The Jester, 1950
Oil on canvas, 72 × 96 inches
Gift of Sol Brody (subject to life interest), 64.36

Ernest Fiene (1894–1965)
Concetta, 1926
Oil on canvas, 40¼ × 30¼ inches
Gift of Gertrude Vanderbilt Whitney, 31.193

Audrey Flack (b. 1931)
Lady Madonna, 1972
Oil on canvas, 78 × 69 inches
Gift of Martin J. Zimet, 72.42

Jared French (b. 1905)
The Rope, 1954
Egg tempera on paper, 11¾ × 12½ inches
Charles F. Williams Fund, 56.3

Emil Ganso (1895–1941)
Gertie, c. 1928
Oil on canvas, 40 × 34 inches
Gift of Gertrude Vanderbilt Whitney, 31.205

Paul Georges (b. 1923)
The Studio, 1965
Oil on canvas, 120½ × 79½ inches
Neysa McMein Purchase Award, 66.12

Gregory Gillespie (b. 1936)
Two Women, 1965
Oil, synthetic polymer, tempera, and collage on wood, 14 × 11 inches
Gift of the Friends of the Whitney Museum of American Art, 66.79

William J. Glackens (1870–1938)
Reclining Nude, 1910
Oil on canvas, 32¾ × 54 inches
Gift of Charles Simon, 78.104
Girl in Black and White, 1914
Oil on canvas, 32 × 26 inches
Gift of the Glackens Family, 38.53

Sidney Goodman (b. 1936)
The Walk, 1963–64
Oil on canvas, 83½ × 65¼ inches
Gift of Dr. and Mrs. Abraham Melamed, 78.80
Room 318, 1971–72
Oil on canvas, 75 × 97 inches
Purchased with the aid of funds from the National Endowment for the Arts (and exchange), 73.8

Robert Gordy (b. 1933)
Boxville Tangle, Number 1, 1968
Synthetic polymer on canvas, 90 × 66 inches
Larry Aldrich Foundation Fund, 68.49

Arshile Gorky (1904–1948)
The Artist and His Mother, 1926–29
Oil on canvas, 60 × 50 inches
Gift of Julien Levy for Maro and Natasha Gorky in memory of their father, 50.17

John D. Graham (1881–1961)
Head of a Woman, 1926
Oil on canvas, 22 × 18 inches
Gift of Gertrude Vanderbilt Whitney, 31.228

Stephen Greene (b. 1918)
The Burial, 1947
Oil on canvas, 42 × 55 inches
Purchase, 49.16

George Grosz (1893–1959)
Peace, II, 1946
Oil on canvas, 47 × 33¼ inches
Purchase, 47.2

Louis Guglielmi (1906–1956)
The Various Spring, 1937
Oil on canvas, 15¼ × 19¼ inches
Promised gift of Flora Whitney Miller, 69.78
Terror in Brooklyn, 1941
Oil on canvas, 34 × 30 inches
Purchase, 42.5

Robert Gwathmey (b. 1903)
Sowing, 1949
Oil on canvas, 36 × 40 inches
Purchase, 49.17

Robert Henri (1865–1929)
Laughing Child, 1907
Oil on canvas, 24 × 20 inches
Gift of Gertrude Vanderbilt Whitney, 31.240
Sammy and His Mother, 1915
Oil on canvas, 32 × 26 inches
Promised gift of Mrs. Percy Uris, 16.77
Gertrude Vanderbilt Whitney, 1916
Oil on canvas, 50 × 72 inches
Promised gift of Flora Whitney Miller, 30.77

Joseph Hirsch (b. 1910)
Interior with Figures, 1962
Oil on canvas, 45 × 72 inches
Gift of Rita and Daniel Fraad, Jr., 62.57

Edward Hopper (1882–1967)
Summer Interior, 1909
Oil on canvas, 24 × 29 inches
Bequest of Josephine N. Hopper, 70.1197
Carolina Morning, 1955
Oil on canvas, 30 × 40 inches
Given in memory of Otto L. Spaeth by his
 family, 67.13

Ben Kamihira (b. 1925)
The Couch, 1960
Oil on canvas, 63 × 79¼ inches
Sumner Foundation Purchase Award,
 60.49

Howard Kanovitz (b. 1929)
New Yorkers I, 1965
Synthetic polymer on canvas, 70 × 93½
 inches
Gift of the artist, 69.172

Bernard Karfiol (1886–1952)
Boy Bathers, 1916
Oil on canvas, 28 × 36 inches
Purchase (and exchange), 54.19

Alex Katz (b. 1927)
Place, 1977
Oil on canvas, 108 × 144 inches
Gift of Frances and Sydney Lewis, 78.23

Herbert Katzman (b. 1923)
Two Nudes Before Japanese Screen, 1952
Oil on composition board, 76 × 43 inches
Juliana Force Purchase, 53.5

James Kearns (b. 1924)
Cat's Cradle, 1959
Oil on composition board, 60 × 48 inches
Neysa McMein Purchase Award, 60.18

Rockwell Kent (1882–1971)
The Trapper, 1921
Oil on canvas, 34 × 44 inches
Gift of Gertrude Vanderbilt Whitney,
 31.258

Henry Koerner (b. 1915)
Vanity Fair, 1946
Oil on composition board, 36 × 42 inches
Purchase, 48.2

Lee Krasner (b. 1908)
Imperfect Indicative, 1976
Collage on canvas, 78 × 72 inches
Gift of Frances and Sydney Lewis, 77.32

Leon Kroll (1884–1974)
Nude in a Blue Chair, 1930
Oil on canvas, 48¼ × 36¼ inches
Gift of Gertrude Vanderbilt Whitney,
 31.264

Walt Kuhn (1877–1949)
The Blue Clown, 1931
Oil on canvas, 30 × 25 inches
Purchase, 32.25

Yasuo Kuniyoshi (1889–1953)
Child, 1923
Oil on canvas, 30 × 24 inches
Gift of Mrs. Edith Gregor Halpert, 55.1
I'm Tired, 1938
Oil on canvas, 40¼ × 31 inches
Purchase, 39.12

Joe Lasker (b. 1919)
Naples, 1952
Oil on canvas, 34¾ × 51 inches
Purchase, 53.50

Jacob Lawrence (b. 1917)
War Series: Another Patrol, 1946
Egg tempera on composition board,
 16 × 20 inches
Gift of Mr. and Mrs. Roy R. Neuberger,
 51.8
War Series: Beachead, 1947
Egg tempera on composition board,
 16 × 20 inches
Gift of Mr. and Mrs. Roy R. Neuberger,
 51.13
War Series: Reported Missing, 1947
Egg tempera on composition board,
 16 × 20 inches
Gift of Mr. and Mrs. Roy R. Neuberger,
 51.18

Alfred Leslie (b. 1927)
Alfred Leslie, 1966–67
Oil on canvas, 108 × 72 inches
Gift of the Friends of the Whitney Mu-
 seum of American Art, 67.30

Jack Levine (b. 1915)
Gangster Funeral, 1952–53
Oil on canvas, 63 × 72 inches
Purchase, 53.42

Richard Lindner (1901–1978)
Ice, 1966
Oil on canvas, 70 × 60 inches
Gift of the Friends of the Whitney Mu-
 seum of American Art, 67.17

George Luks (1867–1933)
Old Woman with White Pitcher, 1926
Oil on canvas, 30 × 25 inches
Gift of Mr. and Mrs. Lesley G. Sheafer,
 55.45
Mrs. Gamley, 1930
Oil on canvas, 66 × 48 inches
Gift of Gertrude Vanderbilt Whitney,
 31.289

Reginald Marsh (1898–1954)
Why Not Use the "L"? 1930
Egg tempera on canvas, 36 × 48 inches
Gift of Gertrude Vanderbilt Whitney,
 31.293
Twenty Cent Movie, 1936
Egg tempera on composition board,
 30 × 40 inches
Purchase, 37.43

Alfred H. Maurer (1868–1932)
An Arrangement, 1901
Oil on cardboard, 36 × 31¾ inches
Gift of Mr. and Mrs. Hudson D. Walker,
 50.13

James McGarrell (b. 1930)
Service, 1962
Oil on canvas, 75 × 68 inches
Sumner Foundation Purchase Award,
 62.52

Richard McLean (b. 1934)
Still Life with Black Jockey, 1969
Oil on canvas, 60 × 60 inches
Purchase, 70.17

Kenneth Hayes Miller (1876–1952)
Shopper, 1928
Oil on canvas, 41 × 33 inches
Gift of Gertrude Vanderbilt Whitney,
31.305

Jan Müller (1922–1958)
The Temptation of St. Anthony, 1957
Oil on canvas, 79 × 120¾ inches
Purchase, 72.30

Alice Neel (b. 1908)
John Perreault, 1972
Oil on canvas, 38 × 63½ inches
Gift of anonymous donors, 76.26
The Soyer Brothers, 1973
Oil on canvas, 60 × 46 inches
Gift of Arthur M Bullowa, Sydney Duffy,
 Stewart R. Mott, Edward Rosenthal
 (and purchase), 74.77

Jim Nutt (b. 1938)
She's Hit, 1967
Synthetic polymer on plexiglas and
 enamel on wood, 36½ × 24½ inches
Larry Aldrich Foundation Fund, 69.101

Nathan Oliveira (b. 1928)
Bather I, 1959
Oil on canvas, 52½ × 45 inches
Gift of Mrs. Iola S. Haverstick, 66.7

David Park (1911–1960)
Four Men, 1958
Oil on canvas, 57 × 92 inches
Gift of an anonymous foundation, 59.27

Philip Pearlstein (b. 1924)
Seated Nude on Green Drape, 1969
Oil on canvas, 60 × 48 inches
Gift of the Friends of the Whitney Mu-
 seum of American Art, 70.2

Fairfield Porter (1907–1975)
The Screen Porch, 1964
Oil on canvas, 79½ × 79½ inches
Lawrence H. Bloedel Bequest, 77.1.41

Maurice Prendergast (1859–1924)
The Promenade, 1913
Oil on canvas, 30 × 34 inches
Bequest of Alexander M. Bing, 60.10

Christina Ramberg (b. 1946)
Istrian River Lady, 1974
Synthetic polymer on masonite,
 34½ × 30 inches
Gift of Mr. and Mrs. Fredric M. Roberts in
 memory of their son, James Reed
 Roberts, 74.12

Abraham Rattner (1895–1978)
Song of Esther, 1958
Oil on composition board, 60 × 48 inches
Gift of the Friends of the Whitney Mu-
 seum of American Art, 58.36

Man Ray (1890–1976)
Five Figures, 1914
Oil on canvas, 36 × 32 inches
Gift of Mrs. Katharine Kuh, 56.36

Siegfried Reinhardt (b. 1925)
Crucifixion, 1953
Oil on composition board, 28 × 45½
 inches
Gift of William Benton, 55.2

Louis Ribak (1902–1979)
Home Relief Station, 1935–36
Oil on canvas, 28 × 36 inches
Purchase, 36.148

Larry Rivers (b. 1923)
Double Portrait of Berdie, 1955
Oil on canvas, 70¾ × 82½ inches
Anonymous gift, 56.9

Peter Saul (b. 1934)
Saigon, 1967
Oil on canvas, 92¾ × 142 inches
Gift of the Friends of the Whitney Mu-
 seum of American Art, 69.103

Katherine Schmidt (1898–1978)
Broe and McDonald Listen In, 1937
Oil on canvas, 30 × 24 inches
Purchase (and exchange), 50.15

Henry Schnakenberg (1892–1970)
Conversation, 1930
Oil on canvas, 50¼ × 36 inches
Gift of Gertrude Vanderbilt Whitney,
 31.338.

Ben Shahn (1898–1969)
The Passion of Sacco and Vanzetti,
 1931–32
Tempera on canvas, 84¼ × 48 inches
Gift of Edith and Milton Lowenthal in
 memory of Juliana Force, 49.22
Reconstruction, 1945
Tempera on composition board, 26 × 39
 inches
Purchase, 46.4

Everett Shinn (1876–1953)
Revue, 1908
Oil on canvas, 18 × 24 inches
Gift of Gertrude Vanderbilt Whitney,
 31.346

Mitchell Siporin (1910–1976)
Dancers by the Clock, 1949
Oil on canvas, 40½ × 60 inches
Purchase, 50.22

John Sloan (1871–1951)
The Picnic Grounds, 1906–07
Oil on canvas, 24 × 36 inches
Purchase, 41.34
Dolly with a Black Bow, 1907
Oil on canvas, 32 × 26 inches
Gift of Miss Amelia Elizabeth White,
 59.28

Isaac Soyer (b. 1907)
Employment Agency, 1937
Oil on canvas, 34¼ × 45 inches
Purchase, 37.44

Moses Soyer (1899–1974)
Julia Evergood, 1962
Oil on canvas, 36 × 30 inches
Gift of Mr. and Mrs. Percy Uris, 63.4

Raphael Soyer (b. 1899)
Office Girls, 1936
Oil on canvas, 26 × 24 inches
Purchase, 36.149
Reading from Left to Right, 1938
Oil on canvas, 26¼ × 20½ inches
Gift of Mrs. Emil J. Arnold in memory of
 Emil J. Arnold and in honor of Lloyd
 Goodrich, 74.3

Bob Thompson (1937–1965)
An Allegory, 1964
Oil on canvas, 48 × 48 inches
Gift of Thomas Bellinger, 72.137

Bradley Walker Tomlin (1899–1953)
Self-Portrait, 1932
Oil on canvas, 17 × 14 inches
Gift of Henry Ittleson, Jr., 55.28

George Tooker (b. 1920)
The Subway, 1950
Egg tempera on composition board,
 18 × 36 inches
Juliana Force Purchase, 50.23

Robert Vickrey (b. 1926)
The Labyrinth, 1951
Casein on composition board, 32 × 48
 inches
Juliana Force Purchase, 52.6

Andy Warhol (b. 1931)
Before and After, 3, 1962
Synthetic polymer on canvas, 74 × 100
 inches
Gift of Charles Simon (and purchase),
 71.226

Neil Welliver (b. 1929)
Girl with Striped Washcloth, 1971
Oil on canvas, 60 × 60 inches
Gift of Charles Simon, 72.17

Tom Wesselmann (b. 1931)
Great American Nude, Number 57, 1964
Synthetic polymer on composition board,
 48 × 65 inches
Gift of the Friends of the Whitney Mu-
 seum of American Art, 65.10

Charles White (b. 1918)
Wanted Poster Number Four, 1969
Oil on composition board, 24 × 24 inches
Gift of The Hament Corporation (and
 purchase), 70.41

Paul Wiesenfeld (b. 1942)
Secrets II, 1968–69
Oil on canvas, 63 × 66½ inches
Richard and Dorothy Rodgers Fund,
 70.15

William Zorach (1887–1966)
The Roof Playground, 1917
Oil on canvas, 29 × 23¾ inches
Gift of Mr. and Mrs. Arthur G. Altschul,
 71.231

Sculpture

Alexander Archipenko (1887–1964)
Torso in Space, 1936
Metalized terra-cotta, 21 × 60 × 13 inches
Gift of Mr. and Mrs. Peter Rubel, 58.24

Robert Arneson (b. 1930)
Whistling in the Dark, 1976
Terra-cotta and glazed ceramic,
 35¼ × 20 × 20 inches
Gift of Frances and Sydney Lewis, 77.37

Saul Baizerman (1889–1957)
Slumber, 1948
Hammered copper, 40 × 25 × 23 inches
Purchase, 48.20

Leonard Baskin (b. 1922)
Hephaestus, 1963
Bronze, 63¼ × 23½ × 23¾ inches
Gift of the Friends of the Whitney Mu-
 seum of American Art, 64.16

Michael Brenner (1885–1969)
Portrait of a Man, before 1930
Bronze, 13 × 9¼ × 7¾ inches
Gift of Mrs. Michael Brenner, 74.8

Doris Caesar (1893–1971)
Woman on One Knee, n.d.
Bronze, 14½ × 4¾ × 8¾ inches
Lawrence H. Bloedel Bequest

Alexander Calder (1898–1976)
Woman, c. 1926
Elmwood, 24 × 6½ × 6 inches
Gift of Howard and Jean Lipman, 75.27
The Brass Family, 1929
Brass wire, 64 × 41 × 8½ inches
Gift of the artist, 69.255
Belt Buckle (Wire Female Figure), 1935
Brass, 8 × 5 × ½ inches
Gift of Mrs. Marcel Duchamp in memory
 of the artist, 77.21

Bruce Conner (b. 1933)
Medusa, 1960
Cardboard, hair, nylon, wax, and wood,
 10¾ × 11 × 22¼ inches
Gift of the Howard and Jean Lipman
 Foundation, Inc., 66.19

Jo Davidson (1883–1952)
Gertrude Vanderbilt Whitney, c. 1917
Bronze, 20 × 5½ × 4¾ inches
Gift of Flora Whitney Miller, 68.24
Gertrude Stein, 1920
Bronze, 31¼ × 23¼ × 24½ inches
Purchase, 54.10
Female Torso, 1927
Terra-cotta, 22½ × 10½ × 6½ inches
Purchase, 33.55
Dr. Albert Einstein, 1934
Bronze, 13¾ × 10 × 11 inches
Purchase, 34.31

José de Creeft (b. 1884)
The Cloud, 1939
Greenstone, 13½ × 12½ × 8½ inches
Purchase, 41.17

Niki de Saint Phalle (b. 1930)
Black Venus, 1967
Painted polyester, 110 × 35 × 24 inches
Gift of the Howard and Jean Lipman
 Foundation, Inc., 68.73

Abastenia St. Leger Eberle (1878–1942)
Roller Skating, before 1909
Bronze, 13 × 11¾ × 6¼ inches
Gift of Gertrude Vanderbilt Whitney,
 31.15

Paul Fiene (1899–1949)
Bust of Grant Wood, c. 1942
Bronze, 17¼ × 7½ × 8 inches
Promised gift of Mr. and Mrs. George D.
 Stoddard, 1.77

Richard Fleischner (b. 1944)
Walking Figure, 1970
Bronze, copper, and silver,
 7¼ × 12½ × 1¾ inches
Anonymous gift, 71.188

Mary Frank (b. 1933)
Swimmer, 1978
Ceramic, 17 × 94 × 32 inches
Gift of Mrs. Robert M. Benjamin, Mrs.
 Oscar Kolin, and Mrs. Nicholas Mill-
 house, 79.31

Frank Gallo (b. 1933)
The Swimmer, 1964
Polyester resin, 65 × 16 × 41¼ inches
Gift of the Friends of the Whitney Mu-
 seum of American Art and the artist,
 65.25

Robert Graham (b. 1938)
Untitled, 1968
Balsa wood, plexiglas, and wax,
 12 × 30 × 15 inches
Gift of the Howard and Jean Lipman
 Foundation, Inc., 69.56

Peter Grippe (b. 1912)
Three Furies, II, 1955–56
Bronze, 14 × 11½ × 9¾ inches
Purchase, 57.44

Chaim Gross (b. 1904)
Acrobatic Dancers, 1942
Ebony, 40½ × 10½ × 7 inches
Purchase, 42.28

Nancy Grossman (b. 1940)
Head, 1968
Epoxy, leather, and wood,
 16¼ × 6½ × 8½ inches
Gift of the Howard and Jean Lipman
 Foundation, Inc., 68.81

Raoul Hague (b. 1905)
Figure in Elm, 1948
Elm, 48½ × 14 × 14 inches
Gift of the Howard and Jean Lipman
 Foundation, Inc., 66.26

Duane Hanson (b. 1925)
Woman and Dog, 1977
Polychromed polyvinyl, life-size
Gift of Frances and Sydney Lewis, 78.6

Malvina Hoffman (1885–1966)
Pavlova, 1915
Bronze, 13¾ inches high
Gift of Gertrude Vanderbilt Whitney,
 31.36

Edward Kienholz (b. 1927)
The Wait, 1964–65
Tableau: epoxy, glass, wood, and found
 objects, 80 × 148 × 78 inches
Gift of the Howard and Jean Lipman
 Foundation, Inc., 66.49

Gaston Lachaise (1882–1935)
Standing Woman, 1912–27
Bronze, 70 × 28 × 16 inches
Purchase, 36.91
Standing Figure, 1927
Bronze, 11¼ × 4¼ × 3¼ inches
Given in memory of Edith Gregor Halpert
 by the Halpert Foundation, 75.14
Torso, 1930
Bronze, 11½ × 7 × 2¼ inches
Purchase, 58.4
Man Walking, 1933
Bronze, 23 × 11¼ × 8½ inches
Purchase, 33.58

Robert Laurent (1890–1970)
Kneeling Figure, 1935
Bronze, 23½ × 11¼ × 12 inches
Purchase, 36.2

Jacques Lipchitz (1891–1973)
Marsden Hartley Sleeping, 1942
Bronze, 10¼ × 7¾ × 10 inches
Gift of Benjamin Sonnenberg, 76.41
Sacrifice, II, 1948/52
Bronze, 49¼ × 33 × 22 inches
Purchase, 52.27

Bruno Lucchesi (b. 1926)
Woman Undressing, 1964
Bronze relief, 27¾ × 17¾ inches
Gift of Mr. and Mrs. Haim Shwisha, 65.91

Marisol (b. 1930)
Women and Dog, 1964
Fur, leather, plaster, synthetic polymer,
 and wood, 72 × 82 × 16 inches
Gift of the Friends of the Whitney Mu-
 seum of American Art, 64.17

Robert Moir (b. 1917)
Mother and Child, 1950
Limestone, 22¼ × 13½ × 10 inches
Purchase, 52.18

Elie Nadelman (1882–1946)
Draped Standing Female Figure, 1908
Marble, 22¾ × 11 × 8 inches
Promised gift of an anonymous donor,
 8.75
Spring, c. 1911, cast 1966
Bronze relief, 47 × 57 × 1½ inches
Gift of Charles Simon, 69.140
Dancing Figure, 1916–18
Bronze, 29½ × 12 × 11½ inches
Promised gift of an anonymous donor,
 7.75

Reuben Nakian (b. 1897)
The Lap Dog, 1927
Terra-cotta, 6½ × 5 × 10½ inches
Gift of Gertrude Vanderbilt Whitney,
 31.56
Pastorale, 1950
Terra-cotta, 15 × 20 × 9 inches
Gift of the artist in memory of Juliana
 Force, 63.47

Louise Nevelson (b. 1900)
Moving—Static—Moving Figures, c. 1945
Terra-cotta; two of fifteen individual
 pieces, sizes vary
Gift of the artist, 69.159

Isamu Noguchi (b. 1904)
The Queen, 1931
Terra-cotta, 45½ × 16 × 16 inches
Gift of the artist, 69.107

Larry Rivers (b. 1923)
Berdie Seated, Clothed, 1953
Bronze, 10 × 6½ × 9¾ inches
Lawrence H. Bloedel Bequest, 77.1.45

Hugo Robus (1885–1964)
Despair, 1927
Bronze, 12¾ × 10 × 13 inches
Purchase, 40.23

Concetta Scaravaglione (1900–1975)
Group, 1935
Mahogany, 24¼ × 10½ × 10 inches
Purchase, 36.4

George Segal (b. 1924)

Walk, Don't Walk, 1976

Plaster, cement, metal, paint, and electric light, 104 × 72 × 72 inches

Gift of the Louis and Bessie Adler Foundation, Seymour M. Klein, President; the Gilman Foundation, Inc.; the Howard and Jean Lipman Foundation, Inc.; and the National Endowment for the Arts, 79.4

Maurice Sterne (1878–1957)

The Bomb Thrower, 1910/14

Bronze, 12 × 7½ × 9½ inches

Bequest of Mrs. Sam A. Lewisohn, 54.51

Harold Tovish (b. 1921)

Vortex, 1966

Bronze, 66 × 18 × 18 inches

Gift of an anonymous donor (and purchase), 66.132

Ernest Trova (b. 1927)

Study/Falling Man 1966, 1966

Silicon bronze, 21 × 78½ × 31 inches

Gift of Howard and Jean Lipman, 67.12

Stephan Von Huene (b. 1932)

Persistent Yet Unsuccessful Swordsman, 1965

Leather and wood, 28½ × 6¾ × 6½ inches

Gift of the Howard and Jean Lipman Foundation, Inc., 68.44

Gertrude Vanderbilt Whitney (1875–1942)

Fountain, 1913

Bronze, 42 × 36 × 29 inches high

Gift of the artist, 31.78

Mahonri M. Young (1877–1957)

Groggy, 1926

Bronze, 14½ × 8¼ × 9½ inches

Gift of Gertrude Vanderbilt Whitney, 31.82

William Zorach (1887–1966)

Figure of a Child, 1921

Mahogany, 24 × 5½ × 6¼ inches

Gift of Dr. and Mrs. Edward J. Kempf, 70.61

The Future Generation, 1942–47

Botticini marble, 40 × 19 × 14¼ inches

Purchase (and exchange), 51.32

Addenda:

Hyman Bloom (b. 1913)

The Anatomist, 1953

Oil on canvas, 70½ × 40½ inches

Purchase, 54.17

Seymour Lipton (b. 1903)

Sailor, 1936

Oak, 18 × 36 × 9 inches

Gift of the artist, 79.80